AESTHETICS AND THE ARTS

AESTHETICS AND THE ARTS

LEE A. JACOBUS

Western Connecticut State College

McGRAW–HILL BOOK COMPANY

New York, St. Louis, San Francisco, Toronto, London, Sydney

ACKNOWLEDGMENTS

HERBERT READ. "A Definition of Art" from *The Meaning of Art* (copyright © 1931 by Faber and Faber Ltd.) Reprinted in the United States by permission of Pitman Publishing Corporation; reprinted in Canada by permission of Faber and Faber Ltd.

BERNARD BERENSON. "The Aesthetic Moment" from *Aesthetics and History* (copyright 1948 by Pantheon Books). Reprinted by permission of Random House, Inc.

WILLIAM H. BOSSART. "Form and Meaning in the Visual Arts," appeared in *British Journal of Aesthetics*, vol. 6, pp. 259-271, 1966. Reprinted by permission.

BERTRAM JESSUP. "What is Great Art?" appeared in *British Journal of Aesthetics*, vol. 2, pp. 26-35, 1962. Reprinted by permission.

P. A. MICHELIS. "Aesthetic Distance" is from "Aesthetic Distance and the Charm of Contemporary Art," *Journal of Aesthetics and Art Criticism*, vol. 18, pp. 1-15, 1969. Reprinted by permission.

CURT JOHN DUCASSE. "Art and the Language of the Emotions," *Journal of Aesthetics and Art Criticism*, vol. 23, pp. 109-112, 1964. Reprinted by permission.

MONROE C. BEARDSLEY. "On the Creation of Art," *Journal of Aesthetics and Art Criticism*, vol. 23, pp. 291-304, 1965. Reprinted by permission.

SUSANNE K. LANGER. "The Dynamic Image" from *Problems of Art*. Reprinted with the permission of Charles Scribner's Sons from *Problems of Art*, pp. 1-12, by Susanne K. Langer. Copyright © 1957 Susanne K. Langer.

SELMA JEANNE COHEN. "A Prolegomenon to an Aesthetics of Dance," *Journal of Aesthetics and Art Criticism*, vol. 21, pp. 19-26, 1962. Reprinted by permission.

MORRIS WEITZ. "Purism and the Dance" from *Philosophy of the Arts*. Reprinted by permission of the publishers from Morris Weitz *Philosophy of the Arts*, Cambridge, Mass.: Harvard University Press, copyright, 1950 by the President and Fellows of Harvard College.

WAYNE SHUMAKER. "The Cognitive Value of Literature" from Wayne Shumaker, *Literature and the Irrational: A Study in Anthropological Backgrounds*, © 1960. By permission of Prentice-Hall, Inc., Englewood Cliffs, N.J.

I. A. RICHARDS. "Poetry and Beliefs" from *Principles of Literary Criticism* by I. A. Richards. Reprinted by permission of Harcourt, Brace & World, Inc.

ERIC CAPON. "Theatre and Reality" appeared in the *British Journal of Aesthetics*, vol. 5, pp. 261-269, 1965. Reprinted by permission.

HUGH KENNER. "The Counterfeiters" first appeared in the Winter, 1966 issue of *The Virginia Quarterly Review*. It will appear as part of Mr. Kenner's book also entitled *The Counterfeiters*. Copyright © 1966 by Hugh Kenner. Reprinted by permission of The Sterling Lord Agency.

AARON COPLAND. "The Creative Process in Music" from *What to Listen For in Music*, rev. ed. by Aaron Copland. Copyright © 1957 by McGraw-Hill, Inc. Used by permission of McGraw-Hill Book Company.

EDUARD HANSLICK. "The Effects of Music" from Eduard Hanslick: *The Beautiful in Music*, translated by Gustav Cohen, edited by Morris Weitz, copyright © 1957 by The Liberal Arts Press, Inc., reprinted by permission of the Liberal Arts Press Division of the Bobbs-Merrill Company, Inc.

SUSANNE K. LANGER. "On Significance in Music." Reprinted by permission of the publishers from Susanne K. Langer, *Philosophy in a New Key*, Cambridge, Mass.: Harvard University Press, Copyright 1942, 1951, 1957 by the President and Fellows of Harvard College.

JOHN HOSPERS. "Meaning in Painting" is from *Meaning and Truth in the Arts*, © 1946 by John Hospers and published by the University of North Carolina Press.

F. DAVID MARTIN. "On Enjoying Decadence," *Journal of Aesthetics and Art Criticism*, vol. 17, pp. 441-446, 1959. Reprinted by permission.

FANCHON FRÖHLICH. "Aesthetic Paradoxes of Abstract Expressionism and Pop Art," *British Journal of Aesthetics*, vol. 6, pp. 17-25, 1966. Reprinted by permission.

ETIENNE GILSON. "Aesthetic Existence" from *Painting and Reality* by Etienne Gilson. Bollingen Series XXXV (New York: Pantheon Books, 1957), pp. 35-50. Reprinted by permission of the Trustees of the National Gallery of Art, Washington, D.C.

ACKNOWLEDGMENTS

v

CLEMENT GREENBERG. "The New Sculpture," reprinted by permission of the Beacon Press, copyright © 1948, 1958, 1961 by Clement Greenberg. From *Art and Culture*.

FRANK LLOYD WRIGHT. "Architecture Is Abstract," reprinted by permission of the publisher, Horizon Press, from *The Future of Architecture* by Frank Lloyd Wright. Copyright 1953.

LEWIS MUMFORD. "Symbol and Function in Architecture" from *Art and Technics*, © 1952 by Lewis Mumford, published by Columbia University Press, New York, pp. 111-136. Reprinted by permission of the publishers.

EDUARDO TORROJA. "Notes on Structural Expression," from *Art and Artist*, © 1956 by University of California Press. Reprinted by permission.

ALBERT BUSH-BROWN. "How a Building May Fail to Become Architecture," from "The Architectural Polemic," *Journal of Aesthetics and Art Criticism*, vol. 8, (1959) pp. 147-148, 1959. Reprinted by permission.

SIEGFRIED KRACAUER. "The Issue of Art," from *Theory of Film: The Redemption of Physical Reality* by Siegfried Kracauer. Copyright © 1960 by Oxford University Press, Inc. Reprinted by permission.

RUDOLF ARNHEIM. "Art Today and the Film" appeared in *Art Journal*, Spring, 1966, pp. 242-244. Reprinted by permission.

MICHAEL ROEMER. "The Surfaces of Reality" © 1964 by the Regents of the University of California. Reprinted from *Film Quarterly*, vol. 18, no. 1, pp. 15-22, by permission of the Regents.

*This book is dedicated with love
to Julia and Ernest Jacobus*

PREFACE

A*esthetics and the Arts* is a first book for students of the arts; it is designed to introduce beginning students to the current thinking among philosophers about art. The basic premise of the book is that an exposure to ideas in aesthetics will help develop an advanced sense of awareness about the arts and their potentials. Further, a familiarity with aesthetic principles should produce a sounder critical attitude toward art, which will permit individuals to trust their own judgments. A grounding in aesthetics should help identify the kinds of judgments which can be reasonably attempted of an art object, just as it should help identify the kinds of statements and judgments which are irrelevant or misleading about the arts. The authors represented in this book think philosophically about art; thinking philosophically means thinking as clearly and reasonably as possible.

It should be pointed out that this book is more selective and suggestive than thorough and exhaustive in presenting the schools of aesthetics which have flourished and are now flourishing. The editorial view here is not limited to any philosophical coterie, and consequently many of the following essays develop points of view with which the editor does not fully agree. Likewise there is healthy disagreement between many represented authors who may feel themselves in strange company at times. All this is by design, in the hope of presenting valuable points which teacher and student can debate. Aesthetics is not a science. As a branch of philosophy it leaves much to be desired. A reading of this book will show quickly that among the qualities wanting are absolute definitions and critical certainty. This is to be understood from the outset. Acceptance of a position in aesthetics without debate is very risky and ultimately not to be desired. These selections are best read in an environment which permits strong disagreement and healthy dialogue.

With the exception of the first few selections, these essays were not chosen because they discuss such specific aesthetic problems as ontology, value, the act of creation, or other topics. Instead, these essays were selected on the basis of their availability—in terms of technical difficulty—to nonspecialists. They were selected to provide some basic philosophical insights into the nature and

limitations of specific art forms such as the dance, literature, and architecture. Each section of the book develops certain useful aesthetic principles which will serve to introduce a student to problems which are specifically related to that art form. Naturally, a few essays can only be suggestive. An adequate, full-scale treatment of the aesthetics of any one of these art forms could be accomplished only by a good-sized volume.

One suggestion which should be taken seriously is that the first section, "Some Overall Views," be read in its entirety immediately. The essays in this section should then be borne in mind when reading the essays in any section that is more particularly concerned with one art form. It will be seen quickly that the first essays were chosen for their usefulness and application in exactly this manner.

Many individuals deserve mention for their help in the making of this book. To Mrs. Katherine Mansbridge I owe what all teachers owe to librarians whose competence accompanies virtuosity and a superior love of learning. My debt extends to David Driscoll and the luxury of long conversations which I shall never forget and which helped sharpen my grasp of all that is worthwhile in the arts. I enjoyed some of the best talk on painting and the arts with two distinguished artists: James Timmins and Stanley Bleifeld. They were not only my colleagues in the search for aesthetic truths but also my instructors. Their hand, though invisible, appears in my selections in this book. I am grateful, too, for many pleasant hours of talk with the composer Richard Moryl and the conductor Marceau Myers. Finally, I owe a debt of appreciation to my formal instructors in the philosophy of the arts: Vincent Tomas and Curt John Ducasse. Though they have probably forgotten me, I shall not forget them.

Ultimately, the intention of this book is to produce more sensitive and conscious viewers of the arts.

<div align="right">LEE A. JACOBUS</div>

CONTENTS

MUSIC *161*

VISUAL ARTS: PAINTING AND SCULPTURE *213*

ARCHITECTURE *261*

FILM *287*

CONTRIBUTORS *309*

SELECTED READINGS *311*

SOME OVERALL VIEWS

One of the most reasonable beginnings for any study of the arts is an attempt at definitions. In one way or another, most of these initial selections are concerned with problems of definitions. It becomes apparent rather quickly that no single definition of the arts or of any art form is totally satisfactory. Some aestheticians will defend a definition vigorously, while others will contend that definitions are overly restrictive and in the final analysis unnecessary. Some aestheticians hold that any object whatever can have aesthetic value, can be regarded in the same way one regards a vase or a play or a painted landscape. Others hold that the expression of an artist is missing from all natural or haphazardly organized objects and events, thereby disqualifying them from being true objects of art with "normal" aesthetic value. Older philosophers of art disqualified all ugly objects from the realm of art, and Herbert Read is quick in his attempt at a definition to suggest that art is not only that which is beautiful and pleasing. His discussion of beauty, the one word central to nineteenth-century aesthetics and still critical to aesthetics today, is an illuminating attempt to show how our preconceptions can limit our thinking about art. His definition of art is purposely unrestrictive and even loose. Consider what the alternatives to a definition of art might be, how one may improve upon Read's definition without excluding objects which may have a claim to be works of art.

William H. Bossart is concerned with the problems of formalism, the organization of the work of art, in contrast with the meaning of the work of art. His discussion should help clarify some of the main positions on this problem while at the same time clarifying the nature of the problem as it relates to all works of art. In a sense Bertram Jessup is taking up the problem again in his try at a definition of great art. He is coping with the question whether the content and meaning of the work of art or its formal organization qualifies it for greatness. Surely there can be no simple answer to the question, and yet the question is relevant to all art forms, most particularly to those forms which have a highly developed meaning or content, such as literature, drama, some forms of dance, and representational painting and sculpture. Reading these essays will make clear the fact that there are several vigorously argued points of view and that none of them can easily be discounted.

P. A. Michelis raises a question of profound importance for anyone develop-

ing a significant concern for the arts: the question of aesthetic distance. This concept demands that one set himself emotionally apart from the work of art to see more clearly what its elements are. Can a viewer who has an emotional "interest" in a work of art really hope to understand it? Or, in a different way: should one be subjectively involved or objectively detached in order to make the best critical judgment? Is there a mean between these two positions? Michelis discusses the views of such "distancers" as Ortega and Bullough. In addition he discusses the problems of spatial and temporal distance and their relationship to producing an ideal aesthetic or psychical distance. One might ask himself as he reads Michelis what the alternatives to aesthetic distance are and what the risks of overdistancing or underdistancing a work of art might be.

When C. J. Ducasse examines the "language of the emotions" in art, he is dealing with the familiar problem of whether art is really expressive of some kind of emotional content. This is a persistent and troublesome dilemma. Ducasse is curious to see if there is any relationship between the aesthetic experience we have of a work of art and the "feelings the artist intended the object he has created to express." And Monroe C. Beardsley's concern for the sources and the quality of the creative impulse in the artist touches one of the fundamental areas of interest for both aestheticians and artists. Beardsley's examination is a rich and suggestive tour through the maze of current thinking on the subject, and it offers as clear an aesthetic statement on the problem as we are likely to have.

A DEFINITION OF ART

HERBERT READ

The simple word "art" is most usually associated with those arts which we distinguish as "plastic" or "visual," but properly speaking it should include the arts of literature and music. There are certain characteristics common to all the arts, and though in these notes we are concerned only with the plastic arts, a definition of what is common to all the arts is the best starting-point of our enquiry.

It was Schopenhauer who first said that all arts aspire to the condition of music; that remark has often been repeated, and has been the cause of a good deal of misunderstanding, but it does express an important truth. Schopenhauer was thinking of the abstract qualities of music; in music, and almost in music alone, it is possible for the artist to appeal to his audience directly, without the intervention of a medium of communication in common use for other purposes. The architect must express himself in buildings which have some utilitarian purpose. The poet must use words which are bandied about in the daily give-and-take of conversation. The painter must express himself by the representation of the visible world. Only the composer of music is perfectly free to create a work of art out of his own consciousness, and with no other aim than to please. But all artists have this same intention, the desire to please; and art is most simply and most usually defined as an attempt to create pleasing forms. Such forms satisfy our sense of beauty and the sense of beauty is satisfied when we are able to appreciate a unity or harmony of formal relations among our sense-perceptions.

Any general theory of art must *begin* with this supposition: that man responds to the shape and surface and mass of things present to his senses, and that certain arrangements in the proportion of the shape and surface and mass of things result in a pleasurable sensation, whilst the lack of such arrangement leads to indifference or even to positive discomfort and revulsion. The sense of pleasurable relations is the sense of beauty; the opposite sense is the sense of ugliness. It is possible, of course, that some people are quite unaware of proportions in the physical aspect of things. Just as some people are color-blind, so others may be blind to shape and surface and mass. But just as people who are color-blind are comparatively rare, so there is every reason to believe that people wholly unaware of the other visible properties of objects are equally rare. They are more likely to be undeveloped.

4

There are at least a dozen current definitions of beauty, but the merely physical one I have already given (beauty is a unity of formal relations among our sense-perceptions) is the only essential one, and from this basis we can build up a theory of art which is as inclusive as any theory of art need be. But it is perhaps important to emphasize at the outset the extreme relativity of this term beauty. The only alternative is to say that art has no necessary connection with beauty—a perfectly logical position to hold if we confine the term to that concept of beauty established by the Greeks and continued by the classical tradition in Europe. My own preference is to regard the sense of beauty as a very fluctuating phenomenon, with manifestations in the course of history that are very uncertain and often very baffling. Art should include all such manifestations, and the test of a serious student of art is that, whatever his own sense of beauty, he is willing to admit into the realm of art the genuine manifestations of that sense in other people at other periods. For him, Primitive, Classical and Gothic are of equal interest, and he is not so much concerned to assess the relative merits of such periodical manifestations of the sense of beauty as to distinguish between the genuine and false of all periods.

Most of our misconceptions of art arise from a lack of consistency in the use of the words art and beauty. It might be said that we are only consistent in our misuse of them. We always assume that all that is beautiful is art, or that all art is beautiful, that what is not beautiful is not art, and that ugliness is the negation of art. This identification of art and beauty is at the bottom of all our difficulties in the appreciation of art, and even in people who are acutely sensitive to aesthetic impressions in general, this assumption acts like an unconscious censor in particular cases when art is not beauty. For art is not necessarily beauty: that cannot be said too often or too blatantly. Whether we look at the problem historically (considering what art has been in past ages) or sociologically (considering what art actually is in its present-day manifestations all over the world) we find that art often has been or often is a thing of no beauty.

Beauty is sometimes defined simply as that which gives pleasure; and thus people are driven into admitting that eating and smelling and other physical sensations can be regarded as arts. Though this theory can quickly be reduced to absurdity, a whole school of aesthetics is founded on it, and until lately this school was even the predominant one. It has now been superseded in the main by a theory of aesthetics derived from Benedetto Croce, and though Croce's theory has met with a flood of criticism, its general tenet, that art is perfectly defined when simply defined as *intuition,* has proved to be much more illuminating than any previous theory. The difficulty has been to apply a theory depending on such vague terms as "intuition" and "lyricism." But the

point to note immediately is, that this elaborate and inclusive theory of the
arts gets on very well without the word "beauty."

The concept of beauty is, indeed, of limited historical significance. It arose
in ancient Greece and was the offspring of a particular philosophy of life. That
philosopy was anthropomorphic in kind; it exalted all human values and saw
in the gods nothing but man writ large. Art, as well as religion, was an
idealization of nature, and especially of man as the culminating point of the
process of nature. The type of classical art is the Apollo Belvedere or the
Aphrodite of Melos—perfect or ideal types of humanity, perfectly formed, per-
fectly proportioned, noble and serene; in one word, beautiful. This type of
beauty was inherited by Rome, and revived at the Renaissance. We still live in
the tradition of the Renaissance, and for us beauty is inevitably associated
with the idealization of a type of humanity evolved by an ancient people in a
far land, remote from the actual conditions of our daily life. Perhaps as an
ideal it is as good as any other; but we ought to realize that it is only one of
several possible ideals. It differs from the Byzantine ideal, which was divine
rather than human, intellectual and anti-vital, abstract. It differs from the
Primitive ideal, which was perhaps no ideal at all, but rather a propitiation,
an expression of fear in the face of a mysterious and implacable world. It
differs also from the Oriental ideal, which is abstract too, non-human, meta-
physical, yet instinctive rather than intellectual. But our habits of thought are
so dependent on our outfit of words, that we try, often enough in vain, to
force this one word "beauty" into the service of all these ideals as expressed
in art. If we are honest with ourselves, we are bound to feel guilty sooner or
later of verbal distortion. A Greek Aphrodite, a Byzantine Madonna and a
savage idol from New Guinea or the Ivory Coast cannot one and all belong to
this classical concept of beauty. The latter at least, if words are to have any
precise meaning, we must confess to be unbeautiful, or ugly. And yet, whether
beautiful or ugly, all these objects may be legitimately described as works of
art.

Art, we must admit, is not the expression in plastic form of any one particular
ideal. It is the expression of any ideal which the artist can realize in plastic
form. And though I think that every work of art has some principle of form
or coherent structure, I would not stress this element in any obvious sense,
because the more one studies the structure of works of art which live in
virtue of their direct and instinctive appeal, the more difficult it becomes to
reduce them to simple and explicable formulae. That "there is no excellent
beauty that hath not some strangeness in the proportion" was evident even
to a Renaissance moralist.

However we define the sense of beauty, we must immediately qualify it as

theoretical; the abstract sense of beauty is merely the elementary basis of the artistic activity. The exponents of this activity are living men and their activity is subject to all the cross-currents of life. There are three stages: first, the mere perception of material qualities—colors, sounds, gestures, and many more complex and undefined physical reactions; second, the arrangement of such perceptions into pleasing shapes and patterns. The aesthetic sense may be said to end with these two processes, but there may be a third stage which comes when such an arrangement of perceptions is made to correspond with a previously existing state of emotion or feeling. Then we say that the emotion or feeling is given expression. In this sense it is true to say that art is expression —nothing more and nothing less. But it is always necessary to remember (which the Croceans sometimes fail to do) that expression in this sense is a final process depending on the preceding processes of sensuous perception and formal (pleasurable) arrangement. Expression can, of course, be completely devoid of formal arrangement, but then its very incoherence forbids us to call it art.

Aesthetics, or the science of perception, is only concerned with the first two processes; art may involve beyond these values of an emotional kind. It may be said that nearly all the confusion in the discussion of art arises from the failure to keep this distinction clear; ideas that concern only the history of art are introduced into discussions of the concept of beauty; the purpose of art, which is the communication of feeling, is inextricably confused with the quality of beauty, which is the feeling communicated by particular forms.

The permanent element in mankind which corresponds to the element of form in art is man's aesthetic sensibility. It is the sensibility that is static. What is variable is the understanding which man builds up from the abstraction of his sensible impressions, his intellectual life, and to this we owe the variable element in art—that is to say, expression. I am not sure that "expression" is a good word to use in contrast to "form." Expression is used to denote natural emotional reactions, but the very discipline or restraint by which the artist achieves form is itself a mode of expression. Form, though it can be analyzed into intellectual terms like measure, balance, rhythm and harmony, is really intuitive in origin; it is not in the actual practice of artists an intellectual product. It is rather emotion directed and defined, and when we describe art as "the will to form" we are not imagining an exclusively intellectual activity, but rather an exclusively instinctive one. For this reason I do not think we can say that Primitive art is a lower form of beauty than Greek art, because although it may represent a lower kind of civilization, it may express an equal or even a finer instinct for form. The art of a period is a standard only so long as we learn to distinguish between the elements of form, which are universal,

and the elements of expression, which are temporal. Still less can we say that in *form* Giotto is inferior to Michelangelo. He may be less complicated, but form is not valued for its degree of complexity. Frankly, I do not know how we are to judge form except by the same instinct that creates it.

THE AESTHETIC MOMENT

BERNARD BERENSON

In visual art the aesthetic moment is that flitting instant, so brief as to be almost timeless, when the spectator is at one with the work of art he is looking at, or with actuality of any kind that the spectator himself sees in terms of art, as form and color. He ceases to be his ordinary self, and the picture or building, statue, landscape, or aesthetic actuality is no longer outside himself. The two become one entity; time and space are abolished and the spectator is possessed by one awareness. When he recovers workaday consciousness it is as if he had been initiated into illuminating, exalting, formative mysteries. In short, the aesthetic moment is a moment of mystic vision.

FORM AND MEANING
IN THE VISUAL ARTS

WILLIAM H. BOSSART

If the literature of twentieth-century aesthetics and art criticism has favored any single definition of art, it is that each work of art is an end in itself. This

is often taken to mean that artistic significance has nothing whatever to do with real life; that the meaning of a work of art lies wholly in its form. In this view the artist is concerned primarily with the creation of those purely formal values which are intrinsic to his work. The successful work, in turn, should fascinate and unify the viewer's attention so that he contemplates it as it is immediately given to him, thus avoiding the tendency to "read into" the work meaning and expression which are extrinsic to its formal structure. And if we follow this line of thought to its logical conclusion, we shall be tempted to agree with Clive Bell that "to appreciate a work of art we need bring with us nothing from life, no knowledge of its ideas and affairs, no familiarity with its emotions . . . nothing but a sense of form and color and a knowledge of three-dimensional space." [1]

Yet someone will certainly object that an art thus conceived would be entirely abstract and devoid of all significance save our fleeting and trivial reactions to certain decorative qualities. Such a theory cannot account for the prophecy of Goya, the wisdom of Rembrandt or the power of the African fetish. And if it is true that Whistler's painting is immediately given to us as an "arrangement in gray and black," it is no less true that we do not rest content with that given. In spite of Whistler's title, we persist in seeing an old woman seated in a chair, and it is forms such as these which prevent our reading the painting merely as a decorative surface.

The formalist would reply that when we read the painting in this way we *interpret* its formal structure in terms of our past experience of real life. In short we turn the painting into a symbol, and when we read a symbol we do not contemplate the symbol itself but look through it to the meaning symbolized. Furthermore, to take Whistler's painting as standing for a real woman seated in a real chair also invites us to ask whether the artist's forms successfully represent their subject. Yet we would no more reject the Whistler on the grounds that it is unlike a real woman than we would reject a Holbein portrait if it could be shown to be a poor likeness. We do not measure the success of a work of art against some external standard but in terms of its own inner coherence and consistency. Thus to hold that a work of art symbolizes meanings drawn from life not only runs counter to the nature of aesthetic experience; it also invites comparisons of the work with that which it symbolizes, and these comparisons are misleading and aesthetically irrelevant.

But despite the clear logic of the formalist's position, art still appears to lie somewhere between the two extremes of decoration and illustration. The statements of the most radical non-objective painters, Kandinsky and Mondrian for example, testify to the artist's belief in the connection between his art and

[1] *Art,* 1923, p. 25.

life.[2] Yet non-formal significance continually eludes our grasp. A self-interview by the contemporary American sculptor Robert Mallary punctuates our dilemma. In an early part of the interview Mallary speaks of his work as having to do with "contemporary man as assailed, harassed, confused, frustrated, befuddled, desperate and hysterical." But then he asks himself: "It would appear then that you place great emphasis on formal values?" and answers: "Finally they are almost everything." [3] An artist need not examine the paradoxical nature of his statements about his art in order to create. For us, however, Mallary's remarks and the perplexing status of meaning in art suggest that another look at the context in which our difficulties arise may be in order.

A work of art is given to us first of all in sense perception, and we have come to learn that the perception of objects is by no means a simple matter. According to M. D. Vernon, when we perceive we are initially aware that there is "something there," that something stands out from the general background of our visual field. Then this "something" begins to assume a shape; first we perceive its outline and then the main interior features and their color and brightness. Finally we begin the process of classifying and identifying the "something" in question.[4] As the problem of identification becomes more complex the process of learning to classify objects appears to be greatly assisted by language. A number of experiments have shown that the naming of an object often affects the way in which the object is perceived in the present and recollected in the future. Thus subjects who have been asked to reproduce a set of simple shapes appear to be more influenced in making their reproductions by the names given them for these shapes than by the shapes themselves.[5] It seems, then, that we have certain conventional ideas about the shapes of objects which are closely related to the names of these objects. And in perceiving we tend to classify such objects according to their names and the shapes associated with their names.

This tendency to perceive the world in accordance with categories which have become familiar to us on the basis of past experience has been explored extensively by Adalbert Ames.[6] In one demonstration Ames asks the observer to look through three peep-holes at what he readily identifies as three conventional chairs. But when the observer goes around the viewing screen and sees these objects from a different point of view, he discovers that two of the

[2] See Kandinsky, *Concerning the Spiritual in Art,* 1912 (Eng. Trans. 1947). Also Mondrian, *Plastic Art and Pure Plastic Art,* 1937.
[3] Robert Mallary, "A Self-Interview," *Location,* vol. I, pp. 61, 63, Spring, 1963.
[4] M. D. Vernon, *The Psychology of Perception,* Penguin Books, 1962, pp. 31 ff.
[5] *Ibid.,* pp. 36–37.
[6] For a detailed discussion of this particular demonstration, see E. H. Gombrich, *Art and Illusion,* Phaidon, 1960, pp. 248–49. For a discussion of other experiments by Ames see Vernon, pp. 133–35, 149.

"chairs" are really constructions of wire and painted backdrops. Ames is trying to make us realize that perceptions do not reveal what is "really out there." There is, in fact, no way of determining what is really there. We can only guess and we will guess in accordance with our expectations. Since we know chairs but have no experience of those nameless constructions which might be read as chairs from one point of view, we always tend to classify what we see according to categories which are familiar to us.

Thus it would appear that we cannot do away so easily with past experience in our contemplation of works of art, for past experience functions in the *recognition* of what is immediately given as well as in its interpretation. Yet the formalist might object that aesthetic contemplation is not merely a special case of sense perception. It has been observed that the generic traits of a work of art—unity in diversity, theme and variation, emphasis, and so forth—those traits which enable us to consider a work of art as an end in itself—are identical with the so-called "factors of advantage" generally recognized by psychologists as controlling attention.[7] If this is so, why shouldn't the artist be able to *direct* our reading of his forms so that all need for guessing and all reference to our past experience would be eliminated?

To answer this question let us turn to Erwin Panofsky's discussion of Roger van der Weyden's *Three Magi*, in which the apparition of a small child is seen in the sky. What assures us that the child is to be read as an apparition? His halo of golden rays is not sufficient evidence, for such haloes also appear in paintings of the Nativity where the Infant Jesus is meant to be read as "real." We recognize the child as an apparition only because he hovers in mid-air, and he appears to hover only because he is surrounded by empty space with no visible means of support. Yet there are other cases in art in which human beings and inanimate objects are surrounded by empty space without seeming to float unsupported in the air. As an example, Panofsky cites a miniature from the *Gospels of Otto* in which a whole city is surrounded by empty space while the figures taking part in the action rest on solid ground. But the city does not float like the figure in the *Three Magi;* for in a miniature of this period empty space does not function as a real three-dimensional medium but serves as an abstract background. Thus while we believe that we are reading the forms of the picture as they are immediately given to us, Panofsky concludes that "we really are reading 'what we see' according to the manner in which objects and events are expressed by forms under varying historical conditions. In doing this we subject our practical experience to a corrective principle which may be called the history of style." [8] The formalist might object that such

7 *E.g.*, Eliseo Vivas, "A Definition of Esthetic Experience," *Journal of Philosophy,* vol. 34, pp. 628–34, 1937.
8 *Meaning in the Visual Arts*, Anchor Books, 1955, p. 35.

descriptions are not concerned with artistic forms but with what such forms *represent*. Hence they are of no importance for aesthetic contemplation. But this objection misses its mark, for these descriptions are also concerned with the organization of forms in space apart from what they represent. And without some familiarity with how space functions in the artistic traditions in question, we should not be able to read the artist's forms as he intended them to be read.

It has also been suggested that the formal significance of a work of art is primarily expressive; that it is as a presentation of certain emotional qualities that a work of art can be apprehended without any reference to the past experience of the viewer. This suggestion is supported by the fact that we tend to ascribe emotional qualities to pure colors and shapes, and by the phenomenon of synaesthesia—the apparent link between visual, auditory and tactile sensations in which the associated imagery does not appear to be the result of past experience. Thus Kandinsky envisaged the development of an art which, through its use of color, would serve as a universal language of the emotions—an analogue of music, whose significance he held to be primarily expressive. From this point of view a work of art is no longer conceived of as standing in a conventional symbolic relation to a meaning; rather it is understood as an "iconic sign" which embodies in itself the emotional qualities in question.

Yet even if we should agree that the formal elements of a work of art are presentations of specific emotional qualities, it is by no means clear that the expressive significance of these elements will remain constant when they appear in different contexts. The relation between expression and context has been brought out quite clearly by E. H. Gombrich. Gombrich asks whether his familiarity with Mondrian's painting *Broadway Boogiewoogie* would enable him to recognize a piece of boogiewoogie without any previous experience of this kind of music. He concludes that it would, provided that the context of the choice situation were made specific enough. Given a choice between a fast and noisy piece and one which is slow and blue, the proper selection is not difficult. But, he points out, our·understanding of the expressive significance of the painting depends not only upon our experience of certain possible types of music, but also on our knowledge of possible types of painting—in other words, on the context or mental set with which we approach the Mondrian. "In most of us the name of Mondrian conjures up the expectation of severity, of an art of straight lines and a few primary colors in carefully balanced rectangles. Seen against this background the boogiewoogie picture gives indeed the impression of gay abandon. . . . But this impression is in fact grounded on our knowledge of the restricted choice open to the artist within his self-imposed discipline. Let us imagine for a moment that we were told the painting is by

Severini, who is known for his Futuristic paintings that try to capture the rhythm of dance music in works of brilliant chaos. Would we then still feel the Mondrian belongs in the pigeon-hole with boogiewoogie, or would we accept a label calling it Bach's First Brandenburg Concerto?" [9]

In art, as in life, recognition always takes place within specific contexts supplied to us by past experience. We have learned to regard the forms of art as records of the artist's intentions; we expect that what he does makes sense and that if we can become familiar with the context in which his expression takes place, the meaning of his work will become clear to us. Yet within the general context of "art" there does not seem to be any single key which can unlock for us all the possible forms of artistic expression. Even where a work of art contains forms which resemble certain "natural" forms, the familiar context of nature may not assist us in reading the artist's work. "Nature" did not enable us to read Impressionist landscapes when they first appeared any more than it enables individuals unfamiliar with the techniques of photography to read photographic images. It is, in fact, only *after* the artist has taught us to see nature in paint that we come to recognize the presence of natural forms in his work.

It appears, then, that a correct reading of an artistic form requires a familiarity with the style in which that form was created. But familiarity with an artist's style entails, in turn, at least some acquaintance with many of those social-historical factors which the formalist's approach to art hopes to eliminate. For while the artist may be dedicated to making a good work, neither his idea of what makes a work good nor his manner of working can be isolated from the artistic traditions which he inherits. These traditions present him with certain problems—the rendering of three-dimensional space, the transformation of pigment into light, or even the expression of the act of painting itself. And they provide as well the initial schemata which aid the artist in solving these problems. Nor do these traditions evolve in complete independence from man's daily life and history. The artist makes use of the themes, patterns of organization and raw materials which are available to him. But the availability of these things is determined by the state of technology, the functions which art serves, dominant ideas in religion and philosophy, and even contemporary theories about space, light and visual perception.

Thus there are cases in which our lack of familiarity with certain of these factors has seriously hampered our appreciation of artistic form. For example, until we became familiar with the functions served by Egyptian art we tended to understand the Egyptian artist in the context provided to us by the Greeks, as striving imperfectly toward the imitation of the sensible world. And there

9 Gombrich, pp. 369–70.

is good reason to suspect that we are in a similar position with regard to the art of those cultures whose history has been lost to us. Yet this does not mean that we must remain fixed within the taste of our time like the observer in one of Ames's experiments. We can always try out new readings suggested to us by the archaeologist and the historian, the critic and the artist, or the work itself. Indeed we constantly make use of such knowledge in our appreciation of works of art. Thus Bernard Berenson once observed that a true appreciation of the Venetian painters and of their color requires that our eye grow accustomed to making allowance for the darkening caused by time and the effects of unsuccessful attempts at restoration.[10] Contrasted with the art of Matisse these paintings would look dull indeed. But seen in their own context and alongside the paintings of Florence, where color serves a different function and where time has also had its effects, their brilliance is clearly evident.

Our experience of a particular style, then, sets up a context of expectation against which we measure deviations and modifications. In art, as in life, we measure the new and unexpected against that which we already know. Because of this Gombrich has suggested that a work of art is really a set of clues which will provoke a correct reading of artistic form in the imagination of the viewer who is familiar with the tradition of viewing and painting in which the work was conceived. Art, then, is a kind of collaboration between artist and viewer, and in each case the conditions of successful collaboration may vary. A work of art may be an icon, but until we are familiar with the context in which the partnership between artist and viewer takes place, we cannot hope to recognize its nature.

The foregoing remarks suggest that there is no reason to exclude from art expression and meaning drawn from life merely because of the role which the viewer's experience plays in the recognition of those forms which bear such meaning. Our experience, we have seen, functions in the recognition of any form whatever. Yet the formalist has made an important point, for experience also functions in *interpretation*, which digresses beyond the content of the aesthetic given. Thus we have now to determine whether forms drawn from life can retain their meaning in that collaboration between artist and viewer about which we have been speaking or whether such meaning is imported illegitimately into aesthetic experience through interpretation, as the formalist maintains. To answer this question we need a clearer notion of the context in which this collaboration takes place. But if each work of art is an end in itself, this context can be clarified only by analogy. The analogue which I should like to employ here is that of *play* as it takes place within the context of the game.

The first essential characteristic of play, according to Johan Huizinga, is

[10] *The Italian Painters of the Renaissance*, 1954, p. 3.

that it is voluntary activity. Play to order is not play. Play, then, is an expression of freedom, and closely connected with this is the fact that play is not "ordinary" or "real" life. "It is rather a stepping out of 'real' life into a temporary sphere of activity with a disposition all of its own. Every child knows perfectly well that he is 'only pretending,' or that it was 'only for fun'. . . . Nevertheless, . . . the consciousness of play being 'only a pretend' does not by any means prevent it from proceeding with the utmost seriousness, with an absorption, a devotion that passes into rapture and, temporarily at least, completely abolishes that troublesome 'only' feeling. Any game can at any time wholly run away with the players." [11] Yet play remains disinterested in the sense that it stands outside the immediate wants and appetites of ordinary life. Play is also distinct from ordinary life as to both locality and duration. "It is 'played out' within certain limits of time and place. It contains its own course and meaning. . . . Once played, it endures as a new-found creation of the mind, a treasure to be retained by the memory. It is transmitted, it becomes tradition." [12]

Finally, there is an element of tension in play. "Tension means uncertainty, chanciness; a striving to decide the issue and so end it. The player wants something to 'go,' to 'come off'; he wants to 'succeed' by his own exertions. . . . Though play as such is outside the range of good and bad, the element of tension imparts to it a certain ethical value in so far as it means a testing of the player's prowess . . . because, despite his ardent desire to win, he must still stick to the rules of the game." [13] The player who breaks these rules is the "spoil-sport," who "shatters the play-world itself. By withdrawing from the game he reveals the relativity and fragility of the play-world in which he had temporarily shut himself with others. He robs play of its *illusion*—a pregnant word which means literally 'in-play' (from *inlusio, illudere* or *inludere*)." [14]

Although Huizinga acknowledges an element of play in artistic conception, he can find no room for play either in the execution of the work, which is "always subjected to the skill and proficiency of the forming hand," or in its enjoyment, "for where there is no visible action there can be no play." [15] But Huizinga overlooks the fact that no matter how carefully the artist conceives his work beforehand, the process of execution is not one of mechanical translation. Throughout this process the artist's hand and eye are constantly alert to possible changes of direction suggested perhaps by accident or by the nature of the materials with which he is working. And if we accept the view that art is the product of a partnership between artist and viewer—of their *collusion* in

[11] *Homo Ludens,* Beacon Press, 1960, p. 8.
[12] *Ibid.,* pp. 9–10.
[13] *Ibid.,* pp. 10–11.
[14] *Ibid.,* p. 11.
[15] *Ibid.,* p. 166.

the sense of "playing together"—Huizinga's conception of aesthetic enjoyment as passive must also be discarded.

Like play, both the creation and appreciation of art are voluntary activities. Though we might be forced to go to a museum and stare, we cannot be forced to have an aesthetic experience. And it is inconceivable that an artist could create without any free play of the imagination. Even within the strictest artistic conventions—in the sculpture of Africa for example—we find evidence of individual style. Nor is art "ordinary" or "real" life. In liberating us from the cares and desires of daily life a work of art introduces us to a world with a structure and meaning all its own. Art is also distinct from ordinary life with regard to location and duration. The museum, the gallery and the artist's studio are places dedicated to the specialized activities of appreciation and creation. They are analogous to the playing-field, the play-ground and the temple.

Finally, both the creation and appreciation of art become tradition, which is transmitted from one generation to the next through the medium of style. As there are different games in the world of play, so there are many traditions in the world of art. Yet despite their variety, these artistic traditions develop in accordance with the fundamental rules of art. Because each work of art is an end in itself, the cardinal rule of making is to make a good work. And the cardinal rule of viewing is that the viewer put aside the cares and desires of daily life and focus his attention exclusively upon the work itself. These rules make themselves felt in a quasi-ethical manner when we encounter in art the counterpart of the spoil-sport in play. This individual must not be confused with the genuine innovator, who breaks with a particular artistic tradition to establish a tradition of his own. He must also be distinguished from the "cheat," who acknowledges the rules but cannot live up to them. The latter is that small talent who must resort to overstatement, shock or gross sentimentality to capture the attention of his audience. The counterpart of the spoil-sport, however, seeks to rob artist and viewer of their successful collaboration by questioning the very context of art. He ridicules art as mere decoration or seeks to explain it away as the product of neurosis or of the forces of history. Or, even more seditiously, he substitutes for art something which resembles it yet whose function is not to lead us to aesthetic contemplation, but back to real life through the medium of illustration.

Like play, art breaks down the distinction between the real and the imaginary. It is neither free undisciplined fancy nor does it bow to the necessities of real life. It is ordered only by those artistic traditions in which artist and viewer are engaged. It is this aspect of art which formalism is so intent upon emphasizing. But if formalism has been able to save art from taking on the

seriousness of life, it has not been able to account for the fact that we, who are so seriously engaged in our daily lives, also take art most seriously. Bent as it is upon a single purpose, the formalist aesthetic is too narrow to include the wealth of meaning which distinguishes art from mere decoration.

By "decoration" I mean the exploration of plane, line, color and texture for their own sake. Decorative qualities are already present in the artist's materials, and through his work he forms them into a coherent whole in which they heighten, complement and contrast with one another. But an art dedicated exclusively to the presentation of these qualities would be like a language which spoke only about itself—beautifully said on occasion, but lacking any significance which would give it staying power in our experience. For no matter how cleverly such qualities may be organized to capture our attention, the fact remains that our response to color and shape becomes quickly attenuated. Thus if we are to explain the fascination which works of art hold for us, we must turn to the so-called "non-formal" significance, meaning and expression drawn from life, which has been in question throughout our discussion.

Just as all works of art contain certain decorative qualities, many works of art can also be read as illustrations. But an illustration does not communicate its significance in the same manner as a work of art. Etienne Gilson has brought the distinction between art and illustration into clearer focus by distinguishing two different but related arts, painting and picturing. A painting, according to Gilson, is primarily a form embodied in a matter, while the nature of a picture is determined by the relation between an image and some external reality. Thus a painting has its rule and justification within itself, while the quality and success of a picture is measured against the external reality which it imitates. Hence Gilson concludes that "all judgments and appreciations of paintings founded upon their relation to an external model are irrelevant to painting." [16] Yet his emphasis upon the role of the image in picturing is misleading, for the illustrator may also make use of abstract designs. Nor is there any need for the artist to restrict himself to abstraction. He may draw his forms from life and invest them with a new meaning within the context of his art or he may order these forms in a manner which parallels their natural order. The forms of the illustrator, however, remind us in some way of what they illustrate, while in a work of art forms do not stand for things which are external to the work. Rather they *are*, like the pieces in a game, the very things which they signify.

The distinction between art and illustration puts in question the distinction

[16] *Painting and Reality*, Routledge, 1957, p. 265. Gilson's discussion is reminiscent of A. C. Bradley's essay "Poetry for Poetry's Sake" in *Oxford Lectures on Poetry*, 1926.

which has been made between formal and non-formal significance. The recognition of a form on the basis of the viewer's experience is not what makes it the bearer of non-formal significance, for experience is involved in the recognition of all forms. Non-formal significance refers to a special kind of form—one which bears a resemblance to the forms of objects (and their expressive qualities) which we encounter in real life. But it is often difficult to determine when a form resembles an object. Do a few marks of crayon by Matisse resemble a bowl of flowers or some daubs of paint by Daumier a human face? Where we do distinguish natural forms from abstract forms, the distinction depends upon what forms we happen to have encountered in real life. But in the imaginative collusion between artist and viewer no distinction between the real and the imaginary is made. Non-formal significance, then, while it may be relevant to illustration, is not a category which applies to works of art. But this does not mean that aesthetic contemplation miraculously transforms faces or flowers into a plane surface covered with dots of color. It means only that if the artist can make us read his paint as an "old woman seated in a chair" within the context of his art, these forms retain their *meaning* but we take no interest in their *source*.

Let us consider, for a moment, Grünewald's *Crucifixion* as an example of how a work of art communicates its significance to us. The nearly symmetrical composition is so calm and balanced that what the brilliant light in the foreground reveals to us comes as a shock. Christ's tortured body, with its heavy head and torn flesh, is re-enforced in its horror by the twisted form and the color and texture of the paint. The roughness of the cross and the tattered loincloth repeat the qualities which we find in the body. These qualities stress Christ's humanity. But the size of the body, its dominant position in the total composition, and the pointing finger of John the Baptist on Christ's left emphasize his nature as the Savior. Even the background makes us aware of this duality. The Crucifixion takes place upon a hill but it is not just any hill. On closer inspection we find that the hill is really a mountain which towers over lesser peaks. And this contrast is repeated plastically in the outline of Christ's body against the black night sky, barely set off from the dark greenish landscape. It is this band of green which unites the figure of the Baptist with the group on Christ's right. This group of three figures, The Virgin, Saint John and the Magdalen, forms a triangular block which balances the powerful figure of the Baptist. This balance is a balance of expression as well, for the figures in the group seem to suffer passively in contrast to the assertive attitude of John the Baptist. Finally, we should note one rather remarkable feature of the painting. The fainting Virgin is clothed in white, which is needed to heighten the expressive quality of the painting. Even here, where the artist is

engaged in depicting the most familiar of scenes, artistic expression, rather than the conventions of daily life, dictates the final form of the painting. Nor does the grotesque character of the painting lead us back, like an illustration, to real life. As Max J. Friedlander has observed: "In spite of the utmost closeness to nature, not the tortured body but the picture of it rises before us; because the master communicates to us his vision and, thereby, his religious fervor in such purity and so decisively, that our imagination, removed far away from disturbing, unrelenting actuality, experiences the distant, sublime myth; and the fearsomeness becomes deeply affecting drama. In the picture Christ dies not once, not here: on the contrary, everywhere and always; hence never and nowhere." [17]

Just as the introduction of artifacts used in daily life may affect the structure of a game, so the introduction of meaning and expression drawn from life may affect artistic form. When Giotto introduced a psychological dimension into painting by creating a theatre in which the actors take notice of one another, he not only introduced a dimension of real life into art; he also set up certain formal restrictions which we cannot ignore. One cannot conceive, for example, of Giotto's Judas embracing Christ while Christ merrily signals another disciple to fill the wine glasses. Nor can we imagine the figures at the foot of the cross in Grünewald's *Crucifixion* attired in gold lamé à Klimt. Yet it is not real life which forbids these innovations but the total artistic context of the paintings in question. And the proof of this lies in the fact that such restrictions can be ignored within a different artistic context. The "pop" artist might show no more hesitation in making the alterations in question than did the surrealist in painting a moustache on the *Mona Lisa*.

Because many works of art contain forms which resemble certain natural forms we often discuss such works as if they were decorations—to distinguish them from the illustrations with which they might otherwise be confused. This is one reason why meaning and expression drawn from life are so difficult to pin down in a work of art. But there is a second reason for this elusiveness. When we try to separate the artist's message from its concrete embodiment in his materials that message becomes trivialized. For the artist conceives of what he has to say not in words but in paint or in some other material. In short the artist thinks plastically, and thinking plastically is an essential factor in the transformation of the artist's materials into artistic form. Thus to state the meaning of a self-portrait by the aging Rembrandt as "the wisdom that comes with age and suffering," or of Goya's *Disaster of War* as "war is hell," is to reduce artistic significance to the most obvious sort of platitude. The test of art over and against illustration is to ask whether the transformation of

[17] *On Art and Connoisseurship* (trans. Tancred Borenius), 1960, pp. 25–26.

meaning and material into artistic form is complete. Only where there is not paint plus meaning but meaning in paint do we find art and not illustration.

Yet even where this transformation is complete there is no guarantee that artistic form will be read correctly. For each of us there remain gaps to be filled in our experience of art and subjective predispositions to be overcome before we can become familiar with the artistic contexts in which certain works of art must be experienced. Aesthetic contemplation, then, is not so much a naïve apprehension of artistic form as it is a *search for meaning*. And the analogy between works of art and games makes us realize that it is possible for an enormously rich tapestry of meaning and expression drawn from life to reappear in art without any compromise of the relative independence of these two spheres of human experience. When we confront a work of art we are aware, like the players in a game, that it is only make-believe. Freed from the context of "real" life, a work of art requires only its own internal coherence. Hence within the interplay of the imagination between artist and viewer we are able to experience significance which need not be tested against the values and commitments of real life. It is for this reason that art can move us much more powerfully than illustration, for, as Huizinga points out, any game can run away with the players for a time and make them forget that it is only make-believe.

Yet this is not to say that art and life have no influence upon one another. Just as social-historical factors, religious and philosophical beliefs and technological progress may affect artistic form, so art may uncover meaning which has gone unnoticed in life. But though we can point to interactions and parallels between art and life, we cannot point out any firm causal relation between them. Like play, art resists any further explanation. Because it lives between "real" life and undisciplined fancy, art can conjure up for the informed and sympathetic viewer a whole universe of meaning as the object of aesthetic contemplation. But what each of us brings with him from that universe back to life is his own responsibility and not the responsibility of art.

WHAT IS GREAT ART?

BERTRAM JESSUP

The question "What is great art?" does not, as far as I have observed, appear in the approved lists of questions which are currently considered significant for aesthetic analysis. I suppose that its absence from such lists is accounted for by the fact that the term "great art" has in the long past figured centrally in that kind of rhetorical and effusive discourse about art which has proved itself fruitless in aesthetic understanding and which is now out of fashion.

Nevertheless, there are at least two sufficient reasons why the question deserves serious attention. The first is that the term "great art" continues in use, not only in lagging and uncritical popular talk, but also in the discourse of artists, museum professionals, academic instructors, and even, passingly at least, philosophical aestheticians. The second is that if it is to be abandoned as incorrigible to disciplined use, this should be after and not without a demonstration of its incorrigibility.

My paper attempts to bring together some of the characteristics which are currently asserted or implied to belong to "great art" and to call attention to some of the consequences for art evaluation which follow from their acceptance.

The traditional or orthodox view of "great art" may, I think, be said to be the "serious content" view, which has held an unbroken, though not unchallenged or untroubled, ascendancy ever since Socrates laid down and Plato enlarged and systematized the position that "that man is a fool who judges the beautiful by any other standard than that of the good."

Through the centuries since Plato, the history of aesthetic thinking has been largely one of disagreement with Plato, but the disagreement has itself been disagreed on the basic respect in which he was wrong. Two lasting traditions resulted from Plato's position. The first accepted his major premise that art is to be judged in terms of its success in conveying "serious content"—namely, factual truth, religious belief, and moral, social and political rightness; and it disagreed with him only, though importantly, in holding that art can and does do this. The second accepted Plato's minor premise that art does not significantly convey serious content, but disagreed with his major that it should do so. The two traditions are the so-called art for life's sake and the art for art's sake traditions. The former maintains the orthodox great art theory, the latter the dissident formalistic or dehumanistic great art theory.

21

Recent or contemporary philosophers who, in various forms, maintain the "serious content" view include S. Alexander, Theodore Greene, S. C. Pepper, Katherine Gilbert, and, in a deviationist way, I. A. Richards. Most of those who hold the position distinguish explicitly between formal and surface excellence, which is sufficient for perfection, and important content, which is additionally needed for greatness' beyond excellence in the work of art. Thus, for example, Theodore Greene:

Two compositions may be similar in artistic quality or degree of perfection . . . but the content of one may be slight, that of the other, rich in human import. . . . The standard of artistic perfection is primarily aesthetic or infra-philosophic, while the standards of truth and greatness are primarily supra-aesthetic or philosophic in character.[1]

And similarly S. Alexander:

In art there are . . . two standards: there is the strictly aesthetic standard: Is the work beautiful or not; has it attained beauty? and there is the question: Is it great or small? . . . Queen Mab (I mean Mercutio's) is not less or more beautiful than "the baseless fabric of this vision," but the second is a greater poem.[2]

"There are thus," says Alexander further, "in works of art a scale of beauty and a scale of greatness."[3] And "greatness and smallness depend upon the subject matter."[4]

This interesting point that "greatness" predicated of art does not in a simple sense mean "aesthetic betterness," though already suggested by Plato, and even earlier by Sappho, was first given explicit modern statement by Walter Pater in the famous, seemingly after-thought paragraph at the end of the *Essay on Style.* The essay argues the full perfection or excellence of art, with particular reference to literature, to be exact expression, "the absolute correspondence of the term to its import." This, concludes Pater, fulfils the "condition of artistic quality . . . of all good art." But then he qualifies in a second conclusion:

Good art, but not necessarily great art; the distinction between great art and good art depending . . . not on its form but on the matter. . . . Given . . . good art;— then, if it be devoted further to the increase of men's happiness, to the redemption of the oppressed, or the enlargement of our sympathies . . . , or to such present-ment of . . . truth . . . as may ennoble and fortify us . . . it will also be great art.

[1] Theodore M. Greene, *The Arts and the Art of Criticism,* 1940, pp. 375–376.
[2] S. Alexander, *Beauty and Other Forms of Value,* 1933, pp. 138–139.
[3] *Ibid.,* p. 141.
[4] *Ibid.,* p. 143.

Professor Pepper, though I do not recall that he anywhere speaks directly to the distinction between great art and good art, and though I am sure he does not hold for content in the form of ennobling truth, does, however, connect great work with extra-aesthetic human appeal. He writes:

. . . *the capacity of a great work of art to be appreciated exists as long as the physical work exists and there are men to perceive it.* So far as the work appeals to our common instincts and our deeper emotions, *it can move men of whatever age or culture.*[5] (*Emphasis mine.*)

The serious content view of great art, which the foregoing quotations express, considers "great art" as a division in the class "good art." It is not a something different, but a something more. Its basic assumptions are:

1 Every work of art is a physical thing, a perceptual object, which is an organization or composition of sensuous materials.
2 Relative to artistic creation, the sensuous materials may be either
(a) merely sensuous materials, such as pigment, sound, wood, stone, textural appearance or feel, etc.; or
(b) meaningful or expressive sensuous material, *i.e.* material which represents, states, suggests, or symbolizes.[6]

Now, of the two kinds of material, the merely sensuous may be called "neutral" in the sense that its value in artistic use or intention is purely sensuous, while the "meaningful" or "expressive" material is "human" in the sense that it has come to be, through association, convention, likeness, or intention, a reflection, or an icon, or a symbol of some interest or value other than the look, the feel or the sound of the physical material itself. Artistically, to treat material neutrally is to keep strictly to its immediate physical qualities, to treat it humanly is to take it in the shapes and meanings which the categories of experience other than the aesthetic have already given it. Human materials are things rather than masses, actions rather than movements, plans and purposes rather than configurations and patterns.
On this distinction, a great work of art, according to the serious content view, is then a work made of human materials, or, more precisely, of important human materials. The excellent or even perfect non-great work of art is, correspondingly, one made of either purely neutral materials or of human materials which are trivial or minor in the scale of importance. A Mondrian (as pure abstraction) and John Lyly's *Euphues* (as play of fancy)

5 S. C. Pepper, *The Basis of Criticism in the Arts*, 1945, p. 72.
6 I do not in this paper consider the question whether art can in this sense be meaningful or expressive. I accept the assumption that the meaningful way is the way most people in most times have experienced art, that they have read poetry for what it says and looked at painting for what it shows.

are then examples of non-great art; a Shakespearian tragedy and Rodin's *Burghers* of obviously great art.

Examples could be endlessly multiplied, and this means that the theory does apply, that it works. But the question may be asked, does it work all the time? I don't believe it does, at least not without serious qualification, and especially not when it is taken along with certain other principles which are usually taken with it as co-equal criteria of greatness, e.g. the standard of "enduringness," or permanence of appeal. Taking this second criterion into account, what will have to be shown to establish a given work as "great" is not merely that it is a good work of serious content, but rather that it is a work of *enduring* serious content. This conjunctive criterion is commonly applied in judgments of greatness. Thus, among the great novels of our century we count Mann's *Magic Mountain*, Proust's *Remembrance of Things Past*, Joyce's *Ulysses* and Gide's *Counterfeiters*. These are serious and seem assured of permanence. The prediction in these cases is, of course, presently unverifiable. But what of great works of the past—which have endured?

In respect to many if not most great works of art of the past a factual perplexity arises for the "serious content" view. It is that the "serious content" which they contain, at least in the plain sense, has undergone radical changes; so that, for example, what was at the time of creation a burning truth, or at least a live option for belief, has become a palpable falsehood or a primitive superstition. And what was once a noble ethical vision becomes a questionable or even an abhorrent dogma. And so on. Major examples of such shifts in moral or cognitive status of serious content can be found in almost every great poet from the past, and especially in the ones to whom Matthew Arnold ascribed the characteristic of "high seriousness." Dante, Homer, Milton, Calderon and the Beowulf poet would certainly be of their number. And probably all the impassioned religious painting of the medieval period would be, for most moderns, in the same position.

The subversion which a given "serious content" in the plain sense can suffer in the passage of time is well illustrated in a reconsideration of Dante from a modern moral point of view by Morris Cohen in an essay entitled "Dante as a Moral Teacher." "Dante's moral and spiritual ideas," avers Professor Cohen, "are as intolerable to modern moral sensibilities as his view of the physical universe is flagrantly false. The divine justice which rules his world is one of infinitely cruel vindictiveness or gratuitous malice.

. . . *he places in Hell not only innocent children, but noble characters like Plato, Socrates, Farinata, while high in Heaven are placed an oppressive and polygamous*

despot like Solomon, a simpleton like Adam and a savagely persecuting bishop of dubious morality like Folquo.[7]

And

The idea of an eternity of suffering is horrible enough, but to glorify it and call it, as Dante does, "supreme wisdom and primal love" makes us ashamed of the human nature that is capable of entertaining such horrible perversity and disloyalty to our natural sympathy.[8]

"This rejection of Dante's claim as a moral teacher, like the rejection of exaggerated claims for the magnitude of his learning does not deny his obvious greatness as a poet . . ."[9] says Professor Cohen further. And with this un-questioned allowance of poetic greatness there is here no disagreement and no concern. However, if there is "obvious greatness" it is also obvious that it cannot be supported in any untortured sense by the "serious content" theory of greatness.

Any number of observations of like import with those of Cohen on Dante and of similar embarrassment to the plain sense of the "serious content" view could be made of the writings of the other poets named and of many besides who have enduringly been rated as great.

Professor Pepper, in the sentences following my previous quotation from him, takes cognizance of the same factual perplexity, but from the appreciative side, and with an essentially easy solution. He writes that the great work of art

. . . may from accident of language and fashion and national or religious bigotry come in and out of popularity, but there it is ready to move the common man or the student who will put himself in contact with it.[10]

The solution is too easy to offer any solid support for a continuing judgment of greatness of works which have suffered an unacceptable change in their serious content. It is too easy because, in the first place, a work must always appear for appreciation in some "accident of language and fashion," and in some national or religious or anti-religious persuasion, if not bigotry. And in the second place, it overlooks the fact that these persuasions are often, perhaps always, as in Dante, built into the work of art as created.

The plain sense of the "serious content" view is still obviously unacceptable. The position must either be abandoned, reinterpreted or amended. There are at least three possibilities.

The first and radical possibility is that the "serious content" view may be

[7] Morris R. Cohen, *The Faith of a Liberal*, p. 236.
[8] *Ibid.*, p. 239.
[9] *Ibid.*
[10] S. C. Pepper, *op. cit.*

rejected in favor of a completely different theory of great art, one which stands for "significant form," "plastic value," "decorative quality" or something else which makes content either innocently irrelevant or harmfully distractive. The absolute alternative to "serious content" is some kind of formalism, as in the theories of Clive Bell, Roger Fry and Ortega y Gasset. This is, of course, the second major tradition, stemming, as noted previously, from a rejection of Plato's major premise about art, and enjoying strong favor in the pure art, dehumanization, and non-objectivist doctrines and practices of our time. As a theory of great art now the position has strength, but as a general theory of great art it lacks empirical support. In the face of the history of art and the still unshaken preferences of taste on the whole, it has to be asserted as a norm, and it has to resort to heroic and not singularly successful measures in accommodating most of the accepted great art of the past, and much of the present too. The rejection simply and *in toto* of the "serious content" view seems, in other words, to entail the rejection of art as well as the theory.

A second way is a way of amendment rather than of rejection of the "serious content" view. Serious content is preserved in appreciation of great art in which it is found, but it is taken aesthetically rather than in a real life way. With this amendment, serious content will be taken as necessary to great art, but necessary only because it affords a richer material for aesthetic uses than merely neutral material or trivial content, as, by way of parallel, it is well recognized that at the sensuous level sound and visual materials are richer for aesthetic uses than smell and taste materials are. Art, it may be argued, which avails itself of perceptual things, passions, ideas, dramatic conflicts, and events, has *materially* much more to go on, and when equally skilful will produce aesthetically more interesting and compelling work than that which eschews such materials.

This view, since it explains the greatness of art not in terms of the intrinsic values of serious content, but rather in terms of something resulting from its use aesthetically, will have to be defended on the meaningfulness of a distinction between "serious content" *constituting* great art and "serious content" *making* for great art. It will have to be shown that something results from the inclusion of "serious content" other than or additional to the presence of serious content itself. This, I believe, can be done. The following sketchy analysis of parts of the first and second scenes of Shakespeare's *Hamlet* may be offered as a suggestive example.

The opening scene is that of a change of guard on the ramparts of the Castle of Elsinore. It is deep night and very cold. A misdirected challenge on the part of the oncoming guard suggests a state of extreme tension. One of the guards on post says to his replacement:

> *For this relief much thanks. 'Tis bitter cold*
> *And I am sick at heart.*

He is never seen or heard of again in the play, and he might be passed over at first reading as merely a fill-in or bit character in the background. But his words, "I am sick at heart," emotional material, already supported by the night, the bitter coldness, and the loneliness of the watch, soon turn out to be the first striking of a major theme of the drama. In the next scene, the first court scene is taken up, varied and enlarged. It is treated first in sheer spectacle through contrast, visual and auditory. The stage is dominated by the royal procession, the king and queen, councillors and attendants. There is color, pomp, gaiety, laughter and lively conversation, fanfare of trumpets. And against all this, at a distance behind, the lone, silent, sombre figure of Hamlet in "inky cloak"—visual "heart sickness" the theme. The dialogue, when he is soon drawn in by the king and queen, repeats it and varies it; and finally when the court goes off and leaves him alone, the heart sickness is uttered directly in the soliloquy "O that this too too solid flesh would melt."

The theme, of course, continues through the drama. But this is enough to show its substance and its direction. A bit of action compounded of night, cold, military routine, royal pomp, dejection, and conflict of emotion and will, all strung on a thread of "heart sickness," yield a marvellously intricate yet closely composed experience, the value of which is certainly different from or more than that of the events, ideas and emotions considered severally in themselves. It is an aesthetic experience which results from the dramatic use of materials which might certainly be used or considered in other ways.

This example is good enough in itself, but I don't think it is sufficient in kind to support this meaning of great art as of general application. In the first place, it is a piece of dramatic literature, where the theory works best. The amended "serious content" view might then be urged strongly as a good theory of great drama, but not as a general theory of great art. In the second place, it may well be that even in dramatic or other literary art the poetic or aesthetic appeal may surpass or outlast the serious content, the latter possibility being affirmed, for instance, in the previously cited reading and judgment of Dante by Cohen. Much great art in all kinds does certainly in general esteem survive in greatness beyond the point at which its serious content ceases to be viable.

A third way of departing from the literal or plain sense of the "serious content" view of great art is one which is emerging from current discussions concerning the relative long-range worth of non-objective as against representational painting. Two important papers directed to this question were published in the same month, March 1953. One is Professor Pepper's article "Is

Non-Objective Art Superficial?"[11] The other is Leo Steinberg's "The Eye is Part of the Mind."[12] For the present discussion the relevant question in both these articles is: Can non-objective art be great? Pepper states it explicitly:

What is the chance that a purely non-objective picture can be as aesthetically satisfying as the most satisfying representative picture? Will a non-objective picture ever be as "great" as the best Giotto, Titian, Grünewald, Van Eyck, El Greco?[13]

Though the question is directed upon non-objective or abstract art, so-named, neither Pepper nor Steinberg conceives such art as necessarily devoid of content. In effect, though neither uses the phrase, Steinberg urges the actuality, Pepper the possibility, of "serious content" in, for them, so-called non-representational art. The common argument is that "serious content" does not depend upon representation or symbolization of recognizable things, objects, events, or situations. It may be conveyed in "pure form." According to Pepper, greatness in this way has long been fully realized in music and may be predicted as a possibility in visual art, especially in painting. The possibility or the actuality exists because non-objective art is not or need not be abstract, that is, without content after all.

Pure music and non-objective painting are not as free from the suggestive, the meaningful, the biologically dramatic, the "literary" as either of the opposing camps seem to assume . . . a flat opposition of the meaningful and the formal is falsifying.[14]

Relationships of sound in pure music and plastic relationships in non-objective painting, Pepper maintains, can be, and in great works are, expressive or "representative" of highly generalized human associations. He writes:

A Beethoven symphony is as full of associative references to human life and action as if a song or dance were accompanying it—possibly more so.[15]

And

. . . a non-objective organization of dynamic tensions in space is just as much an integration of meanings as Rembrandt's Portrait of an Old Woman.[16]

Steinberg maintains essentially the same point. Non-objective painting is not really devoid of content. Its proximate content is a visual correlate of the

[11] In *Journal of Aesthetics and Art Criticism*, vol. 11, no. 3, pp. 255–261, March, 1953.
[12] In the *Partisan Review*, vol. 20, no. 2, pp. 194–212, March, 1953. Republished in Susanne K. Langer (ed.), *Reflections on Art*, 1958, pp. 243–261.
[13] S. C. Pepper, *loc. cit.*, p. 256.
[14] *Ibid.*
[15] *Ibid.*, p. 259.
[16] *Ibid.*, p. 260.

non-visual world of modern science, together with accreting emotional asso-
ciations which come of living in the scientifically conditioned modern world.
It is then the modern scientific world and modern cognitive and emotional life
in that world which is the "serious content" of modern non-objective art. The
non-objective artist, he says, works in a "stream of suggestions issuing from
the laboratories" of science, "from magnifications of minute natural textures,
from telescopic vistas, submarine scenery and X-ray photographs." From these
"visual data of the scientist" the non-objective artist takes many of his sup-
posedly pure forms; but actually, "the shapes of his choice are recruited in
good faith for their suggestiveness as shapes, and for their obscure corre-
spondence to his inner state . . . to his own sentient being. . . ." [17]

 The view which is common in both Pepper and Steinberg may be sum-
marized as follows.—Great art may occur in either the traditional representa-
tional mode or in the so-called non-objective mode. Representational art is
not great when its content is relatively slight, non-objective art is not great
when its sensory components are organized in a merely decorative or pleasing
way. But this is not the only way sensory elements can be chosen and or-
ganized. They can be taken and organized so as to express or symbolize, in
Pepper's phrase, "highly generalized associations," and then a condition of
greatness is realized. This is the latest attempt to give meaning to the term
"great art." It is interesting to note in passing, however, that, though it is only
recently being given systematic attention, it was already strongly suggested
over a quarter of a century ago within the then strenuously asserted formalistic
position itself, by Roger Fry. In "The Artist and Psychoanalysis" from *The
Hogarth Essays* (1924), Fry, after arguing at length for a pure aesthetic art,
an art of pure form, in which no importance is attached to subject or what is
represented, and towards which no emotion other than a pure aesthetic emo-
tion is allowed as relevant, writes in a curious conclusion:

*Now, from our definition of this pure beauty, the emotional tone is not due to any
recognizable reminiscence or suggestion of the emotional experiences of life; but
I sometimes wonder if it nevertheless does not get its force from arousing some very
deep, very vague, and immensely generalized reminiscences. It looks as though art
had got access to the substratum of all the emotional colors of life, to something
which underlies all the particular and specialized emotions of actual life.*

 This conclusion clearly anticipates both Pepper's "Plastic associations are
highly generalized associations," but "genuine associations just the same," and
Steinberg's basic thesis that "many abstract painters recognize an intenser
mode of natural truth."

17 Steinberg, in Langer, *op. cit.,* p. 259, *passim.*

In any case, this third way of giving meaning to the term "great art" does not abandon the "serious content" view. It retains it in its plain sense to apply to traditional representational art. And it does not abandon it, but amends it, to apply to non-representational art. The amendment seeks to extend or deepen the meaning of "serious content" to cover the facts of the world and of human experience which lie beyond or below the scientific surface of the ordinary perceptual world and obvious "real life" cognitions and responses. The amendment adds a new characteristic to the concept, namely, that there is such a thing as "abstract serious content," a visually generalized serious content. The view might be called, with suitable reference to the contemporary movement in art practice, "the abstract expressionist theory of great art."

AESTHETIC DISTANCE AND THE
CHARM OF CONTEMPORARY ART

P. A. MICHELIS

Pythagoras, in defining the philosopher's attitude, compared life to a fair, to which some come to take part in the games, others to trade, and others—the best—to watch the spectacle; thus in life, he says, the slavish pursue wealth, the philosophers truth. In other words, the philosopher is not moved in life either by desire for action, as are the participants in the games, who strive for victory; or by practical motives, as are the traders who pursue wealth; he is moved only by the desire to contemplate the scene, as a spectator at the games.

Philosophy presupposes such contemplation ($\theta\epsilon\omega\rho\iota\alpha$),[1] a survey of phenomena; and in order to make his survey, the philosopher must remain a spectator, taking no part in the action; he must, like the spectator at the games, watch them outside the arena. But the objective judgment which the philosopher's contemplation of the scene calls for, though it is facilitated, is not to be induced by spatial distance alone; temporal distance is equally essential; time in which to retreat from and consider the events, so that he may, as a serene spectator, an unimpassioned participant, appreciate the passions which possess

[1] *Theoria,* a predecessor of our word "theory." [Ed.]

men in life, and perceive the motives or ideas that stir those passions. From this withdrawn attitude, mentally detached from practical and individual interests, he can survey and sum up the phenomena.

Now it is not only the philosopher who is a contemplator; there is the artist too, the detached participant of the enthusiasm impelling the contestants—like Pindar, who praised the Olympic victors in his odes. Both artist and philosopher are spectators, or rather, contemplators, maintaining the required distance in space and time from the action—with this difference, that the first interprets the phenomena in abstract intellectual theories, and the second in poetic figures. Both need to set themselves at a distance, not only *external* but also *internal*, before they can reach their individual spheres. In other words, the inner distance is achieved by mental withdrawal that releases the philosopher's intellect or the artist's poetic imagination, as the case may be, enabling a philosophical approach in the one, and an aesthetic approach in the other. Therefore, the nature of this inner distance promotes and to a certain extent determines their attitude towards things, whether it shall be *aesthetic* or *philosophic*. We shall, accordingly here refer to the distance achieved in aesthetic contemplation as "aesthetic distance," in contradistinction to the "contemplative distance," which pertains to the philosopher's realm.

Schopenhauer [2] said that on finding ourselves in a foreign city in which we do not know the persons, we derive pleasure and a strange impression because we see them absolutely objectively. Indeed, be it added here, because we feel remote from that new environment, they seem to us to be enacting a play with the city for their setting.

The aesthetic distance at which we stand from things and from our own selves is worth analyzing, because it bears directly on crucial problems of art and shows us the nature of contemporary art from an unexpectedly revealing angle.

The need of a certain remoteness from our experiences during aesthetic contemplation has been broached mainly by the school of the *Einfühlung* theorists.[3] The latest and most systematic theories on the subject are generally termed theories of "psychological detachment." [4] Two of its most important exponents—the English psychologist, E. Bullough,[5] and the Spanish philosopher, José Ortega y Gasset [6]—express diametrically opposed views on the

2 Schopenhauer, *Die Welt als Wille und Vorstellung, Sämtliche Werke* (Reclam Jun. Leipzig), vol. 2, p. 436. [Schopenhauer, *The World as Will and Idea, Collected Works*, Ed.]
3 Cf., e.g., Theodor Lipps, *Aesthetic*, Leipzig, 1920, vol. 2, pp. 51–52. [*Einfühlung* means "empathy," Ed.]
4 Cf. M. Rader, *A Modern Book of Aesthetics*, New York, 1935, pp. 311–356, for an anthology of E. Bullough's and Ortega y Gasset's theories.
5 Edward Bullough, "Psychical Distance as a Factor in Art and an Aesthetic Principle," *British Journal of Psychology*, vol. 5, no. 2, pp. 87–118, 1913.
6 José Ortega y Gasset, "The Dehumanization of Art," in J. Burnham and Ph. Wheelwright (eds.), *Symposium*, vol. 1, no. 2, pp. 194–205, April, 1930.

magnitude of the distance in question. The first thinks that "the utmost de-
crease of distance without its disappearance" would provide that "psychical
distance" which is the main characteristic of aesthetic contemplation, and in
this connection he directs attention to the "antinomy of distance." By such
"psychical distance," he maintains, "the objectification of one's mental states"
can be achieved. The second considers that the distance should be the greatest
possible; "to give style," he says, "is to deform reality, to make unreal"; and
he proceeds to explain that in order to derealize we must confront reality not
"as being lived" but "as contemplated reality." Bullough's theory, then, would
keep contemplation close to the spectator's psychological experience, while
the theory of Ortega y Gasset would liberate it from every emotional link with
the object, by the greatest possible retreat from it, thus making of aesthetic
contemplation an almost exclusively intellectual act. Both theories, notwith-
standing their divergence as to the magnitude of the distance and the concep-
tion of aesthetic contemplation, refer for the most part to the spectator and
his mental detachment, and only very slightly—and that in Bullough's case
alone—to the object of contemplation. Yet surely the object also, the work of
art particularly, has its own way of suggesting to the spectator the distance
necessary to its aesthetic contemplation.

The study of aesthetic distance teaches us much about the artist's attitude
as a creator; it tells us whether he can better express his experiences when
they are near, or when they are remote; whether or not there are limits to the
spatial and temporal distance; and when the artist chooses a lesser, and when
a greater distance. Finally, it tells us what part memory plays in the creation
of an immediate aesthetic experience.

The proper aesthetic distance, then, concerns both creator and spectator if
he is to appreciate the work of art which indeed itself suggests this distance
by its isolation in its own ideal sphere.

It would thus seem that Beauty repels us away from physical reality—a
movement which, I think, has not so far been analyzed in aesthetic studies,
any more than have the means employed by art to achieve this repulsion. How
do the arts of space and those of time accomplish this repulsion away from
the reality on which both depend, since the first cannot exist without space
and the second without time?

So far, we know about Beauty only that it attracts us. We propose now to
show that it reveals an ability to repulse. How is this contradiction to be
explained, if contradiction it is?

Classical aesthetics knew that the Beautiful attracts us, the Sublime annihi-
lates us, the Ugly repels us. But since repulsion, like attraction, grows, or at

least fluctuates in an aesthetic experience, may not aesthetic distance also fluctuate accordingly, and is it not therefore mutable?

Again, naturalistic art seems to decrease to the utmost the distance from the phenomena, while abstract art seems to increase it to the utmost. Even the style of an art-era establishes its own aesthetic distance, collectively imposed by the art of the age. A style, and therefore a distance, is invariably in advance of its time even when—seemingly retrogressive, as in the Renaissance—it refers to subjects or ideals of the past. How does this contradiction of advance and retrogression resolve itself in aesthetic distance?

Of course, in the last analysis, the aesthetic distance is an inner distance of spiritual dimensions; its external conditions, limitations, and contradictions are ultimately eliminated because the spectator transcends them. But it is through our strife with these very conditions and, thanks to the power of art, not only to remove but indeed to pose them, that our aesthetic approach is effected. Our strife entails a mental readjustment which, despite the ultimate reconciliation it achieves, would have been a painful and a toilsome process, without the power of art to numb its spectator. But if art numbs him, can it still move him?

Finally, the pleasure which springs in the contemplator's spirit from his appreciation of art does not derive principally from intellectual enlightenment, as in philosophy, but from a kind of oracular insight, because art interprets phenomena through intuition and imagination. The charm of all art, therefore, lies primarily in its divinatory nature. But what is the particular charm of contemporary art? What aesthetic distance has it adopted? Is it, in fact, charged with ugliness and does it lead to "dehumanization," as is affirmed of it?

DISTANCE IN SPACE

The story of the fireman [7] who, watching a theatrical performance from off stage, suddenly cried out warning the leading lady of her imminent danger, is not new. This fireman had, of course, lost the aesthetic distance by which he would have realized that the performance he was watching was an imitation of life; but it is equally certain that his physical proximity to the stage was, to a large extent, responsible for the disappearance of the aesthetic distance. From where he stood back stage, he could not see the scene as a whole; he was, therefore, apt to be carried away by the emotions displayed by an in-

[7] Th. Moustoxydes, *Aesthetic Triptych*, Athens, 1954, p. 70. This and similar other examples are mentioned in this work. There are frequent instances in which, despite the spatial distance between stage and audience, its members intervene in the play, voicing protest or approval, or are overcome by emotion even to the point of fainting. Quite simply in such cases, the distance has been abolished either by poor acting, or by an inferior play, or by an uncultured audience, or by all three together.

dividual actor, and to lose sight of the balance and general meaning of the work. That is why the producer, while rehearsing his cast, often comes off stage into the auditorium to watch the acting in perspective and enjoy the scene as a spectator, interposing the appropriate space between himself and the work. Naturally, if the spectator sits too far away from the stage, he is cut off from the spectacle, because the intense concentration of sight and hearing then necessary impedes his enjoyment of the work. Only the middle distance provides him with a comprehensive view and simultaneously helps him to share the emotions displayed, so that he can appreciate the work with the due aesthetic "disinterested interest."

Similarly, in looking at a painting from nearby we lose the unity of the whole, we are apt to dwell on its incidental detail and its technique, sometimes being even tempted to touch it, so as to feel the texture of the material. The picture thus falls in our appreciation from an image to an object, a thing. Or, if we stand too near an architectural work, we become preoccupied with its detail, its construction, and the condition of its material. Again, if we stand too far away from it, we get only the silhouette of the work, a shadow, and only the middle distance will allow us to appreciate the relation of the parts to the whole and the whole as a unit. Of course, in looking at an architectural work, we do so from a number of points, but still three of these are the main ones, as Maertens [8] fixed them, and of these three the most important is the middle distance, which forms an optical angle of 27° and allows the parts and the whole to be viewed as a unit. Studying the work from many points, the spectator ultimately grasps its organization and general structure and is in a position to appreciate it aesthetically from any distance; for having once obtained this view of its inner economy, he now contemplates it as the expression of an idea in space and time.

The artist too, who creates the work, needs to be at a distance from his object. The painter makes this patently obvious when he recedes from his model and half-shuts his eyes to get it into focus, then opens them again to study it in detail, always, however, retaining the appropriate distance that will enable him to effect the necessary eliminations; if he came too near his model, superfluous details would stand out too large for elimination, but if he stood too far from it, then the elimination would be effected not by his judgment, but by his strained eyesight which could not, at that distance, distinguish things clearly. His modifications would cease then to be mental and would become a physical, visual abstraction. Whenever the artist does go right up to his model, he does so only to verify a detail, or clarify some

[8] Maertens, in his *Der Optische Masstab* [*The Visual Measure*, Ed.], establishes three distances, with optical angles of 18, 27, and 45 degrees. From the first, we see the whole in its background, from the second we see the whole and the parts, and from the third we see the details.

vague point, or even to get the feel of the material's texture, but he must at no time lose sight of the whole, even while studying his detail. Again, whenever he moves right away from it, it is only in order to bring the whole silhouette within his range and get a general impression of his model. At last, he chooses the *most favorable distance* and applies himself to his painting, though without for a moment ceasing to employ his mental as well as his visual perception. The appropriate spatial distance in part gives him the necessary aesthetic distance, or rather helps him to acquire it, since obviously the first is of material, external dimensions, whereas the second—the aesthetic distance —is one of super-sensible, spiritual dimensions. The first aids the eyesight to a visual perspective; the second helps the mind to a mental perspective, in which the non-essential is discarded and the essential thus extolled. Aesthetic distance, indeed, in enabling the artist to survey his subject as well as his own impressions of it, allows him to compose it into an artistic vision; to attain that immaterial domain—the sphere of art—in which the mind's creations live, as the fish live in water and the birds in the air.

Indeed, art introduces a space of its own in which the figments of the imagination can be accommodated and to which it beguiles our spirit, so that it may live there free among its own creations. Even the arts of time, like music and poetry, weave their own space. In the musical space sounds do not act as merely audible phenomena, but as musical revelations. Sounds are transmuted there and pulsate and come to life, as do in the ideal space of the picture, satyrs, nereids and gods, which seen in real space would seem freakish.

Nonetheless, the space created by art does not minimize the importance of the most favorable distance in real space. In the case of classical painting, in fact, which employs perspective, it is essential to view the scene from a fixed point in order to produce a *represented distance* in the picture. For this purpose the artist creates different planes on which he gradates the size of the figures, thus being able to produce impressions of different depths and of a three-dimensional space. And as a painting within its canvas reproduces but one view of its subject, the artist selects this view when he determines the place which will give him his appropriate distance from his subject in space. Modern art, of course, has abolished the perspective rigidity of the fixed point of view and is aperspective—non-perspective—presenting composite pictures which combine numerous views of one and the same object. But here too, the multiple views form a unity. The planes here are not perspectively arranged with one appearing nearer and another remoter by the gradual diminution of the figures; for usually, the intention is to enhance not external, but psychical, space. The gradation of distances is effected here by the comparative sizes of

the figures, and comparative values of colors and symbols. The perspective of such pictures is exclusively internal, this inner view alone determining the favorable position and distance in their case.

In sculpture and architecture, which place their works bodily in space, we find that works on a large scale demand to be viewed from far away, those on a small scale, from fairly close, each suggesting the most favorable distance in space for its contemplation. But even such works cannot avoid emphasizing some point about them—the first, say, an attitude; the second, perhaps, a façade —and by such emphasis guiding the spectator to stand at that position and distance in space which best display their most salient feature. Without the proper position and distance in real space, as imposed by the work, its contemplation from the necessary aesthetic distance is impeded. In other words, the *most favorable position* and most favorable distance in physical space promote the establishment of the aesthetic distance that will bring the spectator to an ideal space. Conversely, the contemplation of a work of art from the necessary aesthetic distance will be impeded if the distance and position taken by the spectator in real space are not the favorable ones, and have not been imposed by the work of art. For from that position and that distance, he can most easily perceive the transfiguration of the work from a real into an ideal creation and find himself gazing on an artist's vision set in the world of reality. It is there and then that the center of the eye's perspective and the center of the mind's perspective coincide.

Now were we to confront the work before we had crossed over to its ideal space, the results would be quite other. Demus,[9] for instance, when he maintained that the presentations of the Byzantine mosaics should be considered as moving in the physical space of the church, did not seem to realize that thus contemplated with the aesthetic distance abolished, these divine visions would be at once converted into finite, concrete creatures. In fact, the need to throw the figures into their own space was met externally by placing the picture in a frame, which in itself isolates and detaches the figures from our own space. That is why, too, in architecture, the temple is placed on a crepis; in sculpture, the statues rest on pedestals; in drama, the actors stand on a stage. Not that these external means would be adequate without the style of the work to impose its aloofness from within. The primary importance of style as an intrinsic, distinctive feature is evident in every form of expression; no less so in the art of speech, which, if it is to escape from prosaic expression, can resort only to the poetic style. Other external aids, such as pedantic words or formal phraseology, may give language a certain impersonal, cold, and

[9] O. Demus, *Byzantine Mosaic Decoration*, London, 1947, p. 4; see also criticism in P. A. Michelis, "Neo-Platonic Philosophy and Byzantine Art," *Journal of Aesthetic and Art Criticism*, vol. 11, September, 1952.

intellectual quality—to serve at most on certain occasions; but they lack that enduring, inner quality which style brings to speech.

That internal unity which style presupposes and which, in setting the work apart, puts us at a distance from it is, in a measure, achieved by the abstraction of the non-essential in order to enhance the essential. Such abstraction certainly creates distance, just as, conversely, distance effects abstraction of details in perspective. But the arts often depend far less for their abstractions on perspective effects than they do on an inner feeling; this latter will sometimes prompt them to magnify a detail that in perspective ought to appear lesser, or to efface one that would, in fact, be visible; or again, to bring close up to us what we should expect to be far off, or vice versa. By such inconsistencies of the purely internal perspective and distances, which create its ideal space, art often underlines what is most characteristic of its subject. Now, whereas classical art creates its ideal space by imitating phenomena living in physical space, aperspective art, as in contemporary painting, goes directly to internal perspective and to the distances of an ideal space. This immediate alighting upon the world of imagination is revealing and startles, but does not alienate in art. Even the various perspective-planes in painting and its abstractions result in jumps from one region to another. The various inconsistencies, to which we have referred, make these jumps more revealing. The leaps of contemporary art differ only in degree of intensity, not in nature. In the last analysis, progress and knowledge in life are achieved only by such revealing jumps, and art is in its nature revealing.

DISTANCE IN TIME

The proper aesthetic distance for contemplating a work of art is not to be established merely by placing ourselves at a suitable distance from it in space. A suitable distance in time is also essential; for art weaves its own time, as it weaves its own space.

A writer, for instance, watching a scene in the street, could not describe it at the very time of its occurrence. Just then he is engaged in watching it with his eyes. When he takes up pen and paper to describe it a certain length of time has elapsed since he witnessed the scene; a distance of time has been set up beween him and the scene. He may describe it either immediately after, or some days after, or even years after, with the scene losing none of its clarity. It depends on how vividly it impressed itself on his mind at the time, on the accuracy with which his inner eye focused it as he watched it unfold. Memory will have retained it and will reproduce it accordingly.

We consider it natural—and up to a point it is natural—that memory should project it more succinctly only after the lapse of a moderate length of time, because the mind has then had time to sift the non-essential from the essential and to readjust and condense the order of events, before it has forgotten any of them. It has been allowed to reflect over its experience as a whole. But until this sifting and readjustment of memories has been effected, there can be no aesthetic results. It is consequently a fallacy to suppose that the author can best describe the events only while they are still in the very foreground, or conversely, only after they have sunk to the background, of his consciousness (*à chaud,* or *à froid,*[10] to use the French expressions); such theories do not take into account the mutable moment when the material length of time becomes spiritual. Sooner or later, that moment comes and it is the *favorable moment,* the "fertile moment" of inspiration the artist expects. The spectator too needs such a moment, for his mind is not at all times receptive to a work of art. This moment is, in time, what the favorable position is in space. But whereas the favorable position in space can be sought and found, the favorable moment in time is not thus to be attained. Of course, mental detachment from practical interests, a knowledge of art, a cultivated taste and imagination, are all necessary, but over and above all this, it is the afflatus that will lead there. That moment of inspiration is unpredictable and depends on several factors.

Memory is a strange force. It may suddenly, when least expected, project poignantly an experience undergone perhaps thirty years ago, while it may refuse to recall a quite recent experience, yesterday's events. And not unnaturally so, since perception does not always imply apperception. Our attention often follows its own independent course. When, however, mental and sense perceptions coincide, we acquire an experience which memory stores, until such time as a sudden impulse to associate an event, or express an emotion, will thrust to the fore apparently forgotten images which represent it vividly. By creative imagination thoughts, experiences, and sensations, related by an inner affinity, help each other to the surface, drawn from any depth. At other times again, an image seen or perhaps unconsciously reproduced—as it evokes feelings that had been repulsed or lay dormant—will fill us with emotion. "When the lips and the skin remember," wrote Cavafy,[11] showing thus that even our senses participate in the revival of emotions and of images, which make up the artist's material. Nor is such material subject to time's wear; indeed, it often becomes the richer and more precious as it mellows and its sharp edges are gradually smoothed. Like the rough diamond that will be turned into a jewel, it then lends itself to idealization.

[10] Hot or cold. [Ed.]
[11] C. Cavafy, *Poems,* trans. J. Mavrocordatos, London, 1951, p. 54.

Works of art, in imposing their own time, prove how necessary is the intervention of a time-distance to their appreciation. For, although they manifest themselves concretely before us, they seem like recollections that follow their own course in time. In drama, events are depicted on the stage, which seem to unfold as in real life, while in fact they take no account of their actual historical duration and continuity. Time-distances are abridged, and so certain scenes in the play which in reality are separated by an interval perhaps of several days, often years, succeed one another swiftly and convincingly. It is not the task of the dramatist to record history, but to draw his reflections from it; he can therefore take vast leaps in time, eliminating the non-essential to display only the vital. Even the novel does not necessarily follow in its narrative the chronological order of events. The unity of the action often demands readjustment of sequences. Homer begins by describing the wrath of Achilles and only afterwards tells why and how the Greeks went to Troy. Byzantine and primitive Italian paintings do not hesitate to reproduce simultaneously the martyrdom and apotheosis of a Saint. This chronological inconsistency should not surprise us more than any other of those inconsistencies [12] that are the prerogative of art. As was pointed out earlier, art creates its own time as it creates its own space; and in both these, past, present, and future things can co-exist.

Time in art is not to be measured by the clock; how often do not lengthy works seem to us all too brief, and sketchy works interminable? Their apparent duration depends on the economy of time in the composition. Such economy implies in time what perspective composition implies in space. That is to say, just as perspective composition creates different planes in space which, while enhancing distance in depth, promote the unity of the space in which the presentations move; so economy of time in a composition creates different phases so gradated that they enhance the passage, while they sustain the continuity of the time in which the characters and events move. In short, it brings into the composition that beginning, middle, and end laid down by Aristotle as a prerequisite for tragedy, which, he claimed, should be easy to memorize. For the spectator is thus helped both to follow the plot and grasp its unity. His attention is more easily attracted. In this connection Aristoxenus,[13] too, has said about music that we hear it simultaneously as it is occurring and as it has occurred (τὸ γινόμενον καὶ τὸ γεγονὸς),[14] while St. Augustine [15] speaks

[12] Cf. also P. A. Michelis, "Refinements in Architecture," *Journal of Aesthetics and Art Criticism*, vol. 14, September, 1955.
[13] Christiansen, in his *Die Kunst* [*Art*, Ed.] Felsen-Verlag, 1930, p. 179, points out that the well-known musical critic, H. Rieman, in his analysis of music, and Oskar Walzel, in his analysis of poetry, both draw attention to this point made by Aristoxenes of Tarantium.
[14] The Greek is translated by the preceding phrase. [Ed.]
[15] St. Augustine, *Confessions*, Book 11, chap. 19.

of three times: a present of things present, a present of things past, and a present of things future. In other words, when hearing the notes, we remember the ones that preceded them and divine those to come. Imagination and memory come into play, the first annihilating the distance of the future, the second that of the past, and both together rendering the distance of the present aesthetic when they reach the idea of the work. Memory and imagination ultimately meet, because they grasp the idea. Only thus, by bringing both to bear actively on the work, may we enter into its own ideal time, in which all exists in unity and due sequence, in an unbroken, unceasing flow, forming a duration as absolute as the duration of time in our consciousness. Thus time ceases to be finite and becomes infinite; it moves on, it elapses, and yet partakes of eternity, it endures; a timeless time, or as Plato has it, "the moving image of eternity." [16]

A temporal distance is as indispensable in contemplating the arts of space as it is in the contemplation of those of time. The painter, in order the better to observe his model, stands at a distance from it, not only in space but also in time; for if he is to reproduce the essence of the object before him, he must paint it in a sense from memory. By persistent and repeated observation, his glance not only collects a variety of views at different moments, but it also obtains so deep an insight into the nature, texture, and expression of the model, that it enriches its representation with properties quite invisible in the object's form from any position whatever. For, as the most favorable position in space—given vision—is, in a way, even *pantoscopic;* so too, the most favorable moment in time—given vision—is even *pantomnemonic.* At that moment, the phenomenon is detached from the finite time of its actual presence. The Chinese painter who suggested that before painting a landscape the artist should spend several days observing it in all its moods was in fact thinking of that favorable moment. Before painting his landscape, he suggested, the artist should contemplate it reverently, absorbing, enriching his memory with impressions of it: in the setting sun, or after rain, or caught in the fury of a storm, or caressed by a breeze. All these memories then, will flow like a hidden spring to bring vitality to the picture, which though necessarily the scene of a certain moment, and taken from a certain position, is yet the picture of a whole world, a self-contained composition. A work relies for its artistic merit, not only on the mere lines and colors that go to reproduce its subject and that are there for any unimaginative spectator to see, but also on its power to evoke in the spectator the recreation of its perfect world and simultaneously an *état d'âme.*[17]

[16] Plato, *Timaeus,* 37d.
[17] Soul-state. [Ed.]

The *état d'âme* suggested to the spectator by a work of art springs from the experience of a certain moment. Just as there is a certain favorable position from which the statue's characteristic attitude, or the building's main facade best stand out and can be contemplated to fullest advantage, so there is a favorable moment for their composition and appreciation. For the mind is not receptive and creative at any and every moment. But at moments when it is, it will, enlightened by heightened vision, endow all it perceives with its own creativeness. And the work of art invariably offers this contrast, of timeless and finite form, as the portrait will best illustrate. The unimaginative spectator expects the portrait to reproduce the exact physical likeness of its model. The artist, however, is concerned with the essence of the form, and not with achieving its photographic resemblance; he seeks its inner character. Liebermann [18] told a man whose portrait he had been commissioned to paint, that his picture was more like him than his own face; in other words, that the portrait brought out his character better than did his own physical traits. Michelangelo, again, in his monument to the Medici in Florence, did not hesitate to represent Lorenzo beardless, though in real life his model wore a beard; and indeed, how immaterial does the detail seem to us now.

Such disregard of characteristics, however, does not mean that a work is executed without regard to the actual model, but that the artist refers the model to its archetype as he visualizes it. In other words, he transcends imitation as insight and memory strive after the ideal type. Certain it is that in the case of the imitative arts, sculptor and painter, relying on their memory and with only certain sketches to help them, will reproduce a more eloquent composition than they would be likely to do with their model constantly within sight. For it is thus easier to make the necessary abstractions and create the distances indicated by the mind's perspective view.

Obviously in the case of purely naturalistic painting or sculpture, the absence of the model, on the contrary, hampers the artist; but this only proves the degree to which naturalism narrows the horizon of art, dismissing memory, or at least, cramping its contribution. It limits the time-distance necessary for reflection that would allow *mental* rejection of the non-essential and relies mainly on space-distance in which, however, such rejection amounts merely to a visual elimination of disturbing detail. Indeed, the Renaissance naturalistic paintings, in reproducing objects perspectively from a fixed viewpoint, narrowed the possibilities of a spatial survey too, whereas the Byzantines, in painting as though they saw from various points of view simultaneously, in fact express themselves better and achieve a more comprehensive spatial survey.

[18] Quoted by Br. Christiansen, *op. cit.*, p. 259.

The Byzantines, too, praying and fasting as they did, before engaging in their paintings of an icon (for which they did not, like our contemporary artists, rely on the presence of their models), come close to their divine vision; their icons are painted better even than the Chinese landscape, whose artist, in order to absorb his subject's character and atmosphere, has had to resort to the spot itself; they work better than the artists of the Renaissance, who painted women for their Virgins without first conceiving an impersonal type of Madonna.

The great Renaissance art itself, of course, is not devoid of either intuition or vision in its representations, because no great artist engages on a painting without an urge to express some inner experience. He cannot, therefore, confine himself only to natural forms, however much of a naturalist he may be. Rather he interprets the phenomena, which he also imbues with his own experiences. But all painters are not great and the naturalistic painting is apt to fall back on the unnatural and the random. Naturalistic art impedes the aesthetic distance, whereas abstract art promotes it; and the fact that art in its acme is invariably prone to naturalism may conceivably be due to consciousness of its artistic force, which impels it to test its ability to imitate nature without abolishing the aesthetic distance.

Be that as it may, we never look even at visual works from any one spot and at a standstill. For even so, our eyes rove all over them and in doing so follow their course in time. Looking at the Parthenon, for instance, we follow the rhythmic striding of its columns, triglyphs, guttae, antifixae, their rhythmic alternations and contrasts, while at the same time we see the whole, and through it the parts, even foreseeing those not within sight. Such dynamic contemplation obviously indicates a movement of our mind in time, and indeed, a readjustment of its standards of time to correspond with the basic rhythmic motion of the work. Finally, we are swayed by the work's own pulsation, we are swept into the time of its music, and each moment seeing its present parts, we remember its past and foresee its future ones. We live now in an ideal space and time, in which the Parthenon's columns indeed come to life, in which the procession of the Panathenea indeed marches along its frieze; in which the Centaurs are in fact fighting the Lapithae in its metopes; while, from its gables, Athena, Zeus, and Poseidon everywhere preside. This point in time is yet eternal; lasting only while the content of the composition is being realized in space, it yet endures and flows on; for the harmony of the composition sustains unceasingly its aesthetic appeal and makes permanent the realization of its content. In this aesthetic sphere, space and time are no longer separate, but a single mental form. Through aesthetic distance, the spectator has moved into the space-time of creative imagination. And in this respect con-

temporary art [19] has not added anything essentially new to all those that have preceded it; it has only expressed differently the space-time relation of phenomena.

AESTHETIC DISTANCE

The conclusion would seem to emerge from the foregoing that spatial and temporal distance are necessary conditions to aesthetic contemplation, as being conducive to aesthetic distance. Yet, they are not in themselves adequate to create it; for aesthetic distance, though it entails the establishment of the most favorable distance in space and time, presents a contradiction in that at the same time it imposes the abolition of every finite aspect of both.

In aesthetic contemplation, the spectator is called on to attain a distance of *spiritual dimensions,* where space and time become an ideal space-time. Thus he may more easily leap over to the poetic realm, while simultaneously, whatever is realized there appears here in finite space and time. Columns stepping rhythmically, eloquent centaurs and gods, triglyphs and metopes, although they compose themselves into an ideal representation, present themselves concretely in real space and time, as "a world within a world."

Thus, detachment from real space and time is not enough for achieving aesthetic distance; so detached the spectator would be in danger of falling into a vacuum. But the work of art saves him from this danger; for, however ideal it may be, it possesses a semblance of reality. Its forms, that is to say, seem able to participate in the life of space and time in which we too move and live. These forms are detached from prosaic reality, are idealized and brought back in order to be realized in matter. The work of art is, after all, the presentation of an idea in matter.

The aesthetic distance, then, from which we must necessarily contemplate the work of art, is both finite and infinite, external and internal, sensible and supersensible. Our transport from one to the other is constant and instantaneous, as we are lifted above reality without losing our sense of it. Aesthetic distance thus provides a magic survey, bringing the firmament of invisible ideas close to our perception. As though art had put on us a pair of magic spectacles, our senses now endow objects of reality with another quality, another significance, making them seem to participate in an ideal existence.

Consequently, both Bullough's view that the distance should be the minimum, and Ortega y Gasset's view that it should be the maximum, are true, if

[19] The writer's views on this subject are expounded in an article entitled "Space-Time and Contemporary Architecture," *Journal of Aesthetics and Art Criticism,* vol. 8, December, 1949.

only in part. The artist must be at the same time close to, and remote from, his experience; both detached spectator and passionate performer, unimpassioned participant of passion, a disinterested but absorbed contemplator, conceiving yet also judging his work. His aesthetic distance, then, if it is to be measured in material physical dimensions, must be the least and at the same time the greatest. And in this, if anywhere, lies the *antinomy of aesthetic distance;* in its touching of reality which at the same time it throws into distant perspective.

This dual task memory alone is able to achieve, as being alone able to register the actual object and at the same time recall its archetype, or to draw from its fund of experiences the material necessary to fulfil an idea. Memory, as the link between spirit and matter, is thus the regulator of the aesthetic distance too. But an aesthetic experience is possible only when memory collaborates with creative imagination to combine the real with the ideal. Imagination and memory meet as the first visualizes a new form which the second refers to its eternal prototype. Memory without imagination is not creative, and imagination without memory is unfounded. For instance, we cannot contemplate the Parthenon from the proper aesthetic distance merely by recalling its picture with our eyes shut, as if looking at a photograph of it, though this may seem to give us the "derealized reality" which Ortega y Gasset advocates.

Recollection, then, becomes an aesthetic experience only when it cooperates with creative imagination to construct, or reconstruct a work—and indeed, so intimately, that we feel as though we almost touched it. Nor can this creative act of memory and of imagination occur simultaneously without a previous irresistible compulsion to realize a vision in space and time. Be it noted here that, whereas the spectator is aided in his act of reconstruction by the presence of the work, the artist constructs from nothing by a sheer feat of creative vision, which he embodies in matter.

Now, if transport to the realm of creative vision automatically sets up the aesthetic distance, and again, if the compulsion to create prompts us to the discovery of the favorable distance which every work demands for its realization, the reverse is not also true: withdrawal to an aesthetic distance does not necessarily entail penetration to the very nucleus of the creative sphere; for our withdrawal may not always be to the *favorable aesthetic distance.* The artist, for instance, is not always creative, even though he is more often than not remote from the affairs of daily life, at an aesthetic distance from them. Indeed, we often find him absent-minded yet oddly observant, maladjusted and yet unexpectedly aware of the essence of things and their meaning; so much so, in fact, that even philsophers draw on his intuitive knowledge. When again, he is in the throes of creation, he is often tormented and restless until

he has adjusted his vision to the *favorable aesthetic distance;* until he has found the place and time in which *this* particular idea presents itself in *this* concrete work.

Now, how does the artist who applies himself, say, to painting a vase, find this favorable distance? The act of vision is, so to speak, a constitutive operation. For instance, when we observe a vase we perceive its structure first, so that whichever way we turn it, and from whichever side we look at it, it still retains its shape in our memory. The artist, when he fashions his work, takes into account this visual survey of the spectator, who in turn relies on it for his own appreciation of the work. That is why it is not unusual for an artist to look at his completed painting in a mirror, or upside down, in an effort to see its pure structure, as distinct from any subject it illustrates or association it evokes. This is true even of works which have been painted in perspective from a fixed point of view, and not only of modern works. Then again, when the artist paints from memory, introducing variations to the form of the model, he always retains its original structure, or at least a structure akin to it.[20]

Memory, that is to say, however much it may modify the form of a prototype, retains its basic structure; if it departs from it at all, it is with the help of imagination in an attempt to interpret, to analyze and recompose the model's form in relation to its structure. And often such modifications, which are, in a sense, memory's own creations and acquisitions, are artistically more useful, more characteristic of their object, and aesthetically more fertile. It may well be that the artist in the throes of creation is waiting for this very act of modification on the part of memory to bring his work into being. This revised recollection (be it but a few seconds old) of a form, a scene, or an event, will turn our previous apprehensions of them into an aesthetic experience, and one more immediate than our original impression. We have said that recollection becomes an aesthetic experience only when it cooperates with creative imagination. It should be stressed here that conversely, no experience, either immediate or aesthetic can exist without recollection, without the collaboration of memory. "The real health of the mind," Schopenhauer maintains, "lies in a sound memory."[21]

Recollections often come to the artist while he is not in a creative mood, and then they remain unexpressed. But if they occur to him at a creative moment, such recollections are nothing short of what we call inspiration, and the joy with which the artist captures them appears from this poem of Cavafy entitled "Far Away":

[20] Experiments in Gestalt psychology have sufficiently proved this. Cf. also R. Arnheim, *Art and Visual Perception,* University of California Press, 1954, pp. 46–47.
[21] Schopenhauer, *op. cit.,* p. 468.

This memory I should like to tell . . .
But it has faded now . . . there is nothing hardly remaining.
So far away it lies in my first years of manhood.

A skin as if made of jasmine in the night . . .
That evening of August—was it August? I hardly remember.
The eyes now? I think they were blue—
Yes, they were blue, as blue as a sapphire's light.[22]

"This memory I should like to tell . . ." begins Cavafy, and though what follows in fact seems to contradict all we have here maintanied—since it goes on to say that now that the recollection is remote "hardly anything remains"— yet, suddenly the poet's opinion is reversed; he now sees the recollection approaching, coming to life, and vividly defining the essential elements of a remote experience. And one is left wondering at the end, whether the poet did not live through the experience he recounts more intensively perhaps in the recollection than he did at the time of its actual occurrence. For now, through the distance of time, the poet can focus his attention on the main constituents of the recollection; he gradates them, interposing distances, as does perspective in a painting with its different planes. The center of this perspective view now is the eyes with their sapphire blue; on the second plane is the August evening; on the third, is the jasmine-like complexion. The space and time of the whole picture are the first years of manhood, but its spiritual space-time is the atmosphere of love. In that way the recollection becomes complete and its dialectics fertile.

In setting up an aesthetic distance from the objects of our contemplation it is as though we went on a journey, leaving them all behind, whereupon we become more deeply attached to them, seeing in them qualities heretofore unobserved, appreciating and grading them more accurately. Consequently, the aesthetic distance, while apparently separating subject from object, in essence constitutes a spiritual bond between them. We move away from the objects of our contemplation, survey them, then return in their midst, seeing them now newly revealed. They are now objects of our consciousness, and in surveying them we survey our own reflections; our memory, untethered, draws from our inner world of feelings and thoughts, relating impressions, visions, concepts, and experiences, which imagination forms into a new world within the world. (It is in this relation we must seek the source of the poetic metaphor, eloquent above all, of man's sense of the correspondence of all things in the Universe.) But before our memory can begin to function thus, in collaboration with imagination, a liberation from our superficial self is necessary. We

22 Cavafy, *op. cit.*, p. 60.

must rise to our higher self, which communes both with our inner self and the Universal Reason (*Logos*). In that communion, subject and object are identified, experiences are objectified, and objective reality acquires a subjective significance and value. As we are psychologically detached, so we are psychically linked with reality.

And here, aesthetic distance which affords our spiritual bond with, as it constitutes our detachment from, the work, presents another antinomy; as a supersensible distance it both is and is not a dimension. In any case, it is not a linear dimension, for it does not extend between one point and another. Objectively, it may be said to be at least four-dimensional, since it extends between two spaces—specifically between the space-time of reality and the space-time of the world of ideas—interposing an additional space-time between them, that separates them as it promotes their fusion. Subjectively, aesthetic distance is multi-dimensional, for it extends from the center of creative imagination to all the other regions of our inner world. Distance in itself is of course neutral; it is a no-man's-land, but on its roads centrifugal and centripetal forces are at work. As a separating road, aesthetic distance is the road of oblivion, from which a new world becomes visible as the old one vanishes. As a connecting road, aesthetic distance is the road of memory along which imagination must travel to reach and realize ideas aesthetically. How right were the Greeks to look upon Mnemosyne [23] as the mother of the Muses!

ART AND THE LANGUAGE
OF THE EMOTIONS

C. J. DUCASSE

That art is the language of emotions has been widely held since Eugène Véron in 1878 declared that art is "the emotional expression of human personality," [1] and Tolstoy in 1898 that "art is a human· activity consisting in this, that one man consciously, by means of certain external signs, hands on to others feelings

[23] The goddess of memory. [Ed.]
[1] Véron, *L'Esthétique*, Paris, 1882, p. 35. 1st ed., 1878.

he has lived through, and that other people are infected by these feelings, and also experience them." [2]

1. *Expression? or expression and transmission?* Whether transmission of the emotions expressed occurs or not, however, is largely accidental; for a given work of art may happen never to come to the attention of persons other than the artist himself; and yet it remains a work of art. Moreover, the individual psychological constitution of persons other than the artist who may contemplate his work is one of the variables that determine whether the feelings those persons then experience are or are not the same as the feelings the artist intended the object he has created to express. Evidently the activity of the artist *as artist* terminates with his creation of the work of art. What the word *language* signifies in the phrase *language of the emotions* is therefore essentially *medium of expression,* and only adventitiously means of transmission.

But even after this has been realized, the term *language of the emotions* still remains ambiguous in several respects. The present paper attempts to eliminate its ambiguities and thereby to make clear in precisely what sense the statement that art is the language of the emotions must be taken if it is to constitute a true answer to the two questions, What is art? and What is a work of art?

2. *The arts, and the fine arts.* The first of the facts to which attention must be called is that the word *art* in its generic sense means *skill;* and that the purposes in pursuit of which one employs skill may be more specifically pragmatic, or epistemic, or aesthetic.

Let it therefore be understood that, in what follows, only *aesthetic* art, i.e., what is commonly called *fine art,* will be in view. Indeed, because of the limited space here available, only the visual and the auditory arts, but not the literary arts, will be directly referred to. What will be said about the former arts, however, would in essentials apply also to the latter.

3. *The two central questions.* So much being clear, the two questions mentioned above may now be stated more fully as follows:

(*a*) Just what does the *creative operation* termed *expression of emotion* consist in, which *the artist* is performing at the time he is creating a work of art?

(*b*) Just what is meant by saying that *the work of art,* once it has come into existence, then itself "expresses emotions"?

4. *The feelings, and the emotions.* Before the attempt is made to answer these two questions, it is necessary to point out that a fairer statement of what is really contended when art is said to be the language of the emotions would

[2] Tolstoy, *What is Art?* (trans. Aylmer Maude), London, 1899.

be that art is the language *of the feelings*. For the term *the emotions* ordinarily designates the relatively few feelings—anger, love, fear, joy, anxiety, jealousy, sadness, etc.—for which names were needed because their typical spontaneous manifestations, and the typical situations that arouse those particular feelings, present themselves again and again in human life. And if, when art is said to be the language of the emotions, "the emotions" were taken to designate only the few dozen varieties of feelings that have names, then that conception of art would apply to only a small proportion of the things that are admittedly works of art. The fact is that human beings experience, and that works of art and indeed works of nature too express, many feelings besides the few ordinarily thought of when the term *the emotions* is used. These other feelings are too rare, or too fleeting, or too unmanifested, or their nuances too subtle, to have pragmatic importance and therefore to have needed names.

5. *Being sad vs. imagining sadness.* Taking it as granted, then, that the emotions of which art is said to be the language include these many nameless feelings as well as the emotions, moods, sentiments, and attitudes that have names, the next important distinction is between *having* a feeling—for instance, *being* sad—and only *imagining* the feeling called sadness; that is, imagining it not in the sense of supposing oneself to be sad, but in the sense of entertaining a *mental image* of sadness.

The essential distinction here as regards feelings, and in the instance as regards the feeling-quality called *sadness*, is the same as the distinction in the case of a color, or a tone, or a taste, etc., between actually *sensing* it, and only *imagining* it; for example, between *seeing* some particular shade of red, and only *imagining* that shade, i.e., calling up a mental image of it as one does when perhaps remembering the red one saw the day before.

6. *Venting vs. objectifying sadness.* Next two possible senses of the statement that *a person* is expressing sadness must be clearly distinguished.

If a person who *is* sad manifests the fact at all in his behavior, the behavior that manifests it consists of such things as groans, or sighs, or a dejected posture or countenance; and these behaviors express his sadness in the sense of *venting* it, i.e., of being *effusions* of it. They are not intentional; and the interest of other persons in them is normally not aesthetic interest, but *diagnostic*—diagnostic of the nature of his emotional state; and possibly also *pragmatic* in that these evidences of his sadness may move other persons to try to cheer him up.

Unlike such venting or effusion, however, which is automatic, the *composing* of sad music—or, comprehensively, the creating of a work of any of the arts—is *a critically controlled purposively creative operation*. If the composer manages to accomplish it, *he* then has expressed sadness. In order to do it, however, he

need not at all—and preferably should not—himself *be* sad at the time but rather, and essentially, *intent* and striving to achieve his intent. This is, to compose music that will be sad not in the sense of itself experiencing sadness, since music does not experience feelings, but in the sense of *objectifying* sadness.

And that a particular musical composition objectifies sadness means that it has the *capacity*—the power—to cause an *image* of sadness to arise in the consciousness of a person who attends to the music with aesthetic interest; or, as we might put it, the capacity to make him taste, or sample, sadness without actually making him sad. It is sad in the sense in which quinine is bitter even at times when it is not being tasted; for bitter, as predicated *of quinine*, is the name of the *capacity or power* of quinine, when put on the tongue, to cause experience of bitter taste; whereas bitter, as predicated *of a taste*, is the name not of a capacity or power of that taste, but *of that taste quality itself*.

7. *Aesthetic contemplation.* A listener who is attending to the music with interest in its emotional import is engaged in aesthetic contemplation of the music. He is doing what the present writer has elsewhere proposed to call *ecpathizing* the music—ecpathizing being the analogue in the language of feeling of what reading is in the language of concepts. Reading *acquaints* the reader with, for instance, the opinion which a given sentence formulates but does not necessarily cause him to adopt it himself. Similarly, listening with aesthetic interest to sad music *acquaints* the listener with the taste of sadness, but does not ordinarily make him sad.

8. *The process of objectification of feeling.* The psychological process in the artist, from which a work of art eventually results, is ordinarily gradual. Except in very simple works of art, the artist very seldom imagines precisely from the start either the finished elaborate work he is about to record or the rich complex of feelings it will objectify in the sense stated above. Normally, the creative process has many steps, each of them of the trial and error type. In the case of music, the process may get started by some sounds the composer hears, or more likely by some sound-images that emerge spontaneously out of his subconsciousness and inspire him. That they inspire him means that they move him to add to them some others in some particular temporal pattern. Having done so, he then contemplates aesthetically the bit of music he has just invented and perhaps actually played; and, if need be, he then alters it until its emotional import satisfies the inspiration that generated it. Next, contemplation in turn of the created and now satisfactory musical fragment generates spontaneously some addition to it, the emotional import of which in the temporal context of the previously created fragment is then in its turn contemplated, judged, and either approved or altered until found satisfac-

tory. Each such complex step both inspires a particular next step, and rules out particular others which a different composer might have preferred.

This process—of inspiration-creation-contemplation-judgment-and correction or approval—is repeated again and again until the musical composition, or as the case may be the painting, or statue, or work of one of the other arts, is finished; each image that is found satisfactory being ordinarily recorded in musical notation, or in paint on canvas, etc., rather than trusted to memory.

9. *The sources of the emotional import of an object.* The feelings, of which images are caused to arise in a person when he contemplates with aesthetic interest a given work of art, or indeed any object, have several possible sources.

One of them is the *form* of the object; that is, the particular *arrangement of its parts in space, or in time, or both.* Taking as simplest example a tone expressive of sadness, its form would consist of its *loudness-shape,* e.g., diminuendo from moderately loud to nothing.

A second source of feeling would be what might be called the *material* of the tone; that is, its *quality* as made up of its fundamental pitch, of such overtones as may be present, and of the mere noise it may also contain.

And still another source of feeling would be the emotional import of what the presented tone may *represent* whether consciously or subconsciously to a particular hearer; that is, the emotional import which the tone may be *borrowing* from past experiences of his to which it was intrinsic, that happened to be closely associated with experience of that same tone at some time in the history of the person now hearing it again. For instance the tone, although itself rather mournful, might happen to have been the signal of quitting time at the factory where he worked at a tedious job. This would have made the tone *represent* something cheerful—would have given the tone a cheerful *meaning;* the cheerfulness of which henceforth automatically mingles with, or perhaps masks for him, the otherwise mournful feeling-import of the tone's presented quality and loudness shape. This third possible source of the emotional import of an aesthetically contemplated object may be termed the object's *connotation;* so that in the example just used the tone has mournfulness of quality and form, but cheerfulness of *connotation.*

Something must be said at this point, however, to make clear both the likeness and the difference between what Santayana, when discussing specifically beauty, means by beauty *of expression,* and what would be meant by beauty *of connotation.*

By beauty of expression, Santayana means such beauty as an object would owe to the fact that, in the past history of the person who now finds it beautiful, it had *pleasurable* associations, and that, if these are not now explicitly recalled, their pleasurableness is automatically borrowed by the object; thus

making it beautiful since, in Santayana's view, that an object is beautiful means that, in aesthetic contemplation, it is found pleasurable.

The likeness between what Santayana means by beauty of expression and what would here be meant by beauty of connotation is that, in both cases, the beauty now found in the object arises from something automatically borrowed by the object from associations it has had in the past experience of the person concerned.

The difference, on the other hand, is that in what Santayana calls beauty of expression, what the object so borrows and connotes, is *not beauty* but, and essentially, *only pleasurableness* (no matter whether sentimental, aesthetic, or other); whereas, in what would properly be called beauty of connotation, what the object borrows and connotes would be the *beauty* of something *itself beautiful*, with which it had been associated. Thus, whereas the cheerfulness of the tone was *cheerfulness* of connotation, the beauty of expression of an object is not *beauty* of connotation, but only *pleasurableness* of connotation.

The sense of the word *expression* in Santayana's phrase *beauty of expression* is thus different from the three senses of expression already distinguished, to wit, (a) expression as designating the kind of *operation* being performed by an artist creating a work of art; (b) expression in the sense it has when one speaks for instance of the sad expression on a man's face, for sad expression then means *symptom* of sadness—*diagnostic sign* that he is sad; and (c) expression as designating the *capacity* of an object when aesthetically contemplated by a person to generate in him an image of sadness, i.e., to make him taste sadness.

10. *"The language of the emotions" defined.* The effect of the several distinctions, to the indispensability of which attention has been called in what precedes, is, the writer believes, to make it possible now to state precisely the sense in which it is true that art is the language of the emotions. This sense is as follows.

Art is the critically controlled purposive activity which aims to create an object having the capacity to reflect to its creator, when he contemplates it with interest in its emotional import, the feeling-images that had dictated the specific form and content he gave the object; the created object being capable also of generating, in other persons who contemplate it aesthetically, feeling-images similar or dissimilar to those which dictated the specific features given the object by the artist, according as the psychological constitution of these other persons resembles or differs from that of the artist who created the particular work of art.

ON THE CREATION OF ART

MONROE C. BEARDSLEY

From the times of Homer and Hesiod, creative artists have wondered about the source of their power to summon into existence things hitherto unseen and even unthought. In our day, it has begun to seem feasible to solve this problem with something like conclusiveness. Yet much of its mystery remains.

A number of distinct questions are involved here, only one of which I shall take up. For example, I shall not inquire why the artist creates in the first place—what obscure impulses compel him to make shapes or melodies, to dance or tell stories. This question has been given two sorts of answer. The first is in terms of conscious motives (the artist wants fame, money, love, power, etc.)— and here it seems pretty evident that there must be a vast variety of true answers, depending on the artist, the work at hand, and even the time of day or night. The second is in terms of unconscious needs and drives—and this I am not competent to pursue. Again, I shall not inquire how the creative process begins—what evokes the first stroke of the brush, the first words of the poem. In the creation of every work, no doubt something does come first, perhaps a single little fragment, perhaps a rush of ideas. This initial element of what later becomes the work has been referred to by various metaphors, some of them misleading, as we shall see—*germ, cell, seed, nucleus;* I will call it the *inceptive element,* or, for short, *incept.* The incept of the work may simply pop into the artist's mind—like Mozart's melodies or Housman's verses—or it may come from external sources, accidentally, like the notes struck by a cat on the keyboard or the pattern made by mud in the gutter. When it does come from within, it no doubt has preconscious causal conditions, though to trace them would surely be a difficult undertaking.

What I mean by the creative process is that stretch of mental and physical activity between the incept and the final touch—between the thought "I may be on to something here" and the thought "It is finished." My problem is about what goes on in this interval—how the work of art itself comes into existence and takes on its character through the stages or phases of this process.

Many students of art have assumed, or expected to find, that there is such a thing as *the* process of art creation—that is, a pattern universally or characteristically discoverable whenever substantial works of art are produced. They

53

would allow, of course, for many differences between one creative process and another, depending on the artist's habits and temperament, the medium in which he moves, and the demands of the particular work in progress. But they argue that beneath these differences there is what we might call the *normal creative pattern,* and that to understand this pattern would contribute much to our understanding of the finished product.

Nor is it unreasonable to suppose that there is such a creative pattern to be isolated and described. First, it might be said, the common character of works of art in all media—whatever it is that enables us to class them together—presents a prima-facie case for a creative pattern. For things that are alike may well have been produced in a similar way. Second, there is the analogy with aesthetic experience. For if there is a pattern of appreciation common to the arts, then why should there not be a pattern of creation, which would, in a sense, be its inverse? Third, there is the analogy with other kinds of creative activity. Dewey's classic description of the process of inquiry, or problem-solving, remains the standard one, though it has been refined and extended since its first appearance in *How We Think.* Practical and scientific problems differ considerably among themselves, just as works of art do, and if there is a common pattern of thought provoked by the former, there may be a common pattern of activity required for the latter.

It is true that the theory of a common character of the arts and the theory of a special aesthetic experience have been questioned in recent years.[1] I appreciate the force of the objections, which I won't go into here, but, like many others, I am not ready to abandon either of the theories. In any case, of course, the three arguments I have mentioned above are not conclusive; they are but suggestive analogies. If there is a common creative pattern, then it can be discovered only by direct study of creative processes. And we might expect to find three main sources of evidence: the artist, the psychologist, and the philosopher.

Our first inclination, of course, is to turn to the creative artist himself, for he ought to know, if anyone does, what is going on in his mind during that mysterious interval between the first pin-fall or brick-fall of an idea and the final laying down of pen or brush. And it is true that much of our best and most useful information about creative processes does come from artists. The trouble is that, for reasons of their own, they are often inclined to the most whimsical and bizarre statements, and seem to enjoy being deliberately misleading. For example, Christian Zervos tells us that Picasso once said to him:

[1] The former by Paul Ziff and Morris Weitz, whose views I have discussed in "Art and the Definitions of the Arts," *Journal of Aesthetics and Art Criticism,* vol. 20, pp. 175–187, 1961, the latter by George Dickie, in "Is Psychology Relevant to Aesthetics?" *Philosophical Review,* vol. 71, pp. 285–302, 1962, and more fully in "The Phantom Aesthetic Experience," forthcoming.

*I take a walk in the forest of Fontainbleau. There I get an indigestion of greenness.
I must empty this sensation into a picture. Green dominates it. The painter paints as
if in urgent need to discharge himself of his sensations and his visions.*[2]

But this is a most curious description of the creative process. If the painter
suffers from a surfeit of green, does he avoid looking at green any more for a
while? No, he goes to his studio, squeezes out the green pigment, and pro-
ceeds, to cover a canvas with it. This is like drinking grapefruit juice to cure
an acid stomach. To make the indigestion theory of artistic creation plausible,
the green-surfeited painter would surely go off to paint a *red* painting—red
being the chromatic analogue of sodium bicarbonate.

We have had, by the way, many other metaphorical models of the creative
process or the mind during creation—though perhaps none more colorful than
Picasso's heartburn. The famous treatise of John Livingston Lowes, *The Road
to Xanadu,* is full of them—the "hooked atoms" jumbled about, the "deep well"
of the unconscious into which the poet dips, the imagination as "loom." Once
we read of Shelley's "fading coal." Now it is the digital computer that fur-
nishes the most tempting figure.

Or consider a famous statement by Henry James, in his preface to *The Spoils
of Poynton.*[3] He begins by saying that the "germ" of his novel, as he called it,
lay in a story told at a dinner party in London. James dilates upon "the sub-
lime economy of art," which starts with such a "prick of inoculation," when
the virus is communicated, and then goes on to build a work out of itself. The
lady who told the story began by mentioning a woman at odds with her son
over the furniture in an old house bequeathed to the son by his father. James
remarks "There had been but ten words, yet I had recognized in them, as in
a flash, all the possibilities of the little drama of my *Spoils,* which glimmered
then and there into life." James says he didn't want to hear any more of the
story, because the germ was complete in itself; the seed had been "transplanted
to richer soil." This claim has often been repeated and taken as a text. But if
we look in his *Notebooks,* where he tells a good deal about the process of
writing *The Spoils of Poynton,* we find that in fact, on the day after the party
(December 24, 1893), James wrote down not only the germ but the whole
story, as it was told him, and that in fact many other germs came into the
picture before very long, as well.[4]

Probably the greatest contributions made by creative artists to the solution
of our problem are not their own theories about what they do, but the records

[2] Brewster Ghiselin (ed.), *The Creative Process: A Symposium,* University of California Press, 1952, p. 51.
[3] Henry James, *The Art of the Novel* (ed. R. P. Blackmur), New York, 1934, pp. 119–124.
[4] *Notebooks,* ed. F. O. Matthiessen and Kenneth Murdock, New York, 1947, pp. 136–137. For further
stages in the development of this novel (tentatively entitled *The House Beautiful*) see the references
on p. 138. (This information was kindly given to me by Professor S. P. Rosenbaum of Indiana University.)

they leave us in the form of sketches and early drafts. We cherish, for example, the notebooks of Beethoven, the sketches and studies in which Picasso worked out his ideas for *Guernica*, and the rich materials contributed to the special collection at the University of Buffalo by living poets who are willing to allow scholars to study their methods of work, their ventures, erasures, substitutions, corrections, and revisions. I shall have occasion to make use of these materials later.

As for the psychologists, despite the considerable effort (or at least speculation) that has gone into the study of the artist's unconscious, not much is available by way of well-established conclusions about the way the poet's or painter's mind is actually working when he is on the job.[5] Some of the most interesting contributions have been made by gestalt psychologists, for example, Rudolf Arnheim, in his psychological study of some materials in the Buffalo collection, and in his recent study of *Guernica*.[6]

Among the most valuable of the psychological investigations are those undertaken nearly thirty years ago by Catharine Patrick.[7] She first secured a group of 55 poets (with 58 "non-poets" as a suitable control group), and, after putting them at ease, confronted them with a certain picture and made them write a poem about it. She asked them to talk aloud as they thought, and took down their words in shorthand. Then she went to the painters, and, tit for tat, presented them with a part of a poem by Milton, which they were to illustrate in some way—while again, she took down their vocal musings, and also kept note of what they were drawing, as time passed. Every encounter was carefully timed. And the results were supplemented by questionnaires.

These interviews resulted in a good deal of very interesting material. Professor Patrick set out to determine whether the typical process of artistic creation passes through the four stages classically distinguished by Graham Wallas in his book on *The Art of Thought*—the stages of preparation, incubation, inspiration, and elaboration. And she concluded that these stages can indeed be distinguished. But the most remarkable feature of her material, it seems to me, is precisely the opposite. All four of these activities are mixed together; they are constantly (or alternately) going on throughout the whole process.

When we turn to the philosophers, we find a few who have tried to bring together into something of a general theory the insights of artists and psychol-

[5] Douglas Morgan, "Creativity Today," *Journal of Aesthetics and Art Criticism*, vol. 12, pp. 1–24, 1953, and Stuart E. Golann, "Psychological Study of Creativity," *Psychological Bulletin*, vol. 60, pp. 548–565, 1963.
[6] *Poets at Work*, New York, 1948, by various authors, and *Picasso's Guernica: The Genesis of a Painting*, University of California, 1962.
[7] *Creative Thought in Poets*, *Archives of Psychology*, no. 178, 1935; "Creative Thought in Artists," *Journal of Psychology*, vol. 4, pp. 35–73, 1937.

ogists. They, too, of course, have their own occupational hazards, or professional vices, and are too readily drawn away from contact with actual works of art into theorizing about what might ideally be true. For one who has a metaphysical axe to grind, it is easy enough to find a congenial formula to describe the creative process. Depending on the angle of approach, the artist will be said to be converting sensations into intuitions, receiving divine inspiration, reshuffling the atoms of immediate experience, embodying the ideal in sensuous form, working out the consequences of an initial postulate, or affirming the authenticity of existence. But I am looking for less ambitious theories than these.

Philosophic reflection on the available empirical data has given us two widely-held accounts of the creative process. When we consider any artistic work of major proportions, whose creation we know something about, we are often struck by the gap between the final achievement and its humble incept. Clearly, the process between can be said to have moved in a desirable direction. Now in the usual case, although lucky accidents may make an important contribution, this process appears to be at least partly controlled. The problem for the aesthetician is, then: What is the nature of this control?

The earliest people who raised this question—Homer, Hesiod, and Pindar—were inclined to give it a supernatural answer, attributing their own feats to the intervention of the Muses. And the theory of divine inspiration, often in a pantheistic version, remains with us. But if we insist upon a naturalistic theory of artistic creation, we find two main ones. And these are distinguished in a way familiar to other branches of philosophy.

According to what I shall call the Propulsive Theory, the controlling agent is something that exists prior to the creative process, and presides over it throughout. According to the Finalistic Theory, the controlling agent is the final goal toward which the process aims. No doubt the two theories run into each other in the minds of some philosophers, and perhaps we need not strain to keep them wholly distinct. But even if there are not two theories, there are at least two errors—and this is what I am most concerned to note.

The theory of art as expression is probably the most popular form of the Propulsive Theory of the creative process. And I shall take R. G. Collingwood as representative of expressionism at its best.

When a man is said to express emotion, what is being said about him comes to this. At first, he is conscious of having an emotion, but not conscious of what this emotion is. All he is conscious of is a perturbation or excitement, which he feels going on within him, but of whose nature he is ignorant.[8]

[8] R. G. Collingwood, *The Principles of Art*, Oxford, 1938, p. 109. See also Alan Donagan, *The Later Philosophy of R. G. Collingwood*, Oxford, 1962, chap. 5, §3.

Before the emotion is expressed, the artist is oppressed by it; he works so his mind will become "lightened and eased." [9] His aim is to make his emotion clear to himself [10] indeed, to discover what the emotion is.[11] Thus Collingwood postulates a single emotion that preserves its identity throughout the process of creation—if the work is to be genuine—and determines the main course of that process.

The first difficulty with this theory is that no principle of identity can be provided for this emotion.

If artists only find out what their emotions are in the course of finding out how to express them, they cannot begin the work of expression by deciding what emotion to express.[12]

Well said. But, on the other hand, after the artist has expressed his emotion, and come to experience it clearly, how does he know it is the same emotion he started with? He cannot compare them, since the other was unknown to him. How does he know that the emotion he feels now is not a new and different emotion—an emotion that is perhaps felt as the *effect* of the finished work, rather than as its cause? As far as I can see, Collingwood has no answer to this. And, moreover, in order to preserve his theory he has to say some rather surprising things. For example,

No artist, therefore, so far as he is an artist proper, can set out to write a comedy, a tragedy, an elegy, or the like. So far as he is an artist proper, he is just as likely to write any one of these as any other.[13]

I am sure that statement would have startled Sophocles or Shakespeare—not to mention Racine and Molière. According to Collingwood, the genuine artist says, "I feel an emotion coming on; no telling what it is until I write something (or paint it, or compose it); how will I know what I've felt until I see what I've done?" If he insists from from the start on writing a tragedy, he will be forcing his emotion into some channel, and the result cannot be art.

The whole concept of *clarifying* an emotion is itself very obscure. I have a suspicion that when Bruckner finished one of his enormous symphonies, his emotions were no more clear to him than they were at the start. At least, they are no more clear to me. They are big emotions; anyone can see that. But clarity is hardly the word for them. On the other hand, nothing could be more clear than the special quality of the opening of Mozart's *G Minor*

[9] Collingwood, *op. cit.*, p. 110.
[10] *Ibid.*, pp. 111, 114.
[11] *Ibid.*, p. 111.
[12] *Ibid.*, p. 117.
[13] *Ibid.*, p. 116.

Symphony; but what reason do we have for thinking that Mozart's composition of this symphony began with some obscure or indescribable emotion, rather than with the subject of the first four bars? And what about artists who have spent years on a single work—are we to say that the very same emotion was there throughout, striving to clarify itself?

An interesting and well-worked-out version of the Finalistic or goal-directed theory of art creation has recently been presented by David Ecker.[14] He describes the creative process as "qualitative problem-solving," borrowing the concept from John Dewey. The stages of the process, he says, consist of a series of problems and solution: if I use this cool green here I can get this plane to recede; "this jagged shape contrasts sharply with those open volumes," [15] etc. Now he makes it clear that the problems posed are within the work itself: "Artistic problem solving takes place in the artist's medium." [16] The problem need not be verbally formulated,[17] and various logical terms that might be applied to the process (such as "verification" and "hypothesis") are "grossly misleading." [18] But the process is to be analyzed in terms of the categories of means and end; the choices involved, and the general direction, are controlled by the previsioned goal. (It is plain that Ecker's account would be strongly repudiated by Collingwood; according to Ecker, the poet *must* begin by intending to write a tragedy, or comedy, or something—for otherwise he has no problem to solve.) Ecker quotes a very illuminating passage from the sculptor Henry Moore:

> . . . *I sometimes begin a drawing with no preconceived problem to solve, with only the desire to use pencil on paper, and make lines, tones and shapes with no conscious aim; but as my mind takes in what is so produced a point arrives where some idea becomes conscious and crystallizes, and then a control and ordering begins to take place.*
>
> *Or sometimes I start with a set subject; or to solve, in a block of stone of known dimensions, a sculptural problem I've given myself, and then consciously attempt to build an ordered relationship of forms . . .*[19]

The first part of this statement is very clear, and restricts one side of Ecker's theory. There may be, says Moore, no "preconceived problem to solve"—the only problem, if there is any, arises after the occurrence of the incept, the first lines of the drawing. The "control and ordering" begins with the elements of the work itself. The second part of the statement can be understood, it seems

[14] "The Artistic Process as Qualitative Problem Solving," *Journal of Aesthetics and Art Criticism*, vol. 21, pp. 283–290, 1963.
[15] *Ibid.*, p. 285.
[16] *Ibid.*, p. 285.
[17] *Ibid.*, p. 286.
[18] *Ibid.*, p. 288.
[19] Ghiselin, *op. cit.*, p. 77.

to me, in a similar way. Sometimes, says Moore, he starts with a subject—say, he is to make a reclining figure. Or a set of outside dimensions, within which to work. But basically this is the same sort of thing; the incept can be some lines randomly drawn on paper, or the subject, or the block of untouched marble, with its own particular size and shape.

The trouble appears when this is called a *problem.* What is the problem? It might be: "How can I make a good drawing using these lines I've already drawn?" Or "How can I make a good sculpture of a reclining figure?" Or "How can I make a good sculpture out of this block of marble?" But these are queer things to call *problems:* they are really *tasks,* the terms of which are voluntarily accepted by the artist. The main question involved in each of them is simply: "What do I do next?" A problem arises out of a conflict of some kind—a goad that the sculptor does not require. And it calls for a specific and determinate solution or set of solutions—which is not what the sculptor achieves.

Elsewhere I have stated my objections to the end-means terminology in art.[20] Actually, when Ecker gives his examples of ends and means, it is clear that he is not really talking about these at all, but about the relation between what I call regional qualities and their perceptual conditions. The cool green is not a means to the receding plane; it is one of the localized features of the visual design that help to make the plane recede. The recession of the plane, to put it another way, is a comparatively large-scale property of the work, which depends (in part) upon a comparatively small-scale property, the cool green. Now, if we ask which the artist first intended and has as an "end-in-view," it is tempting to say, with Ecker, that the artist

arranges qualitative means *such as lines, colors, planes, and textures, to achieve his qualitative* end, *which we might name "cubist," "impressionist," or "expressionist."* [21]

But Ecker has already conceded that the end-in-view may be "some intended order" as well as a "pervasive quality." [22] It may often be the case that what the artist is consciously after is a certain arrangement of lines, colors, planes, and textures, and the resulting regional quality is unexpected. It is odd to speak of the color as a "means" when it is chosen for no ulterior motive.

The error here is a subtle one, but a very crucial one in talking about art. It consists in jumping from the fact that regional qualities depend upon their perceptual conditions to the conclusion that the former are therefore always ends-in-view and the latter means, in the process of creation. Perhaps no great

[20] *Aesthetics: Problems in the Philosophy of Criticism,* New York, 1958, pp. 78–80.
[21] *Ibid.,* p. 287
[22] *Ibid.,* p. 286.

harm would usually be done, but this way of speaking leads to an impasse, which is fully exhibited in a sentence quoted from John Dewey by Ecker:

The doing or making is artistic when the perceived result is of such a nature that its *qualities* as perceived *have controlled the question of production.*[23]

Take the finished painting; note its quality. Now suppose we have photographs of various stages of the work, taken at daily or hourly intervals, let us say, while the painter was working. None of these, of course, has the *specific* quality of the finished painting. But Dewey says this quality was all along controlling the artist's work. Since the quality did not exist until the painting was finished, it could only have been in the artist's mind. Does that mean that from the earliest stages of a painting, from the incept onward, the painter has definitely in mind some regional quality that he is trying to bring into existence on the canvas? It is conceivable that this is sometimes the case, but most of the experience of artists goes against it: it would be remarkable if the exact regional quality of the final painting were that plain to the painter from the start.

Now, Dewey's statement can be interpreted in a somewhat more plausible way, if we introduce the notion of degrees of intensity for these regional qualities. The final painting, let us say, is characterized by a firm semi-geometrical solidity and rigidity, with decisive lines and interlocking forms. We look at the first tentative strokes put down by the painter, in the earliest photograph, and we see that somehow, dimly but unmistakably, this final quality is foreshadowed in the early draft—a touch of it is already there, though nothing like the way it is there at the end. So the process of creation lying between these stages could be described, at least in part, as one in which a regional quality hit upon early in the game is gradually intensified with the complication of new lines and colors. So in this sense, it could be that the final quality has been at work throughout—not as a foreseen goal to which the process is heading teleologically, but as a present quality whose immediately perceivable value suggests to the painter that it would be even more valuable if there were, so to speak, more of it.

There is no doubt that something like this does often happen. Sometimes, we can see in the earliest stages of a great work that the quality we value so highly in the finished product has begun to emerge. But this is not always the case, by any means. Sometimes the quality that appears most definitely at the start turns out not to be fruitful; the artist's attempt to intensify it leads to radical formal rearrangements that end by destroying the original quality and substituting a very different one. The melody that was first tried out as a quick

[23] *Art as Experience,* New York, 1934, p. 48.

rondo theme becomes the subject of a slow movement—almost unrecognizably altered. The poem that started out as a few ironic lines about a current political issue transforms itself, almost against the poet's will, into a moving meditation on the human condition. Nor is such a process—contrary to what Dewey implies—any the less artistic because not the same, but different, qualities have been active in generating the process at different stages.

Vincent Tomas has effectively criticized the finalistic view that artistic creation is "a paradigm of purposive activity." [24] There is a sense of "heading somewhere," though without a given goal in terms of which success or failure can be defined as it can when the torpedo is launched towards a target. Yet, paradoxically, "the artist *can* say that certain directions are not right." And Tomas' solution, sound so far as it goes, is to emphasize the critical ingredient in creation. His theory is that creation is a self-correcting process, in which the artist constantly redirects its aims. Tomas does not show in detail how the artist does this. But I believe he is right, and I will try to develop and defend this theory.

The real nature of the artist's control over the creative process will elude anyone who looks for a single guiding factor, whether a need or an end. It is internal to the process itself. I do not plan to argue for a single creative pattern, but to show how, in the absence of any such general pattern, each individual process that eventuates in a work of art *generates* its own direction and momentum. For the crucial controlling power at every point is the particular stage or condition of the unfinished work itself, the possibilities it presents, and the developments it permits. There are three things to discuss here, and I will say something about each—the incept, the development, and the completion of the work.

The first control over the artistic process is set up by the incept itself. And I want to emphasize, as I have said before, that the incept may be any sort of thing: the first sentence of a story or the last, a simple plot situation, a character, theme, scene, figure of speech, or tone or style. Paul Valéry has told us, instructively:

My poem Le Cimetière marin *began in me by a rhythm, that of a French line . . . of ten syllables, divided into four and six. I had as yet no idea with which to fill out this form. Gradually a few hovering words settled in it, little by little determining the subject, and my labor (a very long labor) was before me.*[25]

[24] "Creativity in Art," *Philosophical Review*, vol. 67, pp. 1–155, 1958; "A Note on Creation in Art," *Journal of Philosophy*, vol. 54, pp. 464–469, 1962. The former is reprinted in Tomas (ed.), *Creativity in the Arts*, Englewood Cliffs, N.J., 1964.
[25] "Poetry and Abstract Thought," *The Art of Poetry* (trans. Denise Folliot), New York, 1961, p. 80.

Elsewhere, Valéry adds that his playing around with possibilities of this rhythm led to a certain kind of stanza, then—

Between the stanzas, contrasts or correspondences would be set up. This last condition soon required the potential poem to be a monologue of "self," in which the simplest and most enduring themes of my affective and intellectual life, as they had imposed themselves upon my adolescence, associated with the sea and the light of a particular spot on the Mediterranean coast, were called up, woven together, opposed . . . All this led to the theme of death and suggested the theme of pure thought.[26]

This is exactly opposite to the usual idea that the poet must begin with his theme, or thesis, and that he characteristically then devises a suitable subject or set of images, and finally settles on the appropriate stanzaic form and meter. Now, I'll have to confess at this point that I am wide open to one kind of skeptical criticism. Considering that this particular poem is one of the most obscure poems in the French language, it might be said, we can draw no general conclusions from Valéry's method of composing it—what can you expect from a poet who begins with rhythms and ends with themes? Still, Valéry's account shows there is no one, privileged, order in which a poem has to get written. And even in the composition of more conventional poems, many different items (including metrical patterns) actually come first. Stephen Spender, for example, tells us in an essay that one of his poems began with a vision of the sea, and that another time, the words "A language of flesh and roses" came into his head as the incept of a possible poem while he was standing in the corridor of a train looking at a landscape of pits and pitheads—though at the time he was writing his essay, the words had not yet grown into an actual poem.[27] From a famous essay by Allen Tate, we gather that two elements of his "Ode to the Confederate Dead" were present from the start—the idea he calls *solipsism* and the idea of the dead—though it took ten years to fuse them together.[28] And according to Muriel Rukeyser, her poem "Orpheus" began with a sudden terrifying image of disintegration that came to her as she walked along a crowded street in New York.[29]

One of the most important questions about the role of the incept in the creative process is this: Does it exercise a pervasive influence throughout? If the Propulsive Theory is correct, one would expect to find the incept dominating the whole process, for whatever appears first would presumably be closely related to the original emotion. On second thought, I am

[26] "Concerning 'Le Cimetière marin,' " *ibid.*, p. 148.
[27] "The Making of a Poem," *Partisan Review*, vol. 13, pp. 294–308, 1946. (Also in Tomas, *op. cit.*).
[28] "Narcissus as Narcissus," *On the Limits of Poetry*, New York, 1948.
[29] Frank Barron, *Creativity and Psychological Health*, Princeton, 1963, p. 229n. For examples of fiction incepts see Malcolm Cowley (ed.), *Writers at Work*, New York, 1959, esp. pp. 7–8.

not sure this really follows; it is hard to say what can be predicted from Collingwood's unknown and unknowable emotion. Again, if the Finalist Theory is correct, one would also expect the incept to dominate, for it would presumably embody the original problem or goal which directs the process to the end.

Now, one thing is evident: once an element is chosen, it sets up demands and suggestions as to what may come next, and also places limits upon it. Draw a single line on a piece of paper. If you do not think what you have there is worth much attention, the question is what you can do next to improve upon it. You can balance it, cross or oppose it by other lines, thicken and emphasize it, transform it into a more complex line or a shape, etc. Or, of course, you can erase it—but then you are rejecting it as an incept, and putting an end to that particular creative process. That every stage of the process powerfully affects the succeeding stage is plain; but our present question is whether the first stage is somehow dominant over all. Artists have spoken rather differently about this. For instance, Picasso once said that "Basically a picture doesn't change, that the first 'vision' remains almost intact, in spite of appearances." [30] But he also said that a picture cannot be thought out ahead of time, and "changes as one's thoughts change." The sketches for *Guernica* do have a notable continuity despite all the changes. The bull and the horse were there in the first sketch, and a woman appeared in one of the later sketches done the same day.

Another example is provided by Beethoven's long series of sketches for the spacious melody that he used for the variations in the slow movement of his string quartet in E flat, *Op. 127*. These have been studied by Victor Zuckerkandl.[31] When they are placed side by side, they illustrate the force of the incept very clearly. The first full bar of the final melody, with its stepwise motion upward from A flat to F, is there almost complete from the very first sketch, though with a slightly different rhythm; and the rest of the story is a struggle, resumed from time to time over a long period, to find an adequate continuation and completion of that incept. Beethoven tries various ways of carrying on the melody, and abandons them; he tries the initial bar in the key of C, in duple tempo, with turns and rhythmic alterations, to see if it can be made to move into the long flowing line that the incept seems to call for. The whole keeps changing its regional character as it grows, yet some of its outstanding final qualities can be described as intensifications of qualities that were there in the first sketch. But this is by no means true of all of Beethoven's

[30] Arnheim, *op. cit.*, p. 30.
[31] I am referring to a lecture given in the spring of 1963 at Swarthmore College.

work; Allen Forte, a careful student of the piano sonata, *Op. 109,* has remarked that "in many instances one can hardly recognize the final version from the initial sketches." [32]

Indeed, an incept that initiates a successful creative process may become almost lost in it. Of course there must be some continuity from incept to final work, otherwise we could not say that the incept was the start of that particular work. But there is a wide range of deviation from the straight line of development. An ingredient that has one quality as it first appears to the artist may later find a context that alters its quality completely. Dostoyevsky's novel *The Idiot* is an interesting case in point. We have a large collection of manuscript notes and drafts to tell us the agonizing story of Dostoyevsky's working out of that novel. In the very early stages, the Idiot (as he is called from the beginning) is

described as a powerful, proud, and passionate individual. There is something Byronic about him, and he resembles those criminal, self-willed creations Valkovski and Svidrigailov. He is sensual, performs extravagant actions, and perhaps his most marked trait is egoism.[33]

Could anything be farther from the Idiot of the final novel? For two months, through eight detailed plans for the novel, Dostoyevsky worked toward the deadline for the first installment (published January 1868). As the plans succeed each other, we see certain characters take on the Christlike characteristics of Prince Myshkin as we now have him, and we see the Idiot developing a double nature that prepares the way, in the eighth plan, for his reversal of personality. Even so, the novel was still significantly changing between the first installment and the later ones.

Once the work is under way, with a tentative commitment to some incept, the creative process is kept going by tensions between what has been done and what might have been done. At each stage there must be a perception of deficiencies in what now exists, plus the sense of unrealized possibilities of improvement. The motivating force, as Tomas says, is a negative critical judgment. And this same point has been made by Valéry. To understand poetry, he remarks, we must study

[32] *The Compositional Matrix,* Baldwin, N.Y., Music Teachers National Association Monographs, 1961, p. 4. Cf. Ernst Krenek's analysis of the sketches for the false entry of the subject in the *Eroica:* "The Problem of Creative Thinking in Music," in *The Nature of Creative Thinking,* a symposium published for the Industrial Research Institute, Inc., New York University, 1952, pp. 54–57.
[33] Ernest J. Simmons, *Dostoyevsky,* Oxford University Press, 1950, p. 202. See his whole book for very illuminating accounts of Dostoyevsky's creative processes.

word combinations, not so much through the conformity of the meanings of these groups to an idea or thought that one thinks should be expressed, as, on the contrary through their effects once they are formed, from which one chooses.[34]

In other words, as the poet moves from stage to stage, it is not that he is looking to see whether he is saying what he already meant, but that he is looking to see whether he wants to mean what he is saying. Thus, according to Valéry, "Every true poet is necessarily a first rate critic"—not necessarily of others' work, but of his own.[35]

Each time the artist—whether poet, or painter, or composer—takes a step, he adds something to what is already there (A), and makes another and different object (B). If he judges B worse than A, he must go back. If B is better than A, the question is whether it is good enough to stand alone as a work of art. If not, the question is whether B can be transformed into still another and better object, C. If this is impossible, if every attempt to improve it only makes it worse, then the whole project is left unfinished, for it is unfinishable.

One of the most puzzling questions about the creative process is how the artist knows when to stop. If the Propulsion Theory is correct, the answer is that he stops when his original impulse has exhausted itself. If the Finalistic Theory is correct, then the artist compares his work at every stage with the intact memory of his original vision of his goal, and when they match the work is done. But without these theories, it becomes more difficult to explain what it means to come to an end of a creative process.[36]

There are really two questions here: how the artist knows when *he* is finished, and how he knows when the *work* is finished. The first question is no doubt the easier. The artist comes to a point where he can no longer think of any way to improve his work. This becomes more and more difficult as work progresses. In the early stages, lines and colors, stanzas and melodic fragments, can be added quite freely to see whether they can be assimilated. But in the later stages, as the work becomes more complex, the effect of every addition or alteration is more serious; a wrong line or color, a wrong word or melodic

34 "A Poet's Notebook," *op cit.*, p. 178. Compare John Dryden's dedication of *The Rival Ladies* (in Ghiselin, *op. cit.*, p. 77): "When the fancy was yet in its first work, moving the sleeping images of things toward the light, there to be distinguished, and then either chosen or rejected by the judgment." The drafts of Yeats's "Sailing to Byzantium," written on looseleaf pages over several years, show how fertile he was in alternative possibilities for lines we now know so well, and that his problem was to select and combine; see Curtis Bradford, "Yeats's Byzantium Poems: A Study of Their Development," *Publications of the Modern Language Association*, vol. 75, pp. 110–125, 1960. (I am indebted to Professor Robert Daniel, of Kenyon College, for this example). Cf. Martin K. Nurmi, "Blake's Revisions of *The Tyger*," *Publications of the Modern Language Association*, vol. 71, pp. 669–685, 1956.
35 "Poetry and Abstract Thought," *ibid.*, p. 76. This is echoed by Richard Wilbur in *The Nature of Creative Thinking*, p. 59, and by Ben Shahn, in *The Shape of Content* (see selection in Tomas, *op. cit.*, p. 20).
36 I. A. Richards, "How Does a Poem Know When It Is Finished?" in Daniel Lerner (ed.), *Parts and Wholes*, New York, 1963.

figure, can throw the whole thing badly off. Of course, the artist can never be certain he has done all he can. Happy is the painter, who can say, with Matisse,

Then a moment comes when every part has found its definite relationship and from then on it would be impossible for me to add a stroke to my picture without having to paint it all over again.[37]

Many a painter has been notorious for a never-say-die determination to hang on to his paintings in the hope that he will think of a way of bettering them— unless extreme poverty or a wily dealer induces him to part with them. (Valéry, by the way, says he wouldn't have published *"Le Cimetière marin"* when he did, had it not been snatched from him. "Nothing is more decisive than the mind of an editor of a review," he remarks—though perhaps he could have put up more of a fight.) [38]

The artist generally knows, then, pretty well whether *he* is finished—but that is not the same as saying that the *work* is finished. For when the artist has done all he can, the question remains whether the work has enough to it, whether it is worthy of standing by itself, as an object of aesthetic enjoyment. If he judges so, the artist says it is done. If he judges not, the artist says it is unfinished. And of course the threshold of contentment varies enormously from artist to artist.

These points are illustrated by the famous puzzle of Schubert's unfinished symphony. Unlike most great unfinished works, it was not cut short by death (Schubert had six more years to live), but simply abandoned by the composer after he had completed two magnificent movements. Hans Gál has proposed an interesting solution.[39] Schubert began a scherzo in B minor, which would have been the third movement. In the manuscript, the parts are first quite fully indicated, then they drop out, as the composer loses interest, and the movement trails off in the trio. The trouble is that the opening subject is one of startling emptiness and dullness—and yet it is a compulsive theme, hard to get away from once it is started, especially if the scherzo must be in the conventional key. "Those obstrusive four bars," as Gál calls them, get a grip on the composer; he cannot shake them off, or, apparently, find a way of starting anew so long as every time he picks up the manuscript they stare him in the face. If we agree with Gál's hypothesis, the scherzo is a formidable example of a composition that cannot be well finished—even by a master. It must have required a powerful force indeed to make a composer leave off a symphony so excellently begun.[40]

[37] "Notes of a Painter," in Eliseo Vivas and Murray Krieger (eds.), *The Problems of Aesthetics*, New York, 1953, p. 259.
[38] *Op cit.*, p. 144.
[39] "The Riddle of Schubert's Unfinished Symphony," *The Music Review*, vol. 2, pp. 63–67, 1941.
[40] It is harder to understand what distractions led Mozart to abandon the more than 100 unfinished compositions (not counting the *Requiem*) that his widow preserved for us. See Erich Hertzmann, "Mozart's Creative Process," *Musical Quarterly*, vol. 43, pp. 187–200, 1957.

In one respect, the foregoing account diverges from a remark by Rudolf Arnheim in his study of Picasso's *Guernica*. Arnheim speaks of the creative process as being "goal-directed throughout" [41]—a view I challenged earlier. And summing up the whole process, he says,

A germinal idea, precise in its general tenor but unsettled in its aspects, acquired its final character by being tested against a variety of possible visual realizations. When at the end, the artist was willing to rest his case on what his eyes and hands had arrived at, he had become able to see what he meant.[42]

I would not put such stress upon the words, if these two sentences had not been so exact and eloquent up to the final clause. But the words "become able to see what he meant" seem to imply that what Picasso ended with was an expression, an explication, an embodiment, a realization, or whatever, of what was already in his mind at the start. Better, I think, to say that he had become able to mean something much better than he was able to mean a few months before, and that what he now was able to mean—that is, to make—was enough.

To draw together these remarks and examples, perhaps we can decide how far to generalize. Though there are no universal *stages* of the creative process, there are two clearly marked *phases*, which constantly alternate throughout. They involve an interplay between conscious and preconscious activities. There is the *inventive* phase, traditionally called *inspiration*, in which new ideas are formed in the preconscious and appear in consciousness. And there is the *selective* phase, which is nothing more than criticism, in which the conscious chooses or rejects the new idea after perceiving its relationships to what has already tentatively been adopted.

The problem of what goes on in the preconscious is apparently still unsolved. We would like to know how it is that a composer, having sung two bars to himself, suddenly thinks of a way to continue it—or that a painter, having outlined a figure, thinks of certain colors that might be added—or that a poet may look at a line he has just written and think of possible substitute words. To take a few examples from R. P. Blackmur,[43] suppose the poet has written "breathless tiptoeing," and it occurs to him that "flowering tiptoeing" might be better; or suppose he has written "chance deepening to choice" and substitutes "chance flowering to choice." Whether the new words are better than the old is the question to be decided by his conscious mind; but why one set of words rather than another comes to consciousness is the more mysterious question.

[41] *Op. cit.*, p. 134.
[42] *Op. cit.*, p. 135.
[43] *Poets at Work*, p. 48.

The psychological dispute seems to be formulable this way: to what extent are the preconscious processes associative; to what extent do they involve closure or strengthening of gestalts? [44] As far as I can make out both of these processes seem necessary to account for what the preconscious presents to the conscious. If, for example, "flowering" replaces "deepening" because of some meaningful connection of this figure with other images earlier in the poem, then we can say that the unconscious has found some degree of closure. On the other hand, the substitution may have only a very remote relationship to other words already set down, but it may serve to break down an existing gestalt, to introduce a more unstable cluster of meanings, which may lead to a more inclusive synthesis later. In this case, the word *flowering* would be described as due to free—or at least freer—association. It seems evident, in any case, that unless the preconscious can produce both kinds of ideas—those that close a gestalt and those that break one—poems could not get composed, nor could paintings or musical works.

It is no doubt high time to face up to the question that is bound to arise after all these reflections and speculations about the creative process: what is the point of them? Or, in other words: what difference does it make to our relationship with the arts that we understand the creative process in one way or another? And here my answer is brief and unequivocal. It makes no difference at all. I think it is interesting in itself to know, if we can, how the artist's mind works, but I do not see that this has any bearing upon the value of what he produces. For that value is independent of the manner of production, even of whether the work was produced by an animal or by a computer or by a volcano or by a falling slopbucket.[45]

This statement would be vigorously repudiated by some who have studied the creative process: they claim that their studies throw light on the "meaning" and "beauty" of poems, to use the words of Donald Stauffer, writing on "Genesis, or the Poet as Maker." [46] If we knew, says Stauffer, the genesis of a poem by Housman, it would "enable us to interpret this particular work with more precision." But his method puts the enterprise in none too favorable a light, it seems to me. Digging through the early stages of the composition of Marianne Moore's poem, "The Four Songs," he finds a typescript in which the poem is entitled "Poet to Lover (Admitting Limitations)." Moreover, he turns up other titles that the poet considered and rejected: "Poet to Plain-

[44] This is the point at issue, for example, between Lawrence S. Kubie, *Neurotic Distortion of the Creative Process*, University of Kansas, 1948, esp. pp. 53–61, and Arnheim, *Picasso's Guernica*, p. 70.
[45] For a decisive argument along this line, see John Hospers, "The Concept of Artistic Expression," *Proceedings of the Aristotelian Society*, vol. 60, pp. 313–344, 1955.
[46] In *Poets at Work*, p. 43.

Reader," "Poet to Ordinary Man," and, oddly, "Asphodel." (This poem has as many titles as the White Knight's song "A-sitting on a Gate.") All these titles, says Mr. Stauffer, "should prove of value in interpreting the complete poem," [47] and he proceeds to put them to use. But think of the implications. The poet discards the titles, and the genetic interpreter plucks them out of the wastebasket and uses them as though they had not been discarded. This is a pretty high-handed way to treat Marianne Moore. The logic of the situation is clear. Either the title of a poem makes a difference to the way it is read, or it does not. If not, then knowing the discarded titles has no effect on our interpretation. If so, then each title makes a slightly different poem, and Mr. Stauffer is simply refusing to read the poem that Miss Moore wanted us to read. Granted that her choice does not have to be final; some of the titles she threw away could conceivably be better than the one she kept. (After all, remember the time she was commissioned to suggest names for a brand-new car that the Ford Motor Company was planning to bring out. She came up with some lovely ones, but in the end they called it the Edsel.) But if you do not accept her title, then at least do not pretend that you are interpreting her final poem.

The informed observer will, of course, detect in these genetic maneuvers a particularly persuasive form of that vulgar error which William Wimsatt, Jr. and I stigmatized some years ago as the Intentional Fallacy. I do not know whether it is in good taste for me to rake over these old coals, but whenever a fallacy gets to be so old-fashioned and so familiar as this one, it is always heartening to find new instances of it, so that you know you are not beating a dead horse—even if he is not exactly the picture of health. What we attacked under a single name (intentionalism) were in fact two closely related forms of unsound argument: that which attributes a certain meaning to a work on the ground that the artist intended the work to have that meaning, and that which appraises the work at a certain value on the ground that it does or does not fulfill the artist's intention. If we took to interpreting poems in terms of what they were like before they were finished, we would be turning the whole creative process upside down, by refusing to consider the final product on its own terms. Let this method become popular, and you can expect poets, painters, and musicians to keep their wastebaskets emptied, by burning their early sketches just as soon as possible.

Is this our final conclusion, then—that questions about creativity are irrelevant to questions about actual works of art? Somehow it does not seem enough. From the beginning of thought about art, though in many different forms, the creativity of art has been noted and pondered. Associationists, intuitionists,

[47] *Ibid.*, p. 63.

romantics, and idealists have offered explanations. In the making of such works, something very special seems to be happening; something fresh is added to the world; something like a miracle occurs. All this is true. There is such a thing as creativity in art, and it is a very important thing. What I want to say is that the true locus of creativity is not the genetic process prior to the work but the work itself as it lives in the experience of the beholder. Let me explain—all too briefly and puzzlingly, no doubt—what I mean.

To begin with, what is a melody? It is, as we all know, a gestalt, something distinct from the notes that make it up, yet dependent upon them for its existence. And it has its own quality, which cannot be a quality of any particular note or little set of notes. Recall that melody from Beethoven's E flat Quartet—grave, serene, soaring, affirmative, yet in a way resigned. Now when we hear a melody, however simple, we hear two levels of things at once: the individual notes and the regionally qualified melody that emerges from them. We hear the melody being born out of the elements that sustain it; or we hear the elements, the tones and intervals, coming together in an order that calls into existence an entity distinct from them, and superior to them. In the experience of a melody, creation occurs before our very ears. And the more intense the created qualities, the more complex the sets of cooperating elements, the tighter their mutual relations, the more fully we can participate in that basic aesthetic experience.

I need not argue in detail that the same holds for works of fine art. The essential feature of such a work—I am tempted to say, but recognizing that I am likely to sound dogmatic—the essential feature is not merely that certain visual elements (lines, shapes, colors) are assembled together, but that as we concentrate on their natures and relations, we become aware, suddenly or gradually, of what they add up to as a whole. For what they add up to is not an addition at all, but the projection of a new pattern, a new quality of grace or power.

When we consider a poem in this perspective, we see again that the important creativity is in the operation of the work itself. The sound-qualities, such as meter and rhyme-patterns, are one sort of emergent; more importantly, the interactions and interinanimations of words, in figurative or unusual language, create hitherto unmeant meanings; and more importantly, the objects and events of the poem mysteriously are made to accumulate symbolic reverberations, by which they seem to have a significance far beyond themselves. And this takes place in the act of reading; the excitement of seeing it happen is precisely the peculiar excitement of reading poetry.

The British literary critic, L. C. Knights, has made some comments that seem to me very similar to what I want to say, in a special issue of *The Times*

Literary Supplement, on "The Critical Moment." [48] His example is from Words-
worth's famous sonnet,

> *Dull would he be of soul, who could pass by*
> *A sight so touching in its majesty.*

That is a strange combination of ideas—"touching" and "majesty." Knights says
this:

> *The peculiar pleasure of that last line—though the pleasure is independent of con-*
> *scious recognition of the source—comes from the movement of mind by which we*
> *bring together on one apprehension 'touching' and 'majesty': feelings and attitudes*
> *springing from our experience of what is young and vulnerable, that we should like*
> *to protect, fuse with our sense of things towards which we feel awe, in respect of*
> *which it is we who are young, inexperienced or powerless.*

The "movement of mind" of which he speaks, in bringing these two opposed
feelings into a fusion, through the words of the poem, is an act of creation,
for out of that fusion comes a new complex, vital feeling that has elements of
both and yet is reducible to neither. So, says Knights, the creative use of words
"energizes" the mind—"new powers of vision and apprehension come into
being."

It may seem that this way of looking at artistic creativity demeans the artist
by making not him, but the work itself, the creative thing. But I do not think
so. I do not forget that man is the maker—of nearly all the great works we
have, or are likely to have. But the finest qualities of a work of art cannot be
imposed on it directly and by fiat; the artist can, after all, only manipulate the
elements of the medium so that *they* will make the quality emerge. He can
only create a solemn melody by finding a sequence of notes that will have that
quality. The powers he works with are, in the end, not his own but those of
nature. And the miracle he makes is a miracle that celebrates the creative
potentialities inherent in nature itself. But when in this way the artist makes
plain to us over and over the marvelous richness of nature's potentialities, he
also presents us with a model of man's hope for control over nature, and
over himself. Artistic creation is nothing more than the production of a self-
creative object. It is in our intelligent use of what we are given to work with,
both in the laws of the universe and in the psychological propensities of man,
that we show our mastery, and our worthiness to inhabit the earth. In this
broad sense, we are all elected, or perhaps condemned, to be artists. And
what keeps us going in the roughest times is the reminder that not all the
forms and qualities and meanings that are to emerge in the fullness of time
have already appeared under the sun—that we do not know the limits of
what the universe can provide or of what can be accomplished with its ma-
terials.

[48] July 26, 1963, p. 569.

THE DANCE

As Susanne Langer points out, the dance is truly the first art form of any society. All that is necessary for a dance is the human body in motion and a floor on which to sustain it. Miss Langer in her brilliantly lucid discussion follows a logical sequence which could well be a model for any philosophical analysis. It is a sequence reminiscent of the question-answer dialogues of Socrates and Plato. The first question about dance is: What do dancers create? The second is: For what purpose do dances create their "dynamic image"? The answers to these questions beget more questions, as in all philosophical enquiries, but the process of asking and answering moves us closer to the nature of the dance itself. As Selma Jeanne Cohen observes, via Edwin Denby, at the end of her essay, the aesthetics of dance is still in a primitive state of development. There are far many more questions than there are answers for what goes on when dancers perform their art.

The problem of form and content is with us here, as we can see from either Miss Cohen's essay or the excerpt from Morris Weitz. Pure dance is that dance which has no story line to it, no narrative base which distracts the viewer from the forms the dancer creates. We normally use the word "pure" to indicate something favorable. However in this context we must be cautious not to permit ourselves to be convinced by the word when it is the concept which is at stake. Miss Cohen discusses the content of several dances in a way that Mr. Weitz might not approve. Likewise, Mr. Weitz himself is not flatly approving the pure dance as opposed to the "enlarged conception of the dance."

In her prolegomenon, Miss Cohen begins by suggesting much that might tend toward a definition of dance. She is able to suggest that probably no dance is not rhythmic but that much which is rhythmic is surely not dance. She is specifically excluding much ordinary and extraordinary human daily action from the realm of dance. A reader cannot help but ask questions of his own about such a judgment. What kinds of actions would Miss Cohen exclude which could, conceivably, be included in a dance? Could a dancer iron clothes, for instance, on a dance stage and yet not cease to dance?

One might consider the nature of Miss Langer's "dynamic image" in light of the comments Miss Cohen and Mr. Weitz make. How is the "dynamic image" related to the music which underlies the dance? How is it related to

the narrative lines of Martha Graham's dances? Is it affected at all by these features of the dance? And then the final question, which begets a host of additional question: How does the concept of the "dynamic image" help distinguish dance from other art forms?

THE DYNAMIC IMAGE: SOME PHILOSOPHICAL REFLECTIONS ON DANCE

SUSANNE K. LANGER

Once upon a time a student, paging through a college catalogue, asked me in evident bewilderment: "What is 'philosophy of art'? How in the world can art be philosophical?"

Art is not philosophical at all; philosophy and art are two different things. But there is nothing one cannot philosophize about—that is, there is nothing that does not offer some philosophical problems. Art, in particular, presents hosts of them. Artists do not generally moot such matters explicitly, though they often have fairly good working notions of a philosophical sort—notions that only have to be put into the right words to answer our questions, or at least to move them along toward their answers.

What, exactly, is a philosophical question?

A philosophical question is always a demand for the *meaning* of what we are saying. This makes it different from a scientific question, which is a question of fact; in a question of fact, we take for granted that we know what we mean—that is, what we are talking about. If one asks: "How far from here is the sun?" the answer is a statement of fact, "About ninety million miles." We assume that we know what we mean by "the sun" and by "miles" and "being so-and-so far from here." Even if the answer is wrong—if it fails to state a fact, as it would if you answered "twenty thousand miles"—we still know what we are talking about. We take some measurements and find out which answer is true. But suppose one asks: "What is space?" "What is meant by 'here'?" "What is meant by 'the distance' from here to somewhere else?" The answer is not found by taking measurements or by making experiments or in any way discovering facts. The answer can only be found by thinking—reflecting on what we mean. This is sometimes simple; we analyze our meanings and define each word. But more often we find that we have no clear concepts at all, and the fuzzy ones we have conflict with each other so that as soon as we analyze them, i.e., make them clear, we find them contradictory, senseless, or fantastic. Then logical analysis does not help us; what we need then is the more difficult, but also more interesting part of philosophy, the part that can not be taught by any rule—logical construction. We have to figure out a meaning for our statements, a way to think about the things that interest us. Sci-

ence is not possible unless we can attach some meaning to "distance" and "point" and "space" and "velocity," and other such familiar but really quite slippery words. To establish those fundamental meanings is philosophical work; and the philosophy of modern science is one of the most brilliant intellectual works of our time.

The philosophy of art is not so well developed, but it is full of life and ferment just now. Both professional philosophers and intellectually gifted artists are asking questions about the meaning of "art," of "expression," of "artistic truth," "form," "reality," and dozens of other words that they hear and use, but find—to their surprise—they cannot define, because when they analyze what they mean it is not anything coherent and tenable.

The construction of a coherent theory—a set of connected ideas about some whole subject—begins with the solution of a central problem; that is, with the establishing of a key concept. There is no way of knowing, by any general rule, what constitutes a central problem; it is not always the most general or the most fundamental one you can raise. But the best sign that you have broached a central philosophical issue is that in solving it you raise new interesting questions. The concept you construct has *implications,* and by implication builds up further ideas, that illuminate other concepts of the whole subject, to answer other questions, sometimes before you even ask them. A key concept solves more problems than it was designed for.

In philosophy of art, one of the most interesting problems—one that proves to be really central—is the meaning of that much-used word, "creation." Why do we say an artist creates a work? He does not create oil pigments or canvas, or the structure of tonal vibrations, or words of a language if he is a poet, or, in the case of a dancer, his body and its mobility. He finds all these things and uses them, as a cook uses eggs and flour and so forth to make a cake, or a manufacturer uses wool to make thread, and thread to make socks. It is only in a mood of humor or extravagance that we speak of the cake Mother "created." But when it comes to works of art, we earnestly call them creations. This raises the philosophical question: What do we mean by that word? What is created?

If you pursue this issue, it grows into a complex of closely related questions: what is created in art, what for, and how? The answers involve just about all the key concepts for a coherent philosophy of art: such concepts as *apparition,* or the image, *expressiveness, feeling, motif, transformation.* There are others, but they are all interrelated.

It is impossible to talk, in one lecture, about all the arts, and not end with a confusion of principles and illustrations. Since we are particularly concerned,

just now, with the dance, let us narrow our discussion and center it about this art. Our first question, then, becomes: What do dancers create?

Obviously, a dance. As I pointed out before, they do not create the materials of the dance—neither their own bodies, nor the cloth that drapes them, nor the floor, nor any of the ambient space, light, musical tone, the forces of gravity, nor any other physical provisions; all these things they *use*, to create something over and above what is physically there: the dance.

What, then, is the dance?

The dance is an appearance; if you like, an apparition. It springs from what the dancers do, yet it is something else. In watching a dance, you do not see what is physically before you—people running around or twisting their bodies; what you see is a display of interacting forces, by which the dance seems to be lifted, driven, drawn, closed, or attenuated, whether it be solo or choric, whirling like the end of a dervish dance, or slow, centered, and single in its motion. One human body may put the whole play of mysterious powers before you. But these powers, these forces that seem to operate in the dance, are not the physical forces of the dancer's muscles, which actually cause the movements taking place. The forces we seem to perceive most directly and convincingly are created for our perception; and they exist only for it.

Anything that exists only for perception, and plays no ordinary, passive part in nature as common objects do, is a virtual entity. It is not unreal; where it confronts you, you really perceive it, you don't dream or imagine that you do. The image in a mirror is a virtual image. A rainbow is a virtual object. It seems to stand on the earth or in the clouds, but it really "stands" nowhere; it is only visible, not tangible. Yet it is a real rainbow, produced by moisture and light for any normal eye looking at it from the right place. We don't just dream that we see it. If, however, we believe it to have the ordinary properties of a physical thing, we are mistaken; it is an appearance, a virtual object, a sun-created image.

What dancers create is a dance; and a dance is an apparition of active powers, a *dynamic image*. Everything a dancer actually does serves to create what we really see; but what we really see is a virtual entity. The physical realities are given: place, gravity, body, muscular strength, muscular control, and secondary assets such as light, sound, or things (usable objects, so-called "properties"). All these are actual. But in the dance, they disappear; the more perfect the dance, the less we see its actualities. What we see, hear, and feel are the virtual realities, the moving forces of the dance, the apparent centers of power and their emanations, their conflicts and resolutions, lift and decline, their rhythmic life. These are the elements of the created apparition, and are themselves not physically given, but artistically created.

Here we have, then, the answer to our first question: what do dancers create? The dynamic image, which is the dance.

This answer leads naturally to the second question: for what is this image created?

Again, there is an obvious answer: for our enjoyment. But what makes us enjoy it as intensely as we do? We do not enjoy every virtual image, just because it is one. A mirage in the desert is intriguing chiefly because it is rare. A mirror image, being common, is not an object of wonder, and in itself, just as an image, does not thrill us. But the dynamic image created in dancing has a different character. It is more than a perceivable entity; this apparition, given to the eye, or to the ear and eye, and through them to our whole responsive sensibility, strikes us as something charged with feeling. Yet this feeling is not necessarily what any or all of the dancers feel. It belongs to the dance itself. A dance, like any other work of art, is a perceptible form that expresses the nature of human feeling—the rhythms and connections, crises and breaks, the complexity and richness of what is sometimes called man's "inner life," the stream of direct experience, life as it feels to the living. Dancing is not a symptom of how the dancer happens to feel; for the dancer's own feelings could not be prescribed or predicted and exhibited upon request. Our own feelings simply occur, and most people do not care to have us express them by sighs or squeals or gesticulation. If that were what dancers really did, there would not be many balletomaniacs to watch them.

What is expressed in a dance is an idea; an idea of the way feelings, emotions, and all other subjective experiences come and go—their rise and growth, their intricate synthesis that gives our inner life unity and personal identity. What we call a person's "inner life" is the inside story of his own history; the way living in the world feels to him. This kind of experience is usually but vaguely known, because most of its components are nameless, and no matter how keen our experience may be, it is hard to form an idea of anything that has no name. It has no handle for the mind. This has led many learned people to believe that feeling is a formless affair, that it has causes which may be determined, and effects that have to be dealt with, but that in itself it is irrational—a disturbance in the organism, with no structure of its own.

Yet subjective existence has a structure; it is not only met from moment to moment, but can be conceptually known, reflected on, imagined and symbolically expressed in detail and to a great depth. Only it is not our usual medium, discourse—communication by language—that serves to express what we know of the life of feeling. There are logical reasons why language fails

to meet this purpose, reasons I will not try to explain now. The important fact is that what language does not readily do—present the nature and patterns of sensitive and emotional life—is done by works of art. Such works are expressive forms, and what they express is the nature of human feeling.

So we have played our second gambit, answering the second question: What is the work of art for—the dance, the virtual dynamic image? To express its creator's ideas of immediate, felt, emotive life. To set forth directly what feeling is like. A work of art is a composition of tensions and resolutions, balance and unbalance, rhythmic coherence, a precarious yet continuous unity. Life is a natural process of such tensions, balances, rhythms; it is these that we feel, in quietness or emotion, as the pulse of our own living. In the work of art they are expressed, symbolically shown, each aspect of feeling developed as one develops an idea, fitted together for clearest presentation. A dance is not a symptom of a dancer's feeling, but an expression of its composer's knowledge of many feelings.

The third problem on the docket—how is a dance created?—is so great that one has to break it down into several questions. Some of these are practical questions of technique—how to produce this or that effect. They concern many of you but not me, except in so far as solutions of artistic problems always intrigue me. The philosophical question that I would peel out of its many wrappings is: What does it mean to express one's idea of some inward or "subjective" process?

It means to make an outward image of this inward process, for oneself and others to see; that is, to give the subjective events an objective symbol. Every work of art is such an image, whether it be a dance, a statue, a picture, a piece of music, or a work of poetry. It is an outward showing of inward nature, an objective presentation of subjective reality; and the reason that it can symbolize things of the inner life is that it has the same kinds of relations and elements. This is not true of the material structure; the physical materials of a dance do not have any direct similarity to the structure of emotive life; it is the created image that has elements and patterns like the life of feeling. But this image, though it is a created apparition, a pure appearance, is objective; it seems to be charged with feeling because its form expresses the very nature of feeling. Therefore, it is an *objectification* of subjective life, and so is every other work of art.

If works of art are all alike in this fundamental respect, why have we several great domains of art, such as painting and music, poetry and dance? Something makes them so distinct from each other that people with superb talent for one may have none for another. A sensible person would not go to Picasso to learn dancing or to Hindemith to be taught painting. How does

dancing, for instance, differ from music or architecture or drama? It has relations with all of them. Yet it is none of them.

What makes the distinction among the several great orders of art is another of those problems that arise in their turn, uninvited, once you start from a central question; and the fact that the question of *what is created* leads from one issue to another in this natural and systematic way makes me think it really is central. The distinction between dancing and all of the other great arts—and of those from each other—lies in the stuff of which the virtual image, the expressive form, is made. We cannot go into any discussion of other kinds, but only reflect a little further on our original query: What do dancers create? What is a dance?

As I said before (so long before that you have probably forgotten), what we see when we watch a dance is a display of interacting forces; not physical forces, like the weight that tips a scale or the push that topples a column of books, but purely apparent forces that seem to move the dance itself. Two people in a *pas de deux* seem to magnetize each other; a group appears to be animated by one single spirit, one Power. The stuff of the dance, the apparition itself, consists of such non-physical forces, drawing and driving, holding and shaping its life. The actual, physical forces that underlie it disappear. As soon as the beholder sees gymnastics and arrangements, the work of art breaks, the creation fails.

As painting is made purely of spatial volumes—not actual space-filling things but virtual volumes, created solely for the eye—and music is made of passage, movements of time, created by tone—so dance creates a world of powers, made visible by the unbroken fabric of gesture. That is what makes dance a different art from all the others. But as Space, Events, Time, and Powers are all inter-related in reality, so all the arts are linked by intricate relations, different among different ones. That is a big subject.

Another problem which naturally presents itself here is the meaning of *dance gesture;* but we shall have to skip it. We have had enough pursuit of meanings, and I know from experience that if you don't make an end of it, there is no end. But in dropping the curtain on this peep-show of philosophy, I would like to call your attention to one of those unexpected explanations of puzzling facts that sometimes arise from philosophical reflection.

Curt Sachs, who is an eminent historian of music and dance, remarks in his *World History of Dance* that, strange as it may seem, the evolution of the dance as a high art belongs to pre-history. At the dawn of civilization, dance had already reached a degree of perfection that no other art or science could match. Societies limited to savage living, primitive sculpture, primitive architecture, and as yet no poetry, quite commonly present the astonished ethnolo-

gist with a highly developed tradition of difficult, beautiful dancing. Their music apart from the dance is nothing at all; in the dance it is elaborate. Their worship is dance. They are tribes of dancers.

If you think of the dance as an apparition of interactive Powers, this strange fact loses its strangeness. Every art image is a purified and simplified aspect of the outer world, composed by the laws of the inner world to express its nature. As one objective aspect of the world after another comes to people's notice, the arts arise. Each makes its own image of outward reality to objectify inward reality, subjective life, feeling.

Primitive men live in a world of demonic Powers. Subhuman or superhuman, gods or spooks or impersonal magic forces, good or bad luck that dwells in things like an electric charge, are the most impressive realities of the savage's world. The drive to artistic creation, which seems to be deeply primitive in all human beings, first begets its forms in the image of these all-surrounding Powers. The magic circle around the altar or the totem pole, the holy space inside the Kiwa or the temple, is the natural dance floor. There is nothing unreasonable about that. In a world perceived as a realm of mystic Powers, the first created image is the dynamic image; the first objectification of human nature, the first true art, is Dance.

A PROLEGOMENON TO AN
AESTHETICS OF DANCE

SELMA JEANNE COHEN

Aesthetics is not equally concerned with all kinds of dancing. The ritual, which is designed to ask a favor of the gods, and the social dance, which provides enjoyment for its participants, may—accidentally—give aesthetic pleasure. But this is not their purpose, nor is it the test of their success. The rain dance succeeds when the rain falls. The square dance goes well when the performers have a good time. Only theatrical dancing is designed to provide the observer with an aesthetic experience.

What is the nature of the dancing that induces this experience? It has been

defined as rhythmical movement of the human body. But this could be applied to a parade, and any woman will agree that ironing is easiest when done to music. While it is hard to conceive of dancing that is not rhythmical, there is no problem at all to finding forms of rhythmical bodily movement that are not dancing.

Does the distinction lie in the expressiveness of dance movement? The pantomime artist is even more expressive. By watching his movements we know exactly the kind of character he is representing, the emotion he is feeling, even the particular action he is performing, such as opening a door or tying his shoes. We can justify by its literal meaning every one of his motions. We try in vain to do this with a dancer. We watch the great adagio in *Swan Lake* for several minutes, and all we can say in the end is that the boy and girl are in love. We would find it difficult to pinpoint the "meaning" of any one of the ballerina's many pirouettes. The dance as a whole has an expressive quality, but this quality does not account for all its parts. It cannot, because its movements are designed for a purpose beyond expressiveness.

Of all the arts to which dance has been likened that of lyric poetry offers the most significant analogies. Like dance, it is both rhythmic and expressive. It makes its statement in a manner that has an important sensuous appeal. In the words of Gerard Manley Hopkins, poetry is "speech framed to be heard for its own sake and interest even above its interest of meaning." Dancing may be thought of as movement framed to be seen for its own sake and interest even above its interest of meaning.

The movements of the marchers in the parade are not interesting for their own sake. Almost anyone who can count can march. The precision of the marchers has some interest, but this is a matter of the coordination visible in a large group. An individual performing these actions alone would not attract much of an audience.

The actions of the pantomime artist would seem to be more interesting, because each of them has a meaning. But it is for this very reason that they differ from the movements of the dancer. We watch the mime attentively in order to identify his actions; he is putting on his coat, now he is opening his umbrella. This is movement that has interest of meaning but not interest above meaning. When we fail to understand the movements of the mime, we find no pleasure in his performance.

But we enjoy the movements of the ballerina without feeling the need to define their meaning. We take pleasure in the visual designs made by her body, in the harmony of her balanced poses, in the contrast between straight legs and gently curved arms. We take pleasure in the musicality of her phrasing, which gives emphasis at climactic moments and provides smooth

transitions between them. We take pleasure in her control of dynamics, the play of swift, sharp movements against softly flowing ones. We enjoy these patterns for their own sake and interest even above their interest of meaning.

Putting aside for the moment the question of whether the dance has to mean, has to express something, to be a dance, we may ask what kinds of meaning are possible to this art that uses as its medium the movement of the human body.

Certainly there are areas that seem unamenable to expression in dance. A choreographer would find it difficult to compose a dance about the distance of the moon from the earth. Or about Kant's categorical imperative. George Balanchine has remarked that there are no mothers-in-law in ballet. And Doris Humphrey has quoted the opening of a rejected dance scenario: "A young man, exhausted, admires the vitality of nature."

None of these will work. The medium of dance is human movement. It deals with people, not with facts or ideas. And it deals with people in motion—not exhausted. We can think very well while sitting very still. We can express the distance of the moon from the earth by gesturing with our fingers, but the matter is better explained in words. We might act out a marriage ceremony to identify the mother-in-law, but it is easier said than done. And what would the poor dancer do with Kant? Neither factual relations nor ideas are promising choreographic material. The area of dance is not that of concepts, which are grasped by the mind by way of words, but of percepts, which are grasped by the eye by way of movement.

What can we tell from movement? We learn two sorts of things about the person who moves. First, he tells us the kind of person he is, his character. He tells us he is confident, shy, vivacious, tough, polite. To see this we need only contrast the walk of a Charlie Chaplin—small steps, chest sunken, shoulders pinched inward—with the walk of the traditional hero: the broad, swinging stride, the chest held high, the shoulders flung backward. Second, the mover tells us his state of feeling at the particular moment. We are familiar with the bowed head of grief, the skip of joy, the clenched fists of anger. Movement gives us sensible images of qualities of character and emotion. These are the proper province of dance.

Within this province, the choreographer's potential range is wide. The degree of particularization may vary greatly. It may come close to that of drama, as in Martha Graham's *Clytemnestra*, in which the individual figures of Greek tragedy relive their sufferings through the patterns of dance. Or it may deal with universals, as in Doris Humphrey's *Day on Earth*, which tells the story of man as the story of mankind—the cycle of birth, love, and death. At a still further remove from drama, the dance may be purely lyrical, like Michel

Fokine's *Les Sylphides*, which has no narrative structure at all, but is merely a sequence of dances of serene joy and romantic love as they might be envisioned by a poet, dreaming in a wood by moonlight.

A choreographer cannot make a dance about the moon, but he can make a dance about the way he feels toward the moon—which may inspire him with wonder or joy or nostalgia. He may make a dance about the way he feels toward his mother-in-law, because irritation, resentment, exasperation are all feelings expressible by bodily movement. If he could get really excited about the categorical imperative, he might make a dance about that. However, unless he has a feeling for the fact or idea, he has nothing to dance about.

The choreographer deals with images of quality of character and emotion. He must devise movements sufficient and appropriate to their representation.

He may begin with the naturally expressive movement of human gesture. This, however, is only his starting point. Fokine defined dance as "the development and ideal of the sign." Taking gesture, the natural sign of character or emotion, as his base, the choreographer builds from it a movement that has both a visual and an aural design. First he gives the gesture a more definitively perceivable shape in space. He may extend or elaborate its configuration, so that the angry stamp is preceded by a high kick into the air or accompanied by a violent series of turns that send the dancer whirling across the entire stage. Then he gives the movement a pattern in time; prolonging or quickening or repeating it, setting it to a definite rhythm, building it into a phrase. Further, he may enhance the dynamics of the movement, sharpening the contrasts between tension and relaxation, between strong and soft, giving it a more distinctive texture.

Such manipulations, when properly employed, contribute to the "development and ideal of the sign." They do not obliterate the significance of the gesture, but rather they enhance it. Prolongation may emphasize a movement; quickening of tempo may create excitement. Choreographic enhancement, or stylization, extends the emotional expressiveness of the gesture. The dance has not merely added form to the movement; it has intensified the meaning of the movement.

Actually the choreographer may begin, not with natural gesture but with dance movements already stylized beyond the form of gesture. That is, he may utilize an established stylistic vocabulary, like that of the ballet or the Spanish dance or the Hindu or jazz. These idioms are products of distinct cultures and represent attitudes toward character and emotion peculiar to those cultures. They are modes of stylization in which comment is implicit. This may involve, as in classical ballet, a polished refining of emotion, for in 17th century France—where the ballet first developed—decorum of be-

havior was the ideal. The Spanish dance, on the contrary, especially the flamenco, heightens emotion to passionate intensity. It represents a different attitude toward life.

Modes of stylization change as cultures evolve. The original vocabulary of the ballet derived from the elegant artificiality of the royal court of 17th and early 18th century France. In the romantic era the heroine, once conceived as a gracious though worldly mistress, became an ethereal being, a symbol of unattainable beauty. And women began to dance on *pointe;* that is, on the tips of their toes, which made them appear as if air-borne. The new style came into being because of the new attitude.

Later developments, promoted most notably by Fokine, paved the way for the contemporary psychological ballet exemplified by the works of Antony Tudor. In the 1830's, when Marie Taglioni stepped onto the toes of one foot, her other leg extended behind her, she looked like some heavenly creature about to fly. In 1945, when Nora Kaye first danced Hagar in Tudor's *Pillar of Fire,* she took what was basically the same pose but she looked like an agonized, frustrated woman. Both poses were variations of the balletic stylization, which is the position called *arabesque.* The change came about through a different use of the arms and torso, but even more significantly through the manner of performance—through a distinctive use of dynamic tension, an "attack" unlike any ballet had used before. It altered completely the nature of the choreographer's comment, eliciting reactions not of wonder and admiration, but of pity and fear. Neither the classic nor the romantic *arabesque* could have served Tudor's purpose. He had to employ another kind of stylization to embody another kind of image of woman.

The works of men like Tudor are, of course, more than reflections of cultural change; they are products of individual genius that mirror and, in some cases, even anticipate or initiate that change. The choreographer with a fresh image in his mind may feel he must reject existing modes of stylization to create a mode of his own. In 1929 Martha Graham wrote: "Life today is nervous, sharp, zigzag. It often stops in midair. It is what I am for in my dances." Her image required an orientation different from anything she found in the dancing of her time. It involved not only the replacement of the flowing, effortless line of ballet with a sharp, percussive thrust, but also the transfer of the source of motor energy from the limbs to the center of the torso. Later in her career, as her approach became more Freudian, she defined the aim of dance as "making visible the interior landscape." Her concept of the image is no longer limited to "life today"; it concerns the whole life of man. Her manner of stylization—now less nervous, somewhat warmer, but still sharp and intense —infuses the image with comment.

The validity of the choreographer's comment is not a strictly aesthetic consideration. From an aesthetic point of view what matters about stylization is its clarity and usefulness to the image. These terms are applicable to both the kind and degree of stylization.

To be clear, the mode of gesture enhancement must be definite and consistent. Otherwise the nature of the comment appears ambiguous, and the audience is left uncomfortably without a point of reference. If clarity were the sole qualification, however, the choreographer would be always safe in using an established vocabulary and this would make the art dull and static. In many periods it has done just that. But through the years there have always been some who find that the standard vocabularies, though clear in their own terms, are inadequate to embody the image they want to project. They have dared to expand, to alter, and even to start fresh. They have risked sacrificing immediate clarity to establish a personal comment. For choreography may only seem unclear until audiences are prepared to accept its unfamiliar kind of stylization for the sake of the fresh image it presents to them.

Stylization is useful in kind when it serves the nature of the image. We have seen that different modes of stylization have evolved for this reason. The safety of a ready-made vocabulary has often proved too tempting. But the lure of unmotivated innovation has also been strong. The resulting discrepancies have been both sad and ridiculous. In 1900 Fokine complained about Egyptian slave girls, who flitted about the stage in pink satin toe shoes. We may equally well complain of the use of agonized, so-called "modern" movements, when they are assigned to a dancer portraying a happy wood-sprite. In either case the intended image is destroyed by an inappropriate kind of stylization.

As regards degree of stylization, we are also concerned with clarity and usefulness. Excessive manipulation obscures the original sign value of the movement. But insufficient enhancement is also a fault. Has the choreographer missed a potential climax by failing to avail himself of devices of stylization? If the movement were still less naturalistic, less literal, would he have achieved a greater effect? Lincoln Kirstein has remarked that dancing on the stage must be "theatrically legible." Stylization makes it so. The purely natural gesture has sufficient meaning for the performer, but for the audience it fails to establish a theatrically perceivable image.

Actually the degree of stylization in dance frequently seems to go beyond the needs of the image. Though it does not interfere with clarity, its positive contribution seems negligible. In terms of the criterion of usefulness, a good part of the great classics would be subject to an editorial red pencil and would never be seen again. Yet we should be wary of hasty condemnation. We have already remarked that dance movement has interest even above its interest of

meaning. Sensuous beauty, after all, is one of the great charms of a dance work. Can we deny the art this source of pleasure simply on the grounds that it does not contribute substantially to the image of character or emotion?

The designing of the movement of the human body is the unique property of dance as an art medium. Expressiveness it shares with other arts; even the expressiveness of gesture, for this belongs to pantomime as well. But dance alone has the power—in the words of Théophile Gautier—"of displaying elegant and correctly proportioned shapes [of the body] in various positions favorable to the development of lines." It would seem wasteful to limit the use of this virtue to its expressive function, even though we demand that it should not interfere with that function. If enhancement does not intensify the emotional image, it may still be non-intrusive if it is consistent with the over-all mode of stylization and does not demand our attention for such a length of time that the focus of expression is sacrificed.

How strict can we be in our demand for non-interference with the clarity of the sign? No dance is based on a steady flow of stylized gestures. The expressive unit is more often the phrase or even an extended sequence of phrases. The smaller, more literal, unit is characteristic of pantomime. Dance stylization involves the more leisurely use of time and space, the degree of admissible leisure depending on the nature of the work.

In some dances any individual passage (though not any individual step) can be justified by its specific, expressive function. This is the case of José Limón's *The Moor's Pavane*, which is based on the plot of *Othello*. One passage shows Othello's love for Desdemona, another the mounting rage of Iago, another the fears of Desdemona, and so on. All the sequences serve to bring about the final catastrophe.

But when a dance relinquishes plot and deals only with the exploration of the facets of an emotion, the standard of dramatic relevance is superseded by that of lyric relevance. Here more time can be taken to develop sheer intensity of a single feeling as opposed to the sequential definition of successive feelings. Thus, Mr. Limón's *Missa Brevis* is constructed as a study of spiritual courage in the aftermath of war. In dramatic terms, the affirmative resolution could have been achieved far earlier than it actually is. There are several scenes that could be labelled as indicative of resignation, where one would seem sufficient. The accumulation cannot be justified in terms of dramatic function. It can, however, be justified as lyrical intensification, and that is proper to this particular dance.

Marius Petipa's three-act *Sleeping Beauty* represents a genre where the over-all structure is dramatic, but the story, which requires little emotional intensity, is told at an especially leisurely pace that allows for the insertion of

a number of dances that—while consistent with the pervading atmosphere—
have no direct bearing on the action. This is not necessarily a weakness. It is
a distinction of genre, which demands a distinction of approach.

In the prologue to *The Sleeping Beauty* there are solo dances (we call them
variations) for each of seven fairies, who have come to the christening of
Princess Aurora. These dances have no dramatic structure in themselves. Yet
each has form, a unity of choreographic theme. One is based on fluttering
hand movements; another is dominated by tiny running steps on the toes; one
is composed of sharp, staccato movements; another of long, legato phrases.
This thematic consistency gives a quality of character to each of the dances—
they are gentle, or spritely or majestic. As a group, they are all rather sweet,
and this serves as a foil to what follows: the entry of the wicked Carabosse,
who is to utter the fatal curse on Aurora. But their individuality does nothing
for the plot. Dramatically, fewer than seven fairies would have served the
purpose. We do not, however, object to the superfluous quantity. The dances
are varied and charming, and the story is not urgent. Why rush?

Then there is the dance that seems to consist of nothing but dancing. No
story. No individual characters. No clear emotional images like love or hate or
fear. Just dancing. Yet even in the so-called "abstract" dance we have a feeling
for the presence or absence of consistency of movement quality that suggests
quality of human behavior.

The Balanchine-Stravinsky *Agon* is an exploration of energetic momentum,
not the momentum of a particular person but of a species of people—jet-age
people, perhaps. There is an explosive drive in a dancer's darting burst of
action that stops as suddenly as it began. But the dynamic pulse is continued
by another dancer, who enters in canonic imitation before the first has fin-
ished. The movement is spasmodic, the phrases cut short, transitions eliminated
—yet the energy flows without ceasing. A legato passage is introduced when
a boy and girl dance quietly together. But the respite is momentary. He stands
holding her hand—then suddenly drops to the floor, letting her find her balance
where she may. She does not care. The couple have no emotional relation to
one another, and in the next scene they are absorbed by the ensemble, never—
though without remorse—to touch hands again. There is leisure here, but not
for romance.

The emotion is not in the relations of the dancers, but in their attitude
toward the movement. *Agon* may be saying that dancing is a marvelously
complex and exciting thing that only seems to stop, but perpetually renews
itself. Or it may be saying this of life. It makes its comment casually and in a
spirit of fun. But it does comment.

Can dance ever be completely devoid of meaning? In recent years some

choreographers have tried to create dances that depend entirely on interest of movement for its own sake. They have attempted to obliterate the sign, to divorce gesture from any connection with emotion by isolating it from its customary context, by subjecting movements to artificial, even chance, forms of combination and continuity. But meaning in dance, as we have seen, need not refer to a specific dramatic character or situation, or even to a personal emotion. The choreographer may comment on depersonalized quality of behavior. Even chance continuity, if it is carried out consistently, makes a comment. It may be: "What wonderfully strange and beautiful things the human body can do when it is not trying to say something."

If the dance image could be obliterated, the problems of clarity and usefulness would vanish. Our sole concern would be the interest of the movement itself. Can this be sufficient? Can interest of movement exist in isolation from meaning? We have yet to determine what makes movement interesting.

A child's dancing is interesting when we say: "How wonderful. Susie is only 8." However, the movement is not interesting for its own sake but because it is performed by a child, and in relation to her capacities it is remarkable. Nor is movement intrinsically interesting because it is novel or unusual. This standard is too dependent on the degree of experience of the observer to have validity. We judge movement interest in terms of the elements of movement: space, time, and dynamics.

A dance is usually performed to music, and when we think of the time element of movement, we think of it in relation to music. The relationship must be clearly perceivable, yet not so simple that it offers no challenge to the intelligent observer. In the 1920's Ruth St. Denis experimented with a form she called music visualization. Each dancer directly mirrored the rhythm and tempo of an instrument of the orchestra and even the melodic line had its parallel in spatial design. Music visualization did not last. It was not interesting. It said the same thing as the music and nothing more. It made no comment. A dance that moves constantly against the music is almost as dull. The right mean will be judged relatively to other factors, which include the complexity of both the musical score and the movement.

A particularly felicitous example occurs in Doris Humphrey's *New Dance* where the music plays a steady 4/4. A row of dancers follow the phrasing of the music with simple movements, while a series of soloists emerge from the group to do their dances in complex, patterned phrases of 7, 7, and 10, returning to the group on the even count of 24. Since the dance deals with the harmonious relation of the individual to society, the device is good on expressive grounds. But even in a purely formal sense, it possesses the virtues of clarity and challenge.

A special case is the dance performed without music. Jerome Robbins' *Moves* is an experiment in that direction. Many of the phrasings are extremely intricate, and several groups of dancers are sometimes following different rhythmic patterns. They are related, however, by a common pulse, so that a norm is established. Here the choreographer has to supply his own meter. Without it, the effect would be chaotic.

Similar criteria are applicable to spatial design. Groups of dancers in circles and parallel lines are easy to perceive, but they become monotonous. And symmetry is pleasant in a serene kind of way, which is not very stimulating in the theater. Complexity, on the other hand, can be excessive. Two dancers alone on the stage can do quite divergent things without taxing the capacity of the eye of the observer. But imagine what would happen if, at any given moment, each of the Rockettes at Radio City Music Hall had an individual movement pattern. The judgment must be made on a relative basis, as it is for time pattern and as it is also for dynamics—the varying textures of movement effected by degrees of tension.

A balance of clarity and challenge, then, makes movement interesting. But is interesting movement equivalent to an interesting dance?

If the choreographer renounces interest of meaning, he may be accused of the wasteful use of his medium. We have argued that the choreographer should not ignore the unique virtue of dance that is its power to form designs of human movement. While movement expressiveness is not an equally unique virtue of dance, it is nevertheless one of its natural properties because its instrument is a person who not only moves but feels. If we want to deal only with designs of moving shapes, we have no need for human performers. Animated drawings can do the job as well and better, for the graphic artist is not limited to using only those shapes that the human body is capable of assuming. If dance, then, is to realize the full potential of its nature, it will draw on its resources of interest of both meaning and design.

However, the greatest richness of design and the greatest richness of meaning do not necessarily combine to make the greatest work of art. The degree of desirable formal complexity in dance must ultimately be viewed in relation to the species of the work. Generally, a comparatively abstract dance can bear more intricacy of formal construction than can a predominantly dramatic one, because the latter must beware of the complexity that destroys the sign value of its movements. The less demanding the drama, the further enhancement of gesture can go—providing the humanity of the movement is not lost in the process. Yet the dramatic dance needs stylization, or it degenerates into self-expression, which is fine in its place, but that place is not the theater. Because

dancers are people, their movements are naturally expressive. It is their un-natural skills that make their movements interesting.

The very elements of stylization—prolongation, repetition, quickening in time, extension in space—require artificial skills in performance. The child jumps for joy; the dancer soars into the air, his body forming a design of harmonious proportions as he does so. Not even the most gifted person was ever born with such power and control. The long training of the dancer de-velops his capacities to realize patterns of movement interest. Most of the time the audience is not compelled to special awareness of these skills. They are used constantly as a means to an end, and it is right that we should be conscious only of the final, total effect. The back fall in Martha Graham's technique is an astonishing feat of physical virtuosity. But when Graham does it as the climax of a phrase indicative of grief or guilt, the audience is so over-whelmed with feelings of pity and terror that it has no attention to spare for wonder at her muscular control.

In other kinds of dances the performer may deliberately draw attention to the extravagant physical demands of a movement. Obvious virtuosity has a two-edged impression. On the one hand, the audience is aware of the difficulty of the feat. Otherwise it would lack brilliance and excitement. On the other, the spectator feels that the performer is executing it with ease, for if the obstacles are too apparent, the observer suffers with the dancer. Virtuosity is abused when it becomes an intrusive element. In part this is up to the choreog-rapher. But the dancer can distort an otherwise consistent passage by stepping out of character to perform it with a special dose of personal bravura.

Brilliance and expressiveness need not conflict. In the Rose Adagio of *The Sleeping Beauty* the radiant youth of the princess, just awakening to the con-ception of the possible joys of love, is shown as she dances with four suitors. She is turned slowly on the toes of one foot by the first partner. She then releases his hand to balance alone, and is then turned by the next partner. This is done four times. As performed by Margot Fonteyn the duration of the un-supported pose is almost incredible, and when the next suitor comes to her she does not snatch at him in desperation—she graciously allows him to take her hand. The effect, as one musician described it, is like that of a resolution on a tonic chord.

The dancer exploits such virtuosic skills comparatively rarely, reserving them for climactic occasions. His constant task is to clarify, to bring out the meaning of the choreography. He must reveal the quality of the style, the consistency of the over-all form of movement enhancement. Classical ballet in its purest manifestations requires great elegance, an assured simplicity of manner, gra-ciousness, and—even in its most expressive moments—a certain aloofness. Some

types of modern dance require a sharp, tense attack. Jazz demands one that is freer, more relaxed. Part of this is implicit in the choreography. Much, however, depends on the performer. Considerable realism of dramatic interpretation is commendable in some modern dance works; it is never right in classical ballet. Matters of projection vary accordingly, for individuality of expression is more desirable in some styles than in others. And the analysis can be extremely minute, coming down to matters of phrasing, line, and texture of movement, all of which the dancer uses to illuminate the image of the choreographer as he sees it.

A theatrical dance work contains many more facets than time will permit us to investigate. The relation of dance to music is in itself an area deserving of full and careful consideration. The role played in the dance by costume, décor, and lighting—the whole question of visual spectacle—is of tremendous importance and merits special study. In this art most of the aesthetic problems are as yet not only unsolved, but even unformulated.

The ephemeral nature of dance has discouraged theoretical discussion. According to Edwin Denby: "Critics have left us as reporters no accurate ballet history, as critics no workable theory of dance emphasis, of dance form, of dance meaning. Dance esthetics is in a pioneering stage; a pioneer may manage to plant a rose bush in his wilderness, but he's not going to win any prizes in the flower show back in Boston."

PURISM AND THE DANCE

MORRIS WEITZ

Finally, in the modern dance there has been similar recognition of the central role of the medium. As is the case in modern architecture, the modern dance arose as a protest against a long period of imitationalism and ornamentalism. The classical ballet, with its adherence to a rigid code of regulations and its hiding of the intrinsic qualities of the body, which it accomplished mainly through the tarlatan skirt and the emphasis upon the decorative skills of the dancer's feet, was the chief irritant.

Isadora Duncan was the first exponent of the modern dance. Her overwhelming desire was to liberate the human body from the trammels of the traditional ballet. Her work proclaimed the body as a powerful source of expressive communication. But paradoxically enough, her revolutionary aims led only to a neoclassicism founded upon Greek ideals.

The real revolution began in 1914 with two other dancers, Mary Wigman and Rudolf von Laban. With absolute conviction, they affirmed the ability of the human body, either alone or in groups, to serve as the total medium and source of expressiveness of the dance. They conceived the dance in completely abstract terms of spatial shape and line, temporal rhythms and mass. Story, character development, psychological narration, even music (at first), were rejected as inimical to the dance as pure art. For gesture, they substituted dynamic body movement; for the hiding or disguising of the body, they offered the exhibition of the quality of weight; and in place of the long melodic lines of the classical ballet, they insisted upon massive, broken chords. With keen understanding, they conceived of the dance as the abstract interpretation of the salient qualities of the tempo of modern life. Strength, gravity, nervousness, tautness, movement, dynamism, were all explored and communicated. "The dance dared once more to be of the present, of the workaday world, of the earth. The earth was no longer a thing to flee from, to be touched on tiptoe only, but 'the earth from whence we came' was newly found."

Following Wigman and von Laban, there have been many brilliant dancers, all of whom have shared the basic conviction of the self-sufficient, all-inclusive character of the bodily medium of the dance. Martha Graham has been one of these.

Today Martha Graham is generally regarded as the greatest living "modern" dancer. And yet, speaking only for myself, I find in her recent work a tendency to abandon her early purism in favor of symbolism, narration, décor, and lately, poetic recitation, as dance accompaniments. All of these she now accepts as legitimate constituents of the dance. Especially in her "Letter to the World," "Dark Meadow" and "Night Journey," there is a rejection of the basic abstractionist ideal of the modern dance. For good or for bad, Martha Graham and in fact most of the "moderns," at least those who are dancing in America, have repudiated the aesthetics of purism and have returned to an enlarged conception of the dance.

LITERATURE

From the time of Aristotle's *Poetics*, that most primary of aesthetic documents, the aesthetic problems of literature have been concerned with its emotive power and its relation to the world of life. Aristotle called art, and literature in particular, mimetic, by which he meant that art imitates or re-presents life. An entire scheme for evaluating literature uses as its standard the achievement of verisimilitude: the illusion of being real. Hugh Kenner points out, almost puckishly in his concern for the "Esthetics of Fraud," that Andy Warhol's art has achieved the centuries-old dream of verisimilitude. From Andy Warhol's soup cans comes real soup! The paradox is apparent immediately. Verisimilitude is an ideal, apparently, only when the illusion remains illusion. When illusion suddenly becomes reality the champions of verisimilitude declare that what has been achieved is not art.

Reality and illusion are the subjects of Eric Capon's discussion of the drama. Since the early days of this century theorists of theater have repeated their pronouncements that what makes theater significant as an art form are those qualities which separate it from literature. Gesture, movement, stillness, color, and silence do not appear on the written page. However, they can be made to contain the meaning of a dramatic work on the stage. The difference between the play on the written page and the play on the living stage is the difference between drama as literature and drama as theater. There is a powerful relationship, probably never to be broken even by the most radical experimenters, but Capon and others are concerned with what drama produced on the stage can do and mean. Capon shows that the aesthetics of drama is fused with the shifting attitudes towards what is real and how it may be treated on stage. As Capon points out, the reality of Ibsen is not the reality of Brecht.

Berenson's "Aesthetic Moment" seems to be echoed in George Santayana. Santayana is concerned with feeling, the emotive power of poetry and its ability to produce in us a feeling of transport and meaningfulness. As Shumaker suggests, feeling and emotion will always be closely entwined with literature, and Santayana is interested in seeing the purport of such a truth. Santayana cannot resist the urge to link poetry and religion, as many have done before and since his time. But he does not make the mistake Shumaker warns against of substituting one for the other without regard for what makes them different. Both Shumaker and I. A. Richards are interested in examining what it is we know

once we have experienced a work of literature. Richards suggests that the ideas and beliefs in a work of literature are not always verifiable by ordinary logical means. Shumaker sees the cognitive element of literature as being closely linked with the feelings evoked by a literary artifact. His discussion of aesthetic distance is particularly illuminating in this regard and in relation to P. A. Michelis' essay.

And finally, all these essays are concerned with what literature is, though none explicitly attempts a definition. All the essays are dealing with what literature can do, though many of them hold different opinions and see the role and function of literature as a highly complex affair. The progress from the observation of what literature can be to what it can do is an aesthetic progress and of utmost importance in helping us understand the nature of literature as art.

THE ELEMENTS AND
FUNCTION OF POETRY

GEORGE SANTAYANA

If a critic, in despair of giving a serious definition of poetry, should be satisfied with saying that poetry is metrical discourse, he would no doubt be giving an inadequate account of the matter, yet not one of which he need be ashamed or which he should regard as superficial. Although a poem be not made by counting of syllables upon the fingers, yet "numbers" is the most poetical synonym we have for verse, and "measure" the most significant equivalent for beauty, for goodness, and perhaps even for truth. Those early and profound philosophers, the followers of Pythagoras, saw the essence of all things in number, and it was by weight, measure, and number, as we read in the Bible, that the Creator first brought Nature out of the void. Every human architect must do likewise with his edifice; he must mould his bricks or hew his stones into symmetrical solids and lay them over one another in regular strata, like a poet's lines.

Measure is a condition of perfection, for perfection requires that order should be pervasive, that not only the whole before us should have a form, but that every part in turn should have a form of its own, and that those parts should be co-ordinated among themselves as the whole is co-ordinated with the other parts of some greater cosmos. Leibnitz lighted in his speculations upon a conception of organic nature which may be false as a fact, but which is excellent as an ideal; he tells us that the difference between living and dead matter, between animals and machines, is that the former are composed of parts that are themselves organic, every portion of the body being itself a machine, and every portion of that machine still a machine, and so *ad infinitum;* whereas, in artificial bodies the organization is not in this manner infinitely deep. Fine Art, in this as in all things, imitates the method of Nature and makes its most beautiful works out of materials that are themselves beautiful. So that even if the difference between verse and prose consisted only in measure, that difference would already be analogous to that between jewels and clay.

The stuff of language is words, and the sensuous material of words is sound; if language therefore is to be made perfect, its materials must be made beautiful by being themselves subjected to a measure, and endowed with a form. It is true that language is a symbol for intelligence rather than a stimulus to sense, and accordingly the beauties of discourse which commonly attract atten-

tion are merely the beauties of the objects and ideas signified; yet the symbols have a sensible reality of their own, a euphony which appeals to our senses if we keep them open. The tongue will choose those forms of utterance which have a natural grace as mere sound and sensation; the memory will retain these catches, and they will pass and repass through the mind until they become types of instinctive speech and standards of pleasing expression.

The highest form of such euphony is song; the singing voice gives to the sounds it utters the thrill of tonality—a thrill itself dependent, as we know, on the numerical proportions of the vibrations that it includes. But this kind of euphony and sensuous beauty, the deepest that sounds can have, we have almost wholly surrendered in our speech. Our intelligence has become complex, and language, to express our thoughts, must commonly be more rapid, copious, and abstract than is compatible with singing. Music at the same time has become complex also, and when united with words, at one time disfigures them in the elaboration of its melody, and at another overpowers them in the volume of its sound. So that the art of singing is now in the same plight as that of sculpture,—an abstract and conventional thing surviving by force of tradition and of an innate but now impotent impulse, which under simpler conditions would work itself out into the proper forms of those arts. The truest kind of euphony is thus denied to our poetry. If any verses are still set to music, they are commonly the worst only, chosen for the purpose of musicians of specialized sensibility and inferior intelligence, who seem to be attracted only by tawdry effects of rhetoric and sentiment.

When song is given up, there still remains in speech a certain sensuous quality, due to the nature and order of the vowels and consonants that compose the sounds. This kind of euphony is not neglected by the more dulcet poets, and is now so studied in some quarters that I have heard it maintained by a critic of relative authority that the beauty of poetry consists entirely in the frequent utterance of the sound of "j" and "sh," and the consequent copious flow of saliva in the mouth. But even if saliva is not the whole essence of poetry, there is an unmistakable and fundamental diversity of effect in the various vocalization of different poets, which becomes all the more evident when we compare those who use different languages. One man's speech, or one nation's, is compact, crowded with consonants, rugged, broken with emphatic beats; another man's, or nation's, is open, tripping, rapid, and even. So Byron, mingling in his boyish fashion burlesque with exquisite sentiment, contrasts English with Italian speech:

> *I love the language, that soft bastard Latin*
> *Which melts like kisses from a female mouth*
> *And sounds as if it should be writ on satin*

> *With syllables which breathe of the sweet South,*
> *And gentle liquids gliding all so pat in*
> *That not a single accent seems uncouth,*
> *Like our harsh Northern whistling, grunting guttural*
> *Which we're obliged to hiss and spit and sputter all.*

And yet these contrasts, strong when we compare extreme cases, fade from our consciousness in the actual use of a mother-tongue. The function makes us unconscious of the instrument, all the more as it is an indispensable and almost invariable one. The sense of euphony accordingly attaches itself rather to another and more variable quality; the tune, or measure, or rhythm of speech. The elementary sounds are prescribed by the language we use, and the selection we may make among those sounds is limited; but the arrangement of words is still undetermined, and by casting our speech into the moulds of meter and rhyme we can give it a heightened power, apart from its significance. A tolerable definition of poetry, on its formal side, might be found in this: that poetry is speech in which the instrument counts as well as the meaning—poetry is speech for its own sake and for its own sweetness. As common windows are intended only to admit the light, but painted windows also to dye it, and to be an object of attention in themselves as well as a cause of visibility in other things, so, while the purest prose is a mere vehicle of thought, verse, like stained glass, arrests attention in its own intricacies, confuses it in its own glories, and is even at times allowed to darken and puzzle in the hope of casting over us a supernatural spell.

Long passages in Shelley's "Revolt of Islam" and Keats's "Endymion" are poetical in this sense; the reader gathers, probably, no definite meaning, but is conscious of a poetic medium, of speech euphonious and measured, and redolent of a kind of objectless passion which is little more than the sensation of the movement and sensuous richness of the lines. Such poetry is not great; it has, in fact, a tedious vacuity, and is unworthy of a mature mind; but it is poetical, and could be produced only by a legitimate child of the Muse. It belongs to an apprenticeship, but in this case the apprenticeship of genius. It bears that relation to great poems which scales and aimless warblings bear to great singing—they test the essential endowment and fineness of the organ which is to be employed in the art. Without this sensuous background and ingrained predisposition to beauty, no art can reach the deepest and most exquisite effects; and even without an intelligible superstructure these sensuous qualities suffice to give that thrill of exaltation, that suggestion of an ideal world, which we feel in the presence of any true beauty.

The sensuous beauty of words and their utterance in measure suffice, therefore, for poetry of one sort—where these are there is something unmistakably

poetical, although the whole of poetry, or the best of poetry, be not yet there. Indeed, in such works as "The Revolt of Islam" or "Endymion" there is already more than mere meter and sound; there is the color and choice of words, the fanciful, rich, or exquisite juxtaposition of phrases. The vocabulary and the texture of the style are precious; affected, perhaps, but at any rate refined.

This quality, which is that almost exclusively exploited by the Symbolist, we may call euphuism—the choice of colored words and rare and elliptical phrases. If great poets are like architects and sculptors, the euphuists are like goldsmiths and jewellers; their work is filigree in precious metals, encrusted with glowing stones. Now euphuism contributes not a little to the poetic effect of the tirades of Keats and Shelley; if we wish to see the power of versification without euphuism we may turn to the tirades of Pope, where meter and euphony are displayed alone, and we have the outline or skeleton of poetry without the filling.

> *In spite of pride, in erring reason's spite,*
> *One truth is clear, Whatever is, is right.*

We should hesitate to say that such writing was truly poetical; so that some euphuism would seem to be necessary as well as meter, to the formal essence of poetry.

An example of this sort, however, takes us out of the merely verbal into the imaginative region; the reason that Pope is hardly poetical to us is not that he is inharmonious,—not a defect of euphony,—but that he is too intellectual and has an excess of mentality. It is easier for words to be poetical without any thought, when they are felt merely as sensuous and musical, than for them to remain so when they convey an abstract notion—especially if that notion be a tart and frigid sophism, like that of the couplet just quoted. The pyrotechnics of the intellect then take the place of the glow of sense, and the artifice of thought chills the pleasure we might have taken in the grace of expression.

If poetry in its higher reaches is more philosophical than history, because it presents the memorable types of men and things apart from unmeaning circumstances, so in its primary substance and texture poetry is more philosophical than prose because it is nearer to our immediate experience. Poetry breaks up the trite conceptions designated by current words into the sensuous qualities out of which those conceptions were originally put together. We name what we conceive and believe in, not what we see; things, not images; souls, not voices and silhouettes. This naming, with the whole education of the senses which it accompanies, subserves the uses of life; in order to thread our way through the labyrinth of objects which assault us, we must make a great selection in our sensuous experience; half of what we see and hear we must

pass over as insignificant, while we piece out the other half with such an ideal complement as is necessary to turn it into a fixed and well-ordered world. This labor of perception and understanding, this spelling of the material meaning of experience is enshrined in our work-a-day language and ideas; ideas which are literally poetic in the sense that they are "made" (for every conception in an adult mind is a fiction), but which are at the same time prosaic because they are made economically, by abstraction, and for use.

When the child of poetic genius, who has learned this intellectual and utilitarian language in the cradle, goes afield and gathers for himself the aspects of Nature, he begins to encumber his mind with the many living impressions which the intellect rejected, and which the language of the intellect can hardly convey; he labors with his nameless burden of perception, and wastes himself in aimless impulses of emotion and revery, until finally the method of some art offers a vent to his inspiration, or to such part of it as can survive the test of time and the discipline of expression.

The poet retains by nature the innocence of the eye, or recovers it easily; he disintegrates the fictions of common perception into their sensuous elements, gathers these together again into chance groups as the accidents of his environment or the affinities of his temperament may conjoin them; and this wealth of sensation and this freedom of fancy, which make an extraordinary ferment in his ignorant heart, presently bubble over into some kind of utterance.

The fulness and sensuousness of such effusions bring them nearer to our actual perceptions than common discourse could come; yet they may easily seem remote, overloaded, and obscure to those accustomed to think entirely in symbols, and never to be interrupted in the algebraic rapidity of their thinking by a moment's pause and examination of heart, nor ever to plunge for a moment into that torrent of sensation and imagery over which the bridge of prosaic associations habitually carries us safe and dry to some conventional act. How slight that bridge commonly is, how much an affair of trestles and wire, we can hardly conceive until we have trained ourselves to an extreme sharpness of introspection. But psychologists have discovered, what laymen generally will confess, that we hurry by the procession of our mental images as we do by the traffic of the street, intent on business, gladly forgetting the noise and movement of the scene and looking only for the corner we would turn or the door we would enter. Yet in our alertest moment the depths of the soul are still dreaming; the real world stands drawn in bare outline against a background of chaos and unrest. Our logical thoughts dominate experience only as the parallels and meridians make a checker-board of the sea. They guide our voyage without controlling the waves, which toss for ever in spite of our

ability to ride over them to our chosen ends. Sanity is a madness put to good uses; waking life is a dream controlled.

Out of the neglected riches of this dream the poet fetches his wares. He dips into the chaos that underlies the rational shell of the world and brings up some superfluous image, some emotion dropped by the way, and reattaches it to the present object; he reinstates things unnecessary, he emphasizes things ignored, he paints in again into the landscape the tints which the intellect has allowed to fade from it. If he seems sometimes to obscure a fact, it is only because he is restoring an experience. We may observe this process in the simplest cases. When Ossian, mentioning the sun, says it is round as the shield of his fathers, the expression is poetical. Why? Because he has added to the word sun, in itself sufficient and unequivocal, other words, unnecessary for practical clearness, but serving to restore the individuality of his perception and its associations in his mind. There is no square sun with which the sun he is speaking of could be confused; to stop and call it round is a luxury, a halting in the sensation for the love of its form. And to go on to tell us, what is wholly impertinent, that the shield of his fathers was round also, is to invite us to follow the chance wanderings of his fancy, to give us a little glimpse of the stuffing of his own brain, or, we might almost say, to turn over the pattern of his embroidery and show us the loose threads hanging on the wrong side. Such an escapade disturbs and interrupts the true vision of the object, and a great poet, rising to a perfect conception of the sun and forgetting himself, would have disdained to make it; but it has a romantic and pathological interest, it restores an experience, and is in that measure poetical. We have been made to halt at the sensation, and to penetrate for a moment into its background of dream.

But it is not only thoughts or images that the poet draws in this way from the store of his experience, to clothe the bare form of conventional objects: he often adds to these objects a more subtle ornament, drawn from the same source. For the first element which the intellect rejects in forming its ideas of things is the emotion which accompanies perception; and this emotion is the first thing the poet restores. He stops at the image, because he stops to enjoy. He wanders into the by-paths of association because the by-paths are delightful. The love of beauty which made him give measure and cadence to his words, the love of harmony which made him rhyme them, reappear in his imagination and make him select there also the material that is itself beautiful, or capable of assuming beautiful forms. The link that binds together the ideas, sometimes so wide apart, which his wit assimilates, is most often the link of emotion; they have in common some element of beauty or of horror.

The poet's art is to a great extent the art of intensifying emotions by assem-

bling the scattered objects that naturally arouse them. He see the affinities of things by seeing their common affinities with passion. As the guiding principle of practical thinking is some interest, so that only what is pertinent to that interest is selected by the attention; as the guiding principle of scientific thinking is some connection of things in time or space, or some identity of law; so in poetic thinking the guiding principle is often a mood or a quality of sentiment. By this union of disparate things having a common overtone of feeling, the feeling is itself evoked in all its strength; nay, it is often created for the first time, much as by a new mixture of old pigments Perugino could produce the unprecedented limpidity of his color, or Titian the unprecedented glow of his. Poets can thus arouse sentiments finer than any which they have known, and in the act of composition become discoverers of new realms of delightfulness and grief. Expression is a misleading term which suggests that something previously known is rendered or imitated; whereas the expression is itself an original fact, the values of which are then referred to the thing expressed, much as the honors of a Chinese mandarin are attributed retro-actively to his parents. So the charm which a poet, by his art of combining images and shades of emotion, casts over a scene or an action, is attached to the principal actor in it, who gets the benefit of the setting furnished him by a well-stocked mind.

The poet is himself subject to this illusion, and a great part of what is called poetry, although by no means the best part of it, consists in this sort of idealization by proxy. We dye the world of our own color; by a pathetic fallacy, by a false projection of sentiment, we soak Nature with our own feel-ing, and then celebrate her tender sympathy with our moral being. This aber-ration, as we see in the case of Wordsworth, is not inconsistent with a high development of both the faculties which it confuses,—I mean vision and feeling. On the contrary, vision and feeling, when most abundant and original, most easily present themselves in this undivided form. There would be need of a force of intellect which poets rarely possess to rationalize their inspiration without diminishing its volume: and if, as is commonly the case, the energy of the dream and the passion in them is greater than that of the reason, and they cannot attain true propriety, and supreme beauty in their works, they can nevertheless, fill them with lovely images and a fine moral spirit.

The pouring forth of both perceptive and emotional elements in their mixed and indiscriminate form gives to this kind of imagination the directness and truth which sensuous poetry possesses on a lower level. The outer world bathed in the hues of human feeling, the inner world expressed in the forms of things, —that is the primitive condition of both before intelligence and the prosaic classification of objects have abstracted them and assigned them to their

respective spheres. Such identifications, on which a certain kind of metaphysics prides itself also, are not discoveries of profound genius; they are exactly like the observation of Ossian that the sun is round and that the shield of his fathers was round too; they are disintegrations of conventional objects, so that the original associates of our perceptions reappear; then the thing and the emotion which chanced to be simultaneous are said to be one, and we return, unless a better principle of organization is substituted for the principle abandoned, to the chaos of a passive animal consciousness, where all is mixed together, projected together, and felt as an unutterable whole.

The pathetic fallacy is a return to that early habit of thought by which our ancestors peopled the world with benevolent and malevolent spirits; what they felt in the presence of objects they took to be a part of the objects themselves. In returning to this natural confusion, poetry does us a service in that she recalls and consecrates those phases of our experience which, as useless to the understanding of material reality, we are in danger of forgetting altogether. Therein is her vitality, for she pierces to the quick and shakes us out of our servile speech and imaginative poverty; she reminds us of all we have felt, she invites us even to dream a little, to nurse the wonderful spontaneous creations which at every waking moment we are snuffing out in our brain. And the indulgence is no mere momentary pleasure; much of its exuberance clings afterward to our ideas; we see the more and feel the more for that exercise; we are capable of finding greater entertainment in the common aspect of Nature and life. When the veil of convention is once removed from our eyes by the poet, we are better able to dominate any particular experience and, as it were, to change its scale, now losing ourselves in its infinitesimal texture, now in its infinite ramifications.

If the function of poetry, however, did not go beyond this recovery of sensuous and imaginative freedom, at the expense of disrupting our useful habits of thought, we might be grateful to it for occasionally relieving our numbness, but we should have to admit that it was nothing but a relaxation; that spiritual discipline was not to be gained from it in any degree, but must be sought wholly in that intellectual system that builds the science of Nature with the categories of prose. So conceived, poetry would deserve the judgment passed by Plato on all the arts of flattery and entertainment; it might be crowned as delightful, but must be either banished altogether as meretricious or at least confined to a few forms and occasions where it might do little harm. The judgment of Plato has been generally condemned by philosophers, although it is eminently rational, and justified by the simplest principles of morals. It has been adopted instead, although unwittingly, by the practical and secular part of mankind, who look upon artists and poets as inefficient and brainsick people

under whose spell it would be a serious calamity to fall, although they may be called in on feast days as an ornament and luxury together with the cooks, hairdressers, and florists.

Several circumstances, however, might suggest to us the possibility that the greatest function of poetry may be still to find. Plato, while condemning Homer, was a kind of poet himself; his quarrel with the followers of the Muse was not a quarrel with the goddess; and the good people of Philistia, distrustful as they may be of profane art, pay undoubting honor to religion, which is a kind of poetry as much removed from their sphere as the midnight revels upon Mount Citheron, which, to be sure, were also religious in their inspiration. Why, we may ask, these apparent inconsistencies? Why do our practical men make room for religion in the background of their world? Why did Plato, after banishing the poets, poetize the universe in his prose? Because the abstraction by which the world of science and of practice is drawn out of our experience, is too violent to satisfy even the thoughtless and vulgar; the ideality of the machine we call Nature, the conventionality of the drama we call the world, are too glaring not to be somehow perceived by all. Each must sometimes fall back upon the soul; he must challenge this apparition with the thought of death; he must ask himself for the mainspring and value of his life. He will then remember his stifled loves; he will feel that only his illusions have ever given him a sense of reality, only his passions the hope and the vision of peace. He will read himself through and almost gather a meaning from his experience; at least he will half believe that all he has been dealing with was a dream and a symbol, and raise his eyes toward the truth beyond.

This plastic moment of the mind, when we become aware of the artificiality and inadequacy of what common sense perceives, is the true moment of poetic opportunity,—an opportunity, we may hasten to confess, which is generally missed. The strain of attention, the concentration and focussing of thought on the unfamiliar immediacy of things, usually brings about nothing but confusion. We are dazed, we are filled with a sense of unutterable things, luminous yet indistinguishable, many yet one. Instead of rising to imagination, we sink into mysticism.

To accomplish a mystical disintegration is not the function of any art; if any art seems to accomplish it, the effect is only incidental, being involved, perhaps, in the process of constructing the proper object of that art, as we might cut down trees and dig them up by the roots to lay the foundations of a temple. For every art looks to the building up of something. And just because the world built up by common sense and natural science is an inadequate world (a skeleton which needs the filling of sensation before it can live), therefore the moment when we realize its inadequacy is the moment when the

higher arts find their opportunity. When the world is shattered to bits they can come and "build it nearer to the heart's desire."

The great function of poetry, which we have not yet directly mentioned, is precisely this: to repair to the material of experience, seizing hold of the reality of sensation and fancy beneath the surface of conventional ideas, and then out of that living but indefinite material to build new structures, richer, finer, fitter to the primary tendencies of our nature, truer to the ultimate possibilities of the soul. Our descent into the elements of our being is then justified by our subsequent freer ascent toward its goal; we revert to sense only to find food for reason; we destroy conventions only to construct ideals.

Such analysis for the sake of creation is the essence of all great poetry. Science and common sense are themselves in their way poets of no mean order, since they take the material of experience and make out of it a clear, symmetrical, and beautiful world; the very propriety of this art, however, has made it common. Its figures have become mere rhetoric and its metaphors prose. Yet, even as it is, a scientific and mathematical vision has a higher beauty than the irrational poetry of sensation and impulse, which merely tickles the brain, like liquor, and plays upon our random, imaginative lusts. The imagination of a great poet, on the contrary, is as orderly as that of an astronomer, and as large; he has the naturalist's patience, the naturalist's love of detail and eye trained to see fine gradations and essential lines; he knows· no hurry; he has no pose, no sense of originality; he finds his effects in his subject, and his subject in his inevitable world. Resembling the naturalist in all this, he differs from him in the balance of his interest: the poet has the concreter mind; his visible world wears all its colors and retains its indwelling passion and life. Instead of studying in experience its calculable elements, he studies its moral values, its beauty, the openings it offers to the soul: and the cosmos he constructs is accordingly an ideal theater for the spirit in which its noblest potential drama is enacted and its destiny resolved.

This supreme function of poetry is only the consummation of the method by which words and imagery are transformed into verse. As verse breaks up the prosaic order of syllables and subjects them to a recognizable and pleasing measure, so poetry breaks up the whole prosaic picture of experience to introduce into it a rhythm more congenial and intelligible to the mind. And in both these cases the operation is essentially the same as that by which, in an intermediate sphere, the images rejected by practical thought, and the emotions ignored by it, are so marshalled as to fill the mind with a truer and intenser consciousness of its memorable experience. The poetry of fancy, of observation, and of passion moves on this intermediate level; the poetry of mere sound and virtuosity is confined to the lower sphere; and the highest is reserved for the

poetry of the creative reason. But one principle is present throughout,—the principle of Beauty,—the art of assimilating phenomena, whether works, images, emotions, or systems of ideas, to the deeper innate cravings of the mind.

Let us now dwell a little on this higher function of poetry and try to distinguish some of its phases.

The creation of characters is what many of us might at first be tempted to regard as the supreme triumph of the imagination. If we abstract, however, from our personal tastes and look at the matter in its human and logical relations, we shall see, I think, that the construction of characters is not the ultimate task of poetic fiction. A character can never be exhaustive of our materials: for it exists by its idiosyncrasy, by its contrast with other natures, by its development of one side, and one side only, of our native capacities. It is, therefore, not by characterization as such that the ultimate message can be rendered. The poet can put only a part of himself into any of his heroes, but he must put the whole into his noblest work. A character is accordingly only a fragmentary unity; fragmentary in respect to its origin,—since it is conceived by enlargement, so to speak, of a part of our own being to the exclusion of the rest,—and fragmentary in respect to the object it presents, since a character must live in an environment and be appreciated by contrast and by the sense of derivation. Not the character, but its effects and causes, is the truly interesting thing. Thus in master poets, like Homer and Dante, the characters, although well drawn, are subordinate to the total movement and meaning of the scene. There is indeed something pitiful, something comic, in any comprehended soul; souls, like other things, are only definable by their limitations. We feel instinctively that it would be insulting to speak of any man to his face as we should speak of him in his absence, even if what we say is in the way of praise: for absent he is a character understood, but present he is a force respected.

In the construction of ideal characters, then, the imagination is busy with material,—particular actions and thoughts,—which suggest their unification in persons; but the characters thus conceived can hardly be adequate to the profusion of our observations, nor exhaustive, when all personalities are taken together, of the interest of our lives. Characters are initially imbedded in life, as the gods themselves are originally imbedded in Nature. Poetry must, therefore, to render all reality, render also the background of its figures, and the events that condition their acts. We must place them in that indispensable environment which the landscape furnishes to the eye and the social medium to the emotions.

The visible landscape is not a proper object for poetry. Its elements, and

especially the emotional stimulation which it gives, may be suggested or expressed in verse; but landscape is not thereby represented in its proper form; it appears only as an element and associate of moral unities. Painting, architecture, and gardening, with the art of stage setting, have the visible landscape for their object, and to those arts we may leave it. But there is a sort of landscape larger than the visible, which escapes the synthesis of the eye; it is present to that topographical sense by which we always live in the consciousness that there is a sea, that there are mountains, that the sky is above us, even when we do not see it, and that the tribes of men, with their different degrees of blamelessness, are scattered over the broad-backed earth. This cosmic landscape poetry alone can render, and it is no small part of the art to awaken the sense of it at the right moment, so that the object that occupies the center of vision may be seen in its true lights, colored by its wider associations, and dignified by its felt affinities to things permanent and great. As the Italian masters were wont not to paint their groups of saints about the Virgin without enlarging the canvas, so as to render a broad piece of sky, some mountains and rivers, and nearer, perhaps, some decorative pile; so the poet of larger mind envelops his characters in the atmosphere of Nature and history, and keeps us constantly aware of the world in which they move.

The distinction of a poet—the dignity and humanity of his thought—can be measured by nothing, perhaps, so well as by the diameter of the world in which he lives; if he is supreme, his vision, like Dante's, always stretches to the stars. And Virgil, a supreme poet sometimes unjustly belittled, shows us the same thing in another form; his landscape is the Roman universe, his theme the sacred springs of Roman greatness in piety, constance, and law. He has not written a line in forgetfulness that he was a Roman; he loves country life and its labors because he sees in it the origin and bulwark of civic greatness; he honors tradition because it gives perspective and momentum to the history that ensues; he invokes the gods, because they are symbols of the physical and moral forces by which Rome struggled to dominion.

Almost every classic poet has the topographical sense; he swarms with proper names and allusions to history and fable; if an epithet is to be thrown in anywhere to fill up the measure of a line, he chooses instinctively an appellation of place or family; his wine is not red, but Samian; his gorges are not deep, but are the gorges of Haemus; his songs are not sweet, but Pierian. We may deride their practice as conventional, but they could far more justly deride ours as insignificant. Conventions do not arise without some reason, and genius will know how to rise above them by a fresh appreciation of their rightness, and will feel no temptation to overturn them in favor of personal whimsies. The ancients found poetry not so much in sensible accidents as in essential

forms and noble associations; and this fact marks very clearly their superior education. They dominated the world as we no longer dominate it, and lived, as we are too distracted to live, in the presence of the rational and the important.

A physical and historical background, however, is of little moment to the poet in comparison with that other environment of his characters,—the dramatic situations in which they are involved. The substance of poetry is, after all, emotion; and if the intellectual emotion of comprehension and the mimetic one of impersonation are massive, they are not so intense as the appetites and other transitive emotions of life; the passions are the chief basis of all interests, even the most ideal, and the passions are seldom brought into play except by the contact of man with man. The various forms of love and hate are only possible in society, and to imagine occasions in which these feelings may manifest all their inward vitality is the poet's function,—one in which he follows the fancy of every child, who puffs himself out in his day-dreams into an endless variety of heroes and lovers. The thrilling adventures which he craves demand an appropriate theater; the glorious emotions with which he bubbles over must at all hazards find or feign their correlative objects.

But the passions are naturally blind, and the poverty of the imagination, when left alone, is absolute. The passions may ferment as they will, they never can breed an idea out of their own energy. This idea must be furnished by the senses, by outward experience, else the hunger of the soul will gnaw its own emptiness for ever. Where the seed of sensation has once fallen, however, the growth, variations, and exuberance of fancy may be unlimited. Only we still observe (as in the child, in dreams, and in the poetry of ignorant or mystical poets) that the intensity of inwardly generated visions does not involve any real increase in their scope or dignity. The inexperienced mind remains a thin mind, no matter how much its vapors may be heated and blown about by natural passion. It was a capital error in Fichte and Schopenhauer to assign essential fertility to the will in the creation of ideas. They mistook, as human nature will do, even when at times it professes pessimism, an ideal for a reality: and because they saw how much the will clings to its objects, how it selects and magnifies them, they imagined that it could breed them out of itself. A man who thinks clearly will see that such self-determination of a will is inconceivable, since what has no external relation and no diversity of structure cannot of itself acquire diversity of functions. Such inconceivability, of course, need not seem a great objection to a man of impassioned inspiration; he may even claim a certain consistency in positing, on the strength of his preference, the inconceivable to be a truth.

The alleged fertility of the will is, however, disproved by experience, from

which metaphysics must in the end draw its analogies and plausibility. The passions discover, they do not create, their occasions; a fact which is patent when we observe how they seize upon what objects they find, and how reversible, contingent, and transferable the emotions are in respect to their objects. A doll will be loved instead of a child, a child instead of a lover, God instead of everything. The differentiation of the passions, as far as consciousness is concerned, depends on the variety of the objects of experience,—that is, on the differentiation of the senses and of the environment which stimulates them.

When the "infinite" spirit enters the human body, it is determined to certain limited forms of life by the organs which it wears; and its blank potentiality becomes actual in thought and deed, according to the fortunes and relations of its organism. The ripeness of the passions may thus precede the information of the mind and lead to groping in by-paths without issue; a phenomenon which appears not only in the obscure individual whose abnormalities the world ignores but also in the starved, half-educated genius that pours the whole fire of his soul into trivial arts or grotesque superstitions. The hysterical forms of music and religion are the refuge of an idealism that has lost its way; the waste and failures of life flow largely in those channels. The carnal temptations of youth are incidents of the same maladaptation, when passions assert themselves before the conventional order of society can allow them physical satisfaction, and long before philosophy or religion can hope to transform them into fuel for its own sacrificial flames.

Hence flows the greatest opportunity of fiction. We have, in a sense, an infinite will; but we have a limited experience, an experience sadly inadequate to exercise that will either in its purity or its strength. To give form to our capacities nothing is required but the appropriate occasion; this the poet, studying the world, will construct for us out of the materials of his observations. He will involve us in scenes which lie beyond the narrow lane of our daily ploddings; he will place us in the presence of important events, that we may feel our spirit rise momentarily to the height of his great argument. The possibilities of love or glory, of intrigue and perplexity, will be opened up before us; if he gives us a good plot, we can readily furnish the characters, because each of them will be the realization of some stunted potential self of our own. It is by the plot, then, that the characters will be vivified, because it is by the plot that our own character will be expanded into its latent possibilities.

The description of an alien character can serve this purpose only very imperfectly; but the presentation of the circumstances in which that character manifests itself will make description unnecessary, since our instinct will supply all that is requisite for the impersonation. Thus it seems that Aristotle was

justified in making the plot the chief element in fiction: for it is by virtue of the plot that the characters live, or, rather, that we live in them, and by virtue of the plot accordingly that our soul rises to that imaginative activity by which we tend at once to escape from the personal life and to realize its ideal. This idealization is, of course, partial and merely relative to the particular adventure in which we imagine ourselves engaged. But in some single direction our will finds self-expression, and understands itself; runs through the career which it ignorantly coveted, and gathers the fruits and the lesson of that enterprise.

This is the essence of tragedy: the sense of the finished life, of the will fulfilled and enlightened: that purging of the mind so much debated upon, which relieves us of pent-up energies, transfers our feelings to a greater object, and thus justifies and entertains our dumb passions, detaching them at the same time for a moment from their accidental occasions in our earthly life. An episode, however lurid, is not a tragedy in this nobler sense, because it does not work itself out to the end; it pleases without satisfying, or shocks without enlightening. This enlightenment, I need hardly say, is not a matter of theory or of moral maxims; the enlightenment by which tragedy is made sublime is a glimpse into the ultimate destinies of our will. This discovery need not be an ethical gain—Macbeth and Othello attain it as much as Brutus and Hamlet—it may serve to accentuate despair, or cruelty, or indifference, or merely to fill the imagination for a moment without much affecting the permanent tone of the mind. But without such a glimpse of the goal of a passion the passion has not been adequately read, and the fiction has served to amuse us without really enlarging the frontiers of our ideal experience. Memory and emotion have been played upon, but imagination has not brought anything new to the light.

The dramatic situation, however, gives us the environment of a single passion, of life in one of its particular phases; and although a passion, like Romeo's love, may seem to devour the whole soul, and its fortunes may seem to be identical with those of the man, yet much of the man, and the best part of him, goes by the board in such a simplification. If Leonardo da Vinci, for example, had met in his youth with Romeo's fate, his end would have been no more ideally tragic than if he had died at eighteen of a fever; we should be touched rather by the pathos of what he had missed, than by the sublimity of what he had experienced. A passion like Romeo's, compared with the ideal scope of human thought and emotion, is a thin dream, a pathological crisis.

Accordingly Aristophanes, remembering the original religious and political functions of tragedy, blushes to see upon the boards a woman in love. And we should readily agree with him, but for two reasons,—one, that we abstract too much, in our demands upon art, from nobility of mind, and from the thought

of totality and proportion; the other, that we have learned to look for a symbolic meaning in detached episodes, and to accept the incidental emotions they cause, because of their violence and our absorption in them, as in some sense sacramental and representative of the whole. Thus the picture of an unmeaning passion, of a crime without an issue, does not appear to our romantic apprehension as the sorry farce it is, but rather as a true tragedy. Some have lost even the capacity to conceive of a true tragedy, because they have no idea of a cosmic order, of general laws of life, or of an impersonal religion. They measure the profundity of feeling by its intensity, not by its justifying relations; and in the radical disintegration of their spirit, the more they are devoured the more they fancy themselves fed. But the majority of us retain some sense of a meaning in our joys and sorrows, and even if we cannot pierce to their ultimate object, we feel that what absorbs us here and now has a merely borrowed or deputed power; that it is a symbol and foretaste of all reality speaking to the whole soul. At the same time our intelligence is too confused to give us any picture of that reality, and our will too feeble to marshal our disorganized loves in a religion consistent with itself and harmonious with the comprehended universe. A rational ideal eludes us, and we are the more inclined to plunge into mysticism.

Nevertheless, the function of poetry, like that of science, can only be fulfilled by the conception of harmonies that become clearer as they grow richer. As the chance note that comes to be supported by a melody becomes in that melody determinate and necessary, and as the melody, when woven into a harmony, is explicated in that harmony and fixed beyond recall; so the single emotion, the fortuitous dream, launched by the poet into the world of recognizable and immortal forms, looks in that world for its ideal supports and affinities. It must find them or else be blown back among the ghosts. The highest ideality is the comprehension of the real. Poetry is not at its best when it depicts a further possible experience, but when it initiates us, by feigning something which as an experience is impossible, into the meaning of the experience which we have actually had.

The highest example of this kind of poetry is religion; and although disfigured and misunderstood by the simplicity of men who believe in it without being capable of that imaginative interpretation of life in which its truth consists, yet this religion is even then often beneficent, because it colors life harmoniously with the ideal. Religion may falsely represent the ideal as a reality, but we must remember that the ideal, if not so represented, would be despised by the majority of men, who cannot understand that the value of things is moral, and who therefore attribute to what is moral a natural existence, thinking thus to vindicate its importance and value. But value lies in meaning,

not in substance; in the ideal which things approach, not in the energy which they embody.

The highest poetry, then, is not that of the versifiers, but that of the prophets, or of such poets as interpret verbally the visions which the prophets have rendered in action and sentiment rather than in adequate words. That the intuitions of religion are poetical, and that in such intuitions poetry has its ultimate function, are truths of which both religion and poetry become more conscious the more they advance in refinement and profundity. A crude and superficial theology may confuse God with the thunder, the mountains, the heavenly bodies, or the whole universe; but when we pass from these easy identifications to a religion that has taken root in history and in the hearts of men, and has come to flower, we find its objects and its dogmas purely ideal, transparent expressions of moral experience and perfect counterparts of human needs. The evidence of history or of the senses is left far behind and never thought of; the evidence of the heart, the value of the idea, are alone regarded.

Take, for instance, the doctrine of transubstantiation. A metaphor here is the basis of a dogma, because the dogma rises to the same subtle region as the metaphor, and gathers its sap from the same soil of emotion. Religion has here rediscovered its affinity with poetry, and in insisting on the truth of its mystery it unconsciously vindicates the ideality of its truth. Under the accidents of bread and wine lies, says the dogma, the substance of Christ's body, blood, and divinity. What is that but to treat facts as an appearance, and their ideal import as a reality? And to do this is the very essence of poetry, for which everything visible is a sacrament—an outward sign of that inward grace for which the soul is thirsting.

In this same manner, where poetry rises from its elementary and detached expressions in rhythm, euphuism, characterization, and story-telling, and comes to the consciousness of its highest function, that of portraying the ideals of experience and destiny, then the poet becomes aware that he is essentially a prophet, and either devotes himself, like Homer or Dante, to the loving expression of the religion that exists, or like Lucretius or Wordsworth, to the heralding of one which he believes to be possible. Such poets are aware of their highest mission; others, whatever the energy of their genius, have not conceived their ultimate function as poets. They have been willing to leave their world ugly as a whole, after stuffing it with a sufficient profusion of beauties. Their contemporaries, their fellow-countrymen for many generations, may not perceive this defect, because they are naturally even less able than the poet himself to understand the necessity of so large a harmony. If he is short-sighted, they are blind, and his poetic world may seem to them sublime

in its significance, because it may suggest some partial lifting of their daily burdens and some partial idealization of their incoherent thoughts.

Such insensibility to the highest poetry is no more extraordinary than the corresponding indifference to the highest religion; nobility and excellence, however, are not dependent on the suffrage of half-baked men, but on the original disposition of the clay and the potter; I mean on the conditions of the art and the ideal capacities of human nature. Just as a note is better than a noise because, its beats being regular, the ear and brain can react with pleasure on that regularity, so all the stages of harmony are better than the confusion out of which they come, because the soul that perceives that harmony welcomes it as the fulfilment of her natural ends. The Pythagoreans were therefore right when they made number the essence of the knowable world, and Plato was right when he said harmony was the first condition of the highest good. The good man is a poet whose syllables are deeds and make a harmony in Nature. The poet is a rebuilder of the imagination, to make a harmony in that. And he is not a complete poet if his whole imagination is not attuned and his whole experience composed into a single symphony.

For his complete equipment, then, it is necessary, in the first place, that he sing; that his voice be pure and well pitched, and that his numbers flow; then, at a higher stage, his images must fit with one another; he must be euphuistic, coloring his thoughts with many reflected lights of memory and suggestion, so that their harmony may be rich and profound; again, at a higher stage, he must be sensuous and free, that is, he must build up his world with the primary elements of experience, not with the conventions of common sense or intelligence; he must draw the whole soul into his harmonies, even if in doing so he disintegrates the partial systematizations of experience made by abstract science in the categories of prose. But finally, this disintegration must not leave the poet weltering in a chaos of sense and passion; it must be merely the ploughing of the ground before a new harvest, the kneading of the clay before the modelling of a more perfect form. The expression of emotion should be rationalized by derivation from character and by reference to the real objects that arouse it—to Nature, to history, and to the universe of truth; the experience imagined should be conceived as a destiny, governed by principles, and issuing in the discipline and enlightenment of the will. In this way alone can poetry become an interpretation of life and not merely an irrelevant excursion into the realm of fancy, multiplying our images without purpose, and distracting us from our business without spiritual gain.

If we may then define poetry, not in the formal sense of giving the minimum of what may be called by that name, but in the ideal sense of determining the goal which it approaches and the achievement in which all its principles would

be fulfilled, we may say that poetry is metrical and euphuistic discourse, expressing thought which is both sensuous and ideal.

Such is poetry as a literary form; but if we drop the limitation to verbal expression, and think of poetry as that subtle fire and inward light which seems at times to shine through the world and to touch the images in our minds with ineffable beauty, then poetry is a momentary harmony in the soul amid stagnation or conflict,—a glimpse of the divine and an incitation to a religious life.

Religion is poetry become the guide of life, poetry substituted for science or supervening upon it as an approach to the highest reality. Poetry is religion allowed to drift, left without points of application in conduct and without an expression in worship and dogma; it is religion without practical efficacy and without metaphysical illusion. The ground of this abstractness of poetry, however, is usually only its narrow scope; a poet who plays with an idea for half an hour, or constructs a character to which he gives no profound moral significance, forgets his own thought, or remembers it only as a fiction of his leisure, because he has not dug his well deep enough to tap the subterraneous springs of his own life. But when the poet enlarges his theater and puts into his rhapsodies the true visions of his people and of his soul, his poetry is the consecration of his deepest convictions, and contains the whole truth of his religion. What the religion of the vulgar adds to the poet's is simply the inertia of their limited apprehension, which takes literally what he meant ideally, and degrades into a false extension of this world on its own level what in his mind was a true interpretation of it upon a moral plane.

This higher plane is the sphere of significant imagination, of relevant fiction, of idealism become the interpretation of the reality it leaves behind. Poetry raised to its highest power is then identical with religion grasped in its inmost truth; at their point of union both reach their utmost purity and beneficence, for then poetry loses its frivolity and ceases to demoralize, while religion surrenders its illusions and ceases to deceive.

THE COGNITIVE VALUE
OF LITERATURE

WAYNE SHUMAKER

Everyone who is deeply interested in literature must remember times when his absorption in a book was virtually complete and everything but the literary work itself slipped to the extreme verge of consciousness. At such a moment, the walls of the room fade or recede, the chair in which the reader is sitting has little tactile substance, and the printed pages of the book itself exist as objects only to the extent that they offer obstacles to the smooth continuity of the experience—as, for instance, when an important word is illegible or by accident two leaves are flipped over together. The foreground of consciousness, in which the literary imagination is active, is brilliantly lighted, the background of practical reality so dim that it hardly has psychological reality. In a sense, the reader's world is radically foreshortened, since the immediate experience has only as much history as is implicit in the literary universe. Yet the total feeling is one of fullness, of extraordinary vitality, of psychic richness and depth. The "unitary consciousness" lamented by recent critics as no longer attainable has been achieved, and will continue until broken by an intrusion from the background, the perception of destructive flaws in the foreground, or fatigue.

How frequently such absorption occurs in a relatively intense form can only be guessed. Some readers are perhaps not capable of it. Others will remember knowing it as children but will pride themselves on having acquired enough maturity to hold art off at a cool distance. Aestheticians, while acknowledging that virtually complete absorption is possible, may deplore it as critically improper. If children were questioned, some would no doubt be incredulous that books could ever be so interesting, whereas others, perhaps more intelligent and certainly more imaginative, would at once exclaim, "Oh, yes!" To everyone, however, except the few lumpish people too phlegmatic ever to become vitally alive, psychic absorption of some kind will be credible, if only because of memories preserved across an expanse of dully sensed years. A boy may have known absorption while staring down, in fascinated horror at the gently rippling water of a swimming pool from a twenty-foot diving platform. A lover may have known it during courtship, a fisherman while playing a steelhead, a politician while maneuvering frantically against odds at a convention. Whatever the external circumstances, however, the psychic mark of the experience is a rapt focusing of attention on something outside the self. In so far as conscious selfhood continues, it is as process rather than state. The boundaries

117

between personality and the situation melt away, and whatever in the background has no relevance to the absorbing object ceases to exist for consciousness.

FEELING TONES

The fact that literature is capable of producing such states is critically significant and must be reckoned with in an adequate aesthetic—and this regardless of whether the most intense degrees of absorption are ultimately to be approved or discouraged. What especially deserves notice is the play, in the aroused state, not only of ideas but also of feelings. The evoked perceptions have affective valences, as it were, and tend to become structured in terms of feeling relationships. Clearly, what happens unmistakably in aroused contemplation happens to some extent in all aesthetic transactions and is responsible for one of their distinguishing qualities. Just as the fisherman, in playing his steelhead, makes physical adjustments which are not preceded or accompanied by trains of discursive thought, so the perceptive reader of a book can follow the development of a literary situation without rationalizing all the formal and material tensions. That literary experience is suffused with feeling tones is, in fact, a commonplace of discussion; and that the tones modify both perceptions and rational processes can be taken for granted.

THE COGNITIVE ELEMENT

All this would hardly be worth saying had there not, for several decades, been a tendency in aesthetic theory—induced, perhaps, by a wish to vindicate art in a social order which finds unrivaled usefulness in science—to play down the affective element in aesthetic experience in favor of a cognitive element. That the cognitive element is also present can be granted happily. As Kant recognized, the mind is active in its contacts with the external world and does not register passively the impulses that impinge on the nerve endings. Instead, it transforms the impulses into impressions, which enter into combination as *Gestalten* [1] and are registered finally as knowledge, the total process, apparently, having a good deal of similarity to aesthetic creation generally and even more similarity to the verbal and imaginal creation which produces literature. Ernst Cassirer made much of the basic Kantian insight in *Philosophie der Symbolischen Formen,* which has already had a considerable impact on aes-

[1] Forms, patterns. [Ed.]

thetics; and other men as well, philosophers, linguists, and critics, have contributed to a recognition that all thought, no matter how strictly "scientific," on an ultimate level is mythical. In so far as we succeed in making a cosmos of the sensory impressions that reach us, we do so very much as a poet creates a poem,[2] by fitting together sensory images and the counters provided us by a symbolic language in such a way as to make a whole. Neither is there much doubt that philosophers and scientists, as well as poets, often feel connections before rationalizing them. Without subscribing to a now thoroughly outdated view that the poet, or any artist, tries merely to give ornamented expression to a notion or feeling which has pre-existed the compositional process and survives it unchanged, it is impossible to deny that art, and a fortiori the art whose medium is words, has cognitive value.

At the same time, it is very far from established that poetry, or any other art, is significant wholly or even chiefly as cognition. The efforts of literary critics to demonstrate that in the future we must look to poetry as a substitute for religion, or philosophy, or ethics, or science have won few converts. Attempts to show that specific works contain many superimposed layers of meaning have been more successful; but the technique lends itself easily to parody, as in the writings of William Empson, and often results in a dissipation of exactly the sense of effective wholeness which tends to permeate absorbed reading—that wholeness which led John Dewey, himself a distinguished proponent of aesthetic cognition, to find the most fundamental characteristic of aesthetic experience in its "consummatory" quality. At any rate, literature is not *merely* cognitive; and, if it is not, an adequate aesthetic must take account of whatever else enters into the total process.

"Virtual" autonomy of the art work

An indication that aesthetic meanings have a very limited and special cognitive significance can be found, indeed, in another principle which is very popular just now and has often been inconsistently associated with an emphasis on aesthetic cognition. Again and again, in recent years, it has been insisted that literary works have autonomy, are *selbständig*, admit no responsibility to the extra-aesthetic universe. Virginia Woolf, in a well-known essay, objected to the novels of H. G. Wells, John Galsworthy, and Arnold Bennett because "they leave one with so strange a feeling of incompleteness and dissatisfaction" and make one feel that it is necessary to "do something—to join a society, or

[2] An early recognition of the similarity between aesthetic and non-aesthetic thought appears in S. T. Coleridge's famous comment on the primary and secondary imaginations in *Biographia Literaria,* chap. 13.

more desperately, to write a cheque." It is different, she believes, with such a novel as *Tristram Shandy* or *Pride and Prejudice*, which is "self-contained" and "leaves one with no desire to do anything, except indeed to read the book again, and to understand it better." [3] The point of view is familiar, and is given weight by the empirical fact that, immediately after one has emerged from what Susanne Langer calls the "virtual" world of a good piece of art, the only appropriate comment seems, for a few charmed moments, to be "Well!" Whatever its other values, aesthetic cognition has little importance as practical wisdom. The closed-off world of aesthetic contemplation is often so discontinuous with the everyday world that a passage from one to the other requires basic readjustments. The "truth-to" theories of art no longer have eloquent advocates, at least in their simpler formulations. If a convincing argument is to be made for the utility of aesthetic cognition, it cannot rest on the assumption that what is true in and for a specific art work is also true outside it.

Aesthetic distance

A related concept which also seems important to contemporary aestheticians is that of aesthetic distance. The emphasis here is on the awareness, throughout a "proper" aesthetic transaction, that the art work is "there" and the percipient "here"; on the necessity that a play be sensed as "staged," a picture as "framed," a novel as "fictive," all art works as "art" and not "reality." Paradoxically, such awareness is by no means incompatible with aesthetic absorption even in its most intense degrees. Writers have more than once shown in creative works a realization that the aesthetic illusion must never become delusion. The classic development of this theme is in *Don Quixote;* but there are many other treatments. In *Huckleberry Finn,* Tom Sawyer is shown to be emotionally absorbed in playing robber without in the least wishing actually to decapitate, burn, and scatter in pieces any member of the band who betrays its secrets. When the threat of betrayal becomes practical, the malcontent is pacified with a nickel. It is Huck, the unimaginative realist, who is constitutionally unable to distinguish between fact and fancy, Huck who is disappointed when a band of Spaniards, together with two hundred elephants and six hundred camels, turns out to be nothing but small girls on a Sunday School picnic. Tom, who invented the fiction and played it out to the end, was never for a moment deceived. Readers who co-operate emotionally with

[3] Virginia Woolf, "Mr. Bennett and Mrs. Brown," in Mark Schorer, Josephine Miles and Gordon McKenzie (eds.), *Criticism: The Foundations of Modern Literary Judgment,* rev. ed., Harcourt, Brace and Company, Inc., New York, 1958, p. 70.

art may, indeed, be enabled to do so precisely by their confident hold on actuality. At any rate, there is little danger, for nonpathological readers, in aiming at affective participation. To cold intelligence, the laws which hold the fictive universe together must remain obscure in the exact proportion in which they are laws not of the reason but of feelings. If participation required the destruction of aesthetic distance, a serious problem would arise. Fortunately it does not. One can feel sensitively at a distance, exactly as one can perceive and think at a distance. The principle of aesthetic distance must be invoked when literature is confused with life, not when readers are moved by their contacts with books.

The role of affections in creation

That good reading demands intellectual co-operation will be granted readily by contemporary critics; that it demands emotional participation will, I fear, be resisted in certain quarters. T. S. Eliot, in a passage which seems often to have been read inaccurately, insisted that poetry is an escape from emotion; and the interest of aestheticians in cognition offers another barrier. Yet there is widespread realization that, as Samuel Alexander urged,[4] aesthetic appreciation is identical in kind with aesthetic creation. If creation can be shown to be flooded with affective tonality, a disposition may be created to admit that in aesthetic contemplation the feelings as well as the intellect must be active.

In such a collection of statements about the psychic experiences of artists as is to be found in Brewster Ghiselin's *The Creative Process*, the emphasis on feelings is surprisingly strong. It is true that there is emphasis also on the necessity of much puttying up after the creative idea has "come to" the artist; but the seizure of the artist by his subject provides a motif which runs through most of the descriptions, and the seizure appears regularly to be accompanied by excitement. If the subject is cognized, it is also felt; so strongly felt, indeed, that the more purely cognitive struggles which follow upon the original seizure, and which may extend over a period of months or years, often have a compulsive character.

The case is very clear for the art with which we are here especially concerned, literature. "All good poetry," said Wordsworth, "is the spontaneous overflow of powerful feelings." In different words, the basic significance of this statement, *that poetry has much to do with the feelings*, is supported by nearly everything that has been written about poetic creation. According to A. E.

4 Samuel Alexander, *Beauty and Other Forms of Value*, Macmillan & Co., Ltd., London, 1933, p. 30.

Housman, poetry is "more physical than intellectual."[5] In the opinion of Amy Lowell, a poet may be defined as "a man of an extraordinarily sensitive and active subconscious personality, fed by, and feeding, a non-resistant consciousness." Sometimes there is no conscious awareness of the initial impulse to composition, or the impulse may have been forgotten; "but whatever it is, emotion, apprehended or hidden, is a part of it, for only emotion can rouse the subconscious into action."[6] W. B. Yeats puts an emphasis on sensation, which in context we may understand to mean excited perception:

Art bids us touch and taste and hear and see the world, and shrinks from what Blake calls mathematic form, from every abstract thing, from all that is of the brain only, from all that is not a fountain jetting from the entire hopes, memories, and sensations of the body . . .

> *God guard me from those thoughts men think*
> *In the mind alone;*
> *He that sings a lasting song*
> *Thinks in a marrow-bone.*[7]

Ghiselin himself, while working on "Bath of Aphrodite," at one point went over the fragments he had already written, "partly in expectation of revising them, but mostly in order to rouse *the images that made me feel my life.*"[8] And these statements suggest not only the compositional process as it appears to individual poets, but also the impact on the reader's consciousness of whole segments of world poetry. Arabic poetry "dealt with the feelings spinning around an event or fact,"[9] Japanese and Chinese poetry are recognized to be instinct with feeling.

Much the same thing is true of prose. On his fifth trip to Europe, Thomas Wolfe felt more desperately homesick than ever before; and (he writes), "I really believe that *from this emotion, this constant and almost intolerable effort of memory and desire,* the material and the structure of the books I now began to write were derived." While he was writing in New York, at times in despair, he nevertheless lived with extraordinary fullness. "My powers of *feeling and reflection*—even the sense of hearing, and above all, my powers of memory, had reached the greatest degree of sharpness that they had ever known.[10] His whole psyche was aroused, not his intellect alone. "One thing,"

[5] Brewster Ghiselin, *The Creative Process: A Symposium,* University of California Press, Berkeley, Calif., 1954, p. 90.
[6] *Ibid.,* p. 111.
[7] *Ibid.,* pp. 107, 108.
[8] *Ibid.,* p. 130 (my italics).
[9] A. L. Kroeber, *Configurations of Culture Growth,* University of California Press, Berkeley, Calif., 1944, p. 518.
[10] Ghiselin, *Creative Process,* pp. 192, 200 (my italics).

remarks Gertrude Stein, "which I have tried to tell Americans is that there can be no truly great creation without passion"; and again, in replying to the question, "What has passion got to do with choosing an art form?" she said "Everything. There is nothing else that determines form." [11] Dorothy Canfield testifies that, "broadly viewed," her stories "all have exactly the same genesis," and she confesses that she "cannot conceive of any creative fiction written from any other beginning . . . that of a generally intensified emotional sensibility." When—for example—after much preliminary thought, she began to write "Flint and Fire," she found, after four hours that had seemed to her only a half hour, that "my cheeks were flaming, my feet were cold, my lips parched." [12] According to Katherine Anne Porter, the creative question is "how to convey a sense of whatever is *there*, as feeling, within you, to the reader." [13] Of drama, John Galsworthy writes that it is "that imaginative expression of human energy, which, through technical concretion of feeling and perception, tends to reconcile the individual with the universal, by exciting in him impersonal emotion"; and, he adds, "the greatest art is that which excites the greatest impersonal emotion in an hypothecated perfect human being." [14] Nietzsche describes vividly the state of heightened emotionality in which he wrote *Zarathustra*: "There is an ecstasy whose terrific tension is sometimes released by a flood of tears." [15]

The citations could be multiplied endlessly. Anyone who has read widely about literary inspiration will recognize these quotations as typical—not, indeed, typical of all that is said about the birth of a poem, play, or novel, but typical of one part or aspect of nearly all such descriptions.

Practitioners of the other arts have described their creative experiences in very similar terms. Julian Levi sees in his own painting a union of thought and emotion:

I am seeking an integration between what I feel and what I have learned by objective criteria . . . above all I hope to resolve the polarity which exists between an essentially emotional view of nature and a classical, austere sense of design.[16]

Picasso's painting seems to the painter himself to be passionate: "I order things in accordance with my passions. . . . What I want is that my picture should evoke nothing but emotion." When he walks in a forest he contracts "an indigestion of greenness" and "must empty this sensation into a picture." [17]

[11] *Ibid.*, pp. 168, 170.
[12] *Ibid.*, pp. 174, 178.
[13] *Ibid.*, p. 206.
[14] Quoted in Ludwig Lewisohn (ed.), *A Modern Book of Criticism*, Boni and Liveright, New York, 1919, p. 118.
[15] Ghiselin, *Creative Process*, p. 210.
[16] *Ibid.*, p. 56.
[17] *Ibid.*, pp. 49–51.

The perception becomes painfully *full*. Van Gogh recognized his successful drawings by sensing feelings in them:

When I have a model who is quiet and steady and with whom I am acquainted, then I draw repeatedly till there is one drawing that is different from the rest, which does not look like an ordinary study, but more typical and with more feeling. All the same it was made under circumstances similar to those of the others, yet the latter are just studies with less feeling and life in them. . . . As to The Little Winter Gardens, *you said yourself they had so much feeling; all right, but that was not accidental—I drew them several times and there was no feeling in them. Then afterwards—after I had done the ones that were so stiff—came the others.*[18]

A sculptor whose work is at the opposite extreme from romantic denies that form is an end in itself: "I am very much aware that associational, psychological factors play a large part in sculpture." For example,

rounded forms convey an idea of fruitfulness, maturity, probably because the earth, women's breasts, and most fruits are rounded. . . . My sculpture is becoming less representational, less an outward visual copy, and so what some people would call more abstract; but only because I believe that in this way I can present the human psychological content of my work with the greatest directness and intensity.[19]

A dancer gives her testimony:

My purpose is not to "interpret" the emotions. . . . My dances flow rather from certain states of being, different stages of vitality which release in me a varying play of the emotions, and in themselves dictate the distinguishing atmospheres of the dances.

When working with a group, her purpose is "to seek out a common feeling." [20] An "intellectual" composer of music adds his voice:

These bars from the Prelude to Tristan do not express for us love or frustration or even longing: but they reproduce for us, both qualitatively and dynamically, certain gestures of the spirit which are to be sure less specifically definable than any of these emotions, but which energize them and make them vital to us.

So it seems to me that this is the essence of musical expression. "Emotion" is specific, individual and conscious; music goes deeper than this, to the energies which animate our psychic life, and out of these creates a pattern which has an existence, laws, and human significance of its own.[21]

Everywhere in the literature which describes aesthetic creation, reports include some such statement as those which have been quoted; and the impres-

[18] *Ibid.*, pp. 46–47.
[19] Henry Moore, quoted *ibid.*, pp. 72–73.
[20] Mary Wigman, quoted *ibid.*, pp. 74–76.
[21] Roger Sessions, quoted *ibid.*, p. 36.

sion is borne out by the observed conduct of artists. That art also includes a cognitive element, and that this too is important, has already been granted. But that aesthetic cognition grows out of, or at intense moments is accompanied by, feelings is quite as significant for the aesthetic theorist. The editor of the collection of reports from which many of the foregoing quotations have been taken sums up his findings by saying flatly, "Production by a process of purely conscious calculation seems never to occur." [22] Connections can be *felt* as well as thought; and, though the ultimate art work has cognitive value, it is also an embodiment of feelings.

Critical recognition of feeling in art

The foregoing quotations have intentionally been drawn, for the most part, from the published writings or conversations of recent artists, since the importance of the emotional element in aesthetic experience has been brought into question only recently. The emphasis of classical, neoclassical, and romantic criticism on feelings is too well known to require documentation. In our own century, too, while influential aestheticians have been urging the importance of aesthetic cognition, other theorists have continued to stress the role of feeling. A few of these must be named, for I am anxious to avoid giving the impression that the approach taken in the present book is either wholly new or, even in the immediate climate of opinion, eccentric.

We may begin with philosophical aestheticians, of whom there is space to mention only a few. Samuel Alexander, a critical realist, in *Beauty and Other Forms of Value*, asserted that "the impulse to creation is based upon the material passions provoked by the subjects, but is distinguishable from them and is formal." The creative process itself, however, "arises from the excitement caused by the subject matter." [23] These statements are significant because Alexander believes art to be cognitive and throughout his discussion shows an especially lively interest in aesthetic form, going so far, at one point, as to recommend that in the reading of poetry no effort be made to throw feeling into the words, lest "the undisturbed appreciation of beauty" be obscured by "over-excitement of the material passions." [24] But if the creative process is accompanied by excitement, and if, as he himself has urged, there is "no difference in kind between aesthetic appreciation and aesthetic creation," there must be some feeling in appreciation also. We can understand his emphasis on a certain coolness in aesthetic contemplation to be motivated by a desire

[22] *Ibid.*, p. 5.
[23] *Beauty and Other Forms of Value*, p. 72.
[24] *Ibid.*, p. 131.

to keep the feelings evoked by an art object in the aesthetic universe instead of allowing them to spill over into the world of practical activity. The example is instructive. In all probability, most, if not all, of the contemporary de-emphasis of emotion in art springs from similar motives, and the very men who have done most to discourage empathetic sensitivity to the affective curves of literary works would admit, if pressed, that of course there is feeling in literature.

Another exponent of aesthetic cognition, John Dewey, speaks frequently about feelings in *Art as Experience:* as, for example, in pointing out that "when excitement about subject matter goes deep, it stirs up a store of attitudes and meanings derived from prior experience." [25] Here again a desire to resist the popular misconception that art has to do *merely* with the emotions has led an influential aesthetician to adopt modes of expression which allow a mis-reading of his total theory. One other example taken from philosophic aesthetics will perhaps serve for all. Wilhelm Worringer's *Abstraktion und Ein-fühlung*, which stresses the effort in much art to render objects in their "re-stricted material individuality" by such means as approximation to "crystalline" form, [26] might easily be misread as an argument for purely intellectual ap-preciation of art. In fact, however, Worringer is much interested in the psycho-logical needs served by art, calls for a "history of world-feeling," and wishes to analyze not the technical abilities of artists but their aesthetic drives (*Kunst-wollen*).[27] Probably no aesthetician of importance has really thought that the aesthetic transaction was or should be completely devoid of feeling. A stressing of the desirability that in aesthetic contemplation a certain composure be maintained is susceptible, however, of misunderstanding.

More directly influential in literary circles have been the ideas of literary theorists—men who sometimes (though by no means always) have some acquaintance with philosophical aesthetics but adapt the principles for a specific use. For example, Louis Cazamian, the French critic and literary historian, would make criticism turn on the *idées génératrices* of literary works, which are "almost always an emotion of some kind." [28] Paul Goodman, in a recent volume called *The Structure of Literature*, thinks that in art "there is less anxiety and withdrawal" than in real life, so that "the meaning of the emotion can flower. . . . Works of plastic and musical art are pure language of the emotions." [29] Richard Moritz Meyer emphasizes excitement in the crea-tive process:

[25] John Dewey, *Art as Experience,* Minton, Balch & Co., New York, 1934, p. 65.
[26] Wilhelm Worringer, *Abstraktion und Einfühlung: Ein Beitrag zur Stilpsychologie,* 3d ed., R. Piper & Co. Verlag, Munich, 1911, p. 41.
[27] See *ibid.,* esp. pp. 9, 14.
[28] Louis Cazamian, *Criticism in the Making,* The Macmillian Company, New York, 1929, p. 31.
[29] Paul Goodman, *The Structure of Literature,* The University of Chicago Press, Chicago, 1954, p. 5.

If we compare but for a moment the birth of a poem among such primitive men as can still be observed with the birth of one within the zones of our civilization, we shall find that there remain but two things common to the two processes, two inevitable circumstances: the element of subjective excitement; the object that induces the excitement.[30]

Another German, Richard Mueller-Freienfels, finds that "in most literature the true significance lies in the images, feelings, passions, volitional stimuli which are merely communicated by" language.[31] Sir Herbert Read, creative artist as well as sensitive critic, once wrote sweepingly: "To render emotion exactly— there is no need to insist on that phrase as the definition of all art whatsoever that is worthy of the name." [32] Rémy de Gourmont, who has had considerable influence among the New Critics of England and America, distinguishes two kinds of style, one visual and one emotional.

If a writer possesses the emotional in addition to the visual memory, if, while evoking a material spectacle he has also the power of replacing himself into the precise emotional state which the spectacle produced in him, he is master of the whole art of writing.[33]

A recent critic of the psychological novel, Leon Edel, believes that "the critical reader who intellectually apprehends a book but has achieved no particular feeling in the process usually has only a ledger-book concept of the work." [34] He suggests that the stimulus to the technical inventiveness of such a novelist as Dorothy Richardson (and perhaps also James Joyce, Marcel Proust, William Faulkner, and Virginia Woolf) was the failure of traditional fictive techniques to render feelings adequately.[35] Without forgetting the part of the aesthetic transaction which has tended to slip from incautious formulations, Jane E. Harrison, after examining the primitive roots of art, expressed what has probably been in the minds of most persons who have objected to an overemphasis on affections: Let the artist

feel strongly, and see raptly—that is, in complete detachment. Let him cast this, his rapt vision and his intense emotion, into outside form, a statue or a painting; that form will have about it a nameless thing, an unearthly aroma, which we call beauty.[36]

With this quotation the series may be brought to an end. Here are to be found all the elements that have been brought centrally into the present dis-

30 Quoted in Lewisohn (ed.), *Modern Book of Criticism*, p. 60.
31 Quoted in Lewisohn, *ibid.*, pp. 76–77.
32 Sir Herbert Read, *Phrases of English Poetry*, Hogarth Press, Ltd., London, 1928, p. 121.
33 Quoted in Lewisohn (ed.), *Modern Book of Criticism*, pp. 31–32.
34 Leon Edel, *The Psychological Novel, 1900–1950*, J. B. Lippincott Company, Philadelphia, 1955, p. 101.
35 *Ibid.*, p. 111.
36 Jane E. Harrison, *Ancient Art and Ritual*, Henry Holt and Company, Inc., New York, 1913, pp. 212–213.

cussion: the absorption experienced in a "good" or "proper" aesthetic transaction; the maintenance at the same time of aesthetic distance—a realization that the art work exists in a universe different from that of everyday experience; and the "vision," or cognitive insight, which has played so important a role in critical theory of the last few decades. For once, all the elements have been brought into combination (together with the concept of beauty, about which nothing has been said). We must leave the matter here, for our purpose is not to review aesthetic speculation in detail but only to say what is necessary to relate the present work to others which have affected the reflective atmosphere in which it will be encountered.

It remains, before proceeding with the task which will occupy us in following chapters, to observe that more than one aesthetician has gone far toward basing a theory of art fundamentally on the recognition of affective patterns. Thus Susanne Langer, in *Feeling and Form*, begins from the premise that art works are symbols of human feelings. Even a simple decorative frieze is structurally similar to an affective pattern. The book has been favorably received: in the *Kenyon Review*, which is edited by one of the staunchest defenders of the art-equals-cognition view, it was reviewed under the heading, "This May Be the Book." Rudolf Arnheim, a psychologist, has not only written brilliantly about art works as isomorphs of feelings but has challenged the naïve realism of Ruskin's nineteenth-century strictures about the pathetic fallacy. The phrase "pathetic fallacy," he has urged,

implies a painful misunderstanding based on a conception of the world which stresses material differences and neglects structural analogies. When Torquato Tasso relates the wailing of the wind and the dewdrops shed by the stars to the departure of his love he is not pretending to believe in a fallacious animism, which endows nature with sympathetic feeling, but is using genuine structural similarities of the perceivable behavior of wind and water on the one hand and the experience and expression of grief on the other.[37]

Baensch on the cognition of feelings

I wish to dwell especially, however, on a remarkable article on "Kunst und Gefühl"[38] to which attention has been called by Mrs. Langer, for in this the contrary emphases on cognition and feeling are reconciled through the perception that aesthetic constructs offer the best possible opportunities precisely for the cognizing of feelings.

[37] Rudolf Arnheim, W. H. Auden, Karl Shapiro, and Donald A. Stauffer, *Poets at Work*, Harcourt, Brace and Company, Inc., New York, 1948, p. 151.
[38] "Art and Feeling." [Ed.]

The author, Otto Baensch, begins by announcing his object.

It will be shown that art, like philosophy, is a spiritual activity through which we raise the world-substance to communal consciousness, and that, moreover, it is the special task of art to accomplish this work for the affective content of the world. According to this view the function of art is not to gratify the percipient in any way— not even the loftiest way—but to make known to him something of which he is ignorant.[39]

Art is thus cognitive, but what it cognizes is feelings. For example, when we say that a landscape has a "mood," we think our real meaning to be that the contemplation of the landscape arouses in us a feeling which we can then read back into it.

This, however, is theory. The immediate, empirical datum suggests to us, at first, nothing of such an objectifying process. What in theory appears to be the result of an objectifying process enters the consciousness as a fact which is simply there, without manifesting itself as something created by us. . . . The landscape does not express a mood, it has the mood; the mood surrounds it, fills it, and pervades it like the light with which it shines, the odor which streams from it; the mood belongs with the total impression and can be separated from it as a part of the whole only by abstraction.[40]

All this does not, of course, mean that the mood would exist in the landscape if no observer were present. Rather, the landscape objectifies a feeling in such a way that it can produce the feeling in spectators who do not come to it with the feeling already prepared. The world as it impinges on human consciousness has affective tones which rather impress themselves on the human psyche than emanate into it from the psyche.[41] Such feelings are the special province of art, which by nonrational processes (at least in part) allows them to be contemplated and hence, in a fashion, *known.*

Baensch's development of this thesis is worked out largely in terms of music and need not be recapitulated in detail; but we may follow briefly his generalization of the aesthetic process. How is it possible, he inquires, to give unity to the qualitatively rich, but formless, impressions received from experience?

The answer is that we can do this by creating objects in which we embody the feelings to be isolated as objective feelings, so that the embodied feelings must come to the consciousness of every empathetic observer of the objects in the mode of affective intuitions.

[39] Otto Baensch, "Kunst und Gefühl," *Logos*, vol. 12, no. 1, 1923.
[40] *Ibid.*, p. 2.
[41] E.g., we are sometimes offended by the sight of a cheerful landscape when our spirits are depressed; we may say of a picture, "Life isn't that bitter"; etc.

Such objects are art objects, and the activity which brings them into being is artistry.

The feelings, both subjective and objective, come to the artist's consciousness, as to every man's, in the forward and backward fluctuations already described between the self and the non-self. . . . It is incumbent upon the artist, however, to give them form (Gestalt). . . . Out of the fullness of his experience he must extract and give relief to complexes which he feels as internally cohering structures. At the same time, out of the endless internal multiplicity of the structures so extracted and given relief, he must undertake a process of abstraction and condensation and set up internal limits, must divide the structures into cohering groups and sub-groups. Because of the peculiar nature and mode of consciousness of the feelings, however, this task cannot be given over wholly and directly to the feelings themselves. The division and the selective condensation, together with the inner framework of the feeling complexes to be structured, can be handled only in such a way that the object in which the feeling complex wins objective status is created and formed at the same moment. In practice the structuring of the feeling and that of the object in which the feeling is to be embodied falls together into a single activity.[42]

Thus the art object and the feeling to be embodied in it gain clarity simultaneously, and artistry at once defines the feeling for the artist's consciousness and makes it accessible to the consciousness of others.

The insight expressed in this analysis is important for aesthetics. If it is perhaps not the whole truth about art (what truth is the whole truth?), it is at least a truth which very much needs emphasizing at present. Indeed, the dignifying and exalting of art that seems to be intended by the exponents of aesthetic cognition can very likely be served best by an aesthetic theory which assigns to art an area of conscious activity that is peculiar to it rather than an area which is shared by such other branches of rational inquiry as philosophy and science. The discipline which most nearly intrudes upon that of philosophical aesthetics as here defined is psychology; but psychology aims at causal explanation, whereas art aims at the contemplation of the thing-in-itself, at the communication and comprehension not so much of its mode of becoming as of its mode of being. If the realm of art is primarily that of the feelings, or of consciousness in which feelings play an active and formative role, that realm is securely and permanently its own.

[42] Baensch, *op. cit.*, pp. 14–15.

POETRY AND BELIEFS

I. A. RICHARDS

What I see very well is the wide-spread, infinite harm of putting fancy for knowledge (to speak like Socrates), or rather of living by choice in a twilight of the mind where fancy and knowledge are indiscernible.—Euripides the Rationalist.

It is evident that the bulk of poetry consists of statements which only the very foolish would think of attempting to verify. They are not the kind of things which can be verified. If we recall what was said in Chapter XVI [1] as to the natural generality or vagueness of reference we shall see another reason why references as they occur in poetry are rarely susceptible of scientific truth or falsity. Only references which are brought into certain highly complex and very special combinations, so as to correspond to the ways in which things actually hang together, can be either true or false, and most references in poetry are not knit together in this way.

But even when they are, on examination, frankly false, this is no defect. Unless, indeed, the obviousness of the falsity forces the reader to reactions which are incongruent or disturbing to the poem. And equally, a point more often misunderstood, their truth, when they are true, is no merit.[2] The people who say 'How True!' at intervals while reading Shakespeare are misusing his work, and, comparatively speaking, wasting their time. For all that matters in either case is acceptance, that is to say, the initiation and development of the further response.

Poetry affords the clearest examples of this subordination of reference to attitude. It is the supreme form of *emotive* language. But there can be no doubt that originally all language was emotive; its scientific use is a later development, and most language is still emotive. Yet the late development has come to seem the natural and the normal use, largely because the only people who have reflected upon language were at the moment of reflection using it scientifically.

The emotions and attitudes resulting from a statement used emotively need not be directed towards anything to which the statement refers. This is clearly evident in dramatic poetry, but much more poetry than is usually supposed is

[1] Of *Principles of Literary Criticism*. [Ed.]
[2] No merit, that is, *in this connection*. There may be some exceptions to this, cases in which the explicit recognition of the truth of a statement as opposed to the simple acceptance of it, is *necessary* to the full development of the further response. But I believe that such cases will on careful examination be found to be very rare with competent readers. Individual differences, corresponding to the different degrees to which individuals have their belief feelings, their references, and their attitudes entangled, are to be expected. There are, of course, an immense number of scientific beliefs present among the conditions of every attitude. But since acceptances would do equally well in their place they are not *necessary* to it.

dramatic in structure. As a rule a statement in poetry arouses attitudes much more wide and general in direction than the references of the statement. Neglect of this fact makes most verbal analysis of poetry irrelevant. And the same is true of those critical but emotive utterances about poetry which gave rise to this discussion. No one, it is plain, can read poetry successfully without, consciously or unconsciously, observing the distinction between the two uses of words. That does not need to be insisted upon. But further no one can understand such utterances about poetry as that quoted from Dr. Mackail in our third chapter, or Dr. Bradley's cry that "Poetry is a spirit," or Shelley's that "A poem is the very image of life expressed in its eternal truth," or the passages quoted above from Coleridge, without distinguishing the making of a statement from the incitement or expression of an attitude. But too much inferior poetry has been poured out as criticism, too much sack and too little bread; confusion between the two activities, on the part of writers and readers alike, is what is primarily responsible for the backwardness of critical studies. What other stultifications of human endeavor it is also responsible for we need not linger here to point out. The separation of prose from poetry, if we may so paraphrase the distinction, is no mere academic activity. There is hardly a problem outside mathematics which is not complicated by its neglect, and hardly any emotional response which is not crippled by irrelevant intrusions. No revolution in human affairs would be greater than that which a widespread observance of this distinction would bring about.

One perversion in especial needs to be noticed. It is constantly present in critical discussion, and is in fact responsible for Revelation Doctrines. Many attitudes, which arise without dependence upon any reference, merely by the interplay and resolution of impulses otherwise awakened, can be momentarily encouraged by suitable beliefs held as scientific beliefs are held. So far as this encouragement is concerned, the truth or falsity of these beliefs does not matter, the immediate effect is the same in either case. When the attitude is important, the temptation to base it upon some reference which is treated as established scientific truths are treated is very great, and the poet thus easily comes to invite the destruction of his work; Wordsworth puts forward his Pantheism, and other people doctrines of Inspiration, Idealism and Revelation.

The effect is twofold; an appearance of security and stability is given to the attitude, which thus seems to be justified; and at the same time it is no longer so necessary to sustain this attitude by the more difficult means peculiar to the arts, or to pay full attention to form. The reader can be relied upon to do more than his share. That neither effect is desirable is easily seen. The attitude for the sake of which the belief is introduced is thereby made not more but less stable. Remove the belief, once it has affected the attitude; the attitude col-

lapses. It may later be restored by more appropriate means, but that is another matter. And all such beliefs are very likely to be removed; their logical connections with other beliefs scientifically entertained are, to say the least, shaky. In the second place these attitudes, produced not by the appropriate means but, as it were by a short cut, through beliefs, are rarely so healthy, so vigorous and full of life as the others. Unlike attitudes normally produced they usually require an increased stimulus every time that they are reinstated. The belief has to grow more and more fervent, more and more convinced, in order to produce the same attitude. The believer has to pass from one paroxysm of conviction to another, enduring each time a greater strain.

This substitution of an intellectual formula for the poem or work of art is of course most easily observed in the case of religion, where the temptation is greatest. In place of an experience, which is a direct response to a certain selection of the possibilities of stimulation, we have a highly indirect response, made, not to the actual influences of the world upon us, but to a special kind of belief as to some particular state of affairs.[3] There is a suppressed conditional clause implicit in all poetry. If things were such and such then . . . and so the response develops. The amplitude and fineness of the response, its sanction and authority, in other words, depend upon this freedom from actual assertion in all cases in which the belief is questionable on any ground whatsoever. For any such assertion involves suppressions, of indefinite extent, which may be fatal to the wholeness, the *integrity* of the experience. And the assertion is almost always unnecessary; if we look closely we find that the greatest poets, as poets, though frequently not as critics, refrain from assertion. But it is easy, by what seems only a slight change of approach, to make the initial step an act of faith, and to make the whole response dependent upon a belief as to a matter of fact. Even when the belief is true, the damage done to the whole experience may be great, in the case of a person whose reasons for this belief are inadequate, for example, and the increased temporary vivacity which is the cause of perversion is no sufficient compensation. As a convenient example it may be permissible to refer to the Poet Laureate's anthology, *The Spirit of Man*, and I have the less hesitation since the passages there gathered together are chosen with such unerring taste and discrimination. But to turn them into a statement of a philosophy is very noticeably to degrade them and to restrict and diminish their value. The use of verse quotations as chapter headings is open to the same objection. The experiences which ensue may seem very similar to the experiences of free reading; they feel similar; but all the signs

[3] In view of a possible misunderstanding at this point, compare chap. X, especially the final paragraph. If a belief in Retributive Justice, for example, is fatal to *Prometheus Unbound*, so in another way is the belief that the Millennium is at hand. To steer an unperplexed path between these opposite dangers is extremely difficult. The distinctions required are perhaps better left to the reader's reflection than labored further in the faulty terminology which alone at present is available.

which can be most trusted, after-effects for example, show them to be different. The vast differences in the means by which they are brought about is also good ground for supposing them to be dissimilar, but this difference is obscured through the ambiguities of the term "belief."

There are few terms which are more troublesome in psychology than belief, formidable though this charge may seem. The sense in which we believe a scientific proposition is not the sense in which we believe emotive utterances, whether they are political "We will not sheathe the sword," or critical "The progress of poetry is immortal," or poetic. Both senses of belief are complicated and difficult to define. Yet we commonly appear to assume that they are the same or that they differ only in the kind and degree of evidence available. Scientific belief we may perhaps define as readiness to act as though the reference symbolised by the proposition which is believed were true. Readiness to act in *all* circumstances and in *all* connections into which it can enter. This rough definition would, of course, need elaborating to be complete, but for our present purposes it may suffice. The other element usually included in a definition of belief, namely a feeling or emotion of acceptance, the "This is sooth, accept it!" feeling, is often absent in scientific belief and is not essential.

Emotive belief is very different. Readiness to act as though some references were true is often involved, but the connections and circumstances in which this readiness remains are narrowly restricted. Similarly the extent of the action is ordinarily limited. Consider the acceptances involved in the understanding of a play, for example. They form a system any element of which is believed while the rest are believed and so long as the acceptance of the whole growing system leads to successful response. Some, however, are of the form "Given this then that would follow," general beliefs, that is to say, of a kind which led Aristotle, in the passage quoted above, to describe Poetry as a more philosophical thing than history because chiefly conversant of universal truth. But if we look closely into most instances of such beliefs we see that they are entertained only in the special circumstances of the poetic experience. They are held as conditions for further effects, our attitudes and emotional responses, and not as we hold beliefs in laws of nature, which we expect to find verified on all occasions. If dramatic necessities were actually scientific laws we should know much more psychology than any reasonable person pretends that we do. That these beliefs as to "how any person of a certain character would speak or act, probably or necessarily," upon which so much drama seems to depend, are not scientific, but are held only for the sake of their dramatic effect, is shown clearly by the ease with which we abandon them if the advantage lies the other way. The medical impossibility of Desdemona's last speech is perhaps as good an example as any.

The bulk of the beliefs involved in the arts are of this kind, provisional acceptances, holding only in special circumstances (in the state of mind which is the poem or work of art) acceptances made for the sake of the "imaginative experience," which they make possible. The difference between these emotive beliefs and scientific beliefs is not one of degree but of kind. As feelings they are very similar, but as attitudes their difference in structure has widespread consequences.

There remains to be discussed another set of emotive effects which may also be called beliefs. Instead of occurring part way in, or at the beginning of a response, they come as a rule at the end, and thus are less likely to be confused with scientific beliefs. Very often the whole state of mind in which we are left by a poem, or by music, or, more rarely perhaps, by other forms of art, is of a kind which it is natural to describe as a belief. When all provisional acceptances have lapsed, when the single references and their connections which may have led up to the final response are forgotten, we may still have an attitude and an emotion which has to introspection all the characters of a belief. This belief, which is a consequence not a cause of the experience, is the chief source of the confusion upon which Revelation Doctrines depend.

If we ask what in such cases it is which is believed, we are likely to receive, and to offer, answers both varied and vague. For strong belief-feelings, as is well known and as is shown by certain doses of alcohol or hashish, and preeminently of nitrous oxide, will readily attach themselves to almost any reference, distorting it to suit their purpose. Few people without experience of the nitrous-oxide revelation have any conception of their capacity for believing or of the extent to which belief-feelings and attitudes are parasitic. Thus when, through reading *Adonais,* for example, we are left in a strong emotional attitude which feels like belief, it is only too easy to think that we are believing in immortality or survival, or in something else capable of statement, and fatally easy also to attribute the value of the poem to the alleged effect, or conversely to regret that it should depend upon such a scientifically doubtful conclusion. Scientific beliefs, as opposed to these emotive beliefs, are beliefs 'that so and so'. They can be stated with greater or less precision, as the case may be, but always in some form. It is for some people difficult to admit beliefs which are objectless, which are not about anything or in anything; beliefs which cannot be stated. Yet most of the beliefs of children and primitive peoples, and of the unscientific generally seem to be of this kind. Their parasitic nature helps to confuse the issue. What we have to distinguish are beliefs which are grounded in fact, i.e., are due to reference, and beliefs which are due to other causes, and merely attach themselves to such references as will support them.

That an objectless belief is a ridiculous or an incomplete thing is a prejudice deriving only from confusion. Such beliefs have, of course, no place in science, but in themselves they are often of the utmost value. Provided always that they do not furnish themselves with illicit objects. It is the objectless belief which is masquerading as a belief in this or that, which is ridiculous; more often than not it is also a serious nuisance. When they are kept from tampering with the development of reference such emotional attitudes may be, as revelation doctrines in such strange forms maintain, among the most important and valuable effects which the arts can produce.

It is often held that recent generations suffer more from nervous strain than some at least of their predecessors, and many reasons for this have been suggested. Certainly the types of nervous disease most prevalent seem to have changed. An explanation not sufficiently noticed perhaps is the break-down of traditional accounts of the universe, and the strain imposed by the vain attempt to orient the mind by belief of the scientific kind alone. In the pre-scientific era, the devout adherent to the Catholic account of the world, for example, found a sufficient basis for nearly all his main attitudes in what he took to be scientific truth. It would be fairer to say that the difference between ascertained fact and acceptable fiction did not obtrude itself for him. To-day this is changed, and if he believes such an account, he does not do so, if intelligent, without considerable difficulty or without a fairly persistent strain. The complete sceptic, of course, is a new phenomenon, dissenters in the past having commonly disbelieved only because they held a different belief of the same kind. These topics have, it is true, been touched upon by psycho-analysts, but not with a very clear understanding of the situation. The Vienna School would merely have us away with antiquated lumber; the Zurich School would hand us a new outfit of superstitions. Actually what is needed is a habit of mind which allows both reference and the development of attitudes their proper independence. This habit of mind is not to be attained at once, or for most people with ease. We try desperately to support our attitudes with beliefs as to facts, verified or accepted as scientifically established, and by so doing we weaken our own emotional backbone. For the justification of any attitude *per se* is its success for the needs of the being. It is not justified by the soundness of the views which may seem to be, and in pathological cases are, its ground and causes. The source of our attitudes should be in experience itself; compare Whitman's praise of the cow which does not worry about its soul. Opinion as to matters of fact, knowledge, belief, are not necessarily involved in any of our attitudes to the world in general, or to particular phases of it. If we bring them in, if, by a psychological perversion only too easy to fall into,

we make them the basis of our adjustment, we run extreme risks of later disorganization elsewhere.

Many people find great difficulty in accepting or even in understanding this position. They are so accustomed to regarding "recognized facts" as the natural basis of attitudes, that they cannot conceive how anyone can be otherwise organized. The hard-headed positivist and the convinced adherent of a religion from opposite sides encounter the same difficulty. The first at the best suffers from an insufficient material for the development of his attitudes; the second from intellectual bondage and unconscious insincerity. The one starves himself; the other is like the little pig in the fable who chose to have his house built of cabbages and ate it, and so the grim wolf with privy paw devoured him. For clear and impartial awareness of the nature of the world in which we live and the development of attitudes which will enable us to live in it finely are both necessities, and neither can be subordinated to the other. They are almost independent, such connections as exist in well-organized individuals being adventitious. Those who find this a hard saying may be invited to consider the effect upon them of those works of art which most unmistakably attune them to existence. The central experience of Tragedy and its chief value is an attitude indispensable for a fully developed life. But in the reading of *King Lear* what facts verifiable by science, or accepted and believed in as we accept and believe in ascertained facts, are relevant? None whatever. Still more clearly in the experiences of some music, of some architecture and of some abstract design, attitudes are evoked and developed which are unquestionably independent of all beliefs as to fact, and these are exceptional only in being protected by accident from the most insidious perversion to which the mind is liable. For the intermingling of knowledge and belief is indeed a perversion, through which both activities suffer degradation.

These objectless beliefs, which though merely attitudes seem to be knowledge, are not difficult to explain. Some system of impulses not ordinarily in adjustment within itself or adjusted to the world finds something which orders it or gives it fit exercise. Then follows the peculiar sense of ease, of restfulness, of free, unimpeded activity, and the feeling of acceptance, of something more positive than acquiescence. This feeling is the reason why such states may be called beliefs. They share this feeling with, for example, the state which follows the conclusive answering of a question. Most attitude-adjustments which are successful possess it in some degree, but those which are very regular and familiar, such as sitting down to meat or stretching out in bed, naturally tend to lose it. But when the required attitude has been long needed, where its coming is unforeseen and the manner in which it is brought about complicated and inexplicable, where we know no more than that formerly we

were unready and that now we are ready for life in some particular phase, the feeling which results may be intense. Such are the occasions upon which the arts seem to lift away the burden of existence, and we seem ourselves to be looking into the heart of things. To be seeing whatever it is as it really is, to be cleared in vision and to be recipients of a revelation.

We have considered already the detail of these states of consciousness and their conjectural impulse basis. We can now take this feeling of a revealed significance, this attitude of readiness, acceptance and understanding, which has led to so many Revelation Doctrines, not as actually implying knowledge, but for what it is—the conscious accompaniment of our successful adjustment to life. But it is, we must admit, no certain sign by itself that our adjustment is adequate or admirable. Even the most firm adherents to Revelation Doctrines admit that there are bogus revelations, and on our account it is equally important to distinguish between "feelings of significance" which indicate that all is well and those which do not. In a sense all indicate that *something* is going well, otherwise there would be no acceptance, no belief but rejection. The real question is "What is it?" Thus after the queer reshuffling of inhibitions and releases which follows the taking of a dose of alcohol, for example, the sense of revelation is apt to occur with unusual authority. Doubtless this feeling of significance is a sign that as the organism is for the moment, its affairs are for the moment thriving. But when the momentary special condition of the system has given place to the more usual, more stable and more generally advantageous adjustment, the authority of the vision falls away from it; we find that what we were doing is by no means so wonderful or so desirable as we thought and that our belief was nonsensical. So it is less noticeably with many moments in which the world seems to be showing its real face to us.

The chief difficulty of all Revelation Doctrines has always been to discover what it is which is revealed. If these states of mind are knowledge it should be possible to state what it is that they know. It is often easy enough to find something which we can suppose to be what we know. Belief feelings, we have seen, are *parasitic*, and will attach themselves to all kinds of hosts. In literature it is especially easy to find hosts. But in music, in the non-representative arts of design, in architecture or ceramics, for example, the task of finding something to believe, or to believe in, is not so easy. Yet the "feeling of significance" is as common [4] in these other arts as in literature. Denial of this is usually proof only of an interest limited to literature.

[4] Cf. Gurney, *The Power of Sound*, p. 126. "A splendid melodic phrase seems continually not like an object of sense, but like an *affirmation;* not so much prompting admiring ejaculation as compelling passionate assent." His explanation, through association with speech, seems to me inadequate. He adds that the use of terms such as "*expressiveness* and *significance*, as opposed to meaninglessness and triviality, may be allowed, without the implication of any reference to transcendental views which one may fail to understand, or theories of interpretation which one may entirely repudiate."

This difficulty has usually been met by asserting that the alleged knowledge given in the revelation is non-intellectual. It refuses to be rationalized, it is said. Well and good; but if so why call it knowledge? Either it is capable of corroborating or of conflicting with the other things we usually call knowledge, such as the laws of thermo-dynamics, capable of being stated and brought into connection with what else we know; or it is not knowledge, not capable of being stated. We cannot have it both ways, and no sneers at the limitations of logic, the commonest of the resources of the confused, amend the dilemma. In fact it resembles knowledge only in being an attitude and a feeling very similar to some attitudes and feelings which may and often do accompany knowledge. But "Knowledge" is an immensely potent emotive word engendering reverence towards any state of mind to which it is applied. And these "feelings of significance" are those among our states of mind which most deserve to be revered. That they should be so obstinately described as knowledge even by those who most carefully remove from them all the characteristics of knowledge is not surprising.

Traditionally what is said to be known thus mystically through the arts is Beauty, a remote and divine entity not otherwise to be apprehended, one of the Eternal Absolute Values. And this is doubtless emotively a way of talking which is effective for a while. When its power abates, as the power of such utterances will, there are several developments which may easily be used to revive it. "Beauty is eternal, and we may say that it is already manifest as a heavenly thing—the beauty of Nature is indeed an earnest to us of the ultimate goodness which lies behind the apparent cruelty and moral confusion of organic life. . . . Yet we feel that these three are ultimately one, and human speech bears constant witness to the universal conviction that Goodness is beautiful, that Beauty is good, that Truth is Beauty. We can hardly avoid the use of the word 'trinity', and if we are theists at all we cannot but say that they are one, because they are the manifestation of one God. If we are not theists there is no explanation." [5]

Human speech is indeed the witness, and to what else does it not witness? It would be strange if in a matter of such moment as this the greatest of all emotive words did not come into play. "In religion we believe that God is Beauty and Life, that God is Truth and Light, that God is Goodness and Love, and that because he is all these they are all one, and the Trinity in Unity and Unity in Trinity is to be worshipped." [6] No one who can interpret emotive language, who can avoid the temptation to illicit belief so constantly presented by it need find such utterances "meaningless." But the wrong approach is easy

[5] Percy Dearmer, The Necessity of Art, p. 180.
[6] A. W. Pollard, ibid., p. 135.

and far too often pressingly invited by the speakers, laboring themselves under misconceptions. To excite a serious and reverent attitude is one thing. To set forth an explanation is another. To confuse the two and mistake the incitement of an attitude for a statement of fact is a practice which should be discouraged. For intellectual dishonesty is an evil which is the more dangerous the more it is hedged about with emotional šanctities. And after all there *is* another explanation, which would long ago have been quietly established to the world's great good had men been less ready to sacrifice the integrity of their thought and feeling for the sake of a local and limited advantage.

THEATER AND REALITY

ERIC CAPON

One of the difficulties of discussing theater as an art-form is its Protean quality. One could, if pressed, make out a case for it as the origin of all the other arts, and there are enough forms, some very recent, to cause confusion. Does theater include ballet, opera, let alone film and now television? Does each of these have an aesthetic of its own or are there certain common rules? Perhaps it is this historical primitivism of the theater that makes it so devoid of aesthetic comment. Most classic statements on the theater are more concerned with literature than theater. Even theories of acting can be easily contained on a single library shelf—and most of them date from the last sixty years. Theories of staging are largely disguised practical advice. In short, there is virtually no written aesthetic of the theater. Consequently in this talk if I cannot lean on other and wiser contemporary authorities, at least I have the advantage of virtually a fresh start. I propose to group under one heading, that of reality, what may well turn out to be a rather general discussion of theatrical topics. I have chosen this title as it seems to be the question under various disguises about which theater-goers are most concerned. If the play fails to "grip them," "hold them," "amuse them" or to use that evasive portmanteau word "entertain them," it is because they were in some way not aware of any impact of reality.

There are many aspects of this and perhaps it is best to dispose at the outset of one that is historically very recent, what can be called photographic reality or as it is sometimes termed, naturalism. This question seems almost irrelevant but it has for long so bedevilled every theatrical discussion at whatever level that it must be cleared away at the outset. Crudely expressed, it is the demand which finds its expression in objections of the sort that the performance on the stage was "not like real life," meaning the stage setting did not seem like a real place or room, the actors were not dressed, or did not talk, like real people, or—a criticism perhaps most frequently voiced—the events depicted seemed unlikely. It is probably flogging a dead horse to spend much time in criticism of the naturalistic type of theater; it has so nearly disappeared that a set with french windows on the West End stage today is almost a historical relic. It may be more profitable to see how it ever arose and why, as it is only about a century old anywhere, in some cases less. Antoine in Paris with his butcher's shop set hanging with real meat, the Saxe-Meiningen company in Germany and later Otto Brahm in the Freie Buhne, even the famous Moscow Arts with Stanislavski and Nemirovich-Danchenko were all in this respect preceded by the Bancrofts when they opened in Charlotte Street (as unfashionable then as now) in what they called The Prince of Wales—where the Scala stands now. (Those arches by the stage-door entrance are all that remain.) Although what are called Box-sets had been known before and a famous woman impresario, Madame Vestris, had even installed a false ceiling in her Olympia theater in the 1850s, it was not till Bancroft opened in 1865 that the public saw plays where the characters were dressed in current fashion and differently dressed according to the type of occasion and time of day, where the stage doors had real handles and opened and shut like real doors and the rooms gave at least the appearance of reality. The fact that the plays (nearly all written by one man, T. W. Robertson) are absurdly artificial and contrived seems to have escaped the notice of the audience, which became distinguished and fashionable. We find Ruskin congratulating Squire Bancroft on a sentimental piece of Robertson called *Ours* and saying: "I get more help in my own work from a good play than from any other kind of thoughtful rest."

Later in the century the plays began to follow the staging, but this still had to be defended. Zola defending Thérèse Raquin in 1873 complains how much more his play would have been appreciated if his merchant's wife had been a queen and the murderer had worn an apricot-colored coat. But "that nasty little shop," and "those lower middle class shopkeepers who pretended to participate in a drama of their own in their own house with their oilcloth tablecover" gives more of a clue to public reaction. The naturalistic theater came into being as a protest against the unreal theatricality of the first half of the

nineteenth century, its restricted social content and its avoidance of any serious subject. In the '90s, with Ibsen as the battlecry and *Ghosts* engraved on the standard, every advanced theater in Europe began to explore hitherto forbidden territory—and invariably in a style that most closely mirrored external reality. The audiences were stunned. Granville-Barker at the Royal Court made Shaw box-office and influenced Winston Churchill to change the law after seeing Galsworthy's *Justice*. It was said of Antoine's *Theatre Libre:* "It is singular, but it seems that there is no stage, and that the raised curtain of the *Theatre Libre* discloses people in their houses going about their affairs unselfconsciously and without knowing they are being watched." With Chekov and The Moscow Art this was carried even further and even today, as recent visits here have shown, this company can give some impression of the excitement generated in those years.

Yet it was not long before this surface reality was shown to be unsatisfactory. Ibsen in his last plays (notably *When We Dead Awaken*) was deserting the cause. Meyerhold, one of the most brilliant actors of the first Moscow Art Company, the original Trepliev of *The Seagull,* had already broken away to produce even Ibsen, as well as Maeterlinck, Hamsun and others, expressionistically several years before the First World War. Naturalism was well set on the road that led to *The Mousetrap*. The unfinished sentences of Chekov became the telegraphese of the English theater of the '20s. Other means of expressing reality were demanded.

Sometimes it appears as if the theater followed a similar pattern to that of poetry, where, as is well-known, stereotyped language, exclusively poetic diction, is brusquely shattered periodically by a new vocabulary as in *Lyrical Ballads* or, nearer this theme, in Hugo's *Hernani,* where to call a character "un lion superbe et généreux" provoked a riot in the theater. Every great actor when he first had a success seems to have been praised in similar terms, for being natural. This was true of Garrick (one remembers Quin's remark: "If this young fellow is right, then we have all been wrong"), of Edmund Kean, and of many others. So in the theater there seems to have been a continual see-saw between an established convention both in acting and setting and, what appeared at least to contemporaries, a sudden return to more recognizable reality. Compare the later Shakespeare and the early Jacobean playwrights with those of thiry years before; or again the familiar gossipy style of the Restoration comedy-writers with the turgid melodramas of the reign of Charles I. But if theater needs a continual return to more recognizable surface reality as a sheet-anchor, this has not prevented it from investigating more profound levels.

These might all be defined as reality of content. In this sort of theater it is not the surface reality of clothes and speech that reassures the audience but

the conviction that the feelings and thoughts that are being displayed have a recognizable contact with reality. We are in tune with what the play is about, not merely with how it is staged.

Here again there are several kinds of inner reality and I propose to group them under three headings. The first is a sort of appendage to the external photographic reality that we have already noted. Indeed most defenders of naturalistic drama would claim that this is all the best plays of this kind are concerned with. The sound of the broken string in *Cherry Orchard*, John Gabriel Borkman's steady footfall on the ceiling in the first Act, or the strait-jacket in Strindberg's *The Father* are all concerned with pin-pointing by re-alistic details a more significant reality that lies behind them. This selective naturalism dominated the theater for approximately half a century. Playgoers became accustomed to recognize familiar objects and sounds and then be led to attach to them a larger-than-life significance. In this sort of drama silences (as in the now almost forgotten plays of Jean- Jacques Bernard) became as important as dialogue. The watchword was motivation. In the whole of Stanislavski's teaching the emphasis was invariably on the psychology. As in an algebraic problem, *What* plus *Why* was declared to equal *How*. One was required to study the characters' imaginary antecedents even if little hint was given in the text. Every move of every character and every grouping on the stage was required to express the symbolic and psychological significance of either the character or the action of the play at that precise moment. In short, from the sudden discovery that one could reproduce the externals of reality on the stage (and this was as much as anything else brought about by the technical changes in the theater—the introduction of electric light, revolving stage and so forth) the whole center of interest became the psychological reality which those externals, properly used and selected, could mirror. This is the essence of the whole Stanislavski system which, after suffering a transat-lantic sea-change, arrived here after the war christened *The Method*. And if I am guilty of giving it rather cursory treatment here, it is because this is still the kind of experience demanded by the vast majority of theater-goers. They often regard it as something immutable and eternal. How different from those who saw Mr. Wopsle, alias Mr. Waldengrave, perform in *Hamlet*.

It is scarcely surprising that many years ago this kind of reality came to be regarded as unsatisfactory. When after the First World War social systems began to totter and seemingly eternal values were questioned, the oak-panelled lounge-hall with the young man entering through the french windows saying: "Who's for Tennis?" seemed inadequate. So in war-wracked Europe vast social themes were treated, particularly in Germany, by dramatists like Kaiser and Toller. Expressionism was born. Leading characters began to be

called Mr. Zero, or to have no names at all. From psychological reality the emphasis was on sociological reality.

The outstanding theorist of this kind of theatrical reality has, of course, been Brecht. A product of the inter-war years in Germany, with wide experience of all kinds of theater, he gradually evolved a theater whose main function was to reveal social reality. Avoiding the classifications of the Expressionists, he insisted on real people surrounded with real objects; yet their setting was to be invariably theatrical. They were on a stage. This, he thought, should resemble more a boxing-ring than the illusory proscenium theater. Brecht hated what he called the culinary theater—a theater where people's emotions were seduced into a tacit identification with the leading characters, a theater where the critical faculty was lulled to sleep and therefore a theater where no one was tempted to question the social basis of the events depicted. His actors were (and are still) asked to examine not only their psychological links with other members of the cast (as in the Stanislavski psychological theater) but how far their thoughts, words and actions are determined by their social position. He deplored groupings in productions that served a narrowly aesthetic purpose—to balance the stage, as it is often put. Instead they should express the exact social as well as the psychological relations at the particular moment in the play. An example of this is in the Hitler play *Arturo Ui* where a parody of the Reichstag Fire Trial is staged. (The whole story is seen in terms of Chicago gangsters but the plot closely mirrors the historical events.) After some experiment in staging the judge was placed with his back to the audience downstage center for the reason that his comments and judgments were a foregone conclusion. Brecht hoped that the main impact of his plays would be to set the audience discussing, considering and finally wishing to change the state of affairs that had brought about the events depicted. Without scorning the psychological reality of the previous decades, he wanted to add a social reality that would make the whole picture correspond to observed fact. Mother Courage lived by buying and selling and thought she could cheat fate in this way and avoid the consequences of war: but she loses everything except her miserable cart of merchandise.

A good performance of his plays, however, reveals a fatal weakness in the basic theory. Although Brecht was at pains to declare that he had excluded emotion, it keeps creeping back. Galileo, roundly condemned by the author, was hailed in the Soviet Union as a hero of science. Mother Courage, after the first performance in Zürich, was compared to Niobe. Brecht fulminated and rewrote but the same reactions persist.

This brings to the fore yet another aspect of reality, the existence of which Brecht, like most Marxists, denied or pretended to ignore. This is what might

be termed metaphysical reality. It is something which is more easily experienced in the theater than in perhaps any other art except music. While it is perfectly true that in the final chapter of *The Actor Prepares* Stanislavski asserts that it is the subconscious that provides the real life-blood of the actor, he never pursued this but wrote before the findings of modern psycho-analysis had made any real impact. Indeed theater people are curiously shy about investigating what the vast majority instinctively recognize as the center of their art. Anyone who has attended theater at all regularly will know that the greater part of the appeal of a successful production is more emotional than intellectual. But it does not stop there. It is not the individual member of the audience's feelings only that are being considered, as when we read a book or stand in an art gallery, but an emotion shared with several hundred others. For the theater is essentially a collective art. There is no need to defend the point made by Professor Ingarden last year to this Society that an aesthetic experience involves the participant as well as the artist—in the theater that is so indisputable as to be almost beyond discussion. I recall many years ago a conversation with Dr. Olaf Stapledon, the philosopher, who had witnessed a production of mine and was unwilling to pronounce definitely on the merit of the play (it was a new O'Casey) because he admitted to being unduly influenced by the rest of the audience. He queried, I remember, whether this was a tenable position. I felt then, and feel now, that it was. The same production in the same theater can give one a different aesthetic response on different nights, partly, it is true, by variations on the part of the cast but equally owing to a variation on the part of the audience. At the end of his life Brecht was abandoning the word "epic" to describe his kind of theater in favor of "dialectic." He would have agreed, I am sure, that this dialectic process involves not merely the clashes of thought, opinion, character, on stage but even more the complicated reciprocal flow that exists every night in every theater between audience and cast.

This is true, of course, also in music, but not in the other arts; and even in some of the offshoots of theater like television it is almost totally absent—or would be if it had not been found essential to smuggle in a studio audience to satisfy a need of the actors, a need found far more with comedy than with serious work. For your comedian, even on television, carries on the one unbroken tradition from the music-hall, the *commédia del arte*, to the Atellanae and Dorian mimes. For him there is no performance without an audience.

If it is agreed that the true aesthetic response to theater involves a great deal of shared emotion—and this is a two-way process, as any actor can testify—then it is a short step to claiming that the unconscious plays a large part not only in the process of acting but in the total aesthetic response. This is to

move the argument on to treacherous quicksands, but it is what I believe lies behind the kind of theatrical reality which has been linked with the name of Antonin Artaud and called the Theater of Cruelty. Artaud, a French actor, poet and metaphysician of the theater, was born in 1896 and died in 1946 after spending many years in an asylum. His writings, which are now slowly appearing in France, have been eagerly seized on in recent years. He stands at the opposite pole to Brecht. For him theater offered not a psychological, characterized and intellectual experience but a deeply emotional, unconscious and metaphysical one. The Balinese Theatre seen in Paris in the early '20s provided him such an experience, and in Mexico he found his spiritual home. As for the title "Theater of Cruelty," he wrote: "As soon as I have said 'cruelty,' everyone will at once take it to mean blood. But the Theater of Cruelty means a theater difficult and cruel for myself first of all. And on the level of performance it is not the cruelty we can exercise upon each other by hacking at each other's bodies, but the much more terrible and necessary cruelty which things can exercise over us." Artaud substituted as the essence of the theater not man in society but man in the cosmos.

In the modern theater we have therefore what appears to be two sharply contrasted planes of reality heading in different directions. On the one hand there is the Brechtian social, rational, intellectual reality which uses the theater to make people aware of personal problems in a social setting. It poses rather than solves problems, using open platform-stage without illusion. It expects an audience to leave the theater aroused, discussing, maybe angry, but never lulled into a soporific acquiescence. On the other hand there is the Artaud theater of the strong theatrical image, the appeal to the deepest psychic rather than psychological responses, the use of song, dance, imagery and every available theatrical and technical resource with no thought of naturalism and no concern for the literary value of the words spoken, but for their emotive power alone. It can, and indeed should, often be wordless; and screams and yells are all part of the armory of the Artaud actor. It is doubtful, however, if these two planes do not intersect more than their progenitors would have admitted.

Martin Esslin has brilliantly demonstrated in his book *Choice of Evils* how Brecht's plays have the strongest emotional undertow frequently pulling in an opposite direction to the intellectual content, yet nevertheless reinforcing the reality rather than confusing it. That curious early work *Baal*, written when he was eighteen (of which London saw an even more curious production recently), is the Brechtian image before it had been ruthlessly split and crammed into a Marxian corset. Baal is shown lacerating his feelings but unable to deny them. Similarly in the Artaud theater his experiments were a record of failure until tied to some intellectual framework. His collaborator,

Roger Vitrac, in his comedy *Victor*, illustrates perhaps the first successful work of that school, anticipating Ionesco and other such writers by twenty years.

Recently, in the Marat/Sade production at the Aldwych, a blend of these two movements was achieved with considerable success. On the one hand the whole nature of political revolution was dissected (in a fashion that would have infuriated Brecht but without whose work the play could never have been written), and on the other hand the means chosen were largely theatrical in the Artaud sense. A good example was the pouring of buckets of blood down the drain instead of red liquid flowing from a supposedly stabbed Marat. (One wonders inevitably if the Elizabethans with their pigs' bladders of blood in fact simulated outward reality quite so narrowly as we have assumed.) Certainly this openly theatrical device seemed to many people in Weiss's play more horrifying and dramatically just than a simulated naturalism.

It is possible therefore to consider theatrical reality as an embracing concept including both a social and if not a metaphysical at least an unconscious reality. Somewhere in the middle comes the psychological reality that I discussed earlier, as many times in theatrical history it has been shown that as the raw material of theater is the live human being so any departure into abstraction (as with the Expressionists in the '20s) courts disaster. Recently Britten referred to the fact that anyone can now hear the Bach *B Minor Mass* from a machine and declared that even the most perfect machine is no substitute for a live performance and cannot offer a comparable musical experience. This has been disputed, but I feel that it unquestionably applies and to an even greater degree in the theater. I cannot accept that a film can offer the same kind of involvement as the theater, and neither can television. It is true that a century or more of proscenium theater has so weakened that involvement that this point has to be stressed more than should be necessary. As I stated at the outset, theater is a very primitive art historically and remains so today. It is a rite in which the finer aesthetic points, such considerations of form, color or symbol, often seem inextricably merged for it is only in the later, more specialized art-forms that it is possible to disentangle the threads and discuss rhythm in poetry or the melodic anticipations aroused in music. Yet just because it is so primitive it frequently demonstrates unmistakably general aesthetic principles which become shadowy in the other arts. Of course the original and still the only all-embracing aesthetic formulation that it has ever received is Aristotle's, who as is well known summed it up in the one word "Imitation." This has sometimes been taken as a defense of the short-lived naturalistic theater, but it has also seemed to me to be a question-begging word. One can grasp that actors imitated other men in their actions, but Aristotle embraces every artistic activity under this head. Dancing, too, can

be based on imitation of human movement, though this is by no means always the case and probably was not so in Aristotle's day. But he claims it equally for flute- and lyre-playing, from which it surely becomes obvious that the imitation is not just that of observed life but of reality considered in its widest aspects. It has even been suggested that he means something equivalent to a Shavian life-force, a sort of primal urge, manifestations of which appear in all the various arts, speaking, singing, dancing, playing and so forth. It might be noticed also that this formulation was made about a theater as "total" in its scope and as stylized in its execution as anything that has ever existed. It was only centuries later in its decadence that an actor playing Electra brought on in an urn the real ashes of his son to give, as he probably imagined, greater reality to his performance.

So the true reality of the theater is clearly one that in embracing every art can cover the greatest range of experience. It may lack subtlety but not breadth. As a foundation for the other arts it may carry more skilfully designed rooms than are found, as it were, in the basement of aesthetic experience. But it probably carries the whole house.

THE COUNTERFEITERS

HUGH KENNER

This is about Campbell's Soup, J. P. Morgan, Friday's footprint, William Ireland, and Stephen Dedalus, with a side glance at Albrecht Dürer's cat, if he had one; the critic needs a good deal of apparatus nowadays. Before longing for simpler times he should reflect that when things were really simpler there were no critics. Critics came into existence when the nature of what artists were doing ceased to be quite clear. Formerly the artist did a job someone wanted done: decorated churches, or kept the records of the tribe, or glorified the Medici, or glorified God. Homer beguiled kings, Shakespeare fed actors, even Tennyson persuaded the restless prisoners of Victorianism that they were not alone (though Tennyson, unlike Homer or Shakespeare, was surrounded by critics, for reasons we shall look into).

Such jobs entailed apprenticeship, of which we have records. "A Portrait of the Artist as a Young Man" (1484) meant that the thirteen-year-old Albrecht Dürer had spent an afternoon investigating the way of bringing together what he knew about drawing and what he could see in a mirror. "Artist," in that time of innocent looking, was simply a word to designate the sitter for an exercise which might on a different afternoon have been performed with the artist's cat. Dürer the craftsman sees nothing particularly mysterious in Dürer's face, though there is much that is mysterious in his ability to draw it.

Rembrandt rather more than a century later takes more interest in the fact that he is looking at himself. When Rembrandt does "A Portrait of the Artist as a Young Man," his attention is divided between the marks time has placed on that face since it last gazed out of a mirror, and the visible tokens, around the eyes and mouth, of something in which Dürer seems to have taken less interest: this man's unique mysterious selfhood. There is no sign however that he is engrossed, or means us to fathom his engrossment, in the face of a unique *type* of man, the creative physiognomy. He is a unique man, no more, and each of us is. What he invites us to study is a face, Rembrandt's face, but not an artist's face. He is a craftsman, like Dürer, meditating on the transiencies of being also a man.

The next famous "Portrait of the Artist as a Young Man" is not a picture but a book. I find it suggestive that the title goes out of its way to suggest analogies with a picture, while the very last line on the last page, the pair of dates, stresses divergences. Far from reproducing the conditions of Dürer's afternoon with his own face or his cat's, this book was written between 1904 and 1914, while the author was aging from twenty-two to thirty-two, and concerns itself with a subject likewise in continual transit, from babyhood to about twenty. The mirror, if mirror there be, is the mirror of memory, and what appears in it is a being called The Artist. We are being shown what The Artist is like when he is a young man, whether the artist's name is Joyce or Wilde or Shelley or Spender or Poe, though probably not Dürer or Rembrandt; the scope of the word "artist" had been suddenly much enlarged a few decades before Joyce's birth.

As a young man, we are told, the artist is different from other young men, because he is a different sort of being. Indeed he may grow so preoccupied with that difference that he will never produce any art, as a look at Stephen Dedalus may suggest. When his difference has been properly validated, Joyce suggests that it resembles a priest's vocation, and his job will be to act as "a priest of the eternal imagination," transmuting, thinks Stephen, "the bread and wine of common experience into the radiant body of life everlasting." Those of us who consume that body (and Joyce, by no accident, speaks in "Finnegans

150 LITERATURE

Wake" of his readers as consumers) will presumably derive from the trans-
muted experience benefits not obtainable from the experience in its unconse-
crated state, when we perhaps merely lived it, just as the bread which has
been transubstantiated in the priest's hands feeds the soul though formerly it
was fit only to feed the body. This gives us reasons for tolerating and feeding
the artist, differences and all, and reasons similar to the ones Catholic Dublin
invariably gave for tolerating and feeding its innumerable priests, who were
also pretty unsettling company, and contributed quite as little as does the
artist to the health of Dublin's economy.

It is easy to recognize here the Shelleyan artist, trumpet who sang to battle
and unacknowledged legislator of the world, though Joyce disliked battles and,
having looked at legislators with a colder eye than Shelley's, provided a more
deliberate metaphor, neither prophet nor king, but the third member of that
romantic triad, the priest. It is less easy to recognize any artist with whom
we are familiar today. Prophet, priest, and king, all three have lost their
symbolic potency, the potency which inspired Shelley and Joyce, who disliked
all three, to regard them as functionaries who had usurped the true preroga-
tives of the artist. A half-century after Joyce's "Portrait" was finished, our
society in considerable anguish of conscience devises for its artists sinecures
and foundation grants, and shelters them in its secular monasteries, the uni-
versities, while the artist on the other hand claims no access whatever to
sacerdotal mysteries. There is something very business-like about the way he
goes about his activities.

It is true that his activities continue to scandalize the popular press, which
was equally scandalized in the time of the first Roosevelt by the activities of
business men. That is because the artist has taken over the rôle of the business
man, who used to call himself a builder to whose concerns the profit motive
was peripheral, though he could also be overheard damning the public. Like
J. P. Morgan, a Picasso or a Dali may make a great deal of money, and seem to
be coining it out of the air, so elusive is the service he performs. Or he may
make none. But, again like Morgan, he spends his life performing actions
against which no one can frame a rational protest, but which make the public
(whenever it notices) extremely uneasy. We pay people to excoriate him for
us from time to time, because we feel he is meddling with some collective
secret we would rather not know about. With the tycoon pretty thoroughly
imprisoned by tax laws and corporate structures, the artist has stepped forward
as the last entrepreneur. And indeed he is engaged at something almost too
scandalous to think about. I am going to suggest that he is a counterfeiter.

That, oddly enough, was the other thing Joyce called him. Stephen goes
forth, we all remember, to forge in the smithy of his soul the uncreated con-

science of his race, and Joyce glosses the verb "forge" when Stephen reappears in "Finnegans Wake" rechristened Shem the Penman, a name drawn from the title of a Victorian melodrama about a forger. Shem's chronicler goes so far as to call "Ulysses" "an epically forged check upon the public," and we are only beginning to realize how thoroughly counterfeit is the "Portrait" itself, that book which passed for so long as autobiography. The hellfire sermon, for instance, was not something Joyce heard in the chapel but something he bought from a pamphlet-rack. Of course, the symbolic union of forger and priest may reflect Joyce's doubts about what actually happens when the words are spoken over the sacramental bread. But it is generally better, in examining Joyce's meanings, to keep his personal history out of mind. As usual, he saw very deeply into what interested him, and in linking the functions of priest and forger freed his thought from his mere time, his mere Shelleyan afflatus, and brought it to the heart of anything an artist does. The artist makes something that is like something else, and yet, not being the thing it is like, exudes a magic to which, whatever our sophistication, we can never grow really indifferent. If we were really indifferent we should not tolerate critics. All art, our critics have taught us, from a time before the bulls in the cave at Lascaux, comes from magical beginnings, about which we vainly guess. The Aurignacian draftsman, like the sculptor at Luxor, may indeed have been a kind of priest, and was certainly a kind of forger. I want to look at the persistence of these concepts into an ecumenical time, when the priest has less status than the social worker, and the forger is merely a technician.

For as the forge of Dedalus has become in modern times the skill of the penman, so the artist, who used to make things that were wanted, like a blacksmith, has come to make things we cannot think why we want, such as reproductions of Campbell's Soup tins. Hence arises what connoisseurs of impasse will one day call the Warhol Situation, after Andy Warhol.

Warhol, who began by imitating soup labels with consummate skill, apparently contemplated a progress from painting to sculpture, in emulation of his colleague Jasper Johns, who had turned out a Ballantine's beer can in solid bronze. This artifact, for which a large price was immediately paid, differs from its original, within the limits of the artist's skill, in only two particulars: it is much heavier, and it contains no beer. But Warhol cast no bronze. For it suddenly appeared that the Campbell Company, which up to that time had let us think that its business was to feed its customers and its stockholders, was actually engaged in a massive counterfeiting operation. It was flooding the supermarkets with cheap imitations of an Andy Warhol sculpture, and before the sculptor had so much as gotten to work. The entrepreneurs who deluge us with cheap Mona Lisas had at least the grace to wait until da Vinci had

finished. Warhol in turn, having over da Vinci the advantage of being on the spot, was equal to the challenge of mass production. He took to carrying home from the supermarket dozens of the 17½ cent imitations, which he proceeded to autograph and place on sale at a price established, as all prices are, by the free market. This proved to be $6 per can. It is clear that Mr. Warhol now has the Campbell Soup Company working for him, part-time at least. It should also be clear that he has posed a neat epistemological problem. For the dream of Zeuxis, at whose painted grapes the birds pecked, is fulfilled at last; the gap between the artifact and the thing represented by the artifact seems virtually closed. It was a Greek dream, that Pygmalion's statue might be conceivably so lifelike it could start to move; it is an American reality, that sculptured soup cans, complete with the sculptor's signature, will if punctured yield real soup.

According to the official theory of representational art, during every one of the 20,000 years since the first bull was drawn on the wall of the first cave the creative imagination has labored to achieve this result, the artifact indistinguishable from its object. One would therefore expect sounds of hosannah from the custodians of this theory: at the very least, a testimonial dinner for Andy Warhol, jointly sponsored by the Anglo-Saxon press and the custodians of socialist realism, the main course perhaps soup instead of peacock. We hear instead ungrateful mutterings. Pygmalion, it is alleged, had to make his statue, whereas Warhol did not make his soup tins. It is difficult to be impressed by this argument. If Pygmalion's statue was in bronze, as important Greek statues were, then it was made at the foundry, as Rodin's were. Rubens operated a factory so skilled it would be difficult to prove he ever touched a brush to numerous paintings conventionally called his, the work of the great nineteenth-century illustrators Doré and Tenniel is known to us by way of engravings not a line of which they executed, and Alexandre Dumas père with his loft full of apprentices perfected the art of issuing whole novels without lifting a pen. No one can deny that the actual shaping of the artifact has frequently and without scandal been delegated to someone with more time or more skill or better facilities than the man who conceived it, and if we are in search of a concern with the skill and facilities to execute perfect Campbell's Soup cans we need not look further than Mr. Warhol did.

The stubborn question remains, by what alchemy the Warhol signature transformed those tins into display pieces (and multiplied their value 35-fold). We may not be able to find a better analogy than Joyce's; by the imposition of the signature, not yours or mine but someone's whom fame had already linked with soup labels, as by the utterance of words of consecration, not by you or by me but by someone duly ordained, the mere sensate thing undergoes a change

which does not affect its physical or chemical properties in the slightest; yet collectors' money has been spent to testify that something has altered. It is even possible to designate that change; in the beginning was the Word, and from being an object the can became an utterance. It became a kind of statement by Andy Warhol. The signature did exactly what a signature does when an executive at Campbell's affixes his own to a letter composed by his secretary. The signature makes the letter a thing uttered by him. Previously it was a typographical doodle confected out of quotations from other letters: dear sir, in reply to, on the other hand. So the signature on the soup tin transforms it from a mere item of commerce into a slight but irreducible, complex, somewhat facetious utterance having to do with the status of the artist, the nature of art, the autism of a culture that buys what it eats unseen and then looks at nothing it buys, photolithographed abundance, conspicuous nonconsumption, and the long history of artifact as counterfeit.

For we need not compose our utterances so long as we endorse them. There are moments to which only a quotation is adequate; and the soup can, signed, may be said to quote one phrase from the stuttering monologue of our beautifully adept machines. And Warhol's gesture in quoting quotes a gesture of Marcel Duchamp's, who about 1906 signed an ordinary snowshovel and placed it in an exhibition of sculpture. And that deed had in its time a different meaning from Warhol's, since its context was not mass-produced abundance but a floundering strife against snow. Both artists invited men to look at some common thing seldom looked at, but the meaning of each invitation is inflected by the context in which it is issued. The object itself at which we are to look is in some respects of minimal importance. Context conveys much, and so does signature. I want to consider now what happens when the signature is tampered with.

Like every other aspect of the Warhol Situation, the importance of the signature on the soup can points up problems that have been latent in the Western psyche ever since, in the seventeenth century, it slowly became aware of art as art. That awareness synchronized with, and may have been caused by, the ascendancy of empirical philosophies. And no sooner had the life of the mind begun to make a virtue of radical empiricism—which assumes that we are to discern things while pretending to ourselves that we do not know what they are—than two related consequences became inevitable. The first consequence was that what the schoolmen used to call accidents, the skin of coherent appearances, became all that there was to know, since the senses stop at appearances and the rules of empiricism forbade the mind to leap past the senses. The second consequence was that works of the imagination became an impediment to orderly knowledge. It became clear for the first time

that there existed, testifying to much human effort, a phenomenon called Poetry, consisting of statements not borne out by careful observation. Thus John Locke was forced to conclude that whereas the Judgment separates and classifies what the senses deliver, the poetic faculty, which he calls Fancy, can only blend and confuse, which is amusing but not enlightening. Such playthings, in the childhood of the race, were understandable, but these times call for men of judgment.

The response of the magicians, who since paleolithic times have had the imagination in their keeping, was characteristic. A fraternity who in various periods have disguised themselves as moralists, as flatterers, as church decorators, had no difficulty now in disguising themselves as men of judgment. And perceiving that the world in the man of judgment's head is an orderly counterfeit of the world by which his body is surrounded, they became counterfeiters. The first notable triumph of the new esthetics of fraud was The Life and Strange Surprising Adventures of Robinson Crusoe, written by Himself. It is a lucid orderly work, devoid of those appurtenances we can no longer defend: fables, expressions drawn from ancient writers, excrescences of rhetoric. The word is attached to the object, not to "literature" or to the adjacent word. The very savages are certified by anthropology. The flaw in this work seems almost too trivial to mention. It is merely that Robinson Crusoe never existed.

We had better examine this strategy very carefully. Unless we perceive the exact scope of the counterfeiter's operations, we shall go badly astray. What we have here, first of all, is the book Robinson Crusoe would have written, if he had existed. This follows directly from the primary dogma of empiricism, that our knowledge is not of things but of their traces. We can see the apple, but it may be wax; luckily we have a sense of taste as well. We can see the bear's footprint, but unless he is standing in front of us we cannot be sure about the bear. Our senses show us only marks in the clay, and some skilful person may have molded them. If you can have the footprint without the bear, you can also have Crusoe's life without Crusoe. Crusoe also saw a footprint, but could not usefully assume it was forged, since to postulate a forger is still to postulate a second man. The reader is meant to respond to Crusoe's book exactly as Crusoe responded to Friday's footprint: he is to assume that the system of reality accessible to him contains one more man than he had previously surmised.

Second, we have a sophisticated consequence of the empirical habit of detaching words from the persons uttering them. Words, the philosophers kept repeating, are labels we gum onto things; grammar is a set of rules for combining words, which ideally would imitate the combining properties of things; and a language is simply a (disorderly) collection of words and a

(haphazard) set of rules, most deplorable but capable of being tidied up somewhat by method. Fictions, in the past, were generated by rhetorical devices, that is, by some ferment within the language itself; but order does not ferment. So be it; we shall write out "Robinson Crusoe" fact by fact, and stuff it with catalogues of things all accurately named; word shall follow word as event would have followed event; and to what end? To this end, that the language will stubbornly coalesce not about these facts but about a person, a person who does not exist.

And thirdly, we see what happens when we try to explain away Warhol transubstantiating soup tins or Picasso metamorphosing a toy car into a baboon's head by protesting that magic is cheap and that the true artist is really a craftsman. The craftsman theory, to put it shortly, assumes that you know what the artist is going to do (translate Homer, for instance) and then watch closely to see how well he does it. It is easy to understand that the minute he does something unexpected he and the theorist are in separate but equal difficulties: he because he has lost touch with his public (a public trained not on art but on the theory), and the theorist because he has lost the use of his criteria, and carries on as though an invisible hand had removed his trousers. Such scandals are familiar. But the craftsman is never really under control even when his hand is moving as we expect. For to ask him to do what has been done before is to ask him to counterfeit something, and the counterfeiter is never doing what we think. We see him bent over his table, and imagine him bent on the manufacture of an object, resembling a $20 bill as closely as his craftsmanship will permit. We suppose that forgery is an exercise in craftsmanship. It is not. It is an exercise in creative metaphysics. What the counterfeiter is imitating is not the bill but the moment when that bill was (we are to suppose) issued by the Treasury of the United States: not a visible thing but an invisible event: perfectly invisible: it never happened.

This grows quite clear if we consider the Shakespearean forgeries of William Ireland, which passed for a while as high tragedy. He did not forge plays; he wrote plays; and he wrote bad ones. "Vortigern: a Tragedy" is "Vortigern: a Tragedy": absurd and unreadable. William Ireland did not counterfeit "Vortigern: a Tragedy." What he counterfeited was the (alleged) occasion on which those acts and scenes, those speeches and rhythms, were composed by William Shakespeare. The text is manufactured, as all texts are, with paper and ink. The created thing, so long as the forgery stands, is not the text but an incident in Shakespeare's biography. Ireland was really a kind of historical novelist.

In the same way Daniel Defoe (whom we have not hitherto mentioned, since it is more convenient to imagine him as amanuensis for the syndicate of magicians) wrote "Robinson Crusoe" but forged a book "by" Robinson Crusoe

and counterfeited Robinson Crusoe himself. The counterfeiting went on all
the time he was writing the book; the forgery occurred on the moment when
he elected to omit his own name from the titlepage. In so slight a moment, as
Adam learned, is the world altered. For to be told, poker-faced, that it is not
the fabrication we would gladly accept, but the very thing that is normally
fabricated—a memoir, a testimony—this somehow changes a book, even when
we do not believe what we are being told about it. We shall be enquiring into
that "somehow."

A remarkable story by Jorge Luis Borges invites us to consider several pages
of manuscript written, at the cost of unimaginable spiritual contortions, by a
twentieth-century Frenchman. These pages are identical word for word with
several pages of "Don Quixote," a work composed with considerably less
trouble by a sixteenth-century Spaniard. And the Frenchman's pages, says
Borges accurately, though literally identical with the Spaniard's, are almost
infinitely richer. As they are, so long as we see behind arranged words the act
of a man finding and arranging them, and do not suppose that these words
were simply copied. I have said that we cannot imagine the spiritual contor-
tions of Pierre Menard, who in modern Paris was driven to express himself in
Spanish, and in antique Spanish, and in locutions whose every contortion
bears a strained and oblique relation to any values with which we are familiar.
And it is doubtful whether we are in the presence of intelligible art, if we
cannot imagine what a man went through to produce it. But this fiction of
Borges presents a hypothetical extreme case, as uninhabitable as the summit of
Everest. Like the summit of Everest it can serve as a vantage-point.

From that vantage-point look back over the decades after Defoe, and behold
an entire civilization preoccupied with contortions like those of Pierre Menard,
who counterfeited from Don Quixote. It is not only the time of Ireland's
"Vortigern," Chatterton's "Rowley," and MacPherson's "Ossian," three border-
line cases, but of outright and cheeky fraud on the one wing and of an esthetic
of imitation on the other. Fake antiques were being manufactured wholesale
in Rome for sale to travelers as Greek and Roman artifacts; a famous picture
shows, hanging in their frames, dozens of other famous pictures, the very
details of their brushwork microscopically imitated; epics and mock-epics
imitate the "Aeneid" and one another; pastorals imitate the "Eclogues" and
Satires imitate Horace; Pope transposes to new language Homer and Donne;
everyone subsequently transposes Pope; and George after George, the First,
the Second, the Third, is transmuted by not always ironic alchemy into the
Emperor Augustus, who himself had transmuted himself into a god.

Many things have been said about Augustan civilization. We can say one

thing more, that related as it was to a philosophy which detached appearances from realities, a science which was learning to read gone history by looking at mute present objects, and a cultivated class preoccupied with knowing simulacra of the prestigious, it was engaged as men were never to be again with massive experimentation governed by the esthetics of fraud. Perhaps its principal masterpiece is a forged travel book complete with forged maps, introduced by a cousin of the non-existent author who discusses the principles upon which he deleted from the manuscript thousands of words that were never written; we learn from it what horses talk about and how men make shift to counterfeit horsey virtues. The man who conceived it earned the undying gratitude of his countrymen for exposing, under an assumed name and in an assumed character, a scheme for flooding Ireland with counterfeit halfpence, and in his will he endowed a mental hospital. We cannot wonder that eventually the cult of sincerity had to be invented, to give us breathing space before Andy Warhol.

But our breathing-time has passed, and now the whole topic is back, its relevance reinforced by our immense proficiency at reproducing things, and by our simultaneous doubts about the value and meaning of personal identity. Accustomed as we are to the form letter, the mechanically reproduced signature, the edited Congressional Record, the doctored tape recording, the Xerox copy, the color photograph, the Van Gogh sunflowers in reproduction with the very texture of the canvas simulated, the documentary film every scene of which has been carefully staged, and the millions upon millions of identical soup tins out of which we nourish bodies containing glass eyes and gold teeth, we are fascinated by synthetic spontaneity and by the subtleties of things that are not quite themselves. Joyce perfected a prose meant to look as though no one had composed it, a prose seemingly the exhalation of its subject, behind which the artist should disappear, "aloof, indifferent, paring his fingernails." This prose lays upon the page glimpses of things and persons actually seen, snatches of conversations actually heard (hence the fallacy that the key to Joyce's work is somewhere in his life); for "he is a bold man," Joyce wrote to a prospective publisher of "Dubliners," "who will dare to alter in the presentation what he has seen and heard." From this there follows his image of artist as priest, changing nothing of his materials except their use. And this invisible artist presiding over a mystery, for all his trappings of *fin-de-siècle* romance, seems closely related to Defoe and Swift, who also pretended not to exist.

Or consider the invisible artist whose esthetic was elaborated in the 1920's, the film director. The Russian director Pudovkin describes an experimental sequence made up of five shots:

1. *A young man walks from left to right.*
2. *A woman walks from right to left.*
3. *They meet and shake hands. The young man points.*
4. *A large white building is shown, with a broad flight of steps.*
5. *The two ascend the steps.*

The pieces, separately shot, were assembled in the order given and projected upon the screen. The spectator was presented with the pieces thus joined as one clear, uninterrupted action: a meeting of two young people, an invitation to a nearby house, and an entry into it. Every single piece, however, had been shot in a different place; for example, the young man near the G.U.M. building, the woman near Gogol's monument, the handshake near the Bolshoi Teatr, the white house came out of an American picture (it was, in fact, the White House), and the ascent of the steps was made at St. Saviour's Cathedral. What happened as a result? . . . By the process of junction of pieces of celluloid appeared a new, filmic space without existence in reality. Buildings separated by a distance of thousands of miles were concentrated to a space that could be covered by a few paces of the actors.[1]

Pudovkin's book was written in 1927. Nearly four decades later its shoptalk has become common property. Everyone in the movie-house knows, when he isn't surrendering himself to the illusion, that location shots and studio interiors have been combined to make Paris or Sinkiang or Shangri-La out of a few glimpses of California real estate. The point to stress is that everybody does know it, and that this affects our sense of what movies are, just as psychoanalysis is affected by all its patients having read Freud, and "Robinson Crusoe" is affected by our knowledge that Crusoe never existed, and "Gulliver's Travels" by its context, unknown to contemporary readers, among the collected works of Jonathan Swift.

We know, moreover, that no one in particular is responsible for these effects, that movie technique is necessarily as collective a phenomenon as the Marxist theoreticians of the twenties could have wished, and that when personalities are mentioned they are apt to be as synthetic as Santa Claus, or Vico's Homer. Alfred Hitchcock on the one hand is largely the creation of his press agents and on the other hand neither produces nor directs the television series that bears his name. We know such things, and are not really disillusioned; they comport with an esthetic of fraud which in turn is continuous with what the newspapers call reality, presided over by Betty Crocker and a chief executive with a suite of ghosts.

We are tough habitués of the counterfeit, in fact, and from this one may draw three useful conclusions. The first has to do with the prophetic power of the imagination, even when it does not invest itself in Shelleyan robes; for the

[1] V. I. Pudovkin, *On Film Technique*, pp. 60-61.

literature of Defoe's time, and Swift's, and Pope's turns out to have been perfectly accurate social prophecy, examining the workings of new technology to create an image of what a technologized civilization would look like. Swift was the Zola of a future in which we communicate by holding up objects (with our names signed to them) and finance projects for talking to chimpanzees or dolphins.

The second conclusion has to do with the anomalous resurgence, amid so much skilled fraud, of an underground consecrated to the personality: a cinema, constantly raided by the police, for which individuals with names and addresses have held the cameras and cut the film, or a poetic of the untamed, practiced by people whose dissent from the consumer economy forbids them to use razors or buy shoes. That this underground, despite precious detailed triumphs, appears to lack the imagination to accomplish anything of sustained interest, should cause no surprise. Not only is it a conforming underground, its members expending such pains on details of costume and behavior that they are as easy to identify as so many pelicans, it is also an underground that in trying to dissent from the present is dissenting from history, and so from history's chief lesson for the artist, that he gains his freedom by seeming to do as he is told. In a counterfeiting time he will be careful to counterfeit.

For (this is the third conclusion) the innovating energy of our time commenced with its rediscovery of the methods of eighteenth-century imitators and forgers. Joyce forged an autobiography and then imitated Homer; Eliot imitated Elizabethan drama; Pound put together a synthetic Latin classic. All three, simultaneously, affected to be imitating the mere surface confusion of their time's public and social life. In their lives they played rôles: the bourgeois father, the banker, the American bohemian in Europe. That Yeats elaborated the theory of the mask, that Pound's third and twenty-seventh published volumes are both called "Personae," that the eighteen sections of "Ulysses" are written in eighteen different styles as though to acknowledge theories of a multiple Homer, that a note to "The Waste Land" invites us to find all its personages melting into one, and that the poem is packed like the official poetry of a time when poetry is dead, with numbered lines and footnotes: these will no doubt seem to the eye of the future details as endemic to our age as the rites of forgery and masques of identity that strike our attention in the literature of the Augustans.

If we are to learn to see our own time with the eye of the future, we shall have to recognize the strategies of counterfeit for what they are, understanding that the counterfeiter imitates not things but occasions; that the work's historical context is part of its meaning, and more intimately so than its author's life; and that nothing can blind us so effectively as the fallacy of the Inten-

tional Fallacy. To pretend, so many decades after Defoe, that the artist is best considered as a craftsman, and the work of art as mute as a Windsor chair, yielding up nothing but empirical information, is to ignore the lesson of generations of counterfeiters who restored the personal to a blank universe by seeming to suppress the person. The soup can that became an utterance might have been contrived to refute this fashionable hypothesis, so comforting to critics and so frigid for artists. What the artist's mere signature does is transform the soup can into a sort of word, totally inexplicit, totally assertive, inexplicably permanent. A word comes from a person, who intends it. A soup can is a soup can, in a different and less accessible universe.

MUSIC

The most abstract of the arts is music. Schopenhauer once described music as frozen architecture. It seems to be all structure, all form. The controversy between form and content would seem to have no place in a discussion of music. It may appear odd, therefore, that the three essays which follow are in one degree or another interested in that very controversy.

Copland, a major figure in American music, offers some insights into the composer's view of what it is he does when he writes music. Hanslick, on the other hand, wrote a book to counter the increasing tendency of nineteenth-century critics toward impressionism. The impressionist still lives, of course, and we can see his work on the back of many concert programs, particularly in small towns. He tends to discuss the scenes and events which are suggested to him by the music and to verify the emotional shifts which he feels the music demands. Hanslick considered this kind of criticism misleading. He felt it handled music too superficially and overlooked the true complexities of harmony, rhythm, melody, and thematic structure. He felt too that the genuine complexity of emotional experience offered by music was simplified and ignored by giving a linguistic explanation of the musical experience. Consequently Hanslick, in his selection "The Effects of Music," is very concerned with discovering what a musical experience is. What effects does music really have on us? What can it accomplish? In essence Hanslick is asking the second of Susanne Langer's questions: What does music create? What is its function? However, Hanslick is purposely limiting the range of his question to the function of music in relation to our emotions. Since his essay is meant as a corrective for what Susanne Langer calls the limited musical response we could well consider whether what he is arguing against is still a vital problem in the criticism and understanding of music.

"On Significance in Music" is an attempt to do for music what Wayne Shumaker tried to do for literature in his "The Cognitive Value of Literature." Shumaker's effort is complicated by the fact that words have a built-in cognitive value which is always intruding into an artistic judgment. Langer's problem is that the notes of music signify nothing by themselves; hence many people load music with a large variety of "meanings" which it cannot resist, but which it also cannot logically support. In a way this is Hanslick's problem, and Langer spends some time discussing his views.

Clear as she is, Miss Langer does not oversimplify the problem. Consequently it is important for us to examine her essay carefully to be certain we understand her most important points. How can music attain significance? Are there several ways or only one? Can music really "mean" something?

Finally we might ask what are these writers most concerned about? Why are they anxious to be corrective? The fact that music is one of the most abstract of arts makes it also one of the easiest to abuse. Goethe, in Langer's example, was unable to cope with the musical experience of a particular composition until he had transformed it into something else: an event, the witches' Sabbath. If Goethe is likely to transform music into something else in order to enjoy it then we all are in danger of doing so. Like the composers of modern electronic music, which ordinarily cannot be attached to other experiences, Copland, Hanslick, and Langer would rather have us listen to the music untransformed.

THE CREATIVE PROCESS IN MUSIC

AARON COPLAND

Most people want to know how things are made. They frankly admit, however, that they feel completely at sea when it comes to understanding how a piece of music is made. Where a composer begins, how he manages to keep going—in fact, how and where he learns his trade—all are shrouded in impenetrable darkness. The composer, in short, is a man of mystery to most people, and the composer's workshop an unapproachable ivory tower.

One of the first things most people want to hear discussed in relation to composing is the question of inspiration. They find it difficult to believe that composers are not as preoccupied with that question as they had supposed. The layman always finds it hard to realize how natural it is for the composer to compose. He has a tendency to put himself into the position of the composer and to visualize the problems involved, including that of inspiration, from the perspective of the layman. He forgets that composing to a composer is like fulfilling a natural function. It is like eating or sleeping. It is something that the composer happens to have been born to do; and, because of that, it loses the character of a special virtue in the composer's eyes.

The composer, therefore, confronted with the question of inspiration, does not say to himself: "Do I feel inspired?" He says to himself: "Do I feel like composing today?" And if he feels like composing, he does. It is more or less like saying to yourself: "Do I feel sleepy?" If you feel sleepy, you go to sleep. If you don't feel sleepy, you stay up. If the composer doesn't feel like composing, he doesn't compose. It's as simple as that.

Of course, after you have finished composing, you hope that everyone, including yourself, will recognize the thing you have written as having been inspired. But that is really an idea tacked on at the end.

Someone once asked me, in a public forum, whether I waited for inspiration. My answer was: "Every day!" But that does not, by any means, imply a passive waiting around for the divine afflatus. That is exactly what separates the professional from the dilettante. The professional composer can sit down day after day and turn out some kind of music. On some days it will undoubtedly be better than on others; but the primary fact is the ability to compose. Inspiration is often only a by-product.

The second question that most people find intriguing is generally worded

thus: "Do you or don't you write your music at the piano?" A current idea exists that there is something shameful about writing a piece of music at the piano. Along with that goes a mental picture of Beethoven composing out in the fields. Think about it a moment and you will realize that writing away from the piano nowadays is not nearly so simple a matter as it was in Mozart or Beethoven's day. For one thing, harmony is so much more complex than it was then. Few composers are capable of writing down entire compositions without at least a passing reference to the piano. In fact, Stravinsky in his *Autobiography* has even gone so far as to say that it is a bad thing to write music away from the piano because the composer should always be in contact with *la matière sonore*. That's a violent taking of the opposite side. But, in the end, the way in which a composer writes is a personal matter. The method is unimportant. It is the result that counts.

The really important question is: "What does the composer start with; where does he begin?" The answer to that is, Every composer begins with a musical idea—a *musical* idea, you understand, not a mental, literary, or extra-musical idea. Suddenly a theme comes to him. (Theme is used as synonymous with musical idea.) The composer starts with his theme; and the theme is a gift from Heaven. He doesn't know where it comes from—has no control over it. It comes almost like automatic writing. That's why he keeps a book very often and writes themes down whenever they come. He collects musical ideas. You can't do anything about that element of composing.

The idea itself may come in various forms. It may come as a melody—just a one-line simple melody which you might hum to yourself. Or it may come to the composer as a melody with an accompaniment. At times he may not even hear a melody; he may simply conceive an accompanimental figure to which a melody will probably be added later. Or, on the other hand, the theme may take the form of a purely rhythmic idea. He hears a particular kind of drumbeat, and that will be enough to start him off. Over it he will soon begin hearing an accompaniment and melody. The original conception, however, was a mere rhythm. Or, a different type of composer may possibly begin with a contrapuntal web of two or three melodies which are heard at the same instant. That, however, is a less usual species of thematic inspiration.

All these are different ways in which the musical idea may present itself to the composer.

Now, the composer has the idea. He has a number of them in his book, and he examines them in more or less the way that you, the listener, would examine them if you looked at them. He wants to know what he has. He examines the musical line for its purely formal beauty. He likes to see the way it rises and

falls, as if it were a drawn line instead of a musical one. He may even try to retouch it, just as you might in drawing a line, so that the rise and fall of the melodic contour might be improved.

But he also wants to know the emotional significance of his theme. If all music has expressive value, then the composer must become conscious of the expressive values of his theme. He may be unable to put it into so many words, but he feels it! He instinctively knows whether he has a gay or a sad theme, a noble or diabolic one. Sometimes he may be mystified himself as to its exact quality. But sooner or later he will probably instinctively decide what the emotional nature of his theme is, because that's the thing he is about to work with.

Always remember that a theme is, after all, only a succession of notes. Merely by changing the dynamics, that is, by playing it loudly and bravely or softly and timidly, one can transform the emotional feeling of the very same succession of notes. By a change of harmony a new poignancy may be given the theme; or by a different rhythmic treatment the same notes may result in a war dance instead of a lullaby. Every composer keeps in mind the possible metamorphoses of his succession of notes. First he tries to find its essential nature, and then he tries to find what might be done with it—how that essential nature may momentarily be changed.

As a matter of fact, the experience of most composers has been that the more complete a theme is the less possibility there is of seeing it in various aspects. If the theme itself, in its original form, is long enough and complete enough, the composer may have difficulty in seeing it in any other way. It already exists in its definitive form. That is why great music can be written on themes that in themselves are insignificant. One might very well say that the less complete, the less important, the theme the more likely it is to be open to new connotations. Some of Bach's greatest organ fugues are constructed on themes that are comparatively uninteresting in themselves.

The current notion that all music is beautiful according to whether the theme is beautiful or not doesn't hold true in many cases. Certainly the composer does not judge his theme by that criterion alone.

Having looked at his thematic material, the composer must now decide what sound medium will best fit it. Is it a theme that belongs in a symphony, or does it seem more intimate in character and therefore better fitted for a string quartet? Is it a lyrical theme that would be used to best advantage in a song; or had it better be saved, because of its dramatic quality, for operatic treatment? A composer sometimes has a work half finished before he understands the medium for which it is best fitted.

Thus far I have been presupposing an abstract composer before an abstract

theme. But actually I can see three different types of composers in musical history, each of whom conceives music in a somewhat different fashion.

The type that has fired public imagination most is that of the spontaneously inspired composer—the Franz Schubert type, in other words. All composers are inspired of course, but this type is more spontaneously inspired. Music simply wells out of him. He can't get it down on paper fast enough. You can almost always tell this type of composer by his prolific output. In certain months, Schubert wrote a song a day. Hugo Wolf did the same.

In a sense, men of this kind begin not so much with a musical theme as with a completed composition. They invariably work best in the shorter forms. It is much easier to improvise a song than it is to improvise a symphony. It isn't easy to be inspired in that spontaneous way for long periods at a stretch. Even Schubert was more successful in handling the shorter forms of music. The spontaneously inspired man is only one type of composer, with his own limitations.

Beethoven symbolizes the second type—the constructive type, one might call it. This type exemplifies my theory of the creative process in music better than any other, because in this case the composer really does begin with a musical theme. In Beethoven's case there is no doubt about it, for we have the notebooks in which he put the themes down. We can see from his notebooks how he worked over his themes—how he would not let them be until they were as perfect as he could make them. Beethoven was not a spontaneously inspired composer in the Schubert sense at all. He was the type that begins with a theme; makes it a germinal idea; and upon that constructs a musical work, day after day, in painstaking fashion. Most composers since Beethoven's day belong to this second type.

The third type of creator I can only call, for lack of a better name, the traditionalist type. Men like Palestrina and Bach belong in this category. They both exemplify the kind of composer who is born in a particular period of musical history, when a certain musical style is about to reach its fullest development. It is a question at such a time of creating music in a well-known and accepted style and doing it in a way that is better than anyone has done it before you.

Beethoven and Schubert started from a different premise. They both had serious pretentions to originality! After all, Schubert practically created the song form singlehanded; and the whole face of music changed after Beethoven lived. But Bach and Palestrina simply improved on what had gone before them.

The traditionalist type of composer begins with a pattern rather than with a theme. The creative act with Palestrina is not the thematic conception so

much as the personal treatment of a well-established pattern. And even Bach, who conceived forty-eight of the most varied and inspired themes in his *Well Tempered Clavichord,* knew in advance the general formal mold that they were to fill. It goes without saying that we are not living in a traditionalist period nowadays.

One might add, for the sake of completeness, a fourth type of composer—the pioneer type: men like Gesualdo in the seventeenth century, Moussorgsky and Berlioz in the nineteenth, Debussy and Edgar Varese in the twentieth. It is difficult to summarize the composing methods of so variegated a group. One can safely say that their approach to composition is the opposite of the traditionalist type. They clearly oppose conventional solutions of musical problems. In many ways, their attitude is experimental—they seek to add new harmonies, new sonorities, new formal principles. The pioneer type was the characteristic one at the turn of the seventeenth century and also at the beginning of the twentieth century, but it is much less evident today.[1]

But let's return to our theoretical composer. We have him with his idea—his musical idea—with some conception of its expressive nature, with a sense of what can be done with it, and with a preconceived notion of what medium is best fitted for it. Still he hasn't a piece. A musical idea is not the same as a piece of music. It only induces a piece of music. The composer knows very well that something else is needed in order to create the finished composition.

He tries, first of all, to find other ideas that seem to go with the original one. They may be ideas of a similar character, or they may be contrasting ones. These additional ideas will probably not be so important as the one that came first—usually they play a subsidiary role. Yet they definitely seem necessary in order to complete the first one. Still that's not enough! Some way must be found for getting from one idea to the next, and it is generally achieved through use of so-called bridge material.

There are also two other important ways in which the composer can add to his original material. One is the elongation process. Often the composer finds that a particular theme needs elongating so that its character may be more clearly defined. Wagner was a master at elongation. I referred to the other way when I visualized the composer's examining the possible metamorphoses of his theme. That is the much written-about development of his material, which is a very important part of his job.

All these things are necessary for the creation of a full-sized piece—the germinal idea, the addition of other lesser ideas, the elongation of the ideas,

[1] Recent experiments with electronically produced music, however, point to a new species of scientifically trained composer as a pioneer type of our own time.

the bridge material for the connection of the ideas, and their full development.

Now comes the most difficult task of all—the welding together of all that material so that it makes a coherent whole. In the finished product, everything must be in its place. The listener must be able to find his way around in the piece. There should be no possible chance of his confusing the principal theme with the bridge material, or vice versa. The composition must have a beginning, a middle, and an end; and it is up to the composer to see to it that the listener always has some sense of where he is in relation to beginning, middle, and end. Moreover, the whole thing should be managed artfully so that none can say where the soldering began—where the composer's spontaneous invention left off and the hard work began.

Of course, I do not mean to suggest that in putting raw materials together the composer necessarily begins from scratch. On the contrary, every well-trained composer has, as his stock in trade, certain normal structural molds on which to lean for the basic framework of his compositions. These formal molds I speak of have all been gradually evolved over hundreds of years as the combined efforts of numberless composers seeking a way to ensure the coherence of their compositions. What these forms are and exactly in what manner the composer depends on them will materialize in later chapters.

But whatever the form the composer chooses to adopt, there is always one great desideratum: The form must have what in my student days we used to call *la grande ligne* (the long line). It is difficult adequately to explain the meaning of that phrase to the layman. To be properly understood in relation to a piece of music, it must be felt. In mere words, it simply means that every good piece of music must give us a sense of flow—a sense of continuity from first note to last. Every elementary music student knows the principle, but to put it into practice has challenged the greatest minds in music! A great symphony is a man-made Mississippi down which we irresistibly flow from the instant of our leave-taking to a long foreseen destination. Music must always flow, for that is part of its very essence, but the creation of that continuity and flow—that long line—constitutes the be-all and the end-all of every composer's existence.

THE EFFECTS OF MUSIC

EDUARD HANSLICK

Though in our opinion the chief and fundamental task of musical aesthetics consists in subordinating the supremacy usurped by the feelings to the legitimate one of beauty—since the organ of pure contemplation from which, and for the sake of which, the truly beautiful flows is not our emotional but our imaginative faculty—yet the positive phenomena of the emotions play too striking and important a part in our musical life to admit of the question being settled simply by effecting this subordination.

However strictly an aesthetic analysis ought to be confined to the work of art itself, we should always remember that the latter constitutes the link between two living factors—the *whence* and the *whither;* in other words, between the composer and the listener, in whose minds the workings of the imagination are never so pure and unalloyed as the finished work itself represents them. Their imagination, on the contrary, is most intimately associated with feelings and sensations. The feelings, therefore, are of importance both before and after the completion of the work, in respect to the composer first and the listener afterward, and this we dare not ignore.

Let us consider the composer. During the act of composing he is in that exalted state of mind without which it seems impossible to raise the beautiful from the deep well of the imagination. That this exalted state of mind will according to the composer's idiosyncrasy, take the form more or less of the nascent structure, now rising like billows and now subsiding into mere ripples without ever becoming an emotional whirlpool which might wreck the powers of artistic invention; that calm reflection again is at least as essential as enthusiasm—all these are well-known principles of art. With special reference to the creative action of the composer, we should bear in mind that it always consists in the grouping and fashioning of musical elements. The sovereignty of the emotions, so falsely reputed to be the main factor in music is nowhere more completely out of place than when it is supposed to govern the musician in the act of composing, and when the latter is regarded as a kind of inspired impovisation. The slowly progressing work of molding a composition—which at the outset floated in mere outlines in the composer's brain —into a structure clearly defined down to every bar, or possibly, without further preliminaries, into the sensitive polymorphous form of orchestra music, requires quiet and subtle thought such as none who have not actually essayed it can comprehend. Not only *fugato* or contrapuntal passages, but the

most smoothly flowing rondo and the most melodious air demand what our language so significantly calls an "elaboration" of the minutest details. The function of the composer is a constructive one, within its own sphere analogous to that of the sculptor. Like him, the composer must not allow his hands to be tied by anything alien to his material, since he, too, aims at giving an objective existence to his (musical) ideal and at casting it into a pure form.

Rosenkranz may have overlooked this fact when he notices the paradox (without, however, explaining it) that women, who by nature are highly emotional beings, have achieved nothing as composers.[1] The cause, apart from the general reasons why women are less capable of mental achievements, is the plastic element in musical compositions which, as in sculpture and architecture, though in a different manner, imposes on us the necessity of keeping ourselves free from all subjective feelings. If the composing of music depended upon the intensity and vividness of our feelings, the complete want of female composers as against the numerous women writers and painters would be difficult to account for. It is not the feelings but a specifically musical and technically trained aptitude that enables us to compose. We think it rather amusing, therefore, to be gravely told by F. L. Schubart that the "masterly andantes" of the composer Stanitz are the natural outcome of his tender heart; [2] or to be assured by Christian Rolle [3] that a loving and amiable disposition makes it possible for us to convert slow movements into masterpieces.

Nothing great or beautiful has ever been accomplished without warmth of feeling. The emotional faculty is, no doubt, highly developed in the composer, no less in the poet; but with the former it is not the productive factor. A strong and definite pathos may fill his soul and be the consecrating impulse to many a work, but it can never become the subject matter, as is obvious from the very nature of music, which has neither the power nor the vocation to represent definite feelings.

An inward melody, so to speak, and not mere feeling, prompts the true musician to compose.

We have tried to show that the composing of music is constructive in its nature and, as such, is purely objective. The composer creates something intrinsically beautiful, while the inexhaustible intellectual associations of sound enable his subjectivity to reflect itself in the mode of the formative process. Every musical note having its individual complexion, the prominent characteristics of the composer, such as sentimentality, energy, cheerfulness, etc., may, through the preference given by him to certain keys, rhythms, and

[1] Rosenkranz, *Psychologie,* 2d ed., p. 60.
[2] Schubart, *Ideen zu einer Aesthetik der Tonkunst* [*Ideas toward an Aesthetic of Music,* Ed.], 1806.
[3] *Neue Wahrnehmungen zur Aufnahme der Musik* [*New Observations on Taking Up Music,* Ed.], Berlin, 1784, p. 102.

modulations, be traced in those general phenomena which music is capable of reproducing. But once they become part and parcel of the composition, they interest us only as musical features—as the character of the composition, not of the composer.[4] That which a sentimental, an ingenious, a graceful, or a sublime composer produces is, above all, *music*, an objective image. Their works will differ from one another by unmistakable characteristics, and each in its complete form will reflect the author's individuality; but all, without exception, were created as independent and purely musical forms of beauty.

It is not the actual feeling of the composer, not a subjective state of mind, that evokes a like feeling in the listener. By conceding to music the power to evoke feelings, we tacitly recognize the cause to be something objective in the music, since it is only the objective element in beauty which can possess the quality of irresistibleness. This objective something is, in this case, the purely musical features of a composition. It is, aesthetically, quite correct to speak of a theme as having a sad or noble accent, but not as expressing the sad or noble feelings of the composer. Even more irrelevant to the character of a composition are the social or political events of the period. The musical expression of the theme necessarily follows from the individual selection of the musical factors. That this selection is due to psychological causes or facts of contemporary history has to be proved by the particular work itself (and not simply by dates or the composer's birthplace), and even when thus established the connection, however interesting it may be, remains a fact belonging solely to history or biography. An aesthetic analysis can take no note of circumstances which lie outside the work itself.

Though it is certain that the individuality of the composer will find a symbolic expression in his works, it would be a gross error from this subjective aspect of the question to deduce conceptions, the true explanation of which is to be found in the objectiveness of the artistic creation. One of these conceptions is style.[5]

Style in music we should like to be understood in a purely musical sense: as the perfect grasp of the technical side of music, which in the expression of the creative thought assumes an appearance of uniformity. A composer shows his "good style" by avoiding everything trivial, futile, and unsuitable as he carries out clearly conceived idea, and by bringing every technical detail

[4] How careful we ought to be when inferring from a composition the character of its composer, and how great the risk is that flights of fancy will take the place of dispassionate research at the expense of truth, has among other instances been shown by the Beethoven biography of A. B. Marx, who based his panegyric on musical predilections, and, scorning a conscientious investigation of facts, had many of his conclusions categorically refuted by Thayer's exhaustive inquiry.

[5] Forkel is, therefore, quite mistaken in his derivation of the various musical styles from "different modes of thought." According to him, "the style of a composer is due to the romantic, the conceited, the apathetic, the puerile, or the pedantic, carrying bombast, arrogance, coldness, and affectation into the expression of his thoughts." (*Theorie der Musik*, 1777, p. 23.)

into artistic agreement with the whole. With Vischer (*Aesthetik*, § 527), we would use the word "style" in music also in an absolute sense and, disregarding the historical and individual meanings of the term, apply the word "style" to a composer as we apply the word "character" to a man.

The architectonic side of beauty in music is brought into bold relief by the question of style. The laws of style being of a more subtle nature than the laws of mere proportion, one single bar, if out of keeping with the rest, though perfect in itself, will vitiate the style. Just as in architecture we might call a certain arabesque out of place, so we should condemn as bad style a cadence or modulation which is opposed to the unity of the fundamental thought. The term unity must, of course, be understood in its wider and loftier acceptation, since it may comprise contrast, episode, and other such departures.

The limits to which a musical composition can bear the impress of the author's own personal temperament are fixed by a pre-eminently objective and plastic process.

The act in which the direct outflow of a feeling into sound may take place is not so much the *invention* of music as its *reproduction*. The fact that from a philosophical point of view a composition is the finished work of art, irrespective of its performance, should not prevent us from paying attention to the division of music into composition and reproduction (one of the most significant classifications of our art) whenever it contributes to the explanation of some phenomenon.

Its value is especially manifest on inquiring into the subjective impression which music produces. The player has the privilege of venting directly through his instrument the feeling by which he is swayed at the time, and to breathe into his performance passionate excitement, ardent longing, buoyant strength, and joy. The mere physical impulse which directly communicates the inward tremor as the fingers touch the strings, as the hand draws the bow, or as the vocal chords vibrate in song, enables the executant to pour forth his inmost feelings. His subjectiveness thus makes itself directly heard in the music, and is not merely a silent prompter. The work of the composer is slow and intermittent, whereas that of the player is an unimpeded flight; the former composes for an age, the latter performs for the fruition of the moment. The piece of music is worked out by the composer, but it is the performance which we enjoy. Thus the active and emotional principle in music occurs in the act of reproduction, which draws the electric spark from a mysterious source and directs it toward the heart of the listener. The player can, of course, give only what the composition contains, and little more than a correct rendering of the notes is demanded of him; he has merely to divine and expose the spirit of the composer—true, but it is the spirit of the player which is revealed in

this act of reproduction. The same piece wearies or charms us according to the life infused into its performance. It is like one and the same person whom we picture to ourselves, now in a state of rapturous enthusiasm, now in his apathetic everyday looks. Though the most ingenious music box fails to move us, a simple itinerant musician, who puts his whole soul into a song, may do so.

A state of mind manifests itself most directly in music when origination and execution coincide. This occurs in the freest form of extempore playing, and if the player proceeds not so much according to the strict methods of art as with a predominantly subjective tendency (a pathological one, in a wider sense), the expression which he elicits from the keys may assume almost the vividness of speech. Whoever has enjoyed this absolute freedom of speech, in total oblivion of all surroundings, this spontaneous revelation of his inner self, will know without further explanation how love, jealousy, joy, and sorrow rush out of their secret recesses, undisguised and yet secure, celebrating their own triumphs, singing their own lays, fighting their own battles, until their lord and master calls them back, quieted and yet disquieting.

While the player gives vent to his emotions, the expression of that which is played is imparted to the listener. Let us now turn to the latter.

We often see him deeply impressed by a piece, moved with joy or grief, his whole being rising far above purely aesthetic enjoyment, now enraptured, now profoundly depressed. The existence of such effects is undeniable, actual, and genuine, attaining at times supreme degrees, and they are, moreover, so notorious that we need not dwell any further on their description. Here only two questions arise: in what respect the specific character of this excitation of the feelings by music differs from other emotions, and to what extent this operation is aesthetic.

Though all arts, without exception, have the power to act on our feelings, yet the mode in which music displays it is, undoubtedly, peculiar to this art. Music operates on our emotional faculty with greater intensity and rapidity than the product of any other art. A few chords may give rise to a frame of mind which a poem can induce only by a lengthy exposition, or a picture by prolonged contemplation, despite the fact that the arts to which the latter belong boast the advantage over music of having at their service the whole range of ideas on which we know our feelings of joy or sorrow to depend. the action of sound is not only more sudden, but also more powerful and direct. The other arts persuade us, but music takes us by surprise. This, its characteristic sway over our feelings, is most vividly realized when we are in a state of unusual exaltation or depression.

In states of mind where paintings and poetry, statues and architectural

beauties fail to rouse us to active interest, music will still have power over us—nay, greater power than at other times. Whoever is obliged to hear or play music while in a state of painful excitement will feel it like vinegar sprinkled on a wound. No other art, under equal conditions, can cut so sharply to the very quick. The form and character of the music lose their distinctiveness; be it a gloomy adagio or a sparkling waltz, we are unable to tear ourselves away from the sounds—we are not conscious of the composition as such, but only of sound, of music, as an undefined and demoniacal power sending a thrill through every nerve of our body.

When Goethe in his old age experienced once again the power of love, a sensibility for music arose such as he had never dreamed of before. Referring to those remarkable days at Marienbad (1823) in a letter to Zelter, he says: "What a stupendous power music now has over me! Milder's voice, Szymanowska's richness of tone—nay, the very performances of the Jägercorps band open my heart as a clenched fist opens to greet a friend. I am firmly convinced that during the first bar I should have to leave your singing academy." Too clear-sighted not to ascribe the effect mainly to nervous excitement, Goethe concludes in the following terms: "You would cure me of a kind of morbid excitability, which is, after all, at the bottom of this phenomenon." [6] From this alone it ought to be clear that the musical excitation of our feelings is often due to other than purely aesthetic factors. A purely aesthetic factor appeals to our nervous system in its normal condition, and does not count on a morbid exaltation or depression of the mind.

The fact of its operating with greater intensity on our nerves proves music to have a preponderance of power as compared with other arts. But on closely examining this preponderance, we find it to be qualitative, and its distinctive quality to depend upon physiological conditions. The material element, which in all aesthetic enjoyment is at the root of the intellectual one, is greater in music than in any other art. Music, through its immateriality the most ethereal art, and yet the most sensuous one through its play of forms without any extraneous subject, exhibits in this mysterious fusion of two antagonistic principles a strong affinity for the nerves, those equally mysterious links in the invisible telegraphic connection between mind and body.

Psychologists and physiologists alike are fully cognizant of the truth that music acts most powerfully on the nervous system, but neither of them, unfortunately, can offer an adequate explanation. Psychologists will never be able to throw any light on the irresistible force with which certain chords, timbres, and melodies impress the entire human organism, the difficulty being to establish a nexus between certain nerve excitations and certain states of

[6] *Briefwechsel zwischen Goethe und Zelter* [*Correspondence between Goethe and Zelter*, Ed.], vol. 3, p. 332.

mind. Nor has the marvelously successful science of physiology made any vital discovery toward a solution of this problem.

As regards the musical monographs on this hybrid subject, they nearly all invest music with the imposing halo of a miracle-worker and descant on some brilliant examples rather than institute a scientific inquiry into the true and necessary relation between music and our consciousness. Of such an inquiry alone are we in need and not of the blind faith of a Dr. Albrecht, who prescribes music as a diaphoretic, nor of the incredulity of an Oerstedt, who explains the howling of a dog on hearing music in certain keys by supposing the dog to have been specially trained to it by a system of whipping.[7]

Many lovers of music may not be aware that there is quite a literature on the physiological action of music and its therapeutic application. Rich in interesting curiosities, but alike unreliable in their observations and unscientific in their explanations, most of these musical quacks magnify a highly composite and secondary endowment of music into one of unconditional efficiency.

From the time of Pythagoras (the first, it is said, to effect miraculous cures by means of music) down to the present day, the doctrine has appeared again and again (enriched, however, by fresh examples rather than by new discoveries) that the exciting or soothing effect of music on the human organism may be utilized as a remedy for numerous diseases. Peter Lichtenthal gives us a detailed account (*Der musikalische Arzt*)[8] of the cure of gout, sciatica, epilepsy, the plague, catalepsy, delirium, convulsions, typhus, and even stupidity (*stupiditas*), merely by the power of music.[9]

These writers may be divided into two classes according to their method of proof.

One class, arguing from the material point of view, seeks to establish the curative effect of music by the physical action of the sound waves which, they say, are transmitted by the auditory nerve to the whole nervous system; and the general shock thus resulting induces a salutary reaction in the morbid part of the organism. The feelings arising at the same time are, it is contended, merely the effect of the nervous shock, since not only do emotions produce bodily changes but the latter, in their turn, may produce corresponding emotions.

According to this theory (championed by an Englishman named Webb), which counts among its followers men like Nicolai, Schneider, Lichtenthal, J. J.

[7] *Der Geist in der Natur* [*The Spirit in Nature,* Ed.], vol. 3, p. 9.
[8] *The Musical Doctor.* [Ed.]
[9] This doctrine reached the height of confusion with the celebrated doctor, Battista Porta, who, combining the ideas of a medicinal plant and a musical instrument, professed to cure dropsy by means of a flute made from the stalk of the hellebore. A musical instrument made from the wood of the poplar (*Populus*) was to cure sciatica, and one made of cinnamon bark was to cure fainting fits. (*Encyclopédie*, article "Musique.")

Engel, Sulzer, and others, music operates on us just as the peals of an organ do on doors and windows, which tremble under the aerial vibrations. In support of this theory cases are mentioned, such as that of Boyle's servant, whose gums commenced to bleed on hearing a saw sharpened, or of people falling into convulsions when the edge of a knife is scraped on glass.

But that is not music, properly so called. The fact that music, in common with those phenomena which so strongly affect our nerves, has sound for its substratum will be found to be one of great importance in respect of certain conclusions to be drawn hereafter; but for our present purpose it is enough to emphasize, in opposition to a materialistic view, the truth that music begins where those isolated auditory impressions terminate; and that the feeling of sadness which an adagio may awaken and the bodily sensation produced by a shrill or discordant sound are totally different in kind.

The other class of writers (to which belong Kausch and most writers on aesthetics) try to explain the therapeutic effect of music on psychological grounds. Music, they argue, arouses emotions and passions which throw the nervous system into a violent agitation, and a violent agitation of the nervous system produces a healthy reaction in the diseased organism. This train of reasoning, the logical defects of which are too obvious to require specification, is carried so far by these idealistic "psychologists," in defiance of the materialistic school of thought and in utter disregard of the truths of physiology, as to deny (on the authority of an Englishman by the name of Whytt) the connection between the auditory nerve and the other nerves, which, of course, involves the impossibility of bodily transmitting to the entire organism an impression produced on the ear.

The notion of awakening by musical means definite feelings such as love, sadness, anger, and delight, which in their turn are to cure the body by salutary excitement, is certainly a plausible one. It always reminds us of the amusing verdict of one of our most distinguished scientists respecting "Goldberg's electromagnetic chains." It was not proved, he said, whether an electric current was capable of curing certain diseases, but it was proved beyond doubt that "Goldberg's chains" were incapable of generating an electric current. Applied to our "musical doctors," this would run thus: It is *possible* that certain emotions may bring about a favorable turn in bodily ailments, but it is *impossible* to call forth at will definite emotions by musical means.

Both theories—the psychological and the physiological—agree in this, that they infer from questionable premises even more questionable conclusions, and that their practical application is the most questionable of all. It may be quite admissible to justify some method of treatment on logical grounds, but it is rather disagreeable that there is no record of a doctor sending his patient to

hear Meyerbeer's *Prophet* in order to cure him of typhus, or of the French horn being used instead of the lancet.

The physical action of music is neither so powerful in itself, nor so certain, nor yet so independent of psychological and aesthetic associations, nor can it be so nicely regulated, as to admit of its being seriously considered a remedy.

Every cure effected by the aid of music must be regarded in the light of an exception, and the success can never be put down to the music alone, being due partly to special causes and often merely to the patient's idiosyncrasy. It is highly significant that the only case in which music is really applied as a remedy is in the treatment of the insane, and this is mainly grounded on the psychological aspect of musical impressions. That in the modern treatment of insanity music is frequently employed with great success is a well-known fact. The success, however, is owing neither to the nervous shock nor to the arousing of the passions, but to the soothing and exhilarating influence which music, at once diverting and fascinating, exerts on a darkened or morbidly excited mind. It is true that the patient listens to the sensuous rather than to the artistic part of the music; yet, if he can but fix his attention, he proves himself capable of aesthetic enjoyment, though in an inferior degree.

Now, in what respect do all these musico-medical works contribute toward a clear knowledge of music? They all confirm what has been observed from time immemorial, namely, that with the "feelings" and "passions" aroused by music there always coexists a strong physical agitation. Once grant the assumption that an integral part of the emotion aroused by music is of physical origin and it follows that the phenomenon, closely related as it is to nerve function, must be studied in this, its physical aspect. No musician, therefore, can expect a scientific solution of this problem without making himself acquainted with the latest results of physiological research into the connection between music and the emotions.

If we follow the course which a melody must take in order to operate on our feelings, we shall find it traced with tolerable accuracy from the vibrating instrument to the auditory nerve, thanks especially to Helmholtz's famous discoveries in this domain of science recorded in his work, *Lehre von den Tonempfindungen.*[10] The science of acoustics has clearly shown what are the outward conditions under which the sensation of sound in general, and of any sound in particular, becomes possible; anatomy, with the help of the microscope, has revealed the most minute and hidden structures of the organ of hearing. Physiology, in fine, though debarred from experimenting directly on the extremely small and delicate constituents of this hidden marvel, has nevertheless to a certain extent ascertained its *modus operandi,* and to a still

[10] *Studies in Sound Perception.* [Ed.]

greater extent explained it by a theory propounded by Helmholtz, so as to render intelligible the whole process by which we become conscious of sound physiologically. Even beyond these limits, in the domain where natural science comes into close contact with aesthetics, much has been elucidated by Helmholtz's theory of consonance and the affinities of sound, which until lately was shrouded in mystery. But this, unfortunately, is the whole extent of our knowledge. The most essential part, the physiological process by which the sensation of sound is converted into a feeling, a state of mind, is unexplained, and will ever remain so. Physiologists know that what our senses perceive as sound is, objectively speaking, molecular motion within the nerve substance, and this is true of the nerve centers no less than of the auditory nerve. They also know that the fibers of the auditory nerve are connected with the other nerves, to which they transmit the impulse received, and that the organ of hearing is connected with the cerebrum and the cerebellum, with the larynx, the lungs, and the heart. About the specific mode, however, in which music affects these nerves they know nothing, nor yet about the different ways in which certain musical factors, such as chords, rhythms, and the sounds of instruments operate on different nerves. Is a sensation of musical sound propagated to all the nerves connected with the auditory nerve, or only to some of them? With what degree of intensity? Which musical elements affect the brain more particularly, and which the nerves supplying the heart and the lungs? It is an undoubted fact that dance music produces in young people (whose natural inclination is not controlled by social restraints) a twitching of the whole body, and especially of the feet. We cannot, without being one-sided, dispute the physiological action of martial or dance music and attribute its effect solely to a psychological association of ideas. Its psychological aspect— the recollection of former pleasures derived from dancing—helps us to understand the phenomenon; but taken alone it does not explain it. The feet do not move because it is dance music, but we call it dance music because it makes the feet move. Whoever glances around in an opera house will notice the ladies involuntarily beating time with their heads to any lively or taking tune, but never to an adagio, however impressive and melodious it may be. Should we infer from this that certain musical factors, and more particularly rhythmical ones, affect the motor and others the sensory nerves? Which affect the former and which the latter?[11] Is the solar plexus, which is reputed to be pre-eminently the seat of sensation, especially affected by music? Or is it the

[11] Carus tries to account for the motor stimulus by supposing the auditory nerve to originate in the cerebellum, the latter to be the seat of volition; and the co-operation of the two to be the cause of the phenomenon that auditory impressions incite us to acts of courage, etc. But this is a very lame hypothesis, seeing that science has not yet proved the auditory nerve to originate in the cerebellum. Harless (see R. Wagner's *Manual of Physiology*, "The Function of Hearing") maintains that the mere *perception of rhythmical motion,* apart from auditory impressions, has the same tendency to give motor impulses as rhythmical music. But this doctrine conflicts with our experience.

sympathetic ganglia (the best part of which is their name, as Purkinje once remarked to me) which are so affected? Why one sound affects us as shrill and harsh, another as clear and mellifluous, the science of acoustics explains by the irregularity or regularity with which the sonorous pulses follow each other; again, that several simultaneously occurring sounds produce now the effect of consonance and now that of dissonance is accounted for by the slow or rapid succession of beats.[12] The explanations of more or less simple sensations of sound, however, cannot satisfy the aesthetic inquirer, who demands an explanation of the *feeling* produced, and asks how it is that one series of melodious sounds induces a feeling of sadness, and another, of equally melodious sounds, a feeling of joy? Whence the diametrically opposed moods which often take hold of us with irresistible force on hearing chords and instruments of different kinds, but of equally pure and agreeable sound?

To all this—at least as far as our knowledge and judgment go—physiologists can give no clue! How, indeed, can they be expected to do so? For they can tell us neither why grief makes us weep, nor why joy makes us laugh—nay, they do not even know what grief and joy are! Let us, therefore, never appeal to a science for explanations which it cannot possibly give.[13]

It is true, of course, that the cause of every emotion which music arouses is chiefly to be found in some specific mode of nerve activity induced by an auditory impression. But how the excitation of the auditory nerve (which we cannot even trace to its source) is transformed into a definite sentiment; how a physical impression can pass into a state of mind; how, in fine, a sensation can become an emotion—all this lies beyond the mysterious bridge which no philosopher has ever crossed. It is the one great problem expressed in numberless ways: the connection between mind and body. This sphinx will never throw herself into the sea.[14]

All that the inquiries into the physiological aspect of music have brought to light is of the utmost importance for the correct appreciation of auditory impressions as such, and in that direction considerable progress may yet be made. But with respect to the main issue in music we shall probably never know more than we do now.

The result thus arrived at, when applied to musical aesthetics, leads to the

12 Helmholtz, *Lehre von den Tonempfindungen,* 2d ed., 1870, p. 319.
13 Lotze, one of our most gifted physiologists, says (*Medicinische Psychologie,* p. 237): "A careful study of melodies would extort from us the admission that we know nothing whatever about the conditions under which the change from one kind of nerve excitation to another becomes the physical substratum of the powerful aesthetic feelings which vary with the music." With respect to the feeling of satisfaction or discomfort which a single tone may evoke, he remarks (p. 236): "It is a matter of utter impossibility to offer a physiological explanation for these simple sensations, in particular, as we do not know with any degree of accuracy in what respect the impressing causes affect the nerve function, and we are, therefore, quite unable to determine to what extent they promote or impede it."
14 While revising the fourth edition of this work, the author came across a most invaluable corroboration of the views here set forth in Dubois-Reymond's speech at the Science Congress of 1872 in Leipzig.

conclusion that those theorists who ground the beautiful in music on the feelings it excites build upon a most uncertain foundation, scientifically speaking, since they are necessarily quite ignorant of the nature of this connection and can therefore, at best, only indulge in speculation and flights of fancy. An interpretation of music based on the feelings cannot be acceptable either to art or science. A critic does not substantiate the merit or subject of a symphony by describing his subjective feelings on hearing it, nor can he enlighten the student by making the feelings the starting point of his argument. This is of great moment; for if the connection between certain feelings and certain modes of musical expression were so well established as some seem inclined to think, and as it ought to be if the importance claimed for it were justified, it would be an easy matter to lead the young composer onward to the most sublime heights of his art. The attempt to do this has actually been made. Mattheson teaches in the third chapter of his *Vollkommener Capellmeister* [15] how pride, humility, and all the other emotions and passions are to be translated into music. Thus he says, "To express jealousy, the music must have something grim, sullen, and doleful about it." Heinchen, another writer of the last century, devotes eight pages in his *Generalbass* to actual examples of the modes in which music should express the "feelings of an impetuous, factious, pompous, timorous, or lovesick mind." [16] To crown the absurdity, directions of this kind should commence with the formula of cookery books: "Take," etc., or with that of medical prescriptions, "R." Such attempts yield the highly instructive lesson that specific rules of art are always both too narrow and too wide.

Those inherently fallacious precepts for the excitation of definite emotions by musical means have so much the less to do with aesthetics as the effect aimed at is not a purely aesthetic one, an inseparable portion of it being of a distinctly physical character. An aesthetic prescription would have to teach the composer how to produce beauty in music, and not how to excite particular feelings in the audience. How impotent these rules are in reality is best proved by considering what magic power they must possess to be efficacious. For if the action of every musical factor on our feelings were a necessary and determinable one, we should be able to play on the mind of the listener as on the keyboard of a piano. And even assuming this to be possible, would the object of music be attained thereby? This is the only legitimate form of the question, and to it none but a negative reply can be given. Musical beauty alone is the true power which the composer wields. With this for his pilot, he safely

[15] *The Perfect Chapel Master.* [Ed.]
[16] Greatly amusing are the discourses of v. Böcklin, Privy Councilor and Doctor of Philosophy, who in his book *Fragmente zur höheren Musik* [*Fragments toward a Higher Music*, Ed.], 1811, p. 34, says among other things: "If the composer wants to represent an offended person, outbursts of aesthetic warmth must follow each other in rapid succession; lofty strains must resound with extreme vivacity; the baritones rave, and terrific blasts inspire the expectant listener with awe."

passes through the rapids of time, where the factor of emotion would be power-less to save him from shipwreck.

The two points at issue—namely, what the distinctive trait is of a feeling aroused by music, and whether this is of an essentially aesthetic nature—are settled by the recognition of one and the same fact: the intense action on our nervous system. This fact explains the characteristic force and directness with which music (as compared with arts that do not employ the medium of sound) is capable of exciting emotions.

But the more overpowering the effect is in a physical, i.e., in a pathological sense, the less is it due to aesthetic causes—a proposition, by the way, the terms of which cannot be inverted. In connection with the production and interpre-tation of music, another factor must be emphasized, which in antithesis to a specifically musical excitation of the feelings approximates to the general aesthetic conditions of all the other arts. This factor is the act of pure contem-plation (*die reine Anschauung*).

ON SIGNIFICANCE IN MUSIC

SUSANNE K. LANGER

What distinguishes a work of art from a "mere" artifact? What distinguishes the Greek vase, as an artistic achievement, from the hand-made bean pot of New England, or the wooden bucket, which cannot be classed as a work of art? The Greek vase is an artifact, too; it was fashioned according to a traditional pattern; it was made to hold grain or oil or other domestic asset, not to stand in a museum. Yet it has an artistic value for all generations. What gives it that preëminence?

To reply, "Its beauty," is simply to beg the question, since artistic value *is* beauty in the broadest sense. Bean pots and wooden buckets often have what artists call "a good shape," i.e., they are in no wise offensive to the eye. Yet, without being at all ugly, they are insignificant, commonplace, *non*-artistic rather than *in*artistic. What do they lack, that a work of art—even a humble, domestic Greek vase—possesses?

In the words of a well-known critic, Mr. Clive Bell, " 'Significant Form' is the one quality common to all works of visual art." [1] Professor L. A. Reid, a philosopher well versed in the problems of aesthetics, extends the scope of this characteristic to all art whatsoever. For him, "Beauty is just expressiveness," and "the true aesthetic form . . . is expressive form." [2] Another art critic, Mr. Roger Fry, accepts the term "Significant Form," though he frankly cannot define its meaning. From the contemplation of (say) a beautiful pot, and as an effect of its harmony of line and texture and color, "there comes to us," he says, "a feeling of purpose; we feel that all these sensually logical conformities are the outcome of a particular feeling, or of what, for want of a better word, we call an idea; and we may even say that the pot is the expression of an idea in the artist's mind." [3] After many efforts to define the notion of artistic expressiveness, he concludes: "I seem to be unable at present to get beyond this vague adumbration of significant form. Flaubert's 'expression of the idea' seems to me to correspond exactly to what I mean, but alas! he never explained, and probably could not, what he meant by the 'idea.' " [4]

There is a strong tendency today to treat art as a *significant* phenomenon rather than as a pleasurable experience, a gratification of the senses. This is probably due to the free use of dissonance and so-called "ugliness" by our leading artists in all fields—in literature, music, and the plastic arts. It may also be due in some measure to the striking indifference of the uneducated masses to artistic values. In past ages, these masses had no access to great works of art; music and painting and even books were the pleasures of the wealthy; it could be assumed that the poor and vulgar would enjoy art if they could have it. But now, since everybody can read, visit museums, and hear great music at least over the radio, the judgment of the masses on these things has become a reality, and has made it quite obvious that *great art is not a direct sensuous pleasure*. If it were, it would appeal—like cake or cocktails—to the untutored as well as to the cultured taste. This fact, together with the intrinsic "unpleasantness" of much contemporary art, would naturally weaken any theory that treated art as pure pleasure. Add to this the current logical and psychological interest in symbolism, in expressive media and the articulation of ideas, and we need not look far afield for a new philosophy of art, based upon the concept of "significant form." [5]

[1] *Art*, 1914, p. 8.
[2] *A Study in Aesthetics*, 1931. See esp. pp. 43 and 197. See also *Knowledge and Truth*, 1923, esp. the final chapter, and "Beauty and Significance," *Proceedings of the Aristotelian Society*, N.S. XXIX, pp. 123–154, 1928–29.
[3] *Vision and Design*, 1925, p. 50.
[4] *Ibid.*, p. 302.
[5] This tendency was recognized long ago by the author of an article on symbolism, which opens with the words: "An exhaustive treatise on the symbol is an aesthetic in miniature; for in recent years symbolism has acquired such a central position in aesthetics that one can hardly take a step in that wide domain without stumbling upon some sort of symbolic relation." R. M. Wernaer, "Das aesthetische Symbol," *Zeitschrift für Philosophie und philosophische Kritik*, vol. 130, no. 1, pp. 47–75, 1907.

But if forms in and of themselves be significant, and indeed must be so to be classed as artistic, then certainly the kind of significance that belongs to them constitutes a very special problem in semantics. What is artistic significance? What sort of meaning do "expressive forms" express?

Clearly they do not convey propositions, as literal symbols do. We all know that a seascape (say) represents water and rocks, boats and fish-piers; that a still-life represents oranges and apples, a vase of flowers, dead game or fish, etc. But such a content is not what makes the paint-patterns on the canvas "expressive forms." The mere notion of rabbits, grapes, or even boats at sunset is not the "idea" that inspires a painting. The artistic idea is always a "deeper" conception.

Several psychologists have ventured to unmask this "deeper" significance by interpreting pictures, poems, and even musical compositions as symbols of loved objects, mainly, of course, of a forbidden nature. Artistic activity, according to the psychoanalysts who have given it their attention, is an expression of primitive dynamisms, of unconscious wishes, and uses the objects or scenes represented to embody the secret fantasies of the artist.[6]

This explanation has much to recommend it. It accounts for the fact that we are inclined to credit works of art with *significance*, although (by reason of the moral censorship which distorts the appearance of basic desires) we can never say what they signify. It does justice to the emotional interest, the seriousness with which we receive artistic experience. Above all, it brings this baffling department of human activity into the compass of a general psychological system—the so-called "dynamic psychology," based on the recognition of certain fundamental human needs, of the conflicts resulting from their mutual interference, and of the mechanism whereby they assert, disguise, and finally realize themselves. The starting-point of this psychology is the discovery of a previously unrecognized *symbolic mode*, typified in dream, and perfectly traceable in all works of fantasy. To assimilate art to the imaginative life in general is surely not a forced procedure. It seems, moreover, to bring the problem of aesthetic experience into the symbol-centered philosophy that constitutes the theme of this book.

These are strong recommendations for the psychoanalytic theory of aesthet-

6 See Ch. Badouin, *Psychanalyse de l'art*, 1929; A. M. Bodkin, "The Relevance of Psychoanalysis to Art Criticism," *British Journal of Psychology*, vol. 15, part II, pp. 174–183, 1924–25; J. W. Brown, "Psychoanalysis in the Plastic Arts," *International Journal of Psychoanalysis*, vol. 10, part I, January, 1929; J. Landquist, "Das künstlerische Symbol," *Imago*, vol. VI, no. 4, pp. 297–322, 1920; Hanns Sachs, "Kunst als Persönlichkeit," *Imago*, vol. 15, no. 1, pp. 1–14, 1929; the same author's bibliographical essay, "Aesthetics and Psychology of the Artist," *International Journal of Psychoanalysis*, vol. 2, part I, pp. 94–100, 1921; George Whitehead, *Psychoanalysis and Art*, 1930. With special reference to music, see A. Elster, *Musik und Erotik*, 1925; Max Graf, *Die innere Werkstatt des Musikers*, 1910; K. Eggar, "The Subconscious Mind and the Musical Faculty," *Proceedings of the Musical Association*, vol. 47, pp. 23–38, 1920–1921; D. Mosonyi, "Die irrationalen Grundlagen der Musik," *Imago*, vol. 21, no. 2, pp. 207–226, 1935; A. van der Chijs, "Ueber das Unisono in der Komposition," *Imago*, vol. 12, no. 1, pp. 23–31, 1926. This list is not exhaustive, but representative.

ics. But despite them all, I do not think this theory (though probably valid) throws any real light on those issues which confront artists and critics and constitute the philosophical problem of art. For the Freudian interpretation, no matter how far it be carried, never offers even the rudest criterion of *artistic* excellence. It may explain why a poem was written, why it is popular, what human features it hides under its fanciful imagery; what secret ideas a picture combines, and why Leonardo's women smile mysteriously. But *it makes no distinction between good and bad art*. The features to which it attributes the importance and significance of a great masterpiece may all be found just as well in an obscure work of some quite incompetent painter or poet. Wilhelm Stekel, one of the leading Freudian psychologists interested in artistic productions as a field for analysis, has stated this fact explicitly: "I want to point out at once," he says, "that it is irrelevant to our purpose whether the poet in question is a great, universally acknowledged poet, or whether we are dealing with a little poetaster. For, after all, we are investigating only the impulse which drives people to create." [7]

An analysis to which the artistic merit of a work is irrelevant can hardly be regarded as a promising technique of art-criticism,[8] for it can look only to a hidden *content* of the work, and not to what every artist knows as the real problem—the *perfection of form*, which makes this form "significant" in the artistic sense. We cannot evaluate this perfection by finding more and more obscure objects represented or suggested by the form.

Interest in represented objects and interest in the visual or verbal structures that depict them are always getting hopelessly entangled. Yet I believe "artistic meaning" belongs to the sensuous construct as such; this alone is beautiful, and contains all that contributes to its beauty.

The most obvious approach to the formal aspect of art would be, of course, through the study of pure design. But in poetry pure design is non-existent, and in the plastic arts it has played but a minor role until very recent times.

[7] *Die Träume der Dichter* [*The Poet's Dream*, Ed.], 1912, p. 32.
[8] Oddly enough, this fact is overlooked by so excellent a literary critic as J. M. Thorburn, who says: "The poet must, I think, be regarded as striving after the simiplicity of a childish utterance. His goal is to think as a child, to understand as a child. . . .
"When he has written, and the work is good, the measure of his genius is the depth to which he has gone back, the originality of his idiom and the degree of its antiquity." (*Art and the Unconscious*, pp. 70–71.)
"If art be symbolic, it is the artist who discovers the symbol. But he need not—though of course he may—recognize it as a symbol. We, the appreciative recipients of his work, must so recognize it." (*Ibid.*, p. 79.)
This makes artistic judgment a special development of psychoanalytic technique. "We try to reconstruct his [the artist's] personality from whatever sources we may." (*Ibid.*, p. 21.) The more dreamlike and subjective the work, the more primitive is its language; the greatest poets should then be the most graphic dreamers. Stekel has pointed out, however, that·at the level of symbol production the poet does not differ from the most prosaic soul. After analyzing three dreams—one reported by a woman under his care, one by Goethe, and one by that poet's friend and henchman, Eckermann—he observes: "Is it not remarkable that the great poet Goethe and the unknown little woman . . . should have constructed such similar dreams? And were one to award a prize for poetic excellence, Eckermann and the deserted woman would both win over Goethe." (*Die Träume der Dichter*, p. 14.)

It is carried to considerable heights in textiles, and occurs as decoration in conjunction with architecture and ceramics. But the world's greatest artists have rarely worked in these media; sculptures and paintings are their high achievements. If we would really restrict ourselves to pure perceptible forms, the plastic arts offer but a sparse field for research, and not a central one.

Music, on the other hand, is preëminently non-representative even in its classical production, its highest attainments. It exhibits pure form not as an embellishment, but as its very essence; we can take it in its flower—for instance, German music from Bach to Beethoven—and have practically nothing but tonal structures before us: no scene, no object, no fact. That is a great aid to our chosen preoccupation with form. There is no obvious, literal content in our way. If the meaning of art belongs to the sensuous percept itself, apart from what it ostensibly represents, then such purely artistic meaning should be most accessible through musical works.

This is not to say that music is the highest, the most expressive, or the most universal art. Sound is the *easiest* medium to use in a purely artistic way; but to work in the safest medium is not at all the same thing as to achieve the highest aim. Furthermore, we should take warning against the fallacy of hasty generalization—of assuming that through music we are studying all the arts, so that every insight into the nature of music is immediately applicable to painting, architecture, poetry, dance, and drama; and above all, that propositions which do not have obvious analogues in all these departments are not very valuable in their restricted musical context.[9] A basic unity of purpose and even of general method for all the arts is a very inviting hypothesis, and may well be demonstrable in the end; but as a foregone conclusion, a dogmatic premise, it is dangerous because it discourages special theories and single-minded, technical study. General theories should be constructed *by generalization* from the principles of a special field, known and understood in full detail. Where no such systematic order exists to serve as a pattern, a general theory is more likely to consist of vague generalities than of valid generalizations.

Therefore let us concern ourselves, at present, with the significance of music alone. A great deal of philosophical thought has been bestowed on this subject, if not since Winkelmann and Herder, at least since Schopenhauer; and not only from the general standpoint of the aesthetician, which those early writers took, but from the more specialized one of the musician and the musical critic. The history of musical aesthetics is an eventful one, as intellectual histories go,

9 An artistic principle may be obvious in just one special field, and prove to be generally applicable only after development in that field; for instance, Edward Bullough's excellent notion of "psychical distance" (of which more will be said later) would probably not have been recognized as an important principle in music or ceramic art, but the peculiar problems of drama required such a concept. Even if it had not proved to be universally applicable, it would be valid in its original domain. (See " 'Psychical Distance' as a Factor in Art and as an Aesthetic Principle," *British Journal of Psychology,* vol. 5, part II, pp. 87–118, 1912.)

so it is unavoidable that a good many theories have to be weighed in considering it. In the course of all this reflection and controversy, the problem of the nature and function of music has shifted its center several times; in Kant's day it hinged on the conception of the arts as cultural agencies, and concerned the place of music among these contributions to intellectual progress. On this basis the great worshiper of reason naturally ranked it lowest of all art-forms.[10] The Darwinians of later days sought the key to its importance in its origins; if it could be proved—or at least, imagined—to have survival value, or even to be the residue of some formerly useful instinct or device, its dignity was saved, even if our interest in it now were only what William James took it to be—"a mere incidental peculiarity of the nervous system, with no teleological significance."[11] Helmholtz, Wundt, Stumpf, and other psychologists to whom the existence and persistence of music presented a problem, based their inquiries on the assumption that music was a form of *pleasurable sensation*, and tried to compound the value of musical compositions out of the "pleasure-elements" of their tonal constituents. This gave rise to an aesthetic based on liking and disliking, a hunt for a sensationist definition of beauty, and a conception of art as the satisfaction of taste; this type of art theory, which of course applies without distinction to all the arts, is "aesthetic" in the most literal sense, and its exponents today are rather proud of not overstepping the limits of the field so defined.[12] But beyond a description of tested pleasure-displeasure reactions to simple sounds or elementary sound-complexes, and certain observations on people's tastes in musical selections, this approach has not taken us; it seems to be an essentially barren adventure.

Another kind of reaction to music, however, is more striking, and seems more significant: that is the *emotional* response it is commonly supposed to evoke. The belief that music arouses emotions goes back even to the Greek philosophers. It led Plato to demand, for his ideal state, a strict censorship of modes and tunes, lest his citizens be tempted by weak or voluptuous airs to indulge in demoralizing emotions.[13] The same principle is often invoked to explain the use of music in tribal society, the lure of the African drum, the clarion call and the "Pibroch" calling armies or clans to battle, the world-old custom of lulling the baby to sleep with slumber songs. The legend of the

10 See the excerpt from Kant's *Kritik der Urteilskraft* [*Criticism of the Power of Judgment*, Ed.] in F. M. Gatz's source-book, *Musik-Aesthetik*, 1929, p. 53.
11 *Principles of Psychology*, 2 vols., 1890. See vol. II, p. 419. His words refer directly to fear-reactions in high places, which, he says, in this respect resemble "liability to sea-sickness, or love of music."
12 Thus Clive Bell, having proposed the concept of "significant form" as the keynote of art criticism, says: "At this point a query arises . . . : 'Why are we so profoundly moved by forms related in a particular way?' The question is extremely interesting, but irrelevant to aesthetics. In pure aesthetics we have only to consider our emotion and its object."
If questions about the *relation* between emotion and object are irrelevant, what is there to "consider" about these factors?
13 *Republic*, bk. iii.

sirens is based on a belief in the narcotic and toxic effect of music, as also the story of Terpander's preventing civil war in Sparta, or of the Danish King Eric, who committed murder as a result of a harpist's deliberate experiment in mood-production.[14] Despite the fact that there is, to my knowledge, not a single authentic record of any specific change of disposition or intention, or even the inhibition of a practical impulse in any person by the agency of music, this belief in the physical power of the art has come down to modern times. Music is known, indeed, to affect pulse-rate and respiration, to facilitate or disturb concentration, to excite or relax the organism, *while the stimulus lasts*; but beyond evoking impulses to sing, tap, adjust one's step to musical rhythm, perhaps to stare, hold one's breath or take a tense attitude, music does not ordinarily influence behavior.[15] Its somatic influences seem to affect unmusical as well as musical persons (the selections usually employed in experimentation would be more likely to irritate than to soothe or inspire a musical person), and to be, therefore, functions of *sound* rather than of *music*.[16] Experiments made with vocal music are entirely unreliable, since words and the pathos of the human voice are added to the musical stimulus. On the whole, the behavior of concert audiences after even the most thrilling performances makes the traditional magical influence of music on human actions very dubious. Its somatic effects are transient, and its moral hangovers or uplifts seem to be negligible.

Granting, however, that the effects do not long outlive their causes, the proposition that music arouses emotions in the listener does not seem, offhand, like a fantastic or mythical assertion. In fact, the belief in the affective power of music is respectable enough to have led some very factual-minded modern psychologists to conduct tests for the emotional effects of different compositions and collect the reported data. They have compiled lists of possible "effects," such as:

Sad	Rested
Serious	Amused
Like dancing	Sentimental
Stirred, excited	Longing

[14] These and other stories are cited by Irmgard Otto in an essay, "Von sonderbahrer Würckung und Krafft der Musik" [*On the Strange Effects and Power of Music*," Ed.], *Die Musik*, vol. 29, part II, pp. 625–630, 1937.

[15] For an exhaustive treatment of the physical and mental effects of music, see the dissertation by Charles M. Disserens, *The Influence of Music on Behavior*, 1926. Dr. Disserens accepts much evidence that I would question, yet offers no report of practical acts inspired by music, or even permanent effects on temperament or disposition, such as were claimed for it in the eighteenth century. (Cf., e.g., *Reflections on Ancient and Modern Musick, with Application to the Cure of Diseases* (Anon., 1749); or Albrecht's *De Effectu Musices in Corpus Animatum*.)

[16] An often neglected distinction pointed out in Ernst Kurth's *Musikpsychologie*, p. 152. Kurth observes that Stumpf, working deliberately with unmusical rather than musical persons, gave us a *Tonpsychologie* but not a *Musikpsychologie*.

| Devotional | Patriotic |
| Gay, happy | Irritated |

The auditors of certain musical selections, which were usually of the so-called "semi-popular" sort (e.g. MacDowell's *To a Wild Rose,* Sousa's *Volunteer March*), were given prepared data-sheets and asked to check their musically stimulated feelings with the rubrics there suggested.[17]

The results of such experiments [18] add very little to the well-known fact that most people connect feelings with music, and (unless they have thought about the precise nature of that connection) believe they *have* the feelings while they are under the influence of the music, especially if you ask them which of several feelings the music is giving them. That quick, lilting tunes are said to make one feel happy or "like dancing," hymns to make one solemn, and funeral marches sad, is hardly surprising; nor that *Love's Old Sweet Song* was generally said to stir "tender memories." The whole inquiry really took for granted what Charles Avison, a British musicologist and organist, said without experimental evidence in 1775: that "the force of sound in alarming the passions is prodigious," and that music "does naturally raise a variety of passions in the human breast, similar to the sounds which are expressed; and thus, by the musician's art, . . . we are by turns elated with joy, or sunk in pleasing sorrow, rouzed to courage, or quelled by grateful terrors, melted into pity, tenderness, and love, or transported to the regions of bliss, in an extacy of divine praise." [19]

The terms "pleasing sorrow" and "grateful terrors" present something of a puzzle. If music really grieves or frightens us, why do we listen to it? The modern experimenters are not disturbed by this question, but Avison felt called upon to meet it. The sorrows and terrors of music, he explained, are not our own, but are sympathetically felt by us; "There are certain sounds natural to joy, others to grief or despondency, others to tenderness and love; and by hearing *these,* we naturally sympathize with those who either enjoy or suffer." [20]

But if we are moved by sympathy, with whom are we sympathizing? Whose

[17] See Esther Gatewood, "The Nature of Musical Enjoyment," in *The Effects of Music,* edited by Max Schoen, 1927.
[18] These results were, of course, not spontaneous, since the questionnaire directed the subjects' expectations to a special kind of experience which is popularly supposed to result from hearing music, and moreover dictated a *choice,* which made it necessary to attribute some particular feeling wholly, or preëminently, to any given piece. Fleeting affects, superseded by others, could not be checked off without creating a wrong impression; only general states of feeling were supposed to result, and were therefore dutifully reported.
 Essentially the same technique is employed by Kate Hevner; see her "Expression in Music: Discussion of Experimental Studies and Theories," *Psychological Review,* vol. 42, no. 2, pp. 186–204, 1935, and "Experimental Studies of the Elements of Expression in Music," *American Journal of Psychology,* vol. 48, no. 2, pp. 246–268, 1936.
[19] *An Essay on Musical Expression,* 1775, pp. 3–4.
[20] *Loc. cit.* See also p. 5n.

feelings do we thus appreciate? The obvious answer is: the musician's. He who produces the music is pouring out the real feelings of his heart. Music is his avenue of self-expression, he confesses his emotions to an audience, or—in solitude—just works them off to relieve himself. In an age when most performers offered their own compositions or even improvisations, this explanation of music was quite natural. Rousseau, Marpurg, Mattheson, C. Ph. E. Bach, were all convinced that (as Bach put it) "since a musician cannot otherwise move people, but he be moved himself, so he must necessarily be able to induce in himself all those affects which he would arouse in his auditors; he conveys his feelings to them, and thus most readily moves them to sympathetic emotions." [21] The problem was somewhat complicated by the growing distinction between composers and performers toward the end of the century; but here the reciprocity of expression and impression came to the rescue. The composer is, indeed, the original subject of the emotions depicted, but the performer becomes at once his confidant and his mouthpiece. He transmits the feelings of the master to a sympathetic audience.

In this form the doctrine has come down to our day, and is widely accepted by musicians and philosophers alike. From Rousseau to Kierkegaard and Croce among philosophers, from Marpurg to Hausegger and Riemann among music critics, but above all among musicians themselves—composers, conductors, and performers—we find the belief very widely disseminated that music is an emotional catharsis, that its essence is self-expression. Beethoven, Schumann, Liszt, to mention only the great, have left us testimonials to that effect. Moreover, it is the opinion of the average sentimental music-lover that all moving and poignant music must translate some personal experience, the longing or ecstasy or despair of the artist's own *vie amoureuse;* [22] and most musical amateurs will accept without hesitation the statement of Henri Prunières, who says categorically that whatever feelings a composer may convey, "we may rest assured that he will not express these sentiments with authority unless he has experienced them at some given moment of his existence." [23] Most likely they will even go so far as to agree that, in the case of a theme which Beethoven used ten years after he had first jotted it down, "It is probable that such a theme, translating an impression of keenest sorrow, came to him during a day of suffering." [24] The self-expression theory, which classes

[21] *Versuch ueber die wahre Art, das Klavier zu spielen* [*Experiment in the True Art of Playing the Clavier*, Ed.] (1925, reprint from 2nd ed.; 1st ed., part I, 1753, part II, 1762). See part I, p. 85. For a detailed study of this early theory, see Wilhelm Caspari's dissertation, *Gegenstand und Wirkung der Tonkunst nach der Ansicht der Deutschen im 18. Jahrhundert* [*The Subject Matter and Effect of Music in Germany in the Nineteenth Century,* Ed.] (1903). For extensive source-material, see Gatz, *Musik-Aesthetik.*
[22] Love-life. [Ed.]
[23] "Musical Symbolism," *Musical Quarterly,* vol. 19, no 1, pp. 18–28, 1933. See p. 20.
[24] *Ibid.,* p. 21.

191 ON SIGNIFICANCE IN MUSIC

music with "such expressions as 'oh-oh,' or at a higher level, lyrical verses," as Carnap says, is the most popular doctrine of the significance and function of music.[25] It explains in a very plausible way the undeniable connection of music with feeling, and the mystery of a work of art without ostensible subject-matter; above all, it brings musical activity within the compass of modern psychology—behavioristic, dynamic, genetic, or what not.

Yet the belief that music is essentially a form of self-expression meets with paradox in very short order; philosophically it comes to a stop almost at its very beginning. For the history of music has been a history of more and more integrated, disciplined, and articulated *forms*, much like the history of language, which waxes important only as it is weaned from its ancient source in expressive cries, and becomes denotative and connotative rather than emotional. We have more need of, and respect for, so-called "pure music" than ancient cultures seem to have had;[26] yet our counterpoints and harmonic involutions have nothing like the expressive abandon of the Indian "Ki-yi" and "How-how," the wailing primitive dirge, the wild syncopated shouts of African tribesmen. *Sheer self-expression requires no artistic form.* A lynching-party howling round the gallows-tree, a woman wringing her hands over a sick child, a lover who has just rescued his sweetheart in an accident and stands trembling, sweating, and perhaps laughing or crying with emotion, is giving vent to intense feelings; but such scenes are not occasions for music, least of all for composing. Not even a theme, "translating an impression of keenest sorrow," is apt to come to a man, a woman, or a mob in a moment when passionate self-expression is needed. The laws of emotional catharsis are natural laws, not artistic. Verbal responses like "Ah!" "Oh-oh!" are not creations, but speech-habits; even the expressiveness of oaths rests not on the fact that such words were invented for psycho-cathartic purposes, but that they are taboo, and the breaking of a taboo gives emotional release. Breaking a vase would do better still.

Yet it may well be argued that in *playing* music we seek, and often find, self-expression. Even Hanslick, to whom emotive *meanings* in a composition were anathema, granted the possibility of relieving one's feelings at the keyboard;[27] and anyone who has a voice or an instrument can verify the relief of musical outpourings, from his own experience. Surely, at some time, he has been moved to vent his excitement in song or rhapsody or furious

[25] Even our leading psychologists subscribe to this conviction: "To be successful the musician must carry his audience on a wave of emotion often bordering on the point of ecstasy." This from Carl Seashore, who prides himself on his strict investigation of facts, not "the rehashing of semi-scientific knowledge under the name of philosophy in aesthetics"! (See *Psychology of Music*, 1938, pp. 174, 377.)
[26] Cf. Eduard Hanslick, *Vom Musikalisch-Schönen* [*The Beautiful in Music*, Ed.], 5th ed. 1876; 1st ed. 1854, p. 103; also Ferruccio Busoni, *Entwurf einer neuen Aesthetik der Tonkunst* [*Toward a New Aesthetic of Music*, Ed.], 1907, p. 5.
[27] *Op. cit.*, pp. 78–79.

tarantelle, and felt better for the manic outburst; and, being "keyed up," he probably sang or played unusually well. He chose the piece because it seemed to "express" his condition. It seemed to him, at least at the time, that the piece was designed to speak his feelings, and not impossibly he may believe forever after that these must be the very feelings the composer intended to record in the score.

The great variety of interpretations which different players or auditors will give to one and the same piece—differences even of such general feeling-contents as sad, angry, elated, impatient—make such confidence in the author's intentions appear somewhat naive. He could not possibly have been feeling all the different emotions his composition seems to be able to express. The fact is, that we can *use* music to work off our subjective experiences and restore our personal balance, but this is not its primary function. Were it so, it would be utterly impossible for an artist to announce a program in advance, and expect to play it well; or even, having announced it on the spot, to *express himself* successively in *allegro, adagio, presto,* and *allegretto,* as the changing moods of a single sonata are apt to dictate. Such mercurial passions would be abnormal even in the notoriously capricious race of musicians!

If music has any significance, it is semantic, not symptomatic. Its "meaning" is evidently not that of a stimulus to evoke emotions, nor that of a signal to announce them; if it has an emotional content, it "has" it in the same sense that language "has" its conceptual content—*symbolically.* It is not usually derived *from* affects nor intended *for* them; but we may say, with certain reservations, that it is *about* them. Music is not the cause or the cure of feelings, but their *logical expression;* though even in this capacity it has its special ways of functioning, that make it incommensurable with language, and even with presentational symbols like images, gestures, and rites.

Many attempts have been made to treat music as a language of emotions. None has been really satisfactory, though some of them are both searching and well-directed. An extraordinary amount of able thinking has been expended on the philosophy of music, and the only stumbling-block which has held up the progress of this central problem of "significant form" has been, I think, a lack of understanding of the ways in which logical structures may enter into various types of "significance." Practically all the work has been done; the anomalies and puzzles that remain, though very baffling, are mainly due to logical misconceptions, or slightly naive assumptions which only a logician could be expected to recognize as such. Here we run into a difficulty inherent in the scholarship of our time—the obstacle of *too much knowledge,* which forces us to accept the so-called "findings" of specialists in other fields, "findings" that were not made with reference to our searchings, and often

leave the things that would be most important for us, unfound. Riemann, for instance, declared with perfect confidence that musical aesthetics may and must accept the laws of logic and the doctrines of logicians as given.[28]

But it happens that just in musical aesthetics the vital problem with which we are faced is one that involves the entire logic of symbolism. It is a logical problem of art, and no logician would be likely to search, in his own interest, for the "findings" that are relevant to it. It concerns the logical structure of a type of symbol that logicians do not use, and would therefore not even stumble upon as an interesting freak. In short, we are dealing with a *philosophical* problem, requiring logical study, and involving music: for to be able to define "musical meaning" adequately, precisely, but *for an artistic, not a positivistic context and purpose*, is the touchstone of a really powerful philosophy of symbolism.

For the sake of orientation, let us now explicitly abandon the problems of music as stimulus and music as emotive symptom, since neither of these functions (though both undoubtedly exist) would suffice to account for the importance we attach to it; and let us assume that its "significance" is *in some sense* that of a symbol. The challenge to our theory, then, is to determine *in what sense* this can be said; for it is certainly not true in every sense. The question takes us back to Chapter 3, to the logic of symbols and the various possibilities of meaning that symbolic structures may contain. Here we should find the conditions for a "language of music" if such there be, or of "significant form" of any other sort than language.

The assumption that music is a kind of language, not of the here-and-now, but of genuine conceptual content, is widely entertained, though perhaps not as universally as the emotive-symptom theory. The best-known pioneer in this field is Schopenhauer; and it has become something of an accepted verdict that his attempt to interpret music as a symbol of the irrational aspect of mental life, the Will, was a good venture, though of course his conclusion, being "metaphysical," was quite bad. However that may be, his novel contribution to the present issue was certainly his treatment of music as an impersonal, negotiable, real semantic, a symbolism with a content of ideas, instead of an overt sign of somebody's emotional condition. This principle was quickly adopted by other thinkers, though there was considerable debate as to what ideational content was embodied in the language of tones. Indeed, one author lists no less than sixteen interpretations, including "the expression of the Freedom of the Will" and "the expression of Conscience." [29]

The most obvious and naive reading of this "language" is the onomatopoetic

[28] Hugo Riemann, *Die Elemente der musikalischen Aesthetik,* 1903, p. 3.
[29] Colin McAlpin, *Hermaia: A Study in Comparative Esthetics,* 1915. See his table of contents.

one, the recognition of natural sounds in musical effects. This, as everybody knows, is the basis of "program music," which deliberately imitates the clatter and cries of the market place, hoof-beats, clanging hammers, running brooks, nightingales and bells and the inevitable cuckoo. Such "sound-painting" is by no means modern; it goes back as far as the thirteenth century, when the cuckoo's note was introduced as a theme in the musical setting of "Sumer is acumen in." [30] An eighteenth-century critic says disapprovingly, "Our intermezzi . . . are full of fantastic imitations and silly tricks. There one can hear clocks striking, ducks jabbering, frogs quacking, and pretty soon one will be able to hear fleas sneezing and grass growing." [31] But its early uses were frankly tricks, like Bach's figure on the letters of his name, B-A-C-H (to a German, B♭-A-C-B♮). Only with the development of opera and oratorio, the orchestra was called upon to furnish *sounds* appropriate to certain scenes. In Haydn's *Creation* the prancing horses and sinuous worms merely furnish musical figures with technical possibilities, like the traditional cuckoos and cocks, but the waters over the earth are certainly used with the serious intent of building up a thought with the sound-effect. In Bach's *Passion According to St. Matthew* the orchestra registers the rending of the temple curtain in midst of an unmistakable musical storm. From this time onward, sound-painting increases until the romantic symphony may require a whole outfit of wooden rattles, cowbells, whistles, even sound-recordings and a wind-machine.[32] A veritable code of "effects" grew up, helped by the more and more detailed and indispensable program notes. Finally, as an eminent *New York Times* critic says, "Strauss, in the heyday of his programmatic frenzy, went so far as to declare that a day would come when a composer could compose the silverware on the table so that the listener could distinguish the knives from the forks." [33]

But not all conceptions of musical semantic were thus naive and literal. Side by side with the evolution of sound-painting runs the development of "dramatic" music in a more subjective sense—music that is intended, and taken, to be a *language of feeling.* Not silverware, nor even parades and thunderstorms, are the objects of musical representation here, but love and longing, hope and fear, the essence of tragedy and comedy. This is not "self-expression"; it is *exposition* of feelings which may be attributed to persons on the stage or fictitious characters in a ballad. In pure instrumental music without dramatic action, there may be a high emotional import which is not referred to any

[30] Cf. Richard Aldrich, *Musical Discourse*, 1928, p. 25.
[31] J. A. Hüller, "Abhandlung von der Nachahmung der Natur in der Musik" ["A Discussion of the Imitation of Nature in Music," Ed.], in Marpurg's *Historisch-kritische Beyträge zur Aufnahme der Musik,* 5 vols., 1754–1760. See vol. I, p. 532.
[32] Respighi's *The Pines of Rome* features a phonograph record of a nightingale's song; Strauss' *Alpine Symphony* calls for the "wind-machine."
[33] Aldrich, *op. cit.*, p. 15.

subject, and the glib assurance of some program writers that this is the com-
poser's protest against life, cry of despair, vision of his beloved, or what not,
is a perfectly unjustified fancy; for if music is really a language of emotion,
it expresses primarily the composer's *knowledge of human feeling*, not how or
when that knowledge was acquired; as his conversation presumably ex-
presses his knowledge of more tangible things, and usually not his first experi-
ence of them.

This is the most persistent, plausible, and interesting doctrine of meaning
in music, and has lent itself to considerable development; on the theoretical
side by Kretschmar, E. v. Hartmann, more recently Schweitzer and Pirro, and
on the practical side by Schumann, Wagner, Liszt, Berlioz (who have all left
us theoretical statements as well), and many others. From Wagner I take what
may be the most explicit rendering of the principle:

*What music expresses, is eternal, infinite and ideal; it does not express the passion,
love, or longing of such-and-such an individual on such-and-such an occasion, but
passion, love or longing in itself, and this it presents in that unlimited variety of
motivations, which is the exclusive and particular characteristic of music, foreign and
inexpressible to any other language.*[34]

Despite the romantic phraseology, this passage states quite clearly that music
is not self-expression, but *formulation and representation* of emotions, moods,
mental tensions and resolutions—a "logical picture" of sentient, responsive life,
a source of insight, not a plea for sympathy. Feelings revealed in music are
essentially *not* "the passion, love or longing of such-and-such an individual,"
inviting us to put ourselves in that individual's place, but are presented directly
to our understanding, that we may grasp, realize, comprehend these feelings,
without pretending to have them or imputing them to anyone else. Just as
words can describe events we have not witnessed, places and things we have
not seen, so music can present emotions and moods we have not felt, passions
we did not know before. Its subject-matter is the same as that of "self-expres-
sion," and its symbols may even be borrowed, upon occasion, from the realm
of expressive symptoms; yet the borrowed suggestive elements are *formalized*,
and the subject-matter "distanced" in an artistic perspective.

The notion of "psychical distance" as the hall-mark of every artistic "pro-
jection" of experience, which Edward Bullough has developed, does not make
the emotive contents typical, general, impersonal, or "static"; but it makes them
conceivable, so that we can envisage and understand them without verbal
helps, and without the scaffolding of an occasion wherein they figure (as all

34 Richard Wagner, "Ein glücklicher Abend" ["A Happy Evening," Ed.], reprinted by Gatz, in *Musik-
Aesthetik*, from the *Gazette Musicale*, nos. 56–58, 1841.

self-expression implies an occasion, a cause—true or imaginary—for the subject's temporary feelings). A composer not only indicates, but *articulates* subtle complexes of feeling that language cannot even name, let alone set forth; he knows the forms of emotion and can handle them, "compose" them. We do not "compose" our exclamations and jitters.

The actual opposition between the two emotive theories of musical meaning—that of self-expression and that of logical expression—is best summed up by contrasting the passage from C. Ph. E. Bach, already quoted on page 190, to the effect that "a musician cannot otherwise move people, but he be moved himself," and always "conveys his feelings to them, and thus most readily moves them to sympathetic emotion," with Busoni's statement:

Just as an artist, if he is to move his audience, must never be moved himself—lest he lose, at that moment, his mastery over the material—so the auditor who wants to get the full operatic effect must never regard it as real, if his artistic appreciation is not to be degraded to mere human sympathy.[35]

This degradation is what Bullough would call a loss of "psychical distance." It is, in fact, a confusion between a symbol, which lets us *conceive* its object, and a sign, which causes us to *deal with* what it means.

Distance . . . is obtained by separating the object and its appeal from one's own self, by putting it out of gear with practical needs and ends. But . . . distance does not imply an impersonal, purely intellectually interested relation. . . . On the contrary, it describes a personal *relation, often highly emotionally colored, but* of a peculiar character. *Its peculiarity lies in that the personal character of the relation has been, so to speak, filtered. It has been cleared of the practical, concrete nature of its appeal. . . .*[36]

The content has been *symbolized* for us, and what it invites is not emotional response, but *insight*. "Psychical Distance" is simply the experience of apprehending through a symbol what was not articulated before. The content of art is always real; the mode of its presentation, whereby it is at once revealed and "distanced," may be a fiction. It may also be music, or, as in the dance, motion. But if the content be the life of feeling, impulse, passion, then the symbols which reveal it will not be the sounds or actions that normally would *express* this life; not associated signs, but *symbolic forms* must convey it to our understanding.

Very few writers who assign significance of any sort to music have kept these several kinds of meaning strictly apart. Literal meanings—the render-

[35] Busoni, *Entwurf einer neuen Aesthetik der Tonkunst,* here quoted from Gatz, *op. cit.,* p. 498.
[36] Bullough, "Psychical Distance," p. 91.

ings of birds and bells and thunder and the Twentieth Century Limited by orchestral instruments—are usually mixed up in a vague way with emotive meanings, which they are supposed to support, or even to inspire by suggestion. And emotions, in turn, are treated now as effects, now as causes, now as contents of so-called "emotive music." Even in Wagner, who stated explicitly the abstractive, generalizing function of music in depicting feelings, there is plenty of confusion. In describing his own *furor poeticus* he presents himself as expressing his personal sentiments and upheavals. In *Oper und Drama* he says that operatic music must express the sentiments *of the speaker and actor* (*"des Redenden und Darstellenden,"* not *"des redend Dargestellten"*).[37] Yet it is perfectly clear that the "poetic intention" (*"die dichterische Absicht"*) which is the *raison d'être* of the work is not to give the actors self-expression, nor the audience an emotional orgy, but is to *put over*, to make conceivable, a great insight into human passional nature. And again, in the same work, he refers to the tragic fate of Beethoven as an inability to communicate his private feelings, *his* sufferings, to the curious but unmoved listener who could not understand him.[38]

So it was that, when Hanslick wrote his famous little book *Vom Musikalisch-Schönen*, which attempted to blast the growing romantic conception of a "language of music," he found himself called upon to combat not only the use of onomatopoeia, the hoofbeats of Wagner's riding Valkyries and the thunderpeals that announce the wreck of the Flying Dutchman, but also the production, exhibition, or symbolic representation of emotions—the moan and tremolo of the orchestra, the surging outbursts of Tristan and Isolde. Against all these alleged "expressive functions" of music the great purist mustered his arguments. Vehemently he declared that music conveys no meanings whatever, that the content of music is nothing but dynamic sound-patterns (*"tönend bewegte Formen"*),[39] and that "the theme of a musical composition in its proper content."[40] But especially the true Wagnerian aim—the *semantic* use of music, the *representation* of emotive life—aroused his opposition.

It is no mere fencing with words, he declares at the very outset, "to protest most emphatically against the notion of 'representation,' because this notion has given rise to the greatest errors of musical aesthetics. To 'represent' something always involves the conception (Vorstellung) of two separate, distinct things, one of which must first be given, by a specific act, an explicit relation of reference to the other.[41]

Music, in his estimation, can never be used in this degrading fashion.

[37] Here quoted from Gatz, *op. cit.*, p. 166.
[38] *Ibid.*, p. 172.
[39] Hanslick, *Vom Musikalisch-Schönen*, p. 45.
[40] *Ibid.*, p. 136.
[41] *Ibid.*, introd., p. viii.

His statement of the conditions for representation can, of course, be challenged in the light of a better knowledge of symbolism. What he says applies generally to literal, especially to scientific, expression; but it is not true of some other modes, which serve rather to formulate knowledge than to communicate its finished products. Yet there is justice, in his protest, too; for the claim of his adversaries to a *language of music* is indeed a misleading one, which may well do mischief among musicians and audiences alike.

Those claims, just like Hanslick's counter-claims, invite logical criticism. So, instead of wrangling over this or that alleged "meaning," let us look at music from the purely logical standpoint as a possible symbolic form of some sort. As such it would have to have, first of all, formal characteristics which were analogous to whatever it purported to symbolize; that is to say, if it represented anything, e.g. an event, a passion, a dramatic action, it would have to exhibit a *logical form* which that object could also take. Everything we conceive is conceived in some form, though there are alternative forms for every content; but the musical figure which we recognize as such must be *a* figuration under which we could apprehend the thing referred to.

That musical structures logically resemble certain dynamic patterns of human experience is a well-established fact. Even Hanslick admitted as much, perhaps with less scientific backing than our modern theorists can claim; for what in his day was a psychological assumption for the sake of musical understanding, has become, in ours, a psychological doctrine aptly illustrated by musical examples. Wolfgang Köhler, the great pioneer of Gestalt psychology, remarks the usefulness of so-called musical "dynamics" to describe the forms of mental life. "Quite generally," he says, "the inner processes, whether emotional or intellectual, show types of development which may be given names, usually applied to musical events, such as: *crescendo* and *diminuendo*, *accelerando* and *ritardando*." He carries these convenient terms over into the description of overt behavior, the reflection of inner life in physical attitudes and gestures.

As these qualities occur in the world of acoustical experiences, they are found in the visual world too, and so they can express similar dynamical traits of inner life in directly observable activity. . . . To the increasing inner tempo and dynamical level there corresponds a crescendo *and* accelerando *in visible movement. Of course, the same inner development may express itself acoustically, as in the* accelerando *and* reforzando *of speech. . . . Hesitation and lack of inner determination become visible . . . as* ritardando *of visible or audible behavior. . . .*[42]

This is just the inverse of Jean D'Udine's description of music, which treats

42 Köhler, *Gestalt Psychology*, pp. 248–249.

it as a kind of gesture, a tonal projection of the forms of feeling, more directly reflected in the mimic "dance" of the orchestral conductor. "All the expressive gesticulations of the conductor," says that provocative and readable book, *L'art et le geste,* "is really a dance . . . all music is dancing. . . . All melody is a series of attitudes." [43] And again: "Every feeling contributes, in effect, certain special gestures which reveal to us, bit by bit, the essential character-istic of Life: movement. . . . All living creatures are constantly consummat-ing their own internal rhythm." This rhythm, the essence of life, is the steady background against which we experience the special articulations produced by feeling; "and even the most uneventful life exhibits some such breaks in its rhythm, sources of joys and sorrows without which we would be as inert as the pebbles of the highway." [44] And these rhythms are the prototypes of musical structures, for all art is but a projection of them from one domain of sense to another, a symbolic transformation. "Every artist is a transformer; all artistic creation is but a transmutation." [45]

Just as Köhler uses the language of musical dynamics to express psychologi-cal phenomena, on the basis of their formal analogy, so D'Udine makes move-ment the prototype of vital forms and thus reduces all the arts to "a kind of dance" (this analogy with life-functions, both lower and higher, was made long ago by Havelock Ellis in *The Dance of Life*); and so the musicologist von Hoeslin likens dance, plastic art, thought, and feeling to music by reason of that same analogy. The fundamental relationships in music, he says, are *tensions and resolutions;* and the patterns generated by these functions are the patterns exemplified in all art, and also in all emotive responses. Wherever sheer contrasts of ideas produce a reaction, wherever experiences of pure form produce mental tension, we have the essence of *melody;* and so he speaks of *Sprachmelodien* [46] in poetry and *Gedankenmelodien* [47] in life.[48] More natural-istically inclined critics often mediate the comparison between the forms of music and those of feeling, by assuming that music exhibits patterns of ex-citation occurring in the nervous tissues, which are the physical sources of emotion; [49] but it really all comes to the same thing. The upshot of all these speculations and researches is, that there are certain aspects of the so-called "inner life"—physical or mental—which have formal properties similar to those

[43] Jean D'Udine, *L'art et le geste,* p. xiv, 1910.
[44] *Ibid.,* p. 6.
[45] *Ibid.,* p. xii.
[46] Speech-melody. [Ed.]
[47] Thought-melody. [Ed.]
[48] J. K. v. Hoeslin, *Die Melodie als gestaltender Ausdruck seelischen Lebens* [*Melody as Forming an Expression of the Soulful Life,* Ed.], 1920.
[49] Both Köhler and Koffka subscribe to this notion of the "physiological picture," of which we see, according to them, not some external duplicate, but the actual outward aspects of a total bodily state or activity. The same standpoint was already defined by C. Beauquier in his *Philosophie de la musique* in 1865, and by subsequent authors too numerous to cite.

of music—patterns of motion and rest, of tension and release, of agreement and disagreement, preparation, fulfilment, excitation, sudden change, etc.

So the first requirement for a connotative relationship between music and subjective experience, a certain similarity of logical form, is certainly satisfied. Furthermore, there is no doubt that musical forms have certain properties to recommend them for symbolic use: they are composed of many separable items, easily produced, and easily combined in a great variety of ways; in themselves they play no important practical role which would overshadow their semantic function; they are readily distinguished, remembered, and repeated; and finally, they have a remarkable tendency *to modify each other's characters in combination*, as words do, by all serving each as a context.[50] The purely structural requirements for a symbolism are satisfied by the peculiar tonal phenomenon we call "music."

Yet it is not, logically speaking, a language, for it has no vocabulary. To call the tones of a scale its "words," harmony its "grammar," and thematic development its "syntax," is a useless allegory, for tones lack the very thing that distinguishes a word from a mere vocable: fixed connotation, or "dictionary meaning." Moreover, a tone has many aspects that enter into the notion of musical significance, but not of harmony. These aspects have been minutely and seriously studied from a psychological standpoint, in ways that fairly well exclude non-musical factors such as personal associations with tunes, instruments, styles (e.g. church music, military music), or programmatic suggestions. In a remarkably able and careful work,[51] Dr. Kurt Huber has traced the successive emergence of expressive factors in the apprehension of the simplest possible tonal patterns—bare pitch-patterns of two to three tones, stripped of all contextual elements of timbre, rhythm, volume, etc., by their uniform production on an electrical instrument, in timed succession and equal strength. The subjects were instructed to describe their experiences in any terms they chose: by their qualities, relations, meanings, emotional characters, somatic effects, associations, suggestions, or what-not. They were asked to report any images or memories evoked, or, failing such experiences, simply to convey their impressions as best they could. This form of experiment is certainly much more controlled and decisive than the Schoen and Gatewood question-

[50] A. Gehring carried this principle of *contextual function* even beyond the compass of the individual composition. "Unrelated compositions," he said, "will affect one another as inevitably as those which are related. The whole realm of music may be regarded as a single huge composition, in which every note that is written exerts its influence throughout the whole domain of tones. To speak with Guyau, . . . it changes the very conditions of beauty.

"This explains the different effects produced by the same composition at different times. The harmonies which sound novel today will be familiar in a few decades; the volume and richness of sound which pleased our ancestors are inadequate today." (*The Basis of Musical Pleasure*, 1910, p. 34.)

Gehring's observation bears out the similarity with language, where every word that is used even in a narrow context contributes its meaning, as there established, to the living and growing language.

[51] *Der Ausdruck musikalischer Elementarmotive. Eine experimental-psychologische Untersuchung* [*The Elementary Motive of Musical Expression. An Inquiry in Experimental Psychology*, Ed.], 1923.

naires on the influence of musical selections; and the results of Huber's ex-
periments, which might be expected to be poorer, by reason of the simplicity
of the material and lack of specific instructions, are actually much more sig-
nificant and more capable of systematic arrangement than the emotive-value
statistics. They may be briefly summarized as follows:

1 The lowest stage of tone-apprehension yields merely an impression of *tone-color*
of the whole tonal complex, or of a difference between tone-colors of the separate
tones.

2 Meanings conveyed by such a mere impression of tonal brightness always involve
states or qualities or their changes, i.e. *passive* changes. Imagination of an *event* does
not occur without an impression of *tonal movement*.

3 The most primitive factor in the perception of tonal movement is a sense of its
direction. This according to the author, "constitutes the point of departure of that
psychological symbolism of figures (*psychische Gestaltsymbolik*) which we encounter
in the tendency to relate musical motives to sentiments."

4 The apprehension of a *width of tonal intervals* is independent of this sense of
direction; and "all spatial symbolism in the interpretation of motives has its roots in
this impression of inter-tonal distance."

5 The idea of a *musical step* requires a joint perception of tonal distance and
direction. "We are not saying too much if we make all the higher psychical interpre-
tation directly dependent on the grasping of *interval-forms*, or at least view them as
mediately related to these."

6 Impressions of consonance, dissonance and relatedness (*Zusammengehörigkeit*)
require the notion of a musical step, or progression (simultaneous tones were not
given; the inquiry rested on *melodic* elements).

7 Tones taken as related may then be referred to a tonic, either chosen among them
or "understood," i.e. imaginatively supplied by the auditor (this orientation is most

forcibly suggested by the perfect fourth, e.g. ♪♪ , which connotes

almost irresistibly the setting: ♪♪).

8 Reference to a tonic determines the feeling of modality; for instance,

♪♪ connotes a different modality if taken as ♪♪

from what it would as ♪♪ .

9 A subjective accent may simply fall upon the tone which is harmonically more

important as the hearer has organized the interval; it may, but need not, suggest a rhythmic structure.

10 Subjective rhythmatization, when it occurs, is built upon mental accentuation.

Since such mental accentuation may occur without any actual emphasis (as in these experiments it necessarily did), the problem of rhythm in music as we know it is immensely complicated, and cannot be solved by mere reference to the drum and footfall of dancing hordes. In fact, Huber distinguishes between such purely temporal *measure*, and "musical rhythm," which latter results from the internal, tonal organization of the motif.[52]

The entire study shows effectively how many factors of possible expressive virtue are involved in even the simplest musical structure, how many things beside the acknowledged materials of composition have crucial functions in conveying a musical message. One may argue that voice-inflections enter into the "expressiveness" of speech, too; but the fact is that the verbal message may be understood apart from these. They do not alter the content of a statement, which is uniquely determined by vocabulary and syntax, but at most they may affect one's reaction to the statement. Musical semantic factors, however, have never been isolated; even the efforts of Schweitzer [53] and Pirro [54] to trace the "emotional vocabulary" of Bach by correlating musical figures with the words he usually sets to them, interesting though they are, show us certain associations in Bach's mind, perhaps also accepted conventions of his day or his school, rather than musical laws of expression. Such precise interpretations of separate figures are inconclusive because, as Huber remarked in his direct psychological study, "It is impossible to determine the absolute expressive value of separate intervals (third, fifth, etc.) because their absolute pitch affects the brightness of their constituents and therewith their qualities of contrast, apprehensibility, etc." [55] That there are tonal figures derived from natural rhythms, that upward and downward direction, pendular motion, etc., may be musically "imitated," that melodic lines may suggest sobs, whimpers, or yodelers, need not be reiterated here; such general classifications [56] do not give us a vocabulary of music; and even if we accept the more ambitious dictionary of Schweitzer or Pirro, what is usually called the "grammar" of music, i.e. harmony, does not recognize such "words" as elements at all. The analogy be-

[52] "So it appears," he says, "upon this view (which is shared, incidentally by Ohmann) that musical rhythm, in contrast with the mere temporal rhythm of *measures*, grows out of the inner *Gestalt*-relations of the motif itself." (*Ibid.*, p. 179.) This conclusion corroborates by scientific evidence the doctrines of Heinrich Schenker concerning meter and rhythm, namely that rhythm is a function of *tonal motion*, not of time-division; such motion depends as much on melodic and harmonic tension and direction as on tempo. (See Schenker's *Neue musikalische Theorien und Phantasien*, 3 vols., 1935, esp. vol. III, *Der freie Satz*, chap. 12, pp. 191–206.)

[53] Albert Schweitzer, *J. S. Bach, le musicien-poète*, 2d ed., 1905.

[54] André Pirro, *L'esthétique de Jean-Sebastien Bach*, 1907.

[55] Huber, *Der Ausdruck musikalischer Elementarmotive*, p. 182.

[56] A perfect example may be found in E. Sorantin's *The Problem of Musical Expression*, 1932.

tween music and language breaks down if we carry it beyond the mere semantic function in general, which they are supposed to share.[57] Logically, music has not the characteristic properties of language—separable terms with fixed connotations, and syntactical rules for deriving complex connotations without any loss to the constituent elements. Apart from a few onomatopoetic themes that have become conventional—the cuckoo, the bugle-calls, and possibly the church-bell—music has no literal meaning.

Yet it may be a presentational symbol, and present emotive experience through global forms that are indivisible as the elements of chiaroscuro. This view has indeed been suggested.[58] But it seems peculiarly hard for our literal minds to grasp the idea that anything can be *known* which cannot be *named*. Therefore philosophers and critics have repeatedly denied the musical symbolization of emotion on the ground that, as Paul Moos puts it, "Pure instrumental music is unable to render even the most ordinary feelings, such as love, loyalty, or anger, unambiguously and distinctly, by its own unaided powers." [59] Or Heinrich, in the same vein: "There are many musical works of high artistic value, that completely baffle us when we try to denote by one word the mood they are supposed to convey. This alone suffices to make the conception of music as a sentimental art, or an art of expressing sentiments, quite untenable." [60] And A. Gehring, pointing out that one cannot prove every musical phrase or figure to mean some nameable feeling, memory, or idea, declares, "Until this is done, we must deny that symbolization accounts for the essential charm of the art." [61]

But this is a fallacy, based on the assumptions that the rubrics established by language are absolute, so that any other semantic must make the same distinctions as discursive thought, and individualize the same "things," "aspects," "events," and "emotions." What is here criticized as a weakness, is really the strength of musical expressiveness: that *music articulates forms which language cannot set forth*. The classifications which language makes automatically preclude many relations, and many of those resting-points of thought which we call "terms." It is just because music has *not* the same terminology and pattern, that it lends itself to the revelation of non-scientific concepts. To render "the most ordinary feelings, such as love, loyalty or anger, unambiguously and distinctly," would be merely to duplicate what verbal appellations do well enough.

57 Cf. Siegfried F. Nadel, *Der duale Sinn der Musik* [*The Two Meanings of Music*, Ed.], 1931, p. 78.
58 Cf. Julius Bittner, "Die Grenzen des Komponierbaren," [*The Limits of Composition*, Ed.], *Der Merker*, vol. 2, part I, pp. 11–14, 1910.
59 Paul Moos, *Die Philosophie der Musik*, 1922, p. 297.
60 F. Heinrich, "Die Tonkunst in ihrem Verhältnis zum Ausdruck und zum Symbol," ["Music in Relation to Expression and Symbol," Ed.], *Zeitschrift für Musikwissenschaft*, vol. 8, pp. 66–92, 1925–1926. See p. 75.
61 *The Basis of Musical Pleasure*, p. 90.

I cannot agree, therefore, with Professor Urban's statement: "It is true that there are other symbols than those of language, namely, the symbols of art and mathematics, by means of which meanings may be communicated. But these symbols themselves require interpretation, and interpretation is only possible in terms of language." [62] His very combination of art and mathematics seems to me to bespeak a misunderstanding; for mathematics is discursive and literal, a specialized and abbreviated language. It appeals essentially to the eye, and is therefore most easily "done on paper," but all its symbols have names; a complex like $\dfrac{\sqrt{a+b}}{c^{m+n}}$ may always be verbally expressed as "the square root of a-plus-b, over c to the m-plus-nth power." This is not a non-linguistic symbolism; it is merely a highly technical jargon, and the teaching of mathematics is its interpretation to the uninitiate. But in art such interpretation is vicious, because art—certainly music, and probably all art—is formally and essentially untranslatable; and I cannot agree that "interpretation of poetry is the determination of what poetry says. . . . One of the essential functions of the teaching of literature is its interpretation. . . . Now a character of such interpretation is that it is always carried out in non-poetic terms or in *less* poetic terms than the thing interpreted." [63] Evidently Professor Urban would extend this sort of explanation even to music, for he says elsewhere: "Even in such non-linguistic arts as music or pure design, where the element of assertion is apparently absent, it is, I should hold, only apparently so." [64]

In that case, of course, Moos and Heinrich and Gehring are justified in denying "emotive" meanings to music on the ground that no propositions about feelings can be assigned, with any confidence, as the contents of its forms. But it seems to me that truth rests rather with another statement of Urban's, which is hard to reconcile with his prevailing, explicit views about the primacy and supremacy of language: "The poet . . . does well to speak in figure, to keep to his own symbolic form. For precisely in that symbolic form an aspect of reality is given which cannot be adequately expressed otherwise. It is not true that whatever can be expressed symbolically can be better expressed literally. For there *is* no literal expression, but only another kind of symbol." [65]

For the musician, this other kind of symbol is not constantly obscured by something that is said; wherefore musicians have grasped its character and

[62] W. M. Urban, *Language and Reality*, p. 55.
[63] *Ibid.*, pp. 487–488.
[64] *Ibid.*, pp. 478.
[65] *Ibid.*, p. 500. Oddly enough, this same passage concludes with the words: "But when all is said and done, it remains true that poetry is covert metaphysics, and it is only when its implications, critically interpreted and adequately expressed, become part of philosophy that an adequate view of the world can be achieved." What *is* this critical and adequate expression, if not literal interpretation?

importance more clearly than literary critics. If music is a symbolism, it is essentially of this untranslatable form. That is the gist of Wagner's description of the "orchestral language." Since this "language" has no conventional words, it can never appeal to discursive reason. But it expresses "just what is unspeakable in verbal language, and what, viewed from our rationalistic (*Verstandesmenschlichen*) standpoint, may therefore be called simply *the Unspeakable*." [66]

Because the forms of human feeling are much more congruent with musical forms than with the forms of language, music can *reveal* the nature of feelings with a detail and truth that language cannot approach. This peculiar articulateness of music as a semantic of vital and emotional facts was discovered nearly two centuries ago by one of the contributors to Marpurg's famous *Beyträge zur Musik*.[67] This writer (the same Hüller who objected to ducks and sneezing fleas in "modern music") says:

There are feelings . . . which are so constantly suppressed by the tumult of our passions, that they can reveal themselves but timidly, and are practically unknown to us. . . . Note, however, what response a certain kind of music evokes in our hearts: we are attentive, it is charming; it does not aim to arouse either sorrow or joy, pity or anger, and yet we are moved by it. We are so imperceptibly, so gently moved, that we do not know we are affected, or rather, that we can give no name to the affect. . . .*

Indeed, it is quite impossible to name *every thing fascinating in music, and bring it under definite headings. Therefore music has fulfilled its mission whenever our hearts are satisfied.*[68]

Since the day when this was written, many musicologists—notably Vischer, Riemann, and Kurth—have emphasized the impossibility of interpreting the "language of feeling," although they admit its function to be, somehow, a revelation of emotions, moods, or subtle nameless affects. Liszt warned specifically against the practice of expounding the emotive content of a symphonic poem, "because in such case the words tend to destroy the magic, to desecrate the feelings, and to break the most delicate fabrics of the soul, which had taken this form just because they were incapable of formulation in words, images or ideas." [69]

But there are musicians for whom it is not enough to recognize the ineffable character of musical significance; they must remove their art from the realm of meaning altogether. They cannot entertain the idea that music expresses anything in any way. The oddest thing about this perfectly legitimate prob-

[66] *Oper und Drama.* See Gatz, *Musik-Aesthetik,* p. 192.
[67] *Contributions to Music.*[Ed.]
[68] Hüller, "Abhandlung von der Nachahmung der Natur in der Musik," pp. 515 and 523. Emphasis mine.
[69] Franz Liszt, "Berlioz und seine Harold-Symphonie," reprinted by Gatz from Liszt's *Gesammelte Schriften.* See Gatz, *op. cit.,* p. 127.

lem of musical meaning is that it seems impossible for people to discuss it with anything like detachment or candor. It is almost like a religious issue; only that in matters of faith the proponents of a doctrine are usually the vehement believers, the passionate defenders, whereas in this musicological argument it is apt to be the non-believers, the scoffers and critics, who are most emotional about it. Those who deny that music is a language of feelings do not simply reject the symbolistic theory as unconvincing or indemonstrable; they are not content to say that they cannot find the alleged meaning in music, and therefore consider the hypothesis far-fetched; no, they reject with horror the very attempt to construe music as a semantic, they regard the imputation of any meaning—emotional or other—as an insult to the Muse, a degradation of the pure dynamic forms, an invidious heresy. They seem to feel that if musical structures should really be found to have significance, to relate to anything beyond themselves, those structures would forthwith cease to be musical. The dignity of music demands that it should be autonomous; its existence should have no explanation. To add "meaning" to its sensuous virtues is worse than to deny it any virtue—it is, somehow, to destroy its life.[70]

Yet the most vehement critics of the emotive-content theory seem to have caught a germ from the doctrine they attacked: in denying the very possibility of any content of music, they have fallen into the way of thinking about it in terms of form and content. They are suddenly faced with the dichotomy: *significant or meaningless.* And while they fiercely repudiate the proposition that music is a semantic, they cannot assert that it is meaningless. It is the problem, not the doctrine, that has infected them. Consequently they try to eat their cake and have it too, by a logical trick that is usually accepted only among mathematicians—by a statement which has the form of an answer to the question in hand, and really commits them to nothing. Musical form, they reply, is its own content; it means itself. This evasion was suggested by Hanslick when he said, "The theme of a musical composition is its essential content." He knew that this was an evasion; [71] but his successors have found it harder and harder to resist the *question* of content, and the silly fiction of self-significance has been raised to the dignity of a doctrine.[72] It is really just

[70] The importance of this conflict was recognized by Dr. Wierling, who says: "The great reaction which Hanslick evoked with his book shows by its harshness that here was no contest of opinions, but a conflict of forces like that of dogma against heresy. . . . The reaction against Hanslick was that of persons attacked in their holiest convictions." (*Das Tonkunstwerk als autonome Gestalt und als Ausdruck der Persönlichkeit,* [*The Work of Music as Autonomous Form and as Expression of Personality,* Ed.], pp. 24-25.) Exactly the same spirit was certainly evinced by Hanslick himself who repulsed what he considered not a mere error, but a pernicious doctrine.

[71] See Hanslick, *op. cit.,* p. 133: "In the art of music there is no content opposed to form, because music has no form over and above its content." This is an effectual repudiation of the form-and-content dichotomy, a rejection of the problem, not of its answers.

[72] See, e.g., E. J. Dent, *Terpander: or, the Music of the Future,* 1927, p. 12; Carroll C. Pratt, *The Meaning of Music,* 1931, p. 237; and F. Heinrich, "Die Tonkunst in ihrem Verhältnis zum Ausdruck und zum Symbol," p. 67.

a talisman against any and every assignment of specific content to music; and as such it will presently appear justified.

Whenever people vehemently reject a proposition, they do so not because it simply does not recommend itself, but because it *does,* and yet its acceptance threatens to hamper their thinking in some important way. If they are unable to define the exact mischief it would do, they just call it "degrading," "materialistic," "pernicious," or any other bad name. Their judgment may be fuzzy, but the intuition they are trying to rationalize is right; to accept the opponent's proposition *as it stands,* would lead to unhappy consequences.

So it is with "significant form" in music: to tie any tonal structure to a specific and speakable meaning would limit musical imagination, and probably substitute a preoccupation with feelings for a whole-hearted attention to music. "An inward singing," says Hanslick, "and not an inward feeling, prompts a gifted person to compose a musical piece." [73] Therefore it does not matter what feelings are afterward attributed to it, or to him; his responsibility is only to articulate the "dynamic tonal form."

It is a peculiar fact that some musical forms seem to bear a sad and a happy interpretation equally well. At first sight that looks paradoxical; but it really has perfectly good reasons; which do not invalidate the notion of emotive significance, but do bear out the right-mindedness of thinkers who recoil from the admission of specific meanings. For *what music can actually reflect is only the morphology of feeling;* and it is quite plausible that some sad and some happy conditions may have a very similar morphology. This insight has led some philosophical musicologists to suppose that music conveys *general forms of feeling,* related to specific ones as algebraic expressions are related to arithmetic; a doctrine put forward by Moritz Hauptmann [74] and also by Moritz Carrière. [75] These two excellent thinkers saw in music what most aestheticians failed to see—its intellectual value, its close relation to concepts, not by reason of its difficult academic "laws," but in virtue of its *revelations.* If it reveals the rationale of feelings, the rhythm and pattern of their rise and decline and intertwining, to our minds, then it is a force in our mental life, our awareness and understanding, and not only our affective experience.

Even Hanslick granted this logical analogy between music and emotions; [76] but he did not realize how much he had granted. Because he considered nothing but conventional denotation as "meaning," he insisted that music could not mean anything. Every mathematician knows how hard it is to con-

[73] *Op. cit.,* p. 75.
[74] *Die Natur der Harmonik und Metrik,* 1853.
[75] *Aesthetik,* 2 vols., 1859.
[76] *Op. cit.,* p. 26.

vince the naive beginner in algebra that its letters have any meaning, if they are not given specific denotations: "Let a = 5, let b = 10," etc. Presently the novice learns that it makes no difference to the validity of the equation how the meanings of terms have been assigned; then he understands the generality of the symbolism. It is only when he sees the balance of the equation as a form in itself, apart from all its possible arithmetical instances, that he grasps the *abstraction*, the real concept expressed through the formula.

Algebraic letters are pure symbols; we see numerical relationships not *in* them, but *through* them; they have the highest "transparency" that language can attain. In likening music to such a symbolism, Hauptmann and Carrière claimed for it that peculiar "significance" that belongs to abstractions—a general reference to the realm of reality from which the form is abstracted, a reflection of the laws of that realm, a "logical picture" into which all instances must fit, yet not a "picture" of any actual instance.

But this explanation of music as a high abstraction, and musical experience as a purely logical revelation, does not do justice to the unmistakably sensuous value of tone, the vital nature of its effect, the sense of personal import which we meet in a great composition every time it is repeated to us. Its message is not an immutable abstraction, a bare, unambiguous, fixed concept, as a lesson in the higher mathematics of feeling should be. It is always new, no matter how well or how long we have known it, or it loses its meaning; it is not transparent but iridescent. Its values crowd each other, its symbols are inexhaustible.

The fact is, I think, that Hanslick, who admitted only the *formal* similarity of music and emotive experience but denied the legitimacy of any further interpretation, and those authors who realized that formality, but took it for the nature of musical *meaning* rather than of musical symbols, were very close to a correct analysis. For music has all the earmarks of a true symbolism, except one: the existence of an *assigned connotation*. It is a form that is capable of connotation, and the meanings to which it is amenable are articulations of emotive, vital, sentient experiences. But its import is never fixed. In music we work essentially with free forms, following inherent psychological laws of "rightness," and take interest in possible articulations suggested entirely by the musical material. We are elaborating a symbolism of such vitality that it harbors a principle of development in its own elementary forms, as a really good symbolism is apt to do—as language has "linguistic laws" whereby words naturally give rise to cognates, sentence-structures to subordinate forms, indirect discourse to subjunctive constructions "by attraction," noun-inflections to inflections of their modifiers "by agreement." No conscious intellectual intent determines vowel changes, inflections, or idioms; the force of what has

been called "linguistic feeling" or a "sense of words"—"the Spirit of Language," as Vossler says—develops the forms of speech. To make up a language upon a preconception of what it is to express never leads to a real language, because language grows in meaning by a process of articulation, not in articulate forms by a process of preconceived expression.

What is true of language, is essential in music: music that is invented while the composer's mind is fixed on what is to be expressed is apt not to be music. It is a limited idiom, like an artificial language, only even less successful; *for music at its highest, though clearly a symbolic form, is an unconsummated symbol.* Articulation is its life, but not assertion; expressiveness, not expression. The actual function of meaning, which calls for permanent contents, is not fulfilled; for the *assignment* of one rather than another possible meaning to each form is never explicitly made. Therefore music is "Significant Form," in the peculiar sense of "significant" which Mr. Bell and Mr. Fry maintain they can grasp, or feel, but not define; such significance is implicit, but not conventionally fixed.

The fact that in music we have an unconsummated symbol, a significant form without conventional significance, casts some light on all the obscure conflicting judgments that the rise of program music has evoked. The expression of an idea in a symbolic mode may be successful or unsuccessful, easy and adequate, or halting, askew, inexact. Ordinarily we have no precise "logical picture" of affects at all; but we *refer* to them, chiefly by the indirect method of describing their causes or their effects. We say we feel "stunned," "left out," "moved," or "like swearing," "like running away." A mood can be described only by the situation that might give rise to it: there is the mood of "sunset and evening star," the mood of a village festival, or of a Vienna soirée. If, now, a composer's musical idiom is not so rich and definite that its tonal forms alone are perfectly coherent, significant, and satisfying, it is the most natural thing in the world that he should supplement them by the usual, non-musical ways of expressing ideas of feeling to ourselves and others; by envisaging situations, objects, or events that hold a mood or specify an emotion. He may use a mental picture merely as a scaffolding to organize his otherwise musical conception. Schumann tells of occasions when he or another composer had envisaged a scene or a being so that the vision directly inspired a coherent, well-wrought musical work.[77] Sometimes the mere suggestion of what Huber calls a "sphere," e.g., "a medieval realm," "a fairy world," "a heroic setting," effected by one title-word such as "Scheherazade" or "Oberon," serves to crystallize a shifting and drifting musical

[77] Robert Schumann on Berlioz' *Symphonie Fantastique,* reprinted by Gatz from *Gesammelte Schriften über Musik und Musiker.* See Gatz, *op. cit.,* pp. 299–303.

theme into artistic form. Sometimes a composer sets himself an elaborate program and follows it as he might a libretto or a choreographer's book. It is true, and natural enough, that this latter practice produces a less perfect musical expression than purely thematic thinking, for it is not single-minded; not everything relevant is contained in the music; and there is nothing *in the work* to force the composer's helpful fancies on the listener. Nothing can constrain us to think of Till Eulenspiegel's escapades while listening to music.

But similarly, nothing can prevent our falling back on mental pictures, fantasies, memories, or having a *Sphärenerlebnis* [78] of some sort, when we cannot directly make subjective sense out of music in playing or hearing it. A program is simply a crutch. It is a resort to the crude but familiar method of holding feelings in the imagination by envisaging their attendant circumstances. It does not mean that the listener is unmusical, but merely that he is not musical enough to think in entirely musical terms. He is like a person who understands a foreign language, but thinks in his mother tongue the minute an intellectual difficulty confronts him.

To a person of limited musical sense, such ideation seems the most valuable response to music, the "subjective content" which the listener must supply. People of this persuasion often grant that there may also be an appreciation of pure beautiful sounds, which "gives us pleasure"; but we can *understand* the music better when it conveys a poetic content.[79] Goethe, for instance, who was not musical (despite his interest in the art as a cultural product), tells how, in listening to a new piano quartet, he could make no sense out of any part save an allegro, which he could interpret as the Witches' Sabbath on the *Blockberg*, "so that after all I found a conception which could underlie this peculiar music." [80]

Where such interpretation is spontaneous, it is a perfectly legitimate practice, common among musically limited persons, and helpful; but it becomes

[78] Literally, a sphere-experience. [Ed.]
[79] Henri Prunières (the same "interpreter" who tells us so categorically how Beethoven felt when he invented his themes) writes of Strauss's programmatic works: "These works are endowed with a form sufficiently beautiful in itself to afford the auditor lively pleasure, even should he not perceive all the the author's intentions. It must be remembered, however, that his pleasure is doubled when he is capable of grasping, of gradually discovering, the hidden symbols." ("Musical Symbolism," p. 20.)
 D. M. Ferguson, in an essay entitled "How can Music Express Emotion?" claims that music, "being unable, as words and pictures can do, to present to our attention the causes of external circumstances of feeling (*from which we largely infer the nature of the feeling itself*), begins *in medias res*, with the nervous disturbance itself and . . . instead of representing the conditions which arouse emotion and demanding that the observer observe therefrom the emotional meaning, music represents the emotional disturbance itself *and demands that for its fullest comprehension its hearers shall infer the cause.*" (*Proceedings of the Music Teachers' National Association*, 1925, pp. 20–32. See pp. 26–27. Italics mine.)
 Another purveyor of interpretations, F. Nicholls, says (after classifying "chords of fear" and "arpeggios of joy"): "It is now desired to illuminate a piece of pure music by reading into it—in accordance with our acquired knowledge of musical symbolism—some more *definite* and *particular* meaning. . . . The music is the higher or cosmic interpretation of definite things. . . . An interpretation, nevertheless, is often very helpful; and a 'parable,' so to speak, in words often, and quite justifiably, adds to the enjoyment of the music." (*The Language of Music, or, Musical Expression and Characterization*, 1924, pp. 77–78.) Hereupon he writes doggerel words to a Beethoven piano sonata.
[80] J. P. Eckermann, *Gespräche mit Goethe*, 1912, p. 158.

pernicious when teachers or critics or even composers initiate it, for then they make a virtue out of walking with a crutch. It is really a denial of the true nature of music, which is unconventionalized, unverbalized freedom of thought. That is why the opponents of program-music and of hermeneutic are so vehement in their protests; they feel the complete misconception of the *artistic* significance of tonal structures, and although they give doubtful reasons for their objection, their reaction is perfectly sound.

The real power of music lies in the fact that it can be "true" to the life of feeling in a way that language cannot; for its significant forms have that *ambivalence* of content which words cannot have. This is, I think, what Hans Mersmann meant, when he wrote: "The possibility of expressing opposites simultaneously gives the most intricate reaches of expressiveness to music as such, and carries it, in this respect, far beyond the limits of the other arts." [81] Music is revealing, where words are obscuring, because it can have not only a content, but a transient play of contents. It can articulate feelings without becoming wedded to them. The physical character of a tone, which we describe as "sweet," or "rich," or "strident," and so forth, may suggest a momentary interpretation, by a physical response. A key-change may convey a new *Weltgefühl*.[82] The assignment of meanings is a shifting, kaleidoscopic play, probably below the threshold of consciousness, certainly outside the pale of discursive thinking. The imagination that responds to music is personal and associative and logical, tinged with affect, tinged with bodily rhythm, tinged with dream, but *concerned* with the wealth of formulations for its wealth of wordless knowledge, its whole knowledge of emotional and organic experience, of vital impulse, balance, conflict, the *ways* of living and dying and feeling. Because no assignment of meaning is conventional, none is permanent beyond the sound that passes; yet the brief association was a flash of understanding. The lasting effect is, like the first effect of speech on the development of the mind, to *make things conceivable* rather than to store up propositions. Not communication but insight is the gift of music; in very naive phrase, a knowledge of "how feelings go." This has nothing to do with "*Affektenlehre*";[83] it is much more subtle, complex, protean, and much more important; for its entire record is emotional satisfaction, intellectual confidence, and *musical* understanding. "Thus music has fulfilled its mission whenever our hearts are satisfied."

It also gives substance to a theory that sounds very odd outside some such context as this, a theory advanced by Riemann, and more recently developed

81 "Versuch einer musikalischen Wertaesthetik," ["Attempting a Musical Aesthetic," Ed.], *Zeitschrift für Musik-wissenschaft*, vol. 17, no. 1, pp. 33–47, 1935.
82 World-feeling. [Ed.]
83 [Learning emotions, Ed.]

by Professor Carroll Pratt, who (apparently quite independently) came to the conclusion that music neither causes nor "works off" real feelings, but produces some peculiar effects we mistake for them. Music has its special, purely auditory characters, that "intrinsically contain certain properties which, because of their close resemblance to certain characteristics in the subjective realm, are frequently confused with emotions proper." [84] But "these auditory characters are not emotions at all. They merely *sound* the way moods *feel*. . . . More often than not these formal characters of music go unnamed: they are simply what the music is. . . ." [85]

The notion that certain effects of music are so much *like* feelings that we mistake them for the latter, though they are really entirely different, may seem queer, unless one looks at music as an "implicit" symbolism; then, however, the confusion appears as something to be expected. For until symbolic forms are consciously abstracted, they are regularly confused with the things they symbolize. This is the same principle that causes myths to be believed, and names denoting powers to be endowed with power, and sacraments to be taken for efficacious acts; the principle set forth by Cassirer, in a passage which I have quoted once before,[86] but cannot refrain from repeating here: "It is typical of the first naive, unreflective manifestations of linguistic thinking as well as the mythical consciousness, that its content is not sharply divided into symbol and object, but both tend to unite in a perfectly undifferentiated fusion." [87] This principle marks the line between the "mythical consciousness" and the "scientific consciousness," or between implicit and explicit conception of reality. Music is our myth of the inner life—a young, vital, and meaningful myth, of recent inspiration and still in its "vegetative" growth.

[84] Pratt, The Meaning of Music, p. 191.
[85] Ibid., p. 203. Compare Hugo Riemann, Wie Hören Wir Musik? [How do We Hear Music? Ed.], pp. 22–23, 1888: "It is really not a question of expressing emotions at all, for . . . music only moves the soul in a way analogous to the way emotions move it, without pretending, however, in any way to arouse them (wherefore it does not signify anything that entirely heterogeneous affects have similar dynamic forms, and therefore may be 'expressed' by the same music, as has already been observed, quite rightly, by Hanslick). . . ."
[86] In The Practice of Philosophy, p. 178.
[87] This identification of symbol and object in music is given remarkable illustration by a passage from Gehring's The Basis of Musical Pleasure, which reads: "If the sequence of thoughts which fills our mind from minute to minute bears any close resemblance to melodic structure, it is so subtle that nobody has yet been able to detect it. However, is it necessary to trace an analogy? May not the mental phenomenon and the musical counterpart here melt together? May not the melodic be substituted for the important train of thought which it is supposed to mirror? In the case of measure, force, and tempo, music duplicates or photographs the mind; in the case of melody, it coincides with it." (Page 98.)

VISUAL ARTS: PAINTING AND SCULPTURE

In arts capable of representing events and materials of life the problem of the relationship between form and content is inevitably of interest to the aesthetician.

Clive Bell, whom John Hospers quotes and analyzes, was convinced that the representation of life in painting distracted from what should be its main concern: achieving a form which can be appreciated by itself. Such a view, coming as it does at the end of a long reign of photographic painting of sometimes "soupy" sentimentalism (at its very worst, of course), can be seen as an effort at correcting our ways of looking at paintings. John Hospers discusses Bell's ideas without siding with him but with a sympathetic understanding of what it was that Bell did not approve of. Hospers' examination of the relationship between life forms and graphic forms in painting should help us clarify the peculiar possibilities for painting to achieve various kinds of meanings.

F. David Martin is also interested in putting into proper context the forms of the mannerist painters as a means of coming to fuller understanding of their achievement. Martin's acceptance of the "meaningful" relationship between form and content conditions the critical judgments he can make of the painting he discusses.

And Etienne Gilson, tackling one of the more formidable problems in aesthetics—that of the mode of existence of a work of art—is also making decisions which can eventually color the value judgments he will make about a painting. His distinction between ontology and phenomenology is a significant one which helps us see from a different point of view the importance of Bell's distinctions between life forms and graphic forms. Our decision about the way in which a painting exists can be meaningful to our critical approach. If the painting exists apart from us as an object, aesthetically, we can conceive of an objective kind of criticism. We can objectively discuss something which exists without dependence on our peculiar psychological limitations. But if the painting exists aesthetically only in our mind, then the possibility of a subjective critical system emerges. We must consider carefully the significance of such an alternative.

Certainly Fanchon Fröhlich's essay on aesthetic paradoxes in certain kinds of modern art is dealing with the same problem. How does a work of art become a work of art? is her way of putting the question. Who is to decide?

Can anyone declare anything a painting? Hugh Kenner, in his essay on the arts, deals with the problem from a different angle, but the questions he poses are recognizable here. The roots of some of Mrs. Frölich's paradoxes are planted squarely in the domain of Gilson's essay. Answering his philosophic question implies an answer of sorts to some of Mrs. Fröhlich's questions.

Clement Greenberg, a practicing critic, speculates about the future of sculpture in his essay. His concern is an aesthetic one, again dealing with a variation of one of Miss Langer's philosophic questions: What does sculpture do? This time the question is asked with a tag: What does sculpture do that painting cannot do as well? Greenberg poses the thought that scultpure may be displacing painting's claim to preeminence in the art world of today. Perhaps the views of Kenner and Fröhlich can help us decide if Greenberg is right.

MEANING IN PAINTING

JOHN HOSPERS

To appreciate a work of art we need bring with us nothing from life, no knowledge of its ideas and affairs, no familiarity with its emotions. Art transports us from the world of man's activity to a world of esthetic exaltation. For a moment we are shut off from human interests; our anticipations and memories are arrested; we are lifted above the stream of life . . . Art . . . inhabits a world with an intense and peculiar significance of its own; that significance is unrelated to the significance of life. In this world the emotions of life find no place. It is a world with emotions of its own.[1]

So begins the theory of Clive Bell, which is a close analogue in visual art of Hanslick's theory in music. Each is intent upon excluding life-values from works of art in his own medium, and upon establishing form as the *sine qua non* of artistic appreciation and achievement. Painters who rely on representation for their effects are not true artists, since their works make the observer respond to the life-situation depicted, substituting the easy life-emotion (which is available outside works of art) for the more pure and difficult art-emotion.

A painter too feeble to create forms that provoke more than a little esthetic emotion will try to eke that little out by suggesting the emotions of life. To evoke the emotions of life, he must use representation. Thus a man will paint an execution, and, fearing to miss with his first barrel of significant form, will try to hit with his second by raising an emotion of fear or pity. But if in the artist an inclination to play upon the emotions of life is often the sign of a flickering inspiration, in the spectator a tendency to seek, behind form, the emotions of life is a sign of defective sensibility always. It means that his esthetic emotions are weak or, at any rate, imperfect. Before a work of art people who feel little or no emotion for pure form find themselves at a loss. They are deaf men at a concert. They know that they are in the presence of something great, but they lack the power of apprehending it. They know that they ought to feel for it a tremendous emotion, but it happens that the particular kind of emotion it can raise is one that they can feel hardly or not at all. And so they read into the forms of the work those facts and ideas for which they are capable of feeling emotion, and feel for them the emotions that they can feel—the ordinary emotions of life. When confronted by a picture, instinctively they refer back its forms to the world from which they came. They treat created form as though it were imitated form, a picture as though it were a photograph. Instead of going out on the stream of art into a new world of esthetic experience, they turn a sharp corner and come straight home to the world of human interests. For them the significance of a work of art depends on what they bring to it; no new thing is added to their lives, only the old material

[1] Clive Bell, *Art*, pp. 25–27.

is stirred. A good work of visual art carries a person who is capable of appreciating it out of life into ecstasy: to use art as a means to the emotions of life is to use a telescope for reading the news. You will notice that people who cannot feel pure esthetic emotions remember pictures by their subjects; whereas people who can, as often as not, have no idea what the subject of a picture is. They have never noticed the representative element, and so when they discuss pictures they talk about the shapes of forms and the relations and quantities of colors. Often they can tell by the quality of a single line whether or no a man is a good artist. They are concerned only with lines and colors, their relations and quantities; but from these they win an emotion more profound and far more sublime than any that can be given by the description of facts and ideas.[2]

The significance of any object in life, for painting, has nothing to do with its function in life or any of its ordinary associations. "What is a tree, a dog, a wall, a boat? What is the particular significance of anything? Certainly the essence of a boat is not that it conjures up visions of argosies with purple sails, nor yet that it carries coals to Newcastle. Imagine a boat in complete isolation, detach it from man and his urgent activities and fabulous history, what is it that remains, what is that to which we still react emotionally? What but pure form?"[3]

The exact nature of this pure form, or as Bell calls it, "significant form," is never described; Bell defines it in terms of the "esthetic emotion" (significant form being present when the esthetic emotion is aroused), but since he defines the esthetic emotion in terms of significant form (the esthetic emotion being limited to what is evoked by the presence of significant form), we are no further than we were before. And indeed Bell conveys the impression that the thing he is referring to can only be intuited but never precisely described. Bell's description is devoted largely to informing his readers what significant form is *not*. In music, for example, Bell explains the inferiority of his appreciation from the standpoint of his ideal of significant form:

At moments I do appreciate music as a pure musical form, as sounds combined according to the laws of a mysterious necessity, as pure art with a tremendous significance of its own and no relation whatever to the significance of life; and in those moments I lose myself in that infinitely sublime state of mind to which pure visual form transports me. How inferior is my normal state at a concert. Tired or perplexed, I let slip my sense of form, my esthetic emotion collapses, and I begin weaving into the harmonies that I cannot grasp, the ideas of life. Incapable of feeling the austere emotions of art, I begin to read into the musical forms human emotions of terror and mystery, love and hate, and spend the minutes, pleasantly enough, in a world of turbid and inferior feeling. . . . I have been using art as a means to the emotions of life and reading into it the ideas of life. I have been cutting blocks with a razor. I

[2] *Ibid.*, pp. 28–30.
[3] *Ibid.*, p. 213.

have tumbled from the superb peaks of esthetic exaltation to the snug foothills of
warm humanity. It is a jolly country. No one need be ashamed of enjoying himself
there. Only no one who has ever been on the heights can help feeling a little crest-
fallen in the cozy valleys. And let no one imagine, because he has made merry in the
warm tilth and quaint nooks of romance, that he can even guess at the austere and
thrilling raptures of those who have climbed the cold, white peaks of art.[4]

Before proceeding further we must avoid several possible confusions. The
distinction between Bell's view and one which would admit life-values is not
the same as the distinction between abstractions and representational schools
of art. Abstract or non-representational painting does not necessarily fulfill
Bell's requirements for art, nor does it necessarily exclude life-values: Mondrian
uses no representational content at all but merely colored lines intersecting at
right angles; nevertheless he does not intend to exclude life-values.

Impressed by the vastness of nature, I was trying to express its expansion, rest and
unity. At the same time, I was fully aware that the visible expansion of nature is at
the same time its limitation; vertical and horizontal lines are the expression of two
opposing forces; these exist everywhere and dominate everything; their reciprocal
action constitutes "life". . . .[5]

Enough has been presented here to show that what Mondrian is trying to
"express" is something very relevant to life indeed—expressive not of any par-
ticular objects or class of objects but of something possessed by all objects in
common (which is why he chose abstract painting as the genre in which best
to express it). And on the other hand, we find a consistently representational
painter like Marc Chagall saying,

But please defend me against people who speak of "anecdote" and "fairy tales" in
my work. A cow and a woman to me are the same—in a picture both are merely
elements of a composition. In painting, the images of a woman or of a cow have
different values of plasticity,—but not different poetic values. As far as literature goes,
I feel myself more "abstract" than Mondrian or Kandinsky in my use of pictorial
elements. "Abstract" in the sense that my painting does not recall reality. . . . In
the case of the decapitated woman with the milk pails, I was first led to separating
her head from her body merely because I happened to need an empty space there. In
the large cow's head in Moi et le Village *I made a small cow and a woman milking*
visible through its muzzle because I needed that sort of form, there, for my composi-
tion. Whatever else may have grown out of these compositional arrangements is
secondary.[6]

[4] *Ibid.,* pp. 31–33.
[5] Piet Mondrian, "Toward the True Vision of Reality," pamphlet published by the Valentine Gallery,
New York.
[6] Marc Chagall, quoted in "An Interview with Marc Chagall," by James Johnson Sweeney, *Partisan
Review,* p. 90, Winter, 1944. The distinction between representation as an aid to life-values and repre-
sentation as an aid to formal intensity is well discussed in an article by Mrs. Helen Knight, "Sense-form
in Pictorial Art," *Aristotelian Society Proceedings,* vol. 31, pp. 150–151, 1930–1931.

From these two quotations it should be abundantly clear that the two sets of distinctions completely cut across each other.

Nor must the exclusion of life-values be confused with "reducing art to mere technique." In whatever sense the elusive word "technique" is used, Bell's ideal of "pure form" is quite a different thing. The very rarity of the achievement of significant form, as opposed to the comparative frequency of painters who are good technicians or "can handle their medium well," should suffice to establish this.

With these stumbling-blocks removed, we may consider briefly a conception of painting which is similar to Bell's. Roger Fry recognizes that the formal and life-values exist in a work of art—he calls them the plastic and dramatic respectively—but he says that the two exist side by side, separately, and generally interfere with each other. When dramatic and plastic values both appear in a painting the result is not a fusion but a tension of interest. "How can we keep the attention equally fixed on the spaceless world of psychological entities and relations and upon the apprehension of spatial relations? What, in fact, happens is that we constantly shift our attention backwards and forwards from one to the other." [7]

Fry illustrates this point at great length with descriptions of paintings of many different types, first those of almost purely psychological or dramatic interest, then those of almost purely plastic interest, and then those in which both appear and the attention must shift from the one to the other. For example, after describing Pieter Brueghel's *Carrying of the Cross*, he remarks:

We recognize at once that this is a great psychological invention, setting up profound vibrations of feeling within us by its poignant condensation of expression. . . . But it is, I repeat, purely literary, and throughout this picture it is clear that Brueghel has subordinated plastic to psychological considerations. It is indeed to my mind entirely trivial and inexpressive when judged as a plastic and spatial creation. In short, it is almost pure illustration, for we may as well use that as a convenient term for the visual arts employed on psychological material. And we must regard illustration as more closely akin in its essence to literature than it is to plastic art, although in its merely external and material aspect it belongs to the latter.[8]

On the other hand, in Poussin's *Achilles Discovered by Ulysses among the Daughters of Lycomedon*, the psychological values are negligible:

The delight of the daughters in the trinkets which they are examining is expressed in gestures of such dull conventional elegance that they remind me of the desolating effect of some early Victorian children's stories. Nor is Ulysses a more convincing psychological entity, and the eager pose of his assistant is too palpably made up

[7] Roger Fry, *Transformations*, p. 23.
[8] *Ibid.*, pp. 15–16.

because the artist wanted to break the rectangle behind and introduce a diagonal leading away from the upright of Ulysses. Finally, Achilles acts very ill the part of a man suddenly betrayed by an overwhelming instinct into an unintentional gesture. Decidedly the psychological complex is of the meagrest, least satisfactory, kind, and the imagination turns from it, if not with disgust, at least with relief at having done with so boring a performance. But on the other hand our contemplation of plastic and spatial relations is continually rewarded. We can dwell with delight on every interval, we accept the exact situation of every single thing with a thrilling sense of surprise that it should so exactly satisfy the demands which the rest of the composition sets up. How unexpectedly, how deliciously right! is our inner ejaculation as we turn from one detail to another or as we contemplate the mutual relations of the main volumes to the whole space. And this contemplation arouses in us a very definite mood, a mood which, if I speak for myself, has nothing whatever to do with psychological entities, which is as remote from any emotions suggested by the subject, as it would be if I listened to one of Bach's fugues. Nor does the story of Ulysses enter into this mood any more than it would into the music if I were told that Bach had composed the fugue after reading that story. As far as I can discover, whatever Poussin may have thought of the matter—and I suspect he would have been speechless with indignation at my analysis—the story of Achilles was merely a pretext for a purely plastic construction.[9]

Most regrettable are the occasions on which the two interfere with each other —where the plastic value is sacrificed or compromised to achieve some psychological end. Fry analyzes Daumier's *Gare St. Lazare* as an example of this.

In the case of Rembrandt both faculties were present in the highest degree. "His psychological imagination was so sublime that, had he expressed himself in words, he would, one cannot help believing, have been one of the greatest dramatists or novelists that has ever been, whilst his plastic constructions are equally supreme." [10] After giving a sensitive analysis of the psychological and dramatic values of Rembrandt's *Christ before Pilate*, he says, "Certainly as drama this seems to me a supreme example of what the art of illustration can accomplish. And as a plastic construction it is also full of interest and strange unexpected inventions. . . ." [11] And then he goes on to analyze the painting plastically. But even here, he concludes, the two values clash with each other, and our attention shifts from the one to the other. "I do not know whether the world would not have gained had Rembrandt frankly divided his immoderate genius into a writer's and painter's portion and kept them separate." [12] Pictures in which representation subserves poetical or dramatic ends are not simple works of art, but are in fact cases of the mixture of two distinct and separate arts; . . . such pictures imply the mixture of the art

9 *Ibid.*, pp. 19–20.
10 *Ibid.*, p. 21.
11 *Ibid.*, p. 22.
12 *Ibid.*, p. 21.

of illustration and the art of plastic volumes. . . ." [13] And since the art of illustration is really "literary" and quite extraneous to the plastic medium, wherever the literary values interfere with the plastic, it is the former that must go. For example: When we observe Raphael's *Transfiguration*, if we are insensitive to plastic values and see it "psychologically," we see a number of persons and objects represented in a certain situation; and if we are familiar with the Christian tradition the painting "brings together in a single composition two different events which occurred simultaneously at different places, the Transfiguration of Christ and the unsuccessful attempt of the Disciples during His absence to heal the lunatic boy. This at once arouses a number of complex ideas about which the intellect and feelings may occupy themselves." [14] But when we see esthetically, we see something quite different:

Let us now take for our spectator a person highly endowed with the special sensibility to form . . . [Such a spectator will be immensely excited by the extraordinary] coordination of many complex masses in a single inevitable whole, by the delicate equilibrium of many directions of line. He will at once feel that the apparent division into parts is only apparent, that they are coordinated by a quite peculiar power of grasping the possible correlations. He will almost certainly be immensely excited and moved, but his emotion will have nothing to do with the emotions which we have discussed hitherto, since in this case we have supposed our spectator to have no clue to them. [15]

One interesting claim which Fry makes in favor of his own case is that when, in the works of a historical painter, the plastic and the psychological values appear together, the psychological ones "evaporate" in the course of time, while the plastic ones remain as a source of permanent enjoyment for each succeeding generation. For example, in the case of El Greco:

. . . I suspect that for his own generation his psychological appeal was strong. His contemporaries knew intimately or at least admired profoundly, those moods of extravagant pietistic ecstasy which he depicts. Those abandoned poses, those upturned eyes brimming with penitential tears, were the familiar indications of such states of mind. To us they seem strangely forced and hint a suspicion of insincerity which forbids our acquiescence, and we almost instinctively turn aside to invitations to a quite different mood which his intense and peculiar plasticity holds out. [16]

[13] *Ibid.*, p. 27.
[14] Roger Fry, *Vision and Design*, p. 296.
[15] *Ibid.*, p. 298. Cf. Clive Bell on illustrational painting: "I often enjoy an illustration, by which I mean a drawing the sole aim of which is to imply a situation by visual means. I delight in Peter Arno and Steig. When it comes to an artist, such as Daumier, whose real object was to create expressive forms but who was paid to tell a tale, I find, as a rule, either that the story gives me no pleasure because of its lack of subtlety, or that it positively vexes because the artist's efforts to tell it have been detrimental to his design. Anyhow, the stories told by the painters whose work you find in the National Gallery—albeit the Primitives were much concerned with story-telling—give me no pleasure at all. The reason seems fairly obvious; it would be hard to devise a technique worse suited to story-telling than that which artists have elaborated for the purpose of expressing their peculiar feelings about visual experience."—(Clive Bell, *Enjoying Pictures*, p. 19.)
[16] Fry, *Transformations*, pp. 20–21.

It is for his "significant form," his wonderful "plastic orchestration" that El
Greco is valued today, and not for any psychological values he may have
rendered. The latter, if anything, interfere. Seldom if ever do the two fuse.

It is doubtless with this in view, plus the growing conviction that the plas-
tic values were of sole (or primary) importance to his work as an artist, that
Whistler changed the name of his *Portrait of His Mother* to *Arrangement in
Grey and Black:*

*Why should I not call my works "symphonies," "arrangements," "harmonies," and
"nocturnes"? I know that many good people think my nomenclature funny and
myself "eccentric" . . .*

*The vast majority of English folk cannot and will not consider a picture as a
picture, apart from any story which it may be supposed to tell.*

*My picture of "Harmony in Grey and Gold" is an illustration of my meaning—a
snow scene\with a single black figure and a lighted tavern. I care nothing for the
past, present, or future of the black figure, placed there because the black was wanted
at that spot. All that I know is that my combination of grey and gold is the basis of
that picture. Now this is precisely what my friends cannot grasp.*

*They say, "Why not call it 'Trotty Veck,' and sell it for a round harmony of golden
guineas?"—naively acknowledging that, without baptism, there is no . . . market!*

*But . . . I should hold it a vulgar and meretricious trick to excite people about
Trotty Veck when, if they really could care for pictorial art at all, they would know
that the picture should have its own merit, and not depend upon dramatic, or
legendary, or local interest. . . .*

*The great musicians knew this. Beethoven and the rest wrote music—simply music;
symphony in this key, concerto or sonata in that. . . .*

*Art should be independent of all clap-trap—should stand alone, and appeal to the
artistic sense of eye or ear, without confounding this with emotions entirely foreign to
it, as devotion, pity, love, patriotism, and the like. All these have no concern with it
and that is why I insist on calling my works "arrangements" and "harmonies."* [17]

Seurat, probably aware of the same "interference-phenomenon," gradually
compressed all the psychologically and dramatically interesting values out of
his paintings, until nothing but "pure form" remained:

*In La Baignade there are still indications of muscles, and I have seen a study for one
of the seated figures wherein the muscles are fully and very beautifully rendered; and
if in such a picture as Chahut (1890) he has reduced muscles to their simplest
geometrical equivalents that is not because he could not draw muscles with the best
—or worst, but because by eliminating details he sought to give his design an easily
apprehended intensity which would have been lost in a multiplicity of complicated
forms. . . . Think of the processional movement of those figures, those cylinders, in
La Grande-Jatte: here is an art nearer to architecture than to painting as understood
and practiced in 1886. . . .*

[17] James MacNeill Whistler, *The Gentle Art of Making Enemies*, pp. 126–128.

Few painters can have felt more passionately than Seurat; none perhaps has compressed his feelings more pitilessly. Every twist he gave the vice meant, at the first pang, the sacrifice of some charming quality; but every sacrifice was rewarded in the end by added intensity. Turn from his grand hieratic compositions to his studies of sea and shore at Grandchamp and Honfleur: all the familiar charm of sand and water has been squeezed out, but in exchange we are offered subtleties of tone —or rather of relations of tones—which I think I am right in saying had never before been rendered. . . . By the remorseless suppression of all those enchanting harmonies by which the Impressionists ravished and still ravish us, Seurat has contrived to reveal relations, to touch chords, I will not say more moving, but rarer and more acute. . . .[18]

Seurat struck out all these things, which would have been so tempting to include, because they interfered with the one all-important thing he wanted to bring out, the "pure form"; from this one supreme end these other factors, charming as they might be in themselves, could only detract. The appreciation of art, according to the Bell-Fry school, is only hindered by the inclusion of these irrelevant and distracting elements.[19]

How are we to combat these charges? I think we can best begin by pointing out that there is a difference between *illustrational* painting, in which the subject-matter interest or the story interest is the only excuse for the existence of the painting, and that kind of painting in which the life-values constitute a part of the work of art; and I want to show that criticisms of the one do not necessarily constitute criticisms of the other. A painting which has no artistic merit of its own but merely illustrates some theme from history or literature, and interests people because of the things it represents or the life-sentiments it evokes rather than by its merits as art, is, I should say, an illustrational painting.[20] Yet no one admits this to be art; to fight it is to fight a straw man.

Illustrational painting is analogous to program music in the worst sense.

[18] Clive Bell, *Landmarks in Nineteenth-Century Painting*, pp. 200-203.
[19] Bell admits that it is sometimes the case that certain representational factors can help to speed one's appreciation of the work of art, since without its aid the work would be hard to "get into"; but he vehemently denies that this representational element has any value in itself. "Let us make no mistake about this. To help the spectator to appreciate our design we have introduced into our picture a representative or cognitive element. This element has nothing whatever to do with art. The recognition of a correspondence between the forms of a work of art and the familiar forms of life cannot possibly provoke esthetic emotion. Only significant form can do that. Of course realistic forms may be esthetically significant, and out of them an artist may create a superb work of art, but it is with their esthetic value that we shall then be concerned. We shall treat them as though they were not representative of anything. The cognitive or representative elements in a work of art can be useful as a means to the perception of formal relations and in no other way. It is valuable to the spectator, but it is of no value to the work of art; or rather it is valuable to the work of art as an ear-trumpet is valuable to one who would converse with the deaf: the speaker could do as well without it, the listener could not. The representative element may help the spectator; it can do the picture no good and it may do harm. It may ruin the design; that is to say, it may deprive the picture of its value as a whole; and it is as a whole, as an organization of forms, that a work of art provokes the most tremendous emotions."—(Clive Bell, *Art*, pp. 225-226.)
[20] Bernard Berenson defines illustrational painting as follows: "Illustration is everything which in a work of art appeals to us, not for any intrinsic quality, as of color or form or composition, contained in the work of art itself, but for the value of the thing represented has elsewhere, whether in the world outside, or in the mind within."—(*The Central Italian Painters of the Renaissance*, p. 10.)

And just as program music can be valuable if it does not exist merely to imitate an object or tell the story to a program, so painting can be representational and still valuable as painting if it does not depend for its effect upon the subject-matter represented simply as subject-matter. Dr. Barnes illustrates this difference very well, first of all with an illustration from music:

When we compare, let us say, a symphony of Haydn with Beethoven's Eroica and Fifth, it is impossible not to be conscious of a difference of a semi-literary quality. Beethoven's own title for his Third Symphony is "In Memory of a Great Man," and the symphony is heroic in essence, as Haydn's is not. Our appreciation is of the intrinsic quality of the music itself, which has the objective quality indicated by the title, and our enjoyment seems to be for that reason not the less but the more esthetic.

In contrast, let us consider Tschaikowsky's overture entitled 1812. With it there is a definite program which narrates Napoleon's invasion of Russia and his ultimate defeat there. After a solemn passage, suggesting the sacrificial frame of mind in which a nation springs to arms for the defense of its soil, we hear the Marseillaise, which struggles in the orchestra with the Russian national anthem, amidst the noise of battle. The Russian hymn is at first given out in snatches, abruptly broken off; but it gradually becomes firmer, and is at last triumphantly played through, while the Marseillaise wavers and disappears, and chimes and trumpets unite in a paean of victory. The pleasure afforded is largely amusement at a tour de force, and it is difficult not to feel that we are in the presence of what is essentially musical vaudeville. The device of representing a war by contention between the national anthems of the nations concerned, and of making music mimic a battle, seems unimaginative and childish. The total effect is sensational and offensive rather than esthetic. We feel that the association between the Marseillaise and France is, from the point of view of music, entirely adventitious, and similarly with the Russian hymn.[21]

The latter is simply "illustrational music"; Haydn and Beethoven are not. Nevertheless Beethoven's music is more "literary" than Haydn's; this, however (according to Dr. Barnes), does not make it any less meritorious as music, so long as the music does not exist simply to "illustrate" a program (as in the case of Beethoven's Battle Symphony); the thick esthetic values are, so to speak, "fused" with the thin. Similarly in painting, when a painting simply depends on its subject-matter values (which, as we saw in Chapter I, are outside the work of art) instead of content or life-values, and thus serves to evoke "the same life-emotions over again"—or as Bell says, "only the old material is stirred"—then it is illustrational. When our reaction to a painting of the Ascension depends simply upon our regard for the Ascension as an event in church history—that is, when the painting is designed to evoke religious feelings, regardless of artistic merit—when our interest in the painting results merely from interest in the subject-matter—then indeed we have not

21 A. C. Barnes, *The Art in Painting*, p. 32.

art but illustration. Once again, it is only what the artist has done with the subject-matter, not the subject-matter itself, that counts in a work of art—from which, as we saw in Chapter I, it does not follow that "only the form is important," since content counts just as much. To repeat a passage already quoted once: "Confusion of values arises only when the spectator is moved, not by what the artist shows him, but by what he does *not* show him—the historical event." [22]

Thus, illustrating the difference between life-values and illustration in painting, Barnes says, speaking of Renoir:

His painting catches the spirit of youth and springtime and vitality; he sees and draws forth the joyous and glamorous in the world. . . . The ornamental motif in evidence in Renoir is so fused with the structural elements that an enriched plastic form emerges. The picture sheds light upon what is represented and this revelation of the world has a value which, though in the strict sense illustrative, is truly plastic or pictorial, and not at all "literary." [23]

So much then for the distinction between illustrational and non-illustrational painting, between subject-matter interest and content-interest. Concerning this I can add little more except that we have "thick" as well as "thin" esthetic experiences, and the introduction of life-values does not render them unesthetic. But as yet I have not replied to Fry's claim that the two clash. Fry says, we may remember, that whenever the introduction into art of emotions from everyday life occurs, the latter interfere with the distinctively esthetic emotions produced by the interplay of forms, so that the observer must shift his attention from one to the other. And, as we have seen, he would amend the situation by abolishing the life-values entirely. Professor Reid replies to this in the following manner:

. . . Is not the cure worse than the disease? Does it not lead to an artificial idea of art and does it not impoverish art of much of its meaning? Life may be difficult to transform esthetically, but is it impossible? Must we simply abandon the attempt, choosing art or life, but not both?

. . . If the artist is interested merely in the "pure" formal relations of the human face, if he is interested, that is, simply in the general emotional values of plastic forms and their relations, he is not painting a human face at all. His subject-matter is merely a general arrangement of plastic forms, which, as it happens, bears some resemblance to a human face. It is not a matter of the psychological factor being "emphasized" less; it is a case of the psychological factor not existing at all for the artist. But it is a strained and unnatural attitude. Of course the painter is interested in the expressiveness of visual forms. But he is interested in their expressiveness. The forms are "significant." And what does a human face express more definitely than human

22 *Ibid.*, p. 25.
23 *Ibid.*, p. 34.

character? Surely the artist has more before him than "lines, planes, and volumes." Surely, if he is not ridden by theories, he is interested in character. Not the disembodied, purely mental character which is the object of the psychologist, but, once again, character plastically expressed in a face which interests him. If this interest can in some sense be called dramatic, it will not be true to say that the "dramatic" painter will give emphasis to ultra-plastic values, in the sense of values outside and independent of the plasticity. Rather, psychological values will become apprehended plastically.[24]

Thus it may well be that the shifting of attention from the plastic to the dramatic or psychological, and vice versa, is a peculiarity of Fry's esthetic experience, or it may be due to a faulty analysis of that experience. Professor Reid declares his own experiences to be quite otherwise:

It is not that we are interested in two things, side by side. Introspection of art experience makes this fairly clear. When I look esthetically at Verocchio's Colleoni I am not in the least interested in the character which the gentleman on the horse originally possessed. Yet I cannot but feel braced up and inspired by the intense vigor of character which is embodied in every inch of horse and man. Or when I see the fresco (in the Arena Chapel at Padua) of Joachim Retiring to the Sheep-fold, it may be that my first interest is psychological, or it may be that it is plastic (in my own case it was the latter). But in a full appreciation I cannot possibly cut out one or other element. In the whole, each becomes transformed. There is not, to repeat, when the experience is complete and mature, psychological interest and plastic interest. There is just the plastic-psychological expressiveness of the forms of the dignified old man with head bent, enwrapt in his mantle, in contrast to the different plastic-psychological expressiveness of the naive-looking shepherds who come to meet him. Our object is plastic psychology, plastic drama.

It is only if the psychological interest in paintings is an extrinsic interest . . . it is only where there are elements of external allusion and mere illustration, that psychological elements will tend to "evaporate." If the artist has imagined his way through to the end, the psychological interest will not evaporate because it will be intrinsic to the painting: the psychology is plastic psychology.[25]

There is, then, naturally an "evaporation" in *illustrational* painting; wherever, that is, the subject-matter of the painting loses its interest (for example, when the political squabbles of seventeenth-century France become outdated, or when medieval habits of dress lose their interest for most people), then, since the interest of the painting depends upon the interest in the subject-matter, the painting automatically loses its excuse for being. This is the inevitable fate of any alleged work of art that depends upon subject-matter for its appeal, and exists only to illustrate that subject-matter. It might be held that some subject-matters are eternal in their interest, such as human nature,

[24] Reid, *A Study in Esthetics*, p. 321.
[25] *Ibid.*, pp. 321–322. Vide also Walter Abell, *Representation and Form.*

love, passion, death, the sky and the fields. Although it is indeed true that these interests are more enduring than, for example, the political machinations of seventeenth-century France, it still remains true that as long as the response to the painting depends solely upon interest in its *subject-matter*, our interest is not in the painting as a work of art. Even if the painting should "reveal" or "disclose" some new insight (a topic which will occupy us in Part II), still we should not likely be able to approach that insight again and again with undiminished interest and enjoyment. This is the point of the distinction which Kenneth Burke makes between the "psychology of form" and the "psychology of information"; [26] the psychology of information is bound to wear out in time—we cannot come back to it indefinitely and enjoy it more each time; once we have learned it, once we have grasped the insight, every repetition of the experience is likely to be less strong.[27]

A painting can be a work of art, however, even if this life-value is not present; some paintings, that is, are esthetic in the thin sense. But all I want to emphasize is that as an art painting is not limited to this "purely esthetic" (in the thin sense) interest; there are life-values that enter painting which are not adventitious, which do not exist merely to illustrate a scene from life or to arouse the same old life-emotion over again. This is not illustrational, since the emotion it evokes is a distinctively esthetic one; it is not duplicated (as we saw in the previous section in the case of music) by any emotion in life.

Mr. Fry, I think, is sometimes guilty of seeking after a too great simplicity of esthetic experience. The esthetic experience is (even when "pure") a complex experience and, even when much psychological fusion occurs, a complexity of meaning remains. This complexity must be fused and unified esthetically, but esthetic fusion does not mean the disappearance of the parts. The esthetic fusion, or assimilation or unification of parts, must simply be accepted as a fact which is irreducible.

To say all this is not to deny that the emphasis in different works may be on different things, or that in the same work the focus of our interest may not shift about. Indubitably the focus does shift. This does not mean the same thing as that of which Mr. Fry is speaking when he speaks of the "shifting of attention." In poetry the images and ideas may be an accompaniment of the delightful words; or the ideas and images may be the focus, and the sound of the words their accompaniment. In representative painting we may now be interested in the character-aspect of the content, and now in the formal aspect. . . . But the "shifting" is not from mere "dramatic," mere "psychological" interest, to mere formal interest. It is only, if the experience be an esthetic one, an emphasis on aspects of a whole, in which one aspect modifies and colors the others. In other words, and to repeat, emphasis upon and attention to this or that, is not incompatible with esthetic fusion.[28]

[26] Kenneth Burke, *Counter-statement*, especially the chapter on "The Psychology of Form."
[27] Cf. I. A. Richards, *Principles of Literary Criticism*, p. 275: "Remove the belief, once it has affected the attitude; the attitude collapses. . . . The belief has to grow more and more fervent, more and more convinced, in order to produce the same attitude."
[28] Reid, *A Study in Esthetics*, p. 324.

In the opinion of many critics, it is only when this fusion occurs that the highest peaks in painting are attained:

To create an effective pattern of line and color is something; if line and color are made instrumental to massiveness, to distance, to movement, that is an important addition; if the dynamic masses in deep space are so composed and interpreted as to render the spirit of place in landscape, as in Claude or Constable, of religious eleva-tion, as in Giotto, of drama and power, as in Tintoretto, of poignant humanity, as in Rembrandt, the total result attains or approaches the highest summits of artistic achievement.[29]

Take from Mozart his gaiety suddenly breaking off into solemnity, from Watteau his sensual melancholy, from Chardin his love of common things . . . and you will no doubt be left with valuable relations of pure form, but you will no longer have Mozart, Watteau or Chardin.[30]

One more comment must be made before I pass on to a consideration of meaning in literature. Even the pure formal values in a painting are not en-tirely "in a world apart," irrelevant to life. Significant form is, contrary to Bell's statement, significant *of* something in life. For, in the first place, whence come these forms? They arise from nature (though they are, needless to say, not for a moment a copying or transcription of forms to be found in nature) and also, I think, from the rhythms within our own bodily organisms. Bell cannot be quite right in saying that we need bring with us nothing from life to art, for the basis of our enjoyment of these forms lies in a feeling, con-scious or unconscious, for the forms and rhythms within us and in the life around us. If we were not as we are, human things, the same forms when presented in a work of art would not evoke the peculiar emotion Bell speaks of. Fry himself admits, speaking of the source of the peculiar satisfaction found in works of art:

. . . It is not a mere recognition of order and interrelation; every part, as well as the whole, becomes suffused with an emotional tone. . . . The emotional tone is not due to any recognizable reminiscence or suggestion of the emotional experiences of life; but I sometimes wonder if it nevertheless does not get its force from arousing some very deep, very vague, and immensely generalized reminiscences. It looks as though art had got access to the substratum of all the emotional colors of life, to something which underlies all the particular and specialized emotions of actual life. . . . Or it may be that art really calls up, as it were, the residual traces left on the spirit by the different emotions of life, without however recalling the actual experi-ences, so that we get an echo of the emotion without the limitations and particular direction which it had in experience.[31]

[29] Barnes, *op. cit.*, p. 49.
[30] Charles Mauron, *Esthetics and Psychology*, pp. 27–28.
[31] Roger Fry, last paragraph of "The Artist and Psychoanalysis."

And, in the second place, these forms are rediscovered in the world around us after we have contemplated these "formally significant" works of art; nature, to our vision, becomes imbued with these forms, and, to parody Pater's famous dictum, aspires to the condition of art. But of this more will be said in Part II. The point here is merely that although the "significant forms" of art are not literally copied from nature, nor are they represented in nature with anything like the fidelity that outright representational content (people, houses, trees) is, or even as the play of light and shadow or spatial extension, still they do have their basis in nature and hence are not, ultimately, as unrelated to it as Bell says.

These statements do not nullify the tripartite division made in Chapter I [32] between surface, form, and life-value, since it *is* possible to observe a painting by merely contemplating and enjoying its abstract design and "plastic orchestration" without regard to any life-relevance it may have (just as we may contemplate color in a painting without seeing it as relevant to, or expressive of, any object in life, or of anything beyond itself). And that is why we still retain it (like color) as a "thinly esthetic" dimension, in spite of the fact that, as we have now seen, the forms perceived are the forms of life.

These observations take on a special importance now that the conception of form has become, in the minds of the greater number of artists and critics today, the essence and *sine qua non* of all painting.

The most numerous and characteristic moderns of today recognize along with the criteria important to earlier generations of art-lovers—along with the subject-and-meaning values and the technical craftsmanship—a super-value, a higher significance caught out of the center of creation in a sort of formal structure or orchestration, possible only to the painting medium, or the sculpture, or the architecture. . . . The achievement of this formal value, in each art according to its kind, affords the safest guide. It is the prime signpost to the appearance and reappearance of the stream of esthetic verity down the ages. It is the one unchanging indication of a timeless excellence. [33]

When discussing this mysterious form as the *sine qua non* of all great painting, Professor Cheney illustrates his point most aptly in his analysis of Chinese paintings. [34] But as to what this "significant form" is, he agrees with other artists that it is quite indefinable; there are no rules for constructing it, but when it is present, it is the one outshining excellence of all visual art. Professor Giles translates Hsieh Ho, a Chinese painter of the sixth century, as calling it "rhythmic vitality." [35] And according to Laurence Binyon, "Mr.

32 *Of Meaning and Truth in the Arts.* [Ed.]
33 Cheney, *A World History of Art*, pp. x-xi.
34 *Ibid.*, esp. pp. 290 ff.
35 Giles, *Introduction to the History of Chinese Pictorial Art*, p. 24.

Okakura renders it 'The life-movement of the Spirit through the Rhythm of things'; or, again, one might translate it 'The fusion of the rhythm of the spirit with the movement of living things.'" [36] This notion of "significant form" or "expressive form" was inaugurated in the Occident largely through Cézanne and other post-impressionists, and has been predominant in Western art since, although it appears in El Greco and indeed to some degree in all Western painters who are currently considered the greatest, since it is itself the chief criterion by which these painters are judged:

The people who have stressed an abstract design, a formal excellence, as the basic creative element in art, have been at the very center of the modernist advance. Some of them have gone on to the conclusion that nature must be wholly squeezed out of the picture, that the new art is to be wholly abstract—and then one has the "purists" and Kandinsky and Klee. From Cezannist to ruthless abstractionist, the factions all are known as "form-seeking," and there is talk of "plastic orchestration" for formal effect. There are even those who carry this effort into mystical regions, asserting that the abstract artist sets down a revelation of cosmic order. [37]

Most artists and critics permit art a much greater "life-relevance" than Bell does; hence their term "expressive form" rather than "significant form," since the latter term has been used by Bell to denote a significance which has nothing to do with the significance of anything in life. As we have seen, however, even Bell's "significant form" is significant of life in indirect and subtle ways.

There are many works of art—which I would consider very great works indeed—that demand *primarily* the kind of response which Bell champions: Cézanne, Seurat, Whistler, and any number of the moderns. But there are many others in which life-values are absolutely essential, and without a feeling for the life-values we quite "miss" the painting. Among these are Turner's flamboyant seascapes and Constable's country landscapes, Michelangelo's feeling for the human body and Rembrandt's for the human soul, Monet's rendition of light and Cézanne's of space. Most critics would refuse to call these "irrelevant to life"; yet they would also refuse not to call them

[36] Laurence Binyon, *The Flight of the Dragon: an Essay on the Theory and Practice of Art in China and Japan*, p. 13. Cf. in this connection Clive Bell's interesting footnote: "When Mr. Okakura, the Government editor of *The Temple Treasures of Japan*, first came to Europe, he found no difficulty in appreciating the pictures of those who from want of will or want of skill did not create illusions but concentrated their energies on the creation of form. He understood immediately the Byzantine masters and the French and Italian primitives. In the Renaissance painters, on the other hand, with their descriptive pre-occupations, their literary and anecdotic interests, he could see nothing but vulgarity and muddle. The universal and essential quality of art, significant form, was missing, or rather had dwindled to a shallow stream, overlaid and hidden beneath weeds, so the universal response, esthetic emotion, was not evoked. It was not till he came on to Henri Matisse that he again found himself in the familiar world of pure art. Similarly, sensitive Europeans who respond immediately to the significant forms of great Oriental art, are left cold by the trivial pieces of anecdote and social criticism so lovingly cherished by Chinese dilettanti." —(Clive Bell, *Art*, pp. 36–37n.)
[37] Cheney, *A World History of Art*, p. 862.

great art. As we have already found in the case of music, they provide experiences different from any life-experience and hence unique, yet not wholly unrelated to it and hence not isolated.

ON ENJOYING DECADENCE

F. DAVID MARTIN

Bernard Berenson is convinced that Italian art after the High Renaissance, after, say, Raphael's death in 1520, declines into decadence. For over two centuries most artists from 1520 to 1600 have been branded as "Mannerists," a description implying decadence first used by Bellori [1] in the Baroque period and derived from Vasari's *maniera*, although for Vasari *maniera* was a perfectly decent term meaning artistic technique (*modo di operare*).[2] Increasingly since Bellori's time "Mannerism" has come to mean the affected imitation of the styles or manners of an earlier and better art without reference to reality. Mannerism historically, especially through the influence of Wölfflin and his school, has been specified as the uncreative transitional epoch between the High Renaissance and the Baroque.[3] Even Vasari and his contemporaries had a difficult time avoiding the unpleasant realization of being caught in inexorable decay, for almost everyone agreed that in Leonardo, Raphael, Titian, and above all in the divine Michelangelo, ultimate perfection had been reached. Thus the only remaining direction was down.[4] In recent years, however, the Mannerists have been exhumed, revived, and returned to Parnassus

1 Gio Pietro Bellori, *Vite de'Pittori, Scultori ed Architetti Moderni*, Rome, 1672, p. 1: "Gli artefici [between Raphael's death and the Carracci] abbandonando lo studio della natura, viziarono l'arte con la maniera, o vogliamo dire fantastica idea, appoggiata alla practica, e non all'imitazione." [*Lives of the Modern Painters, Sculptors and Architects:* "The artists deserted the study of nature, corrupting their art with mannerism, or whatever the fantastic concept is called, supported by experience and not by imitation." Ed.]
2 This is its basic meaning; for the complications see John Grace Freeman, *The Maniera of Vasari*, London, 1867.
3 Heinrich Wölfflin, *Principles of Art History*, trans. M. D. Hottinger, New York, 1932.
4 Julius Schlosser Magnino, *La Letteratur Artistica*, Sec. Ed., Trad. di Filippo Rosso, Firenze, 1956, p. 318: "L'idea della decadenza era naturale nel Vasari e fino ad un certo punto anche giusta. . . . I fiori del piano Rinascimento dovevano appassire per far posto al ricco autunno del Barocco pieno di frutti, e il Vasari e il suo tempo si trovano in una poco chiara e poco commoda fase di transizione." ["The concept of decadence was natural in Vasari and up to a certain point still legitimate. . . . The flower of the Renaissance had to wither in order to bear the rich autumnal fruit of the overabundant Baroque, and in Vasari and his time is found a small bright convenient transitional phase." Ed.]

by writers such as Friedlaender, Dvořàk, Pevsner, Hauser, and Brigante, who claim that Mannerist art expresses a significant content revealing the un- certainties of an age of crisis. Berenson and some others are unconvinced, and find in this resurrection a further sign of twentieth-century decadence. Manner- ism remains for them an imitative playing with the forms of the preceding Golden Age.

Berenson may be wrong. But suppose we agree with him for the sake of a possibly revealing argument? Then it would seem to follow that it might not be quite proper to enjoy Mannerist art, for this would involve an embarrassing disclosure of our own decadence. Berenson is quite aware of the problem, although not in ethical terms, for surprisingly he finds some of the Mannerists, the early ones, quite delightful. He asks: "What, then, is the aesthetic value of the earliest phase of art's decline?" His answer merits full quotation:

Perhaps if we seriously follow the decline of art we should discover that the processes of decay, while altogether swifter than those of growth, are not precipitous. The first who venture on the downward path . . . would hear with amazement accusations made against them of apostasy from the creed of their masters, and would appear to themselves as piously giving the last touches to the task of their predecessors. . . . The paradox might be maintained that the master's purpose reveals itself with com- pleteness to his pupil only. The master can never wholly emancipate himself from the ideals, can never entirely rid himself of the habits imposed upon him while he was young. But the pupil remains a stranger to this conflict in the master's mind; and in the master's art the follower takes cognizance of those elements only which are fashionable, and these will always be elements bearing the least resemblance to what had existed hitherto . . .

Doubtless the Lion in its struggle with Hercules took shapes and attitudes which the hero was too occupied to admire, but a spectator lurking out of harm's way in the bushes, had seen and appreciated and reported. Now that the beautiful monster was toothless and clawless, what sport to train it to take the same attitudes—but this time as steps of the dance!

It is perhaps in the exhilarating spectacle of this play that the pleasure we take in the first phases of declining art consists. . . . And this new beauty they [the Mannerists] preferred to see isolated, and of course exaggerated, as everything is when isolated from its native concomitants. It needed only this isolation and conse- quent exaggeration of certain of the master's shapes and attitudes and their recom- bination with no purpose dictated by the essential and eternal requirements of the figure arts, to change the grandeur and dignity of Michelangelo into the decorative- ness, the elegance, and the distinction of Cellini and Pontormo.[5]

In this delightful account there is one flaw, however, which must be remedied before the enjoyment of decadence can be fully justified and therefore en-

[5] Bernard Berenson, *The Drawings of the Florentine Painters*, 2 vols., Amplified Ed. Chicago, 1938, vol. 1, pp. 301–302.

joyed with propriety. Berenson splits too sharply the creative process and the aesthetic experience.

The above quotation shows clearly Berenson's conception of the influence of the style of the classic or High-Renaissance artist upon the creative process of the sixteenth-century artist. Mannerism is post-classic, a child of the classic which never forgets its parentage. In turn the classic style is the culmination of a long preparatory archaic or pre-classic period. Archaic artists are going through the process of learning to solve independent and yet related problems. They are aiming for a goal which at best they may vaguely conceive and which none of them can hope to reach, for then they would be classic. Artists are influenced and in their turn they influence. Berenson is far too sensitive to the developments in art forms to accept for a moment the mystical creation "ex nihilo" of Aldous Huxley: "Every artist begins at the beginning. The man of science, on the other hand, begins where his predecessors left off." "The work of a man of science is a creation on which others build; it has implications, it grows. . . . But Macbeth is a thing in itself, not a discovery on which other men can improve." [6]

Fertile styles, such as that of Italian Renaissance art, have a wide but finite range of possibilities that require many artists to realize. The earlier artists can realize only so much; the imaginations of those who follow are fired by the contrast between the realized possibilities or accomplishments of the preceding tradition and the unrealized possibilities they suggest. [7] The development of a style with many potentialities proceeds by many streets, many twists and turns and detours. Thus in the pre-classic period of the Renaissance there were many independent although related problems that demanded a certain degree of specialization—perspective, the structure of the human body, movement and proportion, tactility, the handling of drapery, the property of pigments, to mention some of the more important problems. Thus Signorelli and Antonio Pollaiuolo attacked the difficulties of representing the structure and energy of the human body, while Uccello became a fanatic battling perspective. The classic artist such as the mature Raphael exploits the solutions of the pre-classic artists, relates and combines them into self-contained wholes which express ease, clarity, and above all inevitability, as if the pre-classic period had to be followed in only this way. Classic works of art seem stamped in formations of absolute finality.

A classic period is always short, relative to the pre-classic, for it is based on a fully conquered control of technical means. Hercules has subdued the Lion

[6] Aldous Huxley, "A Night in Pietramala" in Along the Road, New York, 1925. Quoted by Thomas Munro, "Do the Arts Progress?", Journal of Aesthetics and Art Criticism, vol. 14, p. 186, December, 1955.
[7] For a fuller discussion of the role of potentiality in the creative process and the aesthetic experience, see my "Unrealized Possibility in the Aesthetic Experience," The Journal of Philosophy, vol. 52, no. 15, pp. 393–400, July, 1955.

and the classic period indirectly reports the tale through its use of a balanced style that incorporates the victories of all or most of the skirmishes. However, artistic equilibriums are delicate; and after all the reports are in, there is no more to do, unless it be to decline or begin a new style. For to play with the manners or forms of previous solutions without a beast to conquer can only be a decorative dance, charming and elegant, perhaps, but that is all—or so says Berenson. Yet in the aesthetic experience of this dance, for the Mannerists did not start a new style, is it only these forms, *isolated* from the past, that we experience? If so, then Berenson is right; if not, then there is more to enjoying decadence than he has been willing to admit.

It is generally agreed that the aesthetic mode of experience when fully paramount involves complete contemplative attention to a presented object, so that all awareness is aroused and centered on the object. Any meaning suggested by an art object enriches our aesthetic experience provided that it intensifies our interest in the work of art. The form of the art object—the relation of part to part and to the total interrelationship of the whole—makes this possible. For if one part suggests a meaning, a successful form will tie that meaning to the other parts and their meanings. Pontormo's Christ in the Santa Felicità *Deposition* may suggest ideas and arouse feelings about death, heaven, and even today sometimes hell and piety; but the relations of line to line, line to color, color to color, color to mass, etc., will keep—for the sensitive observer of Pontormo's form—such ideas and feelings related to the painting. It is the form of a work of art that makes possible the expression of a content, and artistic form, as distinct from decorative form, always has a content; i.e., a significant revelation of the values and disvalues of human experience. Nevertheless, there is a sense in which, as Henri Focillon likes to put it, forms have a life of their own, as can be seen in the development of Renaissance art.

Now let us put a sophisticated observer like Berenson in front of Pontormo's *Deposition*. We already know of his keen awareness of the origin of Pontormo's form, and this can no more be subtracted from his experience of the *Deposition* than can his awareness that this is a representation of Christ being lowered from the cross. Juxtaposed with the vivid concreteness of Pontormo's form is the imaginative contrast of the generic structures of High-Renaissance forms, and perhaps also specific structures, such as those of the early Michelangelo. The *Deposition* is nervous and unreal, colors are off-key, space is crowded and irrational, figures lack mass, faces are masks, movement is strained, proportions are strange, but to be fully aware of these peculiarities necessitates contrasting them imaginatively, to a large extent automatically in the trained observer, with the classic forms, for otherwise they would not be felt as either peculiar or meaningful. The classic forms are presupposed in Pontormo's

creative process, they must have been as ingrained in him as a mathematician's postulates, for every thing he did artistically derives from them. He and the other Mannerists of any worth were playing out and making concrete unrealized possibilities that the classic forms still suggested to their imaginations. To call Mannerism anti-classic, along with Walter Friedlaender,[8] falsifies its genesis; to call Mannerism archaistic, along with Berenson,[9] falsely suggests a closer relation to the archaic than to the classic. Mannerism is a post-classic art. It is understandable only within the framework of its classic parentage, and understanding is the key to appreciation. Awareness of classic form is essential to the full appreciation of Pontormo. The contrast in the aesthetic experience between the concrete post-classic and the imaginary classic enriches Pontormo's form by providing depth, by giving it a context. The proper context, furthermore, for the contrast of the forms of other traditions would lack the close identity necessary to enhance rather than slacken awareness of the art object, and this would be enjoying decadence—improperly.

By emphasizing the isolation of post-classic forms Berenson fails to do justice to the role of the imagination in the aesthetic experience, and this kind of theorizing if followed in practice may destroy any chance of our enjoying Mannerist art. The *Deposition* is like a coda that recalls the whole tradition, the vividness of the present form makes immanent more or less dimly the past forms of the tradition, even the pre-classic, and makes the significance of that past more complete because its development is taken to its final consequences. Post-classic art carries with it a sense of age and fatigue as contrasted with the youth and power of the archaic which still has some place to go. Post-classic art lacks the richness and balance of the classic, but age has its unique reward of reflection, of summing up. The struggle is over, but Hercules and his struggles are not forgotten, or at least they need not be.

Still we may have to agree with Berenson that Mannerism is a decorative dance, even if it has been given a richer context, for where is its content, its life-enhancing qualities, as Berenson likes to say? This is another story, but if, as has been suggested, there is still vitality of a fading but special kind left in post-classic forms, then perhaps there exists also a special kind of subject matter that requires this kind of form for its expression. Is the *Deposition* devoid of all religious significance? And what about the mystical canvases of Rosso, Beccafumi, Tintoretto, and El Greco? Yet it is in the portrait especially that the Mannerist's style is uniquely endowed for reaching into the mysterious inner side of man and expressing through his features his anxieties and his self-consciousness, the "existential self," as in so many of the portraits of the Man-

8 Walter Friedlaender, *Mannerism and Anti-Mannerism in Italian Painting*, New York, 1957, p. 11.
9 Bernard Berenson, *The Italian Painters of the Renaissance*, London, 1952, p. 152.

nerists, above all in Pontormo, Parmigianino, and Salviati. If only the forms of these paintings are appreciated, isolated from their content, then this too would be improper enjoyment. But this need not and should not be. Berenson has more reasons for enjoying decadence than he has given us. Decadence may be enjoyed—properly.

AESTHETIC PARADOXES OF ABSTRACT
EXPRESSIONISM AND POP ART

FANCHON FRÖHLICH

This paper is *about* the new relations that arise between contemporary works of art and the person concerned with aesthetics or the observant observer or the ideal critic or whatever you call him. Perhaps it *is* itself aesthetics in that it examines this relation and points out the paradoxes inherent in the relation and in the activity of the artist himself.

Like many of the barriers between what were formerly separate branches of art or even completely different practices—for instance, between painting and sculpture or between literature and painting or between music and speech—the barriers and divisions between painting or creation in the visual arts and aesthetics or criticism are collapsing in an illuminating way in contemporary art. So are the once clear distinctions between "art" and "life" and between "art" and "nature" and with this collapse of distinctions in the concrete subject matter of aesthetics the distinctions between critical activities such as ethics and aesthetics also dissolve. Such merging, regrouping and reversal of usual functions lead to paradoxes which can be concretely presented as absurd questions. The exploration of the way such paradoxes necessarily arise from the operations and intentions of contemporary art can be darkly illuminating of the way modern artists operate near or on the edge of the impossible—in the field of the absurd as has been said—and of their new, more complex and intimate relation to the observer.

The field of contemporary art might be described as being concentrated at two poles of creative activity. At the one pole that which is externally given

by the urban environment is selected and accepted as creation. This is popularly called "Pop Art." The other pole consists of a creation out of no given, or the minimum possible given—out of the act of painting itself—what is called abstract expressionism or action painting. These two involve diametrically different interrelations between the art work and the critic or the act of criticizing. In between these poles lie many intermediate activities—such as conventional or unconventional representational painting where the objects represented are presented by the external world but the artist does the painting himself by his own activity and the phenomenologically interesting "op" art where the artist works more or less as an engineer and the *activity* of the work of art occurs as an optical phenomenon in the viewer's eyes. But consideration of the extremes should be most illuminating.

Pop Art is in a way a return to the object as an *avant garde* movement after abstract painting by literally presenting the ordinary object itself, not a painted representation of it, or else by making large images for serious or satiric contemplation from the banal images of advertising and newspapers to which one normally gives only fleeting attention. One of its first exponents, Robert Rauschenberg, had a large retrospective exhibition at the Whitechapel Gallery two years ago. Into the context of an abstract painting he fastened photographs of objects, clocks or radios that were functioning, and made subtle visual puns between painting and everyday objects or between levels of images. For instance one of his paintings embodied the visual pun between an orange spot and a still life painting of an orange and a photograph of an orange and the written word 'orange'. It forced the spectator to shift his way of looking at things several times within the same picture, as a good joke does. He formulated his activity aptly in the statement: "I act in the region between art and life." Other painters and sculptors, in the way in which *avant garde* artists do, hurried to the extreme of this position by giving up more and more of the painterly context and interplay with the object and presenting either the object increasingly on its own or merely the image of a banal environmental image say from the comics or tabloid papers. The tendency was well exemplified in an exhibition of post-war art at the Tate Gallery last year and also in the American section of the Venice Biennale. For instance, one pop artist presented earlier in an elegant formal context of geometrical painting a bathroom shower spray with real light from a concealed electric bulb spreading from it as water would—an almost poetical "conceit." This was partly transformed and commented on by juxtaposition and paint. Later he presented barely a white washbasin attached to a black canvas—just by itself, no comment. Or Warhol presented first a complex of overlapping and richly interfering silk-screen copies of a tabloid photograph that had a certain painterly

richness in their accidental irregularities and color interferences and even a
certain formal structure in the irregularly repeated rectangles. Later he carried
this to the extreme, presenting only an enlarged silk-screen reproduction of a
photograph of a film star. A pop sculptor, Chamberlain, "presents" obsolete
or wrecked cars, which have been crushed into a more or less neat rectangular
shape by a car demolition machine, as themselves ready-made sculpture. The
complete self-destroying extreme of this activity is in the Artists' Supermarket
in New York, where ordinary supermarket items—tins of Heinz soup signed
by artists or plastic replicas of them—can be bought for very high prices.

The Pop Art movement is not a straightforward critical satire of society as
was the somewhat similar Dadaist movement between the wars. It is more a
delight or satisfaction in what *is* in the modern city and an endless repetition
of it or a participation as artists in the endless repetition of industrial produc-
tion. In pop art a great proportion of the creative activity—or that activity in-
volved which is different from what any non-artist or non-critic could do in
buying a washbasin or a smashed-up car or a photograph of Marilyn Monroe
—consists in making the aesthetic judgment: "This object is worthy of de-
tached sustained contemplation. This is beautiful—out of all context of its
place and use in ordinary life—stop and look." This attitude demands the
cessation of the ulterior motives with which one normally looks at useful articles
or commercial images. The veil of utility and intentions is rent and one sees
them new in their forms and is sophisticatedly aware of the joke of their being
there. Thus the spectator can exactly repeat the experience of the artist, look-
ing hard for the first time at something banal without being excluded from the
mysterious act of actually making it. His activity is in seeing significances into
it, seeing the joke or making up apt jokes of his own, seeing it as a form. In
a sense, if he has appreciated it, he has done it; he has by his attention trans-
formed an ordinary object into an object of art.

This results in various paradoxes. Is a given object a work of art or not
depending on who says it is? Is the same object a better work of art if it is
found or selected by a better critic or artist or placed in a better museum? Is
a broken-up car a work of art in a museum and a broken-up car in a car dump
not or vice versa? (Was a particularly elegant and spectator-involving object
in a recent exhibition at the Tate, which consisted of a white translucent
curtain and a red sign with "Fire Exit" written on it, less a work of art than the
white washbasin attached to a black canvas which was its companion, simply
because it *was* a fire exit?) Thus arise absurdities which are, however, in a
way apt because this kind of art functions partly by making witty or ironi-
cal or simply hysterical comments on its environment. Thus it is that such
paintings, like jokes that cannot bear repetition or like a shock of surprise

which is not a surprise the second time, become rapidly obsolescent. (In a recent discussion of *avant garde* art on the third programme it was commented "Art aspires to the condition of cooking.")

But such paradoxes are more importantly illuminating of the new and different relations between spectator and object—the object is not in itself an object of art; it becomes one only through its relation to him. This is the inverse of the usual situation in which the artist or collector becomes such through the works of art he has made or collected. The work of art might be said to exist in the logical space between the spectator and itself-as-an-independent-object. He creates it as art by the attention he brings to it. So these paradoxes bring the art object, the artist and the spectator closer together.

And then what happens when artist, art object and spectator do come together? What becomes of the critic's function when the artist has appropriated his usual function of saying "This object is worth looking at," and thereupon signing it? In the detached serious or sophisticated contemplation of any object one can find some illuminations—about the civilization which produced it or the civilization which produced the industry which produced it, the beauty of cracked and twisted metal, the interplay of violent accident and nature as corrosion and industrial design, or sociological reflections on the love of speed, death in violence, planned obsolescence and the destroying industry. The spectator shares the world of the artist and of the art object— that is, the given everyday world of an industrial urban society—and he can articulate new insights gained when full, long attention is focused on any one of its details presented in a pop art work. This might be like a sort of aesthetic sociology. In a wider context such art might be judged as a social phenomenon —What are its environmental and social causes? Does it merely reflect them or embody them or comment on them? If the last, what does it say? Where did it come from and where is it going? Is it worth going there? Such questions can be pertinently asked about it by the reflective observer and may illuminate more than that section of the world isolated in a museum. Or the critic may describe the new attitude towards the world or the new way of being *in* the world when art and life become *continuous*, when useful objects are isolated from their use and the everyday world in the artist's studio gets attached literally to his canvas. The situation in which one can no longer tell whether a given object is a work of art or a used-up useful object is absurd. As the ultimate absurdity is inclined to do, it leads to a sort of science fiction state of utterly detached observation of an environment meant to be used. Like an archaeologist from another planet, one can look at the paraphernalia of life without involvements in its functions. One can thus start to look at everything independently of its use and context in a detached aesthetic frame of

mind. The extreme stage of this state of mind would be paralysis in pure stunned contemplation of all surrounding objects and industrial products abstracted from their proper purposes and use. This was beautifully exemplified in the film *The Red Desert*, but in the film mental paralysis or dissociation was taken as cause rather than as effect of aesthetic contemplation of the industrial landscape.

But must the aesthetic observer or critic be thus limited to describing and reflecting on what *is* in the gallery or can he also judge whether it ought to be there? Once the artist has taken over the critic's essential function of aesthetic judgment, how can the critic take it back again? Suppose the critic or spectator were to draw the line sharply and say: "This washbasin is not a work of art, it is a washbasin." In the present situation this might seem like usurping authority, might somehow turn him into an unlicensed artist. But then who does issue artists' licenses? The whole question of the source of authority becomes problematical once the work of art is more or less defined by having been selected by an artist rather than the artist being distinguished through the quality of the work of art he has created. Indeed, this is a circular definition and leads to the internal contradiction from which the movement at present seems to be dying out. For if all the objects in ordinary life are essentially worthy of aesthetic contemplation, then there is really no need for artists to select them nor for museums to isolate them. One is surrounded by relatively inexpensive objects of art in the kitchen, and everybody can be his own artist and any place a museum.

In fact, following this dialectical path with admirable logic, the movement has degenerated literally into an artistic supermarket where one can buy for a hundred dollars or so tins of soup, etc., or replicas of them, signed by artists. But it has had the effect of changing the way of looking and the attitude involved in looking at the industrial environment and turning much that was irritating and hideous but fairly inescapable into something which can be enjoyed with amused detachment as Pop Art.

The other tendency of contemporary art goes in the direction opposite to that of selecting the given as creation. It moves towards creation out of no given or the minimum possible given. The artist creates not only his own paintings but also his own world and the laws by which it operates, its own intrinsic aim and even himself, out of the act of painting. He simultaneously creates and destroys paintings, the possibility of painting, and himself. This painting is called Abstract Expressionism and was illuminatingly named by the American critic Harold Rosenberg "Action Painting." At a certain moment the canvas began to appear to one American painter after another as an arena in which to act rather than as a space in which to reproduce, redesign,

analyze or express an object, actual or imagined. What was to go on the canvas was not a picture but an event." Such painting might be likened to the exploration of a land that does not yet exist—which comes into being by being explored—or more abstractly to the series of real numbers in which new operations create new kinds of numbers. For instance the mathematician who decided that it was a permissible operation to subtract a larger number from a smaller number thereby created negative numbers and all their possibilities. Jackson Pollock who decided (by doing it, not by thinking it) that it was possible to paint a picture with his own bodily movements and paint which left a trace of them, created a new field of possibilities in painting.

This sort of painting also generates its own group of paradoxes. (Perhaps all movements in painting contain their own intrinsic paradoxes from which they eventually die or are transformed, and a dialectical history of painting might be written. But it is a characteristic of contemporary art that it rushes to its own extremes, so the intrinsic paradoxes become more rapidly and vividly evident.) For the critic the paradox is: if painting is essentially an action without any extrinsic goals, then how can the resulting painting be judged as an aesthetic object? A consistent critic of this conviction could only logically distinguish between real actions and unreal actions (what would they be?) or pretended real actions—those whose aim was really thought out beforehand but slyly concealed. As with Pop Art, the possibility of making a clear distinction between "good" and "bad" paintings tends here to get lost in metaphysically arguable distinctions between real action and pseudo-action, new or not new, moral good and bad. Thus it is that Rosenberg, considering such painting as essentially actions or segments of life, tends to judge them almost morally. I quote Rosenberg again: "With traditional aesthetic references discarded as irrelevant, what gives the canvas its meaning is not psychological data but *role*, the way the artist organizes his emotional and intellectual energy as if he were in a living situation.—The test of any of the new paintings is its seriousness—and the test of its seriousness is the degree to which the act on the canvas is an extension of the artist's total effort to make over his experience—Action Painting has extracted the element of *decision* inherent in all art in that the work is not finished at its beginning but has to be carried forward by an accumulation of 'right' gestures. In a word, Action Painting is the abstraction of the *moral* element in art; its mark is moral tension in detachment from moral or aesthetic certainties; and it judges itself morally in declaring that picture to be worthless which is not the incorporation of a genuine struggle." But these are not the criteria usually given or accepted. His real criterion of the excellence of a painting is whether doing the painting has transformed the artist—the effect of the act of painting on the artist. Accord-

ing to such a criterion one ought to be able to find traces of the painting's transforming power in the personality of the artist. But suppose that you meet the artist afterwards and find that he isn't transformed. Would you judge the paintings by the personality of the artist or because of the qualities of the paintings themselves would you say that the artist *must* have undergone some inner transformation whether it is noticeable or not—that in life he only exhibits his superficial mask or external concerns? The first alternative seems excessively superficial, but the second seems to drain the assertion of all empirical content. Paintings and painter define each other in a way that becomes circular. One would want to say not that the value of the paintings could be found in the quality of the artist's life, but rather the opposite. The paintings are what one actually *sees*. So it is really the *moral* quality of the objects—of the paintings as given objects—which one is trying to find and judge. And at the same time it is the more or less aesthetic qualities of the artist's life that are relevant and illuminating. Thus considering paintings as essentially actions has the effect of reversing the activities of ethics and aesthetics or at least dissolving the boundaries between them. In this way ethical terms, in fact ethical "good," become applicable to objects of art and aesthetic terms, aesthetic "good," become applicable to the life of the artist. The question "Can a bad man paint a good picture?" embodies this new and more intimate relation between life and art and between ethical and aesthetic good. In this context it would seem that one must deny the logical possibility of a bad man painting a good picture. For if he could paint a good picture, then he must in some interior way—not necessarily in his relations to society or to non-artists—be a good man. This might suggest a glimpse of an aesthetically modi-fied conception of a good man, and of an ethically modified conception of a good painting. They define each other in a way that is more illuminating than a simple circular definition—it might be called a spiral definition.

For the artist at work the corresponding paradox is a concrete problem. How do you know whether you have succeeded when you don't know what you have set out to do? How do you know when an action that has no prede-termined end and purpose is finished? Confronted by something really new —the result of his own action—the artist may well ask himself "Is that what I wanted to do?" Perhaps the only answer here is "It must be because I have done it." For the working artist the only kind of resolution he can find between the demands of ultimate freedom and ultimate precision is complete acceptance of what he has done. Paintings of this kind go in series, develop-ing, affirming "This is what I wanted to do," finding piece by piece *precisely* what it is he wanted to do, and learning how to do it. They are a kind of self-exploration. The unspoken unstatable intrinsic "intention" of an act, which is

its motive force, can only become apparent in a series carrying on the act. If the artist could say what his intention was apart from the act, then he could fulfil it in one act but it wouldn't be a genuine exploratory act. But once the artist has understood it, mastered it and is able to do it, then he logically and psychologically ceases to be able to do it. Then doing it ceases to be an act of discovering by exemplifying new laws, but a production according to them. Within the framework of this art production is the opposite of creativity. Once one already knows the terrain exploration turns into leading safaris. The act becomes a making, and the artist becomes a craftsman. Psychologically this is the problem and danger of becoming uncreative by repeating oneself. So there is the paradox logically speaking or the very delicate balance psychologically speaking between repeating a similar action frequently enough to define and affirm what one wants to do and repeating it too often once one knows what one wants to do so that it becomes production instead of discovery.

Such painting is ultimately tragic because it lives by consuming its own possibilities. The artist must always be working on the verge of the impossible. One can see this in the work itself—it has a quality of tragic intensity and involvement, as opposed to the "coolness" and comic detachment of Pop Art.

This paper has been a sketch of the limits of the impossible. Since most contemporary *avant garde* art exists in this region, near or at the limit of the impossible, it is filled with paradoxes, which are sometimes destructive, sometimes animating, sometimes both at the same time. Indeed it is probably in the latter way, as simultaneously self-destructive and life-giving that the paradoxes within contemporary art function to keep it perpetually new.

Such paradoxes within the processes of contemporary visual art itself propagate more paradoxes in the relation of the judging spectator to the work of art and in his traditional activity of judging "This is a good or a bad work of art." Indeed, they obliterate or render obsolete this detached independent-spectator-judging-independent-object attitude and introduce new, more intimate relations between aesthetic observer and work of art, which relations themselves are filled with paradoxes. Such paradoxes turn the traditional relationships inside out. Thus in the case of Pop Art the observer now assumes part of the active role of making the object into an object of art, and the artist undertakes a more connoisseur-like role of selecting objects for aesthetic contemplation. But if *anything* can be an object of artistic contemplation, then why does one need to have artists to select some things rather than others or museums to isolate them? Or in the case of action painting, if the painting is to be judged as an action—a segment of life, an action which transforms its doer—then the moral or spiritual state of the artist rather than the physical state of

the picture becomes in a way the ultimate criterion. Then the meaning of "good" and "bad" as aesthetic terms are altered and shifted into another category, that of ethical good and bad, and aesthetics is transferred into a kind of ethics.

AESTHETIC EXISTENCE

ETIENNE GILSON

In what precedes, the words "physical existence" signify the existence of paintings conceived as simple material objects. To simplify the problem, we can consider each painting as constituting a single physical unit made up of a support (plaster, wood, plywood, canvas, cardboard, paper, etc.), its underpainting, and a coat of colors. But it can be objected that thus to consider a painting as any other material object is not to consider it as a painting at all. And, indeed, each and every material object that we can see and handle is likewise a solid, located in space and enjoying a continuous existence in time. From this point of view, there does not seem to be any difference between a painting and the brush of the painter or his easel. Hence the conclusion that, although the physical mode of existence of paintings may well differ from that of music, their artistic and their aesthetic modes of existence can nevertheless be the same. Like a poem or a musical piece, a painting has actual existence only during those moments that it is being actually experienced as a work of art.

This position has recently been maintained with great force by excellent aestheticians. In order to understand it, one must first remember the modern distinction introduced by philosophers between ontology and phenomenology. Ontology deals with being, or beings, such as they are in themselves, irrespective of the fact that they are apprehended or not as well as of the particular way in which they may happen to be apprehended. From this point of view, it is true to say that, like every other solid body, a painting continues to be that which it is, irrespective of the fact that it is being seen or not. Even artistic existence belongs to paintings irrespective of the fact that they are being experienced or not. The modern preponderance attributed to the point of view of the onlooker has finally led the aestheticians to reason as though to experi-

ence a painting as a work of art was to cause its existence as a work of art. In fact, just as a work of nature is such because it owes its existence to the efficacy of natural forces, so also a work of art is such because it is the work of a certain artist who has caused it to be by means of his own art. Up to what point our awareness of their artistic existence is implied in our aesthetic experience of paintings is a point to be discussed later. For the present, the point at stake is that the consideration of the artistic mode of existence of a painting, since it hangs on that of its efficient cause, belongs in ontology.

Phenomenology rests upon the assumption that, as it has been established by Kant's *Critique of Pure Reason,* we cannot speculate about what things are in themselves, since this would entail an attempt to know things such as they are while they are not being known. To avoid this contradiction, phenomenology substitutes, for the knowledge of things in themselves, the knowledge of things such as they are in human experience. In other words, what philosophers call a "phenomenon" is "being" as an object of experience. In the light of this distinction, it is commonly said that the only being of a painting in which we should take an interest is not its so-called physical being, but rather the phenomenological being that it has as an actually experienced work of art.

This is a good occasion to remember the great saying of Leibniz, that systems are true in what they affirm and false in what they deny. For, indeed, phenomenology is a very important discovery and it is here to stay. Even if its arrival should not prevent the survival of ontology, the fecund investigation of the manifold modes of phenomenological existence deserves to be carried on, as it has been ever since the time of Hegel, with increased care, but the aesthetic implications of this new philosophical attitude are not so simple as they seem to be in the eyes of some contemporary aestheticians.

Let us first observe that, from a strictly phenomenological point of view, the distinction should not simply *be* between a painting taken as a physical being and the same painting taken as an object of aesthetic experience. Philosophers are mainly concerned with knowing. Consequently, the type of phenomenological existence in which they are interested is the one that belongs to things inasmuch as they are being known. Now, the distressing fecundity of the notion of phenomenon is such that the analysis of no phenomenological being ever comes to an end. Because any object can enter human experience in a practically infinite number of different ways, the investigation of its various modes of existence—that is, its "phenomenology"—can be indefinitely pursued without ever exhausting the object in question.

This, which is both the greatness and the misery of phenomenology, can be verified in the case of paintings. Apart from having its physical existence, a

painting has the being of that which is known and seen; but it can also exist as an object of aesthetic experience, which is a mode of being distinct from the two preceding ones. To the painter himself, a painting is first something to be done, but it also is something to be sold, and very great painters, such as van Gogh, have known the distance from a completed picture to a sold picture. Nor is this all, for the mode of existence of the painting we intend to buy is not the same as that of the same painting the art dealer is trying to make us buy. Still more modest modes of existence should be listed, even in the case of the greatest masterpieces. Paintings are things to be stored, or to be exhibited, or to be packed and carted or shipped; they are things to be dusted, repaired, restored, or more simply protected by guardians. As a mere suggestion, let us try to imagine what a world-famous masterpiece really would mean to us if we were in charge of seeing to it, eight hours a day, that no one should touch it, scratch it, or steal it. From the point of view of phenomenological existence, all these are so many different modes of being. Considering these various modalities of their existence, it is at least doubtful that all works of art can be said to exist in the same way. Many problems arise, in connection with paintings, that do not arise, at least under the same form, in connection with poetry or music. To mention only one of them, the problem of selling art is not at all the same for the art dealer as it is for the bookseller to sell art books. Our present problem is to ascertain the common origin of these differences, and our tentative answer is that we should look for it in the fundamental mode of physical existence that is proper to each specifically distinct type of work of art.

Let us call aesthetic existence the mode of existence that belongs to paintings inasmuch as they are being actually perceived as works of art and as objects of aesthetic experience. It then becomes obvious that, like music or poetry, paintings enjoy only a discontinuous mode of existence, which lasts as long as aesthetic experience itself and varies together with it. Everyone will grant that there is such a mode of existence, but some philosophers maintain that works of art, taken precisely as such, have no other one. Their reason for upholding this thesis is both subtle and simple; it is that, so long as it is not being perceived as a work of art, an object is not a work of art. In other words, what is not a work of art for somebody is not a work of art at all.

There is something to be said in favor of this philosophical position. In Europe at least, small forests of seventeenth- and eighteenth-century furniture have been used to keep stoves burning; to those who were using it that way, such furniture was just fuel. Quite recently (July, 1954), a Milan newspaper announced that a large-sized Tintoretto had just been discovered in the basement of the Cathedral. Up to that day it had been used to cover a pile of junk.

The question then is, To those who had been using it that way what was it? Was it a Tintoretto or was it a covering? But the problem can be generalized. What is a cathedral, while nobody is looking at it, if not a heap of stones? In the same way, while nobody is looking at them and enjoying them precisely as paintings, these are nothing more than colored pieces of canvas, cardboard, or wood. It seems therefore that, like musical pieces, paintings exist only while they actually *are* being perceived.

These remarks are justified to the extent that aesthetic existence is at stake, but they do not apply to the artistic existence of the experienced works of art. Taken in itself, aesthetic experience involves time. It is only one among many psychological events that all have a beginning and an end and whose nature is such that they can be more or less exactly repeated. From this point of view —that is, considered as an object of actual aesthetic experience—the existence of a painting, and even that of a statue or of a monument, is just as fleeting and discontinuous as that of music. We all know this from bitter experience. Being abroad and in one of the rooms of some art gallery to which his chances of ever returning are remote, does not an art lover experience a feeling of distress at the thought that, after crossing the next door, he will never again find himself face to face with one of the world's masterpieces? Especially if he is advanced in years, an art pilgrim cannot leave even certain art cities without thinking that this time is perhaps the last time. At any rate, there is no doubt that for each of us, whatever his age, the mode of existence that belongs to objects of aesthetic experience is discontinuous and fragmentary.

Let us go further still. There are, on the part of paintings themselves, subjective causes for this discontinuity. One of these causes, at least, is familiar to all, namely, the presence or the absence of light. However long they try to stay open, a moment comes every day when art galleries have to close their doors. Darkness then sets in, and, from the point of view of possible aesthetic experience, all the paintings cease provisorily to exist. Is not this another feeling familiar to most of us? At the time the guardians of art first begin surreptitiously to look at their wrist watches, and then, politely but firmly, escort us from room to room until they finally march us out of some art gallery, do we not sometimes wonder what kind of existence those masterpieces are still enjoying during the long hours that their colors are blacked out and can no longer be seen? Nor is this all. For, indeed, works of art can disappear for years, sometimes even for centuries, with the result that, as did happen in the case of cave paintings, some of them ceased to be actually experienced for some fifteen thousand years. Moreover, even after being thus rediscovered, they were not recognized at once as works of art, much less as the kind of works of art that they are.

The radical contingency of aesthetic existence is strikingly symbolized by the story of the discovery of the rock paintings of Altamira. In 1879, the Spanish archaeologist, Marcelino de Sautuola, was exploring a cave near Santander, in Spain. While he was at work, his little daughter, who was playing around him, suddenly told him that she saw a beast on the rock. De Sautuola looked at it and saw several animal forms painted on the walls of the gallery he was in as well as of the following ones. Thus and in this way did works of art buried in darkness for many thousands of years relive for the first time in the eyes of a child wholly unaware of having made a momentous archaeological discovery. At the time, however, nobody paid attention to it. It was going to take a few more years before, being at last recognized for what it was, the prehistoric cave art of Altamira achieved the fullness of its aesthetic existence. The more recent, but equally accidental, discovery of the Lascaux murals bears witness to the same truth. Far from being identical, ontological existence and phenomenological existence are not always compatible. Unseen, the Lascaux murals have victoriously stood the strain of many millenniums. Exposed to the natural vandalism of crowds, the crucifixion of Avignon is now ending an agony of five hundred years.

The same conclusion can be directly obtained by considering the problem from the point of view of aesthetic experience itself. In the case of painting as well as of music, there are an experiencing subject and an experienced object. In both cases, the experiencing subject is a human consciousness that endures in time and whose fluidity communicates itself to the very being of aesthetic experience. A certain painting may not have perceptibly changed during fifty or sixty years, but the man who sees it at the age of sixty is very different from the young boy of ten or from the man of thirty who had seen it before. Let us leave aside the tricky problem of artistic tastes and of the way they have of changing with age; the same painting, even if it is as much admired as it ever was, is not seen in the same way by the child, by the same child now become a mature man, and by the same man now entering a ripe old age. It is the same painting; it is the same human being; it is by no means the same being of aesthetic experience in one and the same person.

Nor is this all. Let us consider ourselves while we are looking at a certain painting in some art gallery. It takes time for us to see it. However long or short this time is, our inspection of the painting has a beginning, a middle, and an end. We see it better and better; at any rate, we see it otherwise, so that its aesthetic mode of existence never ceases to change even while we are looking at it. The same remark applies to the various modes of existence of one and the same painting in the consciousness of five or six different persons looking at it at one and the same time. They do not all see it under the same angle or

in the same light. Even if they did, they still would not be the same person, so that there still would be five or six different modes of aesthetic existence, each of them continually changing, for one and the same painting.

It is therefore true to say that, because all human experience is subjective and takes place in time, the aesthetic mode of existence of painting is somewhat similar to that of music. And yet, when all is said and done, even this is not wholly true, because the difference between their respective modes of physical existence is confusedly perceived in aesthetic experience, and this is enough to render the aesthetic existence of a painting specifically different from that of a musical piece. In the case of music, we have a fleeting apprehension of a fleeting and always incompletely existing thing; in the case of painting, we have a changing, fleeting, and always incomplete experience of a stable, complete, and enduring entity. This is enough to account for the fact that we do not expect the same kind of emotion from paintings and from music. Some of us are tone-deaf to music, others are color-blind, and while many men are fortunate in being able to enjoy both painting and music, very few, if any, are equally sensitive to both. At any rate, personal experience, to which one often appeals in the last resort, seems to confirm the fact that the physical difference there is between their respective relations to space and time remains perceptible in our different ways of apprehending the existence of music and the existence of painting.

The easiest way to realize this difference is perhaps to compare the two kinds of places where music and painting are to be found. Musical scores exist in libraries where they can be consulted; only, as has already been said, musical scores are not in themselves music. In order to hear music, we have to go to appointed places, such as theaters and concert halls, and it is necessary for us to be there at certain appointed times that are the only ones during which some music will exist in those places. During the interval between two performances or two rehearsals, an opera house or a concert hall is totally empty of music. There is nothing there. On the contrary, museums and art galleries are permanently inhabited by a multitude of man-made things whose unseen presence is perceptible to us even when, having something else to do, we must content ourselves with passing by. Every time we can enter one of these buildings, and especially one of the rooms in which some world-famous painting is exhibited, our impression of being admitted to an awesome presence becomes irresistible. One enters the room of the Brera, in Milan, where the sole painting exhibited is Raphael's *Marriage of the Virgin*, as he would enter the hall in which some sovereign is sitting in state, waiting for the homage of his visitors.

This solid physical presence is part and parcel of the aesthetic existence of

paintings, and it renders their aesthetic experience specifically different from that of music, which, far from being focused upon a whole completely given at once in an intuition of the present, consists of a succession of instants each of which is full of memories of the past as well as of expectations of the future. To experience music is to communicate with the kind of order, and therefore of unity, of which becoming is capable. Sonorous structures have their own forms, without which they would not exist as works of art, but here again we can apply to music what St. Augustine once said about poetry; all the rhythms, numbers, proportions, and, generally speaking, all the rules to which poets or musicians resort in order to turn the words of common language into poetry, or the sounds of human voices and of instruments into music, have no other effect than to impart to a fleeting multiplicity the only kind of unity, order, and stability of which it is capable. It is no mediocre achievement, for a musician, to fill up the emptiness of silence with sounds whose intelligible structure is perceived by man's ears as endowed with a unity of its own and, consequently, with a certain degree of entity. But painters have no such problems to solve. The difficulty for them is not to impart to becoming enough unity to turn it into some sort of being. Precisely because they are material solids, paintings enjoy the same kind of concrete existence, the same sort of actually complete being, that belongs to things of nature. The painter's own problem rather is to obtain from the solid and immobile objects produced by his art an expression of movement, of becoming, and in short, of life.

All painters are aware of the problem, but some of them give in to the desire of obtaining from their art results that it is not in its nature to yield. In the case of great artists, the result is always interesting, yet it never wholly fulfills the ambitions of the painter. In such pictures as the *Bonaparte Crossing the St. Bernard,* by David, the eternally rearing horse whose forelegs never touch the ground offers a rather disturbing contrast between the immobility of the painting and the frantic intensity of the action it attempts to represent. In his famous *Epsom Derby,* Géricault has cleverly avoided attributing to his galloping horses any one of the many positions in which a snapshot would catch them in reality. His intention has certainly been to suggest motion rather that to represent it. Yet, when all is said and done, there remains a puzzling ambiguity in the sight of these horses that always fly and never move. Many pictures of battles, fighting animals, and hunting scenes call for similar remarks. In them, whirls of apparently frantic motions stay frozen solid in an everlasting immobility.

There are ways of palliating the difficulty. One of them consists in representing a scene implying motion at the very moment that the forces at play are reaching a point of equilibrium. This is what Manet has done in his

Tumblers (*Les Saltimbanques*). We all know the moment of suspense during which, having at last achieved a precarious poise, an acrobat keeps us breathless; this is also the moment for a painter to get us interested in a combination of lines that represents an interval of rest between two motions. In his *Horses Fighting*, Delacroix has achieved a similar result by means of another triangular composition whose summit, irresistibly attracting the eye, is the head of the tall dark horse. As will presently be seen, the static equilibrium of the figure interests the painter much more than his apparent intention of representing movements. Another, and a hardly less perfect, answer to the same problem is exemplified by Seurat's *Circus*. An important part of it is in motion, but our eyes cannot possibly follow its lines without going full circle and, by the same token, without achieving some sort of immobility.

Not so, however, in the many cases in which painters obviously lose sight of the problem. When they are not mere feats of skill to be enjoyed as such, their unconvincing renderings of motion by means of cleverly combined immobilities achieve no other result than to mislead us as to the true pictorial meaning of the works in question. Seen as a snapshot, *The Sabine Women* of David is hardly bearable. After a first glance at it, which immediately reveals the accomplished mastery of the classical traditions typical of David's art, most of us consider that we are done with this gigantic canvas. But it may happen that a painter knowing his craft invites us to spend a few more moments in the contemplation of this cumbersome structure and points out for us the true result that David intended to achieve. Our painter friend first warns us to forget any idea of motion and even any desire, on the part of the artist, to convey to us any impression of mobility. Only one thing interests him, as it should interest us, namely, the visual pattern formed by the intricate lines indicating the supposed motions of the painted figures. As soon as we look at it, not as suggesting motion in time but as a visual pattern in space, the work of David becomes highly interesting. Without attempting one of those endless analyses which mean little to anybody except their own authors, let us briefly observe the striking horizontal line that divides the picture from the extremity of the spear leveled by the warrior on the right up to the crest on the helmet of the opposite warrior on the left. Let us also observe the dominating rectangle determined by these two opposite figures between which, in point of fact, the whole subject is depicted: a Sabine woman attempting to separate a Roman warrior from a Sabine warrior. But, above all, let us note the triangular structure of the middle group formed at its base by the central figure of the Sabine woman with extended arms and descending to the apex formed by the playing children. On the right, it follows the line that goes from the hand of the standing figure to the head of the older woman, then of the younger woman;

the line continues following the arm of the younger woman to her own right hand, but at the very point where it reaches the tip of her fingers this descending line begins to reascend through the raised hand of the child on the left, then through the drapery of the gown, then through the left leg of the standing woman who shows a child to the warriors, until it reaches again the fingers of the other extended arm of the central figure. Other similar patterns will easily be detected by any careful observer of this complex composition. Its true pictural meaning then clearly appears. We would achieve nothing by giving these frozen figures a mental push in order to set them in motion. They cannot move without wrecking the composition. But we shall be amply rewarded if, forgetting everything about motion, we concentrate upon the structured interplay and the arabesque of the lines.

The static nature of paintings is therefore included in our aesthetic experience of them. This conclusion can be verified by comparing the effect produced by *The Sabine Women* of David with our immediate impression of any other similar composition in which, because no suggestion of motion is intended, the geometrical pattern is immediately discernible. David's *Distribution of the Eagles* cleverly picks up the moment that, for a split second, all the movements are supposed to stop; there is perfect harmony between the static nature of the art of painting and the equally static nature of the subject. But the contrast is still more fully perceptible if we compare *The Sabine Women* with Velázquez's *Surrender of Breda*. In this masterpiece, there is hardly a trace of motion left. Time seems to have come to a standstill. Human beings themselves, however well painted they may be, are only second in importance to the pattern of the lines and to the balance of the masses. Nor is it without reason that this world-renowned picture is often called *The Lances*. Most of those who admire it do not know with perfect precision where Breda is, nor by whom it was taken, nor at what date; but they all perceive at once the impressive hedge of verticals that, while dividing its surface according to the "golden section," establishes communication between the verticals of the lower part and the horizontals of the higher part of the painting. For, indeed, the powerful effect produced by these vertical lances is largely owing to the fact that the horizontal landscape in the background still remains visible behind them.

This, of course, does not mean that a painter is wrong when he tries to represent action. Few pictures are completely free from action, and some very great painters have often taken pleasure in representing it. The reason for this is not hard to find: the more action there is in a subject, the more opportunity it affords to achieve complex patterns of lines and combinations of forms in whose apprehension, as will be seen, the cause of our pleasure chiefly resides.

If the artist is a master in his art, the effect of the represented action is precisely to lead our eyes along lines whose pattern we might otherwise fail to discern. As has been seen, such was the case in *The Sabine Women* of David; but such had already been the case with *The Rape of the Sabine Women* by Nicolas Poussin, in which, provided only it follows the lines of the represented action, the eye spontaneously perceives the general distribution of the masses and the main lines of the composition. The point we are enforcing is that, whether or not it harbors the secret ambition to represent action, a painting first is a static pattern of colors, forms, and, in the last analysis, lines. Moreover, a painting is experienced as being such a static pattern, and this fact accounts for the feeling of incongruity that, after a short moment of full satisfaction, most people experience at the sight of the static representation of some intensely dynamic action. If we compare the two versions of Poussin's *Rape of the Sabine Women* with either his *Baptism of Christ* or his *Funeral of Phocion*, the two latter works, in which the maximum of composition combines with the minimum of action, convey an impression of solid and harmonious stability more in keeping with the physical mode of existence that belongs to paintings.

As it is not easy to dissociate the two notions of suggested motion and of represented motion, a simple experience can help in realizing the distinction. It consists, while looking at the painting of some animated scene, in trying to imagine what would happen to the composition if the figures depicted in it really began to move. Most of the time the composition would be wrecked without being replaced by a new one. Pictorial composition requires immobility. In the words of Baudelaire: "Je hais le mouvement qui déplace les lignes." While looking at *The Forge*, by Goya some visitors to the Frick Collection express misgivings about what would happen to the skull of the person who holds the iron on the anvil in case the blacksmith wielding the hammer really should strike. One prefers not to think of it. But, precisely, this has nothing to do with the quality of the painting. A certain pyramidal structure, and the trace left in space by a possible movement, not actual movement, is what the painter was interested in. To sum up, the aesthetic mode of existence of a painting includes an awareness of the static mode of existence of its object just as, on the contrary, the aesthetic mode of existence of music includes the awareness of the discontinuous and fleeting existence of its object. And no wonder. It is as difficult for painting to move as it is for music to stand still.

This specificity of the physical mode of existence proper to paintings accounts for the growing importance attributed to still life in the history of art. On the one hand, most of the aestheticians and painters who insist that there is a

hierarchy of genres of painting seem to agree that still life is the humblest of these genres. There is nothing particularly noble about representing fruit, loaves of bread, forks, knives, cups, and other such objects whose sight evokes nothing more than the most modest aspects of everyday life. On the other hand, one cannot look at one of the best Chardins, or, for that matter, at any good still life of any school and any period, without feeling that this is indeed a genre in which painting reveals its very essence and reaches one of its points of perfection. A still life does not inspire us with the same kind of admiration as the frescoes of Michelangelo in the Sistine Chapel, but we derive from it a different and, in a sense, a fuller feeling of contentment. However great the artist, he cannot convince us that his immobile puppets are really running, talking, and acting. Not so in a still life, which, by definition, is a picture consisting of inanimate objects. It may comprise animals, provided these animals be dead. In a still life nothing acts, nothing gesticulates, nothing does anything else than to be. Now, precisely, this is what painting is best equipped to depict. The kind of plenary satisfaction we experience while looking at a still life is due to the perfect adequacy that obtains, in this case, between the substance of the work of art and the reality that it represents. Such pictures are solid and inanimate objects enjoying a continuous mode of physical existence; the cups, the forks, or the books they represent are beings of the same sort, and they enjoy the kind of continuous existence that belongs to inanimate solids situated in space. In this case, the artist is not attempting to make his art say more than it can say. The specific pleasure given by the best still lifes clearly reveals the radical difference there is between the aesthetic mode of existence of paintings and that of music.

The notion of "still life" does not apply only to the pictures representing dead animals or inanimate household objects. It is surely not by chance that the seventeenth-century Dutch painters, who were the first to handle still life as a distinct genre and brought it to its point of perfection, were also the first to find fitting subjects in many other man-made objects, or things, whose only common quality precisely is their stillness. The old belief, expressed by Reynolds, that a still-life painter simply aims to imitate the visual appearance of the lowest kinds of objects befits a large number of still lifes whose authors never imagined that another conception of their art was possible. But when the still-life style extended itself from household objects to houses themselves; then to churches, which are the houses of God; then to cities, which are made up of houses and of churches, it became obvious that the aim and scope of a still life was something far beyond the mere imitation of inanimate objects.

There is magic in the art of the great Dutch painters. The same intense feeling of reality and of enduring stability suggested by their fruit bowls and

their loaves of bread remains perceptible in the interiors painted by Pieter de Hooch before, yielding to a temptation fatal to so many painters of still lifes, he began to turn out mere genre pictures. Generally speaking, the best Dutch interiors invite the spectator to partake of a life that is not his own, but with which he communicates without disturbing it in the least. Their quiet house-wives do not mind us; they are not even aware of our presence; as to them-selves, even if they pretend to be doing something, all that they really have to do is to be. Many Dutch pictures of church interiors proceed from the same spirit. The small personages that people the churches painted by H. van der Vliet do not prevent them from remaining so many still lifes. This is still truer of the churches painted with a unique blending of finish and sensibility by Pieter Saenredam. But there is a short distance, if any, from an interior by Jan Vermeer to his justly celebrated *Street in Delft*, whose life is no less still than that of his own interior scenes. Even his equally famous *View of Delft* shares in the same qualities of quiet presence and actionless existentiality that characterize his little street. A similar extension is observable in the works of Saenredam when he passes from the inside of his churches to their external appearance. There is something of the stillness of Vermeer's *View of Delft* in the portrait of a Utrecht public place by Saenredam. One might feel tempted to include some landscapes in the same class, but even when they are peaceful, Dutch landscapes and seascapes are not still. An intense life quickens their skies as well as their seas. The spirit of still life is no longer there. But we find it again every time we turn our attention to one of the masterpieces anterior to the time, when, even in Holland, still life deteriorated into plain imagery. And since the corruption of the best brings about the worst, we should not feel surprised to find in the most mediocre of modern genre pictures the posterity of such perfect masterpieces.

There is a sort of metaphysical equity in the fact that this humblest genre is also the most revealing of all concerning the essence of the art of painting. If, by the word "subject" we mean the description of some scene or some action, then it can rightly be said that a still life has no subject. Whether its origin be Dutch or French, the things that a still life represents exercise only one single act, but it is the simplest and most primitive of all acts, namely, to be. Without this deep-seated, quiet, and immobile energy from which spon-taneously follow all the operations and all the movements performed by each and every being, nothing in the world would move, nothing would operate, nothing would exist. Always present to that which is, this act of being usually lies hidden, and unrevealed, behind what the thing signifies, says, does, or makes. Only two men reach an awareness of its mysterious presence: the philosopher, if, raising his speculation up to the metaphysical notion of being,

he finally arrives at this most secret and most fecund of all acts; and the creator of plastic forms, if purifying the work of his hands from all that is not the immediate self-revelation of the act of being, he provides us with a visible image of it that corresponds, in the order of sensible appearances, to what its intuition is in the mind of the metaphysician.

THE NEW SCULPTURE

CLEMENT GREENBERG

Art looks for its resources of conviction in the same general direction as thought. Once it was revealed religion, then it was hypostatizing reason. The nineteenth century shifted its quest to the empirical and positive. The notion of the empirical and the positive has undergone much revision over the last hundred years, and generally become stricter and perhaps narrower. Aesthetic sensibility has shifted accordingly. The growing specialization of the arts is due chiefly not to the prevalence of the division of labor, but to our increasing faith in and taste for the immediate, the concrete, the irreducible. To meet this taste, the various modernist arts try to confine themselves to what is most positive and immediate in themselves.

It follows that a modernist work of art must try, in principle, to avoid dependence upon any order of experience not given in the most essentially construed nature of its medium. This means, among other things, renouncing illusion and explicitness. The arts are to achieve concreteness, "purity," by acting solely in terms of their separate and irreducible selves.

Modernist painting meets our desire for the literal and positive by renouncing the illusion of the third dimension. This is the decisive step, for the representational as such is renounced only in so far as it suggests the third dimension. Dubuffet shows that as long as the representational does not do that, taste continues to find it admissible; that is, to the extent that the representational does not detract from literal, sensational concreteness. Mondrian, on the other hand, has shown us that the pictorial can remain pictorial when every trace or suggestion of the representational has been eliminated. In

short, neither the representational nor the third-dimensional is essential to pictorial art, and their absence does not commit the painter to the "merely" decorative.

Abstract and near-abstract painting has proved fertile in major works, especially in this country. But it can be asked whether the modernist "reduction" does not threaten to narrow painting's field of possibilities. It is not necessary here to examine the developments inside abstract painting that might lead one to ask this. I wish to suggest, however, that sculpture—that long-eclipsed art—stands to gain by the modernist "reduction" as painting does not. It is already evident that the fate of visual art in general is not equated as implicitly as it used to be with that of painting.

After several centuries of desuetude sculpture has returned to the foreground. Having been invigorated by the modernist revival of tradition that began with Rodin, it is now undergoing a transformation, at the hands of painting itself, that seems to promise it new and much larger possibilities of expression. Until lately sculpture was handicapped by its identification with monolithic carving and modeling in the service of the representation of animate forms. Painting monopolized visual expression because it could deal with all imaginable visual entities and relations, and also because it could exploit the post-medieval taste for the greatest possible tension between that which was imitated and the medium that did the imitating. That the medium of sculpture was apparently the least removed from the modality of existence of its subject matter counted against it. Sculpture seemed *too* literal, *too* immediate.

Rodin was the first sculptor since Bernini to try seriously to arrogate to his art some of the essential, rather than merely illustrative, qualities of painting. He sought surface- and even shape-dissolving effects of light in emulation of Impressionism. His art, for all that it contains of the problematical, triumphed both in itself and in the revival of monolithic sculpture that it initiated. That revival shines with names like Bourdelle, Maillol, Lehmbruck, Despiau, Kolbe, Marcks, Lachaise, Matisse, Degas, Renoir, Modigliani. But, as it now looks, the greatness of this revival was like the final flare-up of something about to die. To all intents and purposes, the Renaissance and monolithic tradition of sculpture was given its quietus by Brancusi. No sculptor born since the beginning of this century (except perhaps the Austrian, Wotruba) appears to be able any longer to produce truly major art in its terms.

Under the influence of Fauve painting and exotic carving (to which painters called his attention), Brancusi drove monolithic sculpture to an ultimate conclusion by reducing the image of the human form to a single geometrically

simplified ovoid, tubular, or cubic mass. Not only did he exhaust the monolith by exaggerating it, but by one of those turns in which extremes meet, he at the same time rendered it pictorial, graphic. Then, while Arp and others carried his monolith over into abstract and near-abstract sculpture, Brancusi himself went on toward something still more radical. Once again taking his lead from painters, he began in his wood carvings to open up the monolith under the influence of Cubism. He then produced what are in my opinion his greatest works, and he had, as it were, a Pisgah view of a new kind of sculpture (at least for Europe) that lay altogether outside the orbit of monolithic tradition. I say Pisgah view because Brancusi did not actually pass over into this new kind of sculpture; that was left to painting and painters, and the real way to it was opened not by him, but by the Cubist collage.

The pieces of paper or cloth that Picasso and Braque glued to the surface of the collage acted to identify that surface literally and to thrust, by contrast, everything else on it back into illusionist depth. But as the language of the collage became one of larger and more tightly joined shapes; it grew increasingly difficult to unlock the flatness of its surface by this means. Picasso (before resorting to color contrasts and to more obviously representational shapes) solved—or rather destroyed—the problem by raising the collage's affixed material above the picture surface, thus going over into bas-relief. And soon after that he subtracted the picture surface entirely, to let what had originally been affixed stand free as a "construction." A new tradition of sculpture was founded, and the fact that it was a new tradition was demonstrated subsequently in the works of the Constructivists, Picasso's own later sculpture, and in the sculpture of Lipchitz, Gonzalez and the earlier Giacometti.

The new construction-sculpture points back, almost insistently, to its origins in Cubist painting: by its linearism and linear intricacies, by its openness and transparency and weightlessness, and by its preoccupation with surface as skin alone, which it expresses in blade or sheet-like forms. Space is there to be shaped, divided, enclosed, but not to be filled. The new sculpture tends to abandon stone, bronze and clay for industrial materials like iron, steel, alloys, glass, plastics, celluloid, etc., etc., which are worked with the blacksmith's, the welder's and even the carpenter's tools. Unity of material and color is no longer required, and applied color is sanctioned. The distinction between carving and modeling becomes irrelevant: a work or its parts can be cast, wrought, cut or simply put together; it is not so much sculptured as constructed, built, assembled, arranged. From all this the medium has acquired a new flexibility in which I now see scultpure's chance to attain an even wider range of expression than painting.

Under the modernist "reduction," sculpture has turned out to be almost as exclusively visual in its essence as painting itself. It has been "liberated" from the monolithic as much because of the latter's excessive tactile associations, which now partake of illusion, as because of the hampering conventions that cling to it. But sculpture is still permitted a greater latitude of figurative allusiveness than painting because it remains tied, inexorably, to the third dimension and is therefore inherently less illusionistic. The literalness that was once its handicap has now become its advantage. Any recognizable image is bound to be tainted with illusion, and modernist sculpture, too, has been impelled a long way toward abstractness; yet sculpture can continue to suggest recognizable images, at least schematically, if only it refrain from imitating organic substance (the illusion of organic substance or texture in sculpture being analogous to the illusion of the third dimension in pictorial art). And even should sculpture be compelled eventually to become as abstract as painting, it would still have a larger realm of formal possibilities at its command. The human body is no longer postulated as the agent of space in either pictorial or sculptural art; now it is eyesight alone, and eyesight has more freedom of movement and invention within three dimensions than within two. It is significant, moreover, that modernist sensibility, though it rejects sculptural painting of any kind, allows sculpture to be as pictorial as it pleases. Here the prohibition against one art's entering the domain of another is suspended, thanks to the unique concreteness and literalness of sculpture's medium. Sculpture can confine itself to virtually two dimensions (as some of David Smith's pieces do) without being felt to violate the limitations of its medium, because the eye recognizes that what offers itself in two dimensions is actually (not palpably) fashioned in three.

Such are what I consider to be present assets of sculpture. For the most part, however, they abide in a state of potentiality rather than of realization. Art delights in contradicting predictions made about it, and the hopes I placed in the new sculpture ten years ago, in the original version of this article, have not yet been borne out—indeed they seem to have been refuted. Painting continues as the leading and most adventurous as well as most expressive of the visual arts; in point of recent achievement architecture alone seems comparable with it. Yet one fact still suggests that I may not have been altogether wrong: that the new construction-sculpture begins to make itself felt as most *representative*, even if not the most fertile, visual art of our time.

Painting, sculpture, architecture, decoration and the crafts have under modernism converged once again in a common style. Painting may have been the first to begin closing out historical revivalism, in Impressionism; it may

have also been the first, with Matisse and Cubism, to give positive definition to modernist style. But the new sculpture has revealed the unifying characteristics of that style more vividly and completely. Having the freedom of a fine art yet being, like architecture, immersed in its physical means, sculpture has had to make the fewest compromises.

The desire for "purity" works, as I have indicated, to put an ever higher premium on sheer visibility and an ever lower one on the tactile and its associations, which include that of weight as well as of impermeability. One of the most fundamental and unifying emphases of the new common style is on the continuity and neutrality of a space that light alone inflects, without regard to the laws of gravity. There is an attempt to overcome the distinctions between foreground and background; between occupied space and space at large; between inside and outside; between up and down (many modernist buildings, like many modernist paintings, would look almost as well upside down or even on their sides). A related emphasis is on economy of physical substance, which manifests itself in the pictorial tendency to reduce all matter to two dimensions—to lines and surfaces that define or enclose space but hardly occupy it. To render substance entirely optical, and form, whether pictorial, sculptural or architectural, as an integral part of ambient space—this brings anti-illusionism full circle. Instead of the illusion of things, we are now offered the illusion of modalities: namely, that matter is incorporeal, weightless and whose paint surfaces and enclosing rectangles seem to expand into surround-exists only optically like a mirage. This kind of illusionism is stated in pictures ing space; and in buildings that, apparently formed of lines alone, seem woven into the air; but better yet in Constructivist and quasi-Constructivist works of sculpture. Feats of "engineering" that aim to provide the greatest possible amount of visibility with the least possible expenditure of tactile surface belong categorically to the free and *total* medium of sculpture. The constructor-sculptor can, literally, draw in the air with a single strand of wire that supports nothing but itself.

It is its physical independence, above all, that contributes to the new sculpture's status as the representative visual art of modernism. A work of sculpture, unlike a building, does not have to carry more than its own weight, nor does it have to be *on* something else, like a picture; it exists for and by itself literally as well as conceptually. And in this self-sufficiency of sculpture, wherein every conceivable as well as perceptible element belongs altogether to the work of art, the positivist aspect of the modernist "aesthetic" finds itself most fully realized. It is for a self-sufficiency like sculpture's, and sculpture's alone, that both painting and architecture now strive.

ARCHITECTURE

Because architecture is so dependent on technological change and development its aesthetic must take into consideration the influence of mathematics and engineering. Architectural forms are achieved only with a heightened awareness of the possibilities that these sciences offer. This is not to say that the architect most proficient in mathematics and engineering will necessarily be the most artistic in his work. Rather, it is to say that the imagination must be informed with all available modes of solution for a given architectural problem.

Lewis Mumford goes even further and suggests that the technology of an age should be fairly reflected in its architecture. He suggests that the forms the architect achieves must be technologically responsible to twentieth-century human needs. Further, those architectural forms must make a statement—in the way that a painting can make a statement—consonant with the functions associated with them. Mumford's view is a highly humanistic one, as we can see by his sympathy with Frank Lloyd Wright. Wright, as Mumford points out, was concerned less with the purely technical features of his buildings than he was with the final look of them, the way they took part in a scene, the way they achieved an environment. Yet, Wright, too, was aware of the formal problems in architecture. In saying that "no mere builder can make architecture," he is agreeing with Mumford, asking that architecture imply more than minimal usefulness. Mumford's discussion of symbol and function, particularly in his adverse criticism of the final result of the United Nations buildings in New York City, demonstrates very swiftly that architecture is capable of achieving a meaning as aesthetically significant as that of any art form.

Eduardo Torroja, a practicing architect, examines one of the most difficult problems in architectural aesthetics. It is the problem of the appearance, or final visible form, failing to remain faithful to the technical means which achieved it. An architect is often almost mysteriously alarmed by buildings which look as if they have solved difficult structural problems with stone, when, in reality, the problems were vastly less difficult because they were solved with steel. The steel support is hidden in these buildings. Unlike the skeleton of the human body it has no visible or aesthetic relation to the exterior which it supports. For Torroja this is not illusion, but deceit. Non-

architects may disagree with him, but architects who take their work seriously as art are more than likely to agree. For Torroja, the forms which we perceive in a building must be true to the technical feats which make them possible.

The excerpt from Albert Bush-Brown's article has implicit in it some major points of agreement with both Mumford and Torroja. Further, Bush-Brown raises the somewhat alarming suggestion (implied in Mumford's essay, too) that a building may actually fail to become architecture. Wright had said it when he insisted that architecture could not be achieved by a "mere builder." Bush-Brown adds to Mumford's symbolic failure, which is not said to disqualify a building from being architecture, the failures of structure and form. All of these, as we can see from the quality of Torroja's concerns are aesthetic failures.

ARCHITECTURE IS ABSTRACT

FRANK LLOYD WRIGHT

Architecture is abstract. Abstract form is the pattern of the essential. It is, we may see, spirit in objectified forms. Strictly speaking, abstraction has no reality except as it is embodied in materials. Realization of form is always geometrical. That is to say, it is mathematic. We call it pattern. Geometry is the obvious framework upon which nature works to keep her scale in "designing." She relates things to each other and to the whole, while meantime she gives to your eye most subtle, mysterious and apparently spontaneous irregularity in effects. So, it is through the embodied abstract that any true architect, or any true artist, must work to put his inspiration into ideas of form in the realm of created things. To arrive at expressive "form" he, too, must work from within, with the geometry of mathematic pattern. But he so works only as the rug maker weaves the pattern of his rug upon the warp. Music, too, is mathematic. But the mathematician cannot make music for the same reason that no mere builder can make architecture. Music is woven with art, upon this warp that is mathematics. So architecture is woven with a super-sense of building upon this warp that is the science of building. It also is mathematical. But no study of the mathematic can affect it greatly. In architecture, as in life, to separate spirit and matter is to destroy both.

Yet, all architecture must be some formulation of materials in some actually significant pattern. Building is itself only architecture when it is essential pattern significant of purpose.

SYMBOL AND FUNCTION
IN ARCHITECTURE

LEWIS MUMFORD

In our discussion of art and technics so far, I have—not entirely by accident—kept away from the one great domain where, in the very nature of things, they have always been united in the closest sort of domestic union; though as often happens even in very close and affectionate families, this union has not been altogether devoid of conflict. I am speaking, of course, of architecture. In that art, beauty and use, symbol and structure, meaning and practical function, can hardly even in a formal analysis be separated; for a building, however artless, however innocent of conscious speech on the part of the builder, by its very presence cannot help saying something. Even in the plainest esthetic choices of materials, or of proportions, the builder reveals what manner of man he is and what sort of community he is serving. Yet despite this close association in building between technics and art, doing and saying, the separate functions are clearly recognizable in any analysis of an architectural structure: the foundations, the inner drainage system, or in later days the heating and cooling systems, plainly belong exclusively to technics; while the shape and scale of the structure, the elements that accentuate its function or emphasize its purpose in order to give pleasure and sustenance to the human spirit, is art.

On one side there is the engineering side of building: a matter of calculating loads and stresses, of making joints watertight and roofs rainproof, of setting down foundations so solidly that the building that stands on them will not crack or sink. But on the other side there is the whole sphere of expression, the attempt to use the constructional forms in such a way as to convey the meaning of the building to the spectator and user, and enable him, with a fuller response on his own side, to participate in its functions—feeling more courtly when he enters a palace, more pious when he enters a church, more studious when he enters a university, more businesslike and efficient when he enters an office, and more citizenlike, more cooperative and responsible, more proudly conscious of the community he serves, when he goes about his city and participates in its many-sided life. Architecture, in the sense that I here present it to you, is the permanent setting of a culture against which its social drama can be played out with the fullest help to the actors. Confusion and cross purposes in this domain—such confusion as has existed in the recent past when businessmen thought of their offices as Cathedrals, or when pious donors treated university buildings as if they were private mausoleums—all this brings about

265

disruption in our life; so that it is of utmost importance that symbol and function in architecture should be brought into an effective harmony.

Once upon a time a great motion-picture palace was opened; and an array of notable New Yorkers was invited to the first night. For at least ten minutes, but for what seemed the better part of an hour, the audience was treated to a succession of lighting effects, to the raising and lowering of the orchestra platform, and to the manifold ways in which the curtain could be lifted and parted. For a while, the audience was delighted by the technical virtuosity displayed: but when nothing further seemed about to happen, they were bored: they were waiting for the real performance to begin.

Modern architecture is now in a state similar to that of the Radio City Music Hall on the opening night. Our best architects are full of technical facility and calculated competence: but from the standpoint of the audience, they are still only going through the mechanical motions. The great audience is still waiting for the performance to begin. Now, in all systems of architecture, both function and expression have a place. Every building performs work, if it is only to keep off the rain or to remain upright against the wind. At the same time, even the simplest structure produces a visual impression upon those who use it or look at it: unconsciously or by design, it says something to the beholder and modifies, in some slight degree at least, his organic reactions. Functions that are permanently invisible remain outside the architectural picture; hence a building below ground may not be called architecture. But every function that is visible contributes in some degree to expression. In simple monuments, like obelisks, or even in more complex structures like temples, the function of the building is subordinate to the human purpose it embodies: if such structures do not delight the eye and inform the mind, no technical audacity can save them from becoming meaningless. Indeed, ideological obsolescence is more fatal than technical obsolescence to a work of architecture. As soon as a building becomes meaningless, it disappears from view, even though it remain standing.

Modern architecture crystallized at the moment that people realized that the older modes of symbolism no longer spoke to modern man; and that, on the contrary, the new functions brought in by the machine had something special to say to him. Unfortunately, in the act of realizing these new truths, mechanical function has tended to absorb expression, or in more fanatical minds, to do away with the need for it. As a result, the architectural imagination has, within the last twenty years, become impoverished: so much so that the recent prize-winning design for a great memorial, produced by one of the most accomplished and able of the younger architects, was simply a gigantic parabolic arch. If technics could not, by itself, tell the story of the pioneer, moving

through the gateway of the continent, the story could not, in the architectural terms of our own day, be told. This failure to do justice to the symbolic and expressive functions of architecture perhaps reached its climax in the design of the United Nations Headquarters, where an office building has been treated as a monument, and where one of the three great structures has been placed so as to be lost to view by most of the approaches to the site.

By now, many architects have become aware of a self-imposed poverty: in absorbing the lessons of the machine and in learning to master new forms of construction, they have, they begin to see, neglected the valid claims of the human personality. In properly rejecting antiquated symbols, they have also rejected human needs, interests, sentiments, values, that must be given full play in every complete structure. This does not mean, as some critics have hastily asserted, that functionalism is doomed: it means rather that the time has come to integrate objective functions with subjective functions: to balance off mechanical facilities with biological needs, social commitments, and personal values. And to understand the new prospects that open before architecture, we must first do justice to functionalism and to see how it came about in our time that the mechanical part was taken for the whole.

As so often happens, functionalism came into the world as a fact long before it was appraised as an idea. The fact was that for three centuries engineering had been making extraordinary advances in every department *except* building; and it was high time that the interest in new materials and technical processes, associated in particular with the fuller use of iron and glass, along with the mass production of standard units, should find its way into building. Functionalism resulted in the creation of machines, apparatus, utensils, structures, completely lacking in any expressive intention, but designed with utmost rigor for effective operation. Even before the machine exerted its special discipline, functionalism tended, in other departments of building, to produce strong geometric or organic forms. A barn or a haystack or a silo, a castle, a bridge, a seaworthy sailing vessel—all these are functional forms, with a certain cleanness of line and rightness of shape that spring, like the shape of a gull or a hawk, from the work to be performed. By and large people do not stop to contemplate or enjoy such structures until they have ceased to use them, or at least until they pause to take in the meaning of what they have done. But these buildings have at least the quality of all organic creations: they identify themselves and so symbolize the function they serve. When a steam locomotive is fully developed, for example, so that all its excrescences and technological leftovers are absorbed in a slick over-all design, "streamlined" as one now hesitates to say, that locomotive not merely *is* more speedy than the primitive

form, but it says speed, too. All these developments had a special message for architecture; for the expressive effects of architecture in all its great periods had been due in large part to the absorption and mastery of these engineering elements: pure building.

One of the first people to understand both the symbolic implications and the practical application of functionalism was an American sculptor, Horatio Greenough. He published his thoughts, at the end of his all-too-brief life, on his return to America, in a series of papers that were first unearthed—they had been lying quietly on library shelves—by Mr. Van Wyck Brooks and have lately been republished. But since Greenough's mind powerfully affected contemporaries like Emerson, it is very likely that his contribution worked quietly under the surface of American life, affecting later critics like James Jackson Jarves and Montgomery Schuyler, even when they were unaware of their sources or negligent in acknowledging their debt. It was Greenough who carried further, as a student of anatomy as well as sculpture, the great theorem of Lamarck: Form follows function. This principle carries two corollaries: forms change when functions change, and new functions cannot be expressed by old forms. Greenough saw that this applied to all organic forms, even man-created ones. He recognized that the effective works of art in his own day, the primitives of a new era, were not the current specimens of eclectic decoration and eclectic architecture, but the strong virile forms, without any other historical attachment than to their own age, of the new tools and machines, forms that met the new needs of modern life. The American ax, the American clock, the clipper ship—in every line of these utilities and machines necessity or function played a determining part. They were without ornament or decorative device of any kind, except perhaps for a surviving ship's figurehead: like the naked body, when harmoniously developed, they needed no further ornament or costume to achieve beauty. For what was beauty? "The promise of function."

As expressed by Greenough, that was a breath-taking, a spine-tingling thought; and in the minds of Greenough's successors, such as the architect Louis Sullivan, who might well have breathed in Greenough's words with his native New England air, this doctrine provided a starting point for the new architecture. Until the twentieth century, however, the movement toward functionalism in architecture went on almost in spite of the architect, rather than through his eager efforts. The great new constructions of the nineteenth century were as often as not the work of engineers: the Crystal Palace of 1851, the Brooklyn Bridge of 1883, the Paris Hall of Machines of 1889 were all works of engineering, though some vestigial remnants of early expressive elements remained even in structures as pure as Roebling's masterpiece, in his

choice of a gothic arch in the stone piers, capped by the remains of a classic cornice.

But though all these new works tended toward a certain starkness, a certain severity and simplicity, that quality was not altogether the work of the new engineers, nor even the automatic result of the new industrial process. Economy and simplicity have their roots in the human spirit, too. The desire to slough off symbolic excrescences, to avoid ornateness of any sort, to reduce even speech to its simplest forms, and to remain quiet when one has nothing to say—behind all that is something else, a religious sense of life, to which those who have dealt with architecture have hardly yet done justice. But the fact is that the new functionalism in architecture owed something to a fresh religious impulse, that of the Society of Friends, those sincere Christian souls who sought to get back to the unadorned innocence of the primitive Christian Church. They rejected ornament of any kind either in dress or in speech, as offensive to an inner purity of spirit; their directness, their matter of factness, their underemphasis, their severity and probity, had an effect upon modern ways out of all proportion to their numbers. Democratic simplicity in dress and in manners passed over into architecture, only to disappear once more in our day as technological over-elaboration takes the place of more obvious forms of symbolic superfluity. On that miscarriage of the machine I shall presently have something further to say.

But while Greenough's doctrine was a salutary one, it was incomplete; for it partly failed to do justice to those human values that are derived, not from the object and the work, but from the subject and the quality of life the architect seeks to enhance. Even mechanical function itself rests on human values: the desire for order, for security, for power; but to presume that these values are, in every instance, all-prevailing ones, which do away with the need for any other qualities, is to limit the nature of man himself to just those functions that serve the machine.

Perhaps it would be profitable at this point to contrast Greenough's doctrine of functionalism with the conception of architecture that John Ruskin advanced in *The Seven Lamps of Architecture*. Contrary to popular misinterpretation, Ruskin had a very healthy respect for the functional and utilitarian triumphs of the Victorian age, and even his complaint against the barbarous effects of the new railroad trains, though petulant and often childish in tone, was only the voice of a good conservationist who understood that filth and dirtiness and land erosion and stream pollution were not evidences of industrial efficiency. But Ruskin insisted that building was one thing and architecture was another: a building became architecture, in his theory, when the structure was enhanced and embellished with original works of sculpture and painting.

This theory of architecture—which would make architecture dependent upon the symbolic contributions of the nonarchitectural arts—seems to me, in the form Ruskin gave it, a downright false one; and certainly it is impossible to reconcile with Greenough's conception of functionalism. But it has the virtue of pointing to the expressive and symbolic aspects of architecture and underlining their importance. The basic truth in Ruskin's statement comes out just as soon as one replaces the restricted notion of painting and sculpture applied to an otherwise finished building, with the larger concept of the building as itself an expressive work of multi-mural painting and architectonic sculpture. By his choice of materials and textures and colors, by the contrasting play of light and shade, by the multiplication of planes, by the accentuation, when necessary, of sculpture or ornament, the architect does in fact turn his building into a special kind of picture: a multidimensional moving picture, whose character changes with the hours and seasons, with the functions and actions of spectators and inhabitants. Similarly, he creates in a building a unique work of sculpture, a form one not merely walks around but walks into, a form in which the very movement of the spectator through space is one of the conditions under which the solids and voids of architecture have a powerful esthetic effect, not known in any other art. The most daring innovations of the sculptor Henry Moore are in fact the esthetic commonplaces of architecture. And only when a building can be conceived and modeled so as to achieve a maximum degree of expression by the use of the material elements proper to building, only when the architect has sufficient means to play freely with the structure as a whole, modeling plan and elevation into a plastic unity, emphasizing its special meanings, intensifying its special values, does architecture in fact emerge from building and engineering. At that moment, Ruskin and Greenough, symbolic beauty and functional beauty are reconciled.

Now, no matter how rapidly our technical processes change, the need for expression remains a constant in every culture; without it the drama of life cannot go on, and the plot itself becomes pointless and empty. Life must have meaning, value, and purpose, or we die: we die standing on our feet, with our eyes open, but blind, our ears open but deaf, our lips moving but speechless. And we cannot, by any mechanical duplication of old symbols, come to a realization of the vital meanings in our own life. Our intercourse with other ages can only be of a spiritual nature. Everything we take over from the past must disappear in the act of digestion and assimilation, to be transformed into our own flesh and bones. Each age then must live its own life. But because of the need for finding meaning and value in our own works and days, our civilization can no more forgo symbolic architecture than could any earlier civilization.

So it came about that symbolic expression, driven out the front door by the doctrine that form follows function, came in by the rear entrance. The conscious theories of functionalists from Greenough to Sullivan, from Adolph Loos to Gropius, have by now succeeded in eliminating almost every historic or archaic mode of symbolism. They established the fact that a modern building cannot be imitation Egyptian, imitation Greek, imitation Medieval, imitation Renascence, or imitation hodgepodge. Their new structures were not refurbished traditional forms, improved with modern plumbing and elevator service; they were naked, clean, properly devoid of extraneous ornament. *But still they said something.* They were not merely products of the machine; they revealed that the machine itself might become an object of veneration; and that an age that despised and debunked symbols might nevertheless, like the hero of a forgotten play by Eugene O'Neill, find itself worshiping a dynamo. Feelings and emotions that hitherto had attached themselves to organisms and persons, to political and religious concepts, were now being channeled into machine forms. These new forms not merely revealed function: they reveled in function, they celebrated it, they dramatized the mathematical and the impersonal aspects of the new environment. And so far forth the new buildings were symbolic structures.

My point here is that much of what was masked as strict functionalism during the last generation was in fact a sort of psychological if not religious fetichism: an attempt, if I may use Henry Adams's well-worn figure, to make the Dynamo instead of the Virgin serve as an object of love and devotion. Since both the true functionalist and the fetichist have used the same kind of technical means, it sometimes requires acute insight to distinguish one from the other at first glance; though with a little further acquaintance with the building itself one readily discovers whether it actually stands up well and works well, or whether it only is an esthetic simulacrum of structures that do such things. In short, those who devaluated the human personality, and in particular subordinated feeling and emotion to pure intellect, compensated for their error by overvaluing the machine. In a meaningless world of sensations and physical forces, the machine alone, for them, represented the purposes of life. Thus the machine became a symbol to contemplate, rather than an instrument to use: it was (mistakenly) identified with the totality of modern life. That error was an easy one to fall into; for a large part of the modern world has been created, with the aid of mathematics and the physical sciences and mechanical invention; and no honest construction in our time can avoid in some measure expressing this discipline and acknowledging this immense debt.

Naturally, a certain unified method of approach, a certain common way of

thinking, a certain common technical facility, must underlie the forms of our age. But to assume that the machine alone should dominate the forms of twentieth century architecture, symbolically as well as functionally, does not show any real insight into either the dangers of mechanization or into the pressing need of bringing other human motives and purposes back into the center of the picture. The machine, treated as a symbol, was used as a substitute for the whole. To assume that seaside houses should look like ocean steamships, as Le Corbusier did in his cruder moments, or to assume that a building should look like a cubist painting or constructivist abstraction, is not a functional assumption at all. As a symbol, the machine might properly have represented the partial, lopsided culture of early nineteenth-century industrialism. But we know in 1951 as men did not know in 1851, that the machine is only a limited expression of the human spirit: that this is not just the age of Faraday and Clerk-Maxwell and Einstein; it is also the age of Darwin and Marx and Kropotkin and Freud, of Bergson and Dewey and Schweitzer, of Patrick Geddes and A. J. Toynbee. In short, ours is an age of deep psychological exploration and heightened social responsibility. Thanks to advances in biology, sociology, and psychology, we begin to understand the whole man; and it is high time for the architects to demonstrate that understanding in other terms than economy, efficiency, and abstract mechanical form.

In the multidimensional world of modern man, subjective interests and values, emotions and feelings, play as large a part as the objective environment: the nurture of life becomes more important than the multiplication of power and standardized goods, considered as ends in themselves. The Machine can no more adequately symbolize our culture than can a Greek Temple or a Renascence Palace. On the contrary, we know that our almost compulsive preoccupation with the rigid order of the machine is itself a symptom of weakness: of emotional insecurity, of repressed feelings, or of a general withdrawal from the demands of life. To persist in the religious cult of the machine, at this late day and date, is to betray an inability to interpret the challenges and dangers of our age. In this sense, Le Corbusier's polemical writings, beginning with his publication of *Towards a New Architecture*, were in no small measure a reactionary influence: retrospective rather than prophetic.

Now all this is not to say that the doctrine that form follows function was a misleading one. What was false and meretricious were the narrow applications that were made of this formula. Actually, functionalism is subject to two main modifications. The first is that we must not take function solely in a mechanical sense, as applying only to the physical functions of the building. Certainly new technical facilities and mechanical functions required new forms: but so, likewise, did new social purposes and new psychological in-

sights. There are many elements in a building, besides its physical elements, that affect the health, comfort, and pleasure of the user. When the whole personality is taken into account, expression or symbolism becomes one of the dominant concerns of architecture; and the more complex the functions to be served, the more varied and subtle will the form be. In other words—and this is the second modification—expression itself is one of the primary functions of architecture.

On hygienic grounds, for example, the architect may calculate the number of cubic feet of space necessary to provide air for a thousand people in a public hall; and with the aid of the exact science of acoustics—plus a little luck—he may design a hall which will enable every person to hear with a maximum of clarity every sound that is made for the benefit of the audience. But after the architect has made all these calculations, he has still to weight them with other considerations that have to do with the effect of space and form on the human soul. In the cathedrals of the Middle Ages economy, comfort, and good acoustic properties were all cheerfully sacrificed to the magnification of glory and mystery, in a fashion designed to overwhelm the worshiper. In terms of medieval culture, that was both effective symbolism and true functionalism. In the strictly graded aristocratic society of the Renascence, in which music itself was subservient to the ostentatious parade of upper-class families, seeking to impress each other and the populace, the Palladian horseshoe form of opera house, with poor acoustic properties but excellent visibility for the box holders, likewise did justice to the functions of the building in the order of their social importance, within that culture.

In other words, every building is conditioned by cultural and personal aims as well as physical and mechanical needs. An organic functionalism, accordingly, cannot stop short with a mechanical or a physiological solution. So in the rebuilding of the House of Commons, Mr. Winston Churchill wisely insisted that the seating space should be considerably smaller than the actual membership, in order to preserve the closeness and intimacy of debate in the House, under normal conditions of attendance. That decision was as wise as the medieval decoration that went with it was inept and meretricious; though an original modern architect might have found a means of echoing, in works of original sculpture, the traditional ceremonies and symbols so assiduously preserved in the British Parliament, beginning with that medieval relic, the Speaker's mace.

The architecture of Frank Lloyd Wright was subjected to a considerable amount of arbitrary critical disparagement during the 1920s when mechanization and depersonalization were regarded, with Le Corbusier, as the all-sufficient ingredients of contemporary form. But this disparagement was based

on the very qualities that made Wright's architecture superior to the work of Le Corbusier's school. In Wright's work, the subjective and symbolic elements were as important as the mechanical requirements. From his earliest prairie houses onward, both the plan and the elevations of Wright's buildings were informed by human ideals, and by a sense of what is due to the person whose varied needs and interests must be reflected in the building. It was the idea of the organic itself, the desire to embrace nature, that led to the introduction of the garden into the interior; it was the idea of horizontality as an expression of the prairie that led Wright to emphasize horizontal lines in his early regional houses. So, too, in Wright's later work, a geometrical figure, a circle or a hexagon or a spiral, the expression of a subjective human preference, supplies the ground pattern for the whole building. In such instances, as the late Matthew Nowicki pointed out, the old formula is reversed—function follows form: man dictates to nature.

Now, when subjective expression is overplayed the results are not always happy—any more than was the case in Renascence buildings, where the idea of axial balance and symmetry determined both plan and elevation. But to say this is only to admit that, if mechanical functions, taken alone, do not fulfill all human needs, so subjective expressions, if divorced from practical considerations, may become willful, capricious, defiant of common sense. Accordingly, the more sensitive the architect is to expression, the more capable he is of transforming "building" into "architecture," the greater the need for his own self-knowledge, self-control, self-discipline: above all, for subordinating his own inner willfulness to the character and purposes of his client.

On this latter score, Frank Lloyd Wright's work is sometimes not impeccable; for all too rarely has he been faced with a client sufficiently strong in his own right to stand up to Wright's overbearing genius, in a way that will do justice to every dimension of the problem. But one thing is usually in evidence in Wright's architecture—not the machine but the human person has taken command. Hence Frank Lloyd Wright's wealth of designs is marked, not by any mechanical uniformity, but by an endless diversity and variety, held together by the underlying unity of Wright's own very positive personality; and whatever criticisms one may make of his buildings in detail—and I have made sundry criticisms in my time—one finds that as a whole they stand preeminent among the structures of our time precisely because they unite the mechanical and the personal. Here form follows function and function follows form, in a rhythmic interplay between necessity and freedom, between construction and choice, between the object-determined self and the self-determined object. In Wright's fertile and inventive use of the machine, combined with a refusal to be cowed by it or intimidated by it into a servile disregard of his own pur-

poses, his work has been prophetic of a future in which art and technics will be effectively united.

How hard it is to achieve such structures, at once functional in all their offices and arrangements and duly symbolic of their own human purposes, we can see when we examine a building near at hand: the new Secretariat Building of the United Nations. That great oblong prism of steel and aluminum and glass, less a building than a gigantic mirror in which the urban landscape of Manhattan is reflected, is in one sense one of the most perfect achievements of modern technics: as fragile as a spider web, as crystalline as a sheet of ice, as geometrical as a beehive. On this structure almost a score of the best architectural and engineering minds of our day were at one time or another at work. But unfortunately, the genius presiding over this design was an architectural doctrine altogether too narrow and superficial to solve the actual problem itself. The very decision to make the Secretariat building the dominant structure in this complex of buildings reveals at the start either a complete indifference to symbolism; or a very wry reading of the nature and destiny of the United Nations. With relation to the city itself, a forty-two story building cannot possibly express dominance: it is just another skyscraper in an urban heap of skyscrapers, actually seeming even lower to the eye than it is in fact, because the river front where it stands drops sharply below the escarpment above it. With relation to the General Assembly Building, the overwhelming dominance of the Secretariat is ridiculous—unless the architects conceived it as a cynical way of expressing the fact that Burnham's managerial revolution had taken place and that the real decisions are made in the Secretariat, by the bureaucracy.

Has this building then been conceived with a strict regard to its functions as an office building? Did the architects seize the opportunity to create, for the example of the rest of the world, an ideal office building, freed as they were from the constraints of realty speculation, constricted building lots, and metropolitan overcrowding? Unfortunately, as a functional unit, the Secretariat Building is even more lacking in merit, if this is possible, than as a symbol. This structure, as the chief architect has explained, is really three separate office buildings, each with its own elevator and ventilating machinery, piled one on top of the other. In other words, there is no functional reason whatever for its present height. For the purely esthetic purpose of creating an unbroken glass surface for the façade, as much money must be spent on washing the spandrels between the windows as for washing the windows themselves; and that high cost of upkeep, added to the excessive cost of artificial ventilation, takes away income sorely needed for other purposes. But this is not all. In order to create the purely abstract esthetic effect of an unbroken marble slab

on the north and south ends of the building—and in order incidentally to give a large expanse of window space to the women's lavatories, for reasons no one can explain—about a quarter of the perimeter of the building, which might have been used to give natural lighting to the offices, has been sacrificed. And what is the functional result? The result is that a large number of secretaries, instead of working under ideal conditions, as they should in such a building, work in dreary interior cubicles that lack sunlight and air and view: advantages they might have enjoyed if functional considerations had been sufficiently respected. Surely that was a disreputable blunder to make in providing working quarters for an organization that is attempting, on a world-wide scale, to improve the conditions of the worker. In such a building bad working conditions mean bad symbolism.

In short, the sound functional requirements of the Secretariat Building were sacrificed so as to give esthetic purity to a symbol that is not a symbol, unless we accept this skyscraper as an eloquent but unintentional symbol of the general perversion of life values that takes place in a disintegrating civilization. The Secretariat Building—or, rather, the complex of modest buildings that might have formed the Secretariat—should have been treated neither as a monument nor a symbol, still less as an imitation of a commercial New York skyscraper. The Secretariat should have been planned on the human scale, subordinated in its placement and design to the Assembly Building. The office buildings should have been designed with something more than lip service to economy, to mechanical function, above all, to the actual working needs of their occupants. Instead of having their substance wasted on elaborate mechanical utilities, introduced to counteract the massive errors in general design, the buildings should have been correctly oriented for sun and wind, and surrounded by trees and lawns that would have provided a pleasant micro-climate both for winter and summer, with due architectural provision for intervals of recreation and social intercourse that are denied the inmates of the present building. By departing from the meretricious errors of New York speculative building—the pattern and model of the present structure—the architects of the Secretariat might have established a model for all future office buildings, in whose design human considerations would predominate above profit or prestige or mechanical fetichism.[1]

Conceived in this fashion, the very functions of the Secretariat would have produced the correct symbol, one duly subordinated to the main effort to hold the eye and elevate the spirit through the development of the Assembly Building and the design and gardening of the site as a whole. Instead, the designers of the Secretariat Building sacrificed both mechanical efficiency and human

[1] For a more detailed analysis, see "The Sky Line," *The New Yorker,* Sept. 15 and Sept. 22, 1951.

values in order to achieve an empty abstract form, a frozen geometrical concept, that reflects the emptiness and purposelessness of modern technics, as now conceived. Certainly it expresses nothing about the purposes and values of a world organization, dedicated to peace and justice and the improvement of human life. In short, the Secretariat Building exhibits both a breakdown of functionalism and a symbolic black-out. Though mechanically new, it is architecturally and humanly obsolete. That is almost a definition of the pseudo-modern.

The architect who perhaps came closest among our contemporaries to resolving function and expression was the late Matthew Nowicki, he whose early death in an airplane accident in 1950 was a loss comparable to that architecture sustained when John Wellborn Root died at an equally early age. In the course of some forty intense years of life, Nowicki had passed through the various phases of modern architecture represented by cubism, by mechanical functionalism and *Sachlichkeit*,[2] by Le Corbusier's "International Style." Firmly rooted in our own age, he regarded the standard unit, the module, as an essential discipline for the modern architect: the minimum ingredient for form. In such designs as that for the great amphitheater in the State Fair Grounds at Raleigh, North Carolina, now under construction, he used that typical modern form, the parabolic arch, to enclose the facing ranks of the grandstand: an acrobatic feat of great audacity and beauty, appropriate to the functions it served.

But Nowicki knew that all buildings speak a language, and that this language must be understood by the people who use it. When he worked on the preliminary designs for the library and the museum that were to be erected near the State House in Raleigh, he took into account the love and affection the people of North Carolina feel toward that fine piece of provincial classicism. For the sake of meeting their sentiment half way, he was ready to utilize artificial lighting throughout the new buildings in order to create a solid masonry structure which, in its own modern way, would carry on the theme of the beloved older building. That tact, that understanding, that human sympathy stand in full contrast to Le Corbusier's constant demand for people cut to the measure of his own architecture: like old Procrustes, he would amputate the human leg or stretch the human soul to fit the form he has arbitrarily provided for it.

So, again, when Matthew Nowicki went to India to work on the design of a new capital for the East Punjab (with Mayer and Whittlesey), he brought with him no ready-made stereotypes from the West, but absorbed, with his marvelous sensitivity and intuitive grasp, the Hindu way of life, sympathetic

2 Matter-of-factness or realism. [Ed.]

even to the fathomless richness and complexity that expressed itself traditionally in ornament. In the intimate plans for housing and neighborhood units, above all in one of the sketches for the Capitol itself, Nowicki translated this richness into patterns and plans that were wholly in the vernacular of modern building, yet were native to the scene and in resonance with the Hindu personality and with Hindu family life.

Rigorous in its physical foundations, Nowicki's architecture rose above them to the plane of the social and the personal. Through his humility and human sympathy, through his reverence for all genuine expressions of life, he was equipped as no other architect of his generation perhaps was to effect a fuller reconciliation of the organic and the mechanical, the regional and the universal, the abstract-rational and the personal. Along the path that he began to blaze, modern architecture, if it is to develop and grow, must follow, creating forms that will do justice to every aspect of the human organism, body and spirit in their living unity.

The problem of form, as I have put it to you in these examples, is plainly one that cannot be solved, even in engineering, to say nothing of architecture, merely by a systematic application of science, or by treating the machine as a religious fetich. The problem of form is not one of esthetics alone, either, though esthetics brings us into one of the inner chambers of the human personality, for a work of organic architecture must take in social and moral needs. When we talk of an organic architecture we refer to a system of order capable of bringing all these requirements into an harmonious and effective relationship. We are looking for a rule, as Louis Sullivan's French mathematics teacher put it, a rule so broad as to admit no exceptions.

Along such lines art and technics, the symbol and the function, are now in process of being reconciled in the best works of modern architecture; and to the extent that this is actually taking place there is reason to hope that our civilization, which shows so many signs of disruption, may in fact be able to halt its insane expansion of power without purpose, and find ways of bringing into effective unity the now hostile and divisive tendencies of men. But this is no easy road; and such backward-looking buildings as the UN Secretariat Building—of all buildings in all places!—are a proof of that fact. Hence in my final lecture, I purpose to examine the more general terms for establishing unity, not merely between art and technics, but between all the divided sides of modern man's life. For unless the will to achieve integration is a universal one, neither art nor technics will long prosper.

NOTES ON STRUCTURAL EXPRESSION

EDUARDO TORROJA

By what process is a good structural design finally evolved? Although I have been asked this question many times I have never known what to reply and I never shall.

The laws that guide our thoughts toward the conception of a new solution remain unknown to us. Undoubtedly our imagination is constrained, guided, and attracted by a complex pattern of knowledge, feeling, ideas, and desires previously experienced. But even though certain results of personal experience can be passed on to others, the nature of the experience itself cannot be fully communicated.

Many concepts, previously unrecognized, are brought to consciousness and clarified by introspection. To order them into a harmonic system; to give each its just, relative value; to combine and balance them—without neglecting any— is an intricate and complex task.

Theory, alone, seldom furnishes sufficient proof of the soundness or efficiency of the structural forms and proportions conceived for a design. These forms and proportions spring, primarily, from an intuitive vision drawn from a nucleus of all the phenomena we have studied and experienced in life.

Calculations are no more than tools for determining whether the forms and dimensions of a structure are adequate to make that structure safe under specified loading conditions. Calculations serve only to ensure that the dimensions of a structure are safe. All the rest cannot be judged by deductive methods. Some calculations can be used to solve problems of economy: to determine, for example, which of two possible solutions is least expensive. The rest of the solution remains predominantly in the realms of subjective thinking and individual opinion and these are always subject to criticism and controversial judgment.

Therefore, structural design is concerned not only with science and techniques, but also with art, common sense, sentiment, aptitude, and joy in creating pleasing outlines. Complex and abstruse mathematical calculations alone are not sufficient to lead to the conception of a structure or to guide the hand in tracing its outline; an intimate and intuitive comprehension of the working form is also needed.

The architect should so familiarize himself with the structure that he feels part of it. He should achieve a sincere *Einfühlung* [1] of the process of resistance

[1] Empathy or "feeling-into." [Ed.]

(demonstrated by deformation), which essentially, is always united with the process of stress. To express it in more concise language: for the architect to comprehend a structure he must have an intuitive knowledge of the character of its resistance and of its constituent materials.

When discussing the beauty of a structure it is difficult to avoid recognizing those errors of design that originate from the partial and distorted vision of the designer. The defects of a structural design generally stem from an incomplete vision of the problem, lack of judgment, or inadequate appreciation of one or several factors. On the other hand, the public's aesthetic evaluation of a building is seldom considered in relation to its basic structural design.

Sometimes this basic structure is visible or constitutes the whole work, in which case it should be aesthetically good. Sometimes it is hidden, but even then it is seldom that the aesthetic value of the whole work is not influenced by the resistant forms of the internal structure. This is true of the most perfect and appealing work of Nature: unquestionably, in my opinion, the female form, whose outer beauty is greatly influenced by the perfection of the skeleton, a functional structure that is unattractive in detail but one that does enhance the poetry of the whole by its own indirect means of expression. The skeleton of the human body has not been pushed with forceps into the empty cavities between the various organs. It is something far more harmonious and reasonable.

The functional purpose and the artistic and strength requirements of a structure must be integrated from the initial conception of the project. The artist should not be required at the last moment to give an artistic appearance to what is already completed; similarly, the technician's task should not be limited solely to devising means of maintaining the structure. Artistic sensibility is, then, as indispensable to the structural designer as technical skill, otherwise the creations of his imagination will remain in the air, like Papini's satirical Gog, who carved statues in smoke; their greatest charms were due to their transient inconsistency.

"Beauty is truth" the poet said, and many infer from this that the primary essence of beauty is the perfect correlation between the real nature of the work and its apparent form. There is little doubt that in this age it is considered desirable for the outward appearance of a structure to distort the true functional and resistant phenomena hidden within. This thesis may have a timeless, essential element of truth, to which we should like to cling, but, as in everything, it is bad to exaggerate. Various factors intervene, and the middle path is the way of virtue.

Never before has the load-bearing structure been so entirely independent of the whole work as in modern constructional practice. Specialization—the

virtue and vice of our age—has invaded construction methods. The wall of a building may require different materials for its load-bearing frame, for its interior sound insulation, and for the surface in contact with the external environment. Yet, we shall not be liars if only this last function is revealed to the world—it is not always reprehensible to hide the whole truth. It would be a lie if the visible external expression of the load-bearing structure were purposely given a form incompatible with the laws of stability and strength, or (at the very least), inconsistent with the visible outer material. It would be false to truth to cover a reinforced concrete beam with stone slabs, so shaped as to give the impression that the transom was actually a stone structure. But it would be a gross lie if the joints between the slabs did not correspond to those of a load-bearing stone transom. And worse, if the transom, imitating an arch, rested on simple columns, obviously incapable of withstanding the side thrust of a stone arch.

In such cases it is not the falsehood in itself that makes us indignant, but rather that an attempt has been made to deceive or to abuse our innocence. It is the artist's attempt to convey the impression that a certain state of stresses is acting on a structure—when it is intrinsically and extrinsically impossible—that is aesthetically repugnant to observers who discover the trick.

It must be realized that although truthful statement is one attribute to strive for, it is not, or it has not always been, regarded as an indispensable one. To include truth as part of the aesthetic problem will further limit the possible solutions. Moreover, if the aim is also to do away with superfluous addition and ornamental frivolity, the artist's imaginative flight is curtailed. His usual resources of correcting and camouflaging the essential form of the structure are denied to him. Thus final success is even more difficult to achieve because of—or perhaps despite—more advanced techniques.

To realize that this has not always been so, we need only turn to the great works of the past. They illustrate how neither truth nor sincerity was pushed to the point of requiring that a work, to be beautiful, should adapt itself strictly to the optimum dimensions dictated by the requirement for strength. Because of its particular shape the cupola of St. Peter's in Rome was unable to withstand, by virtue of its stonework alone, the tensile forces acting upon its parallel layers with the adopted directrix. Hence it was necessary initially to fit it with iron rings to bind the stonework; later these rings had to be reinforced. Since the fittings are not visible, nor is it likely that their existence is conceived of by the spectator, it cannot be said that the external design is a good or exact impression of the loaded structure. The fact that St. Peter's cupola is buttressed along the meridian haunches, sometimes plainly evident to the observer, does not tell us anything about the internal outline of the

cupola. (The buttresses do not detract from the beauty of the cupola.) Michelangelo knew beforehand that the shape of the cupola was a structurally weak point, but he did not hesitate to adhere to his design.

The present trend seems to be toward an architectural style that aesthetically expresses the functional strength of the design. This is logical, for the strength properties of structures were never better known than today. More than ever before, we know how to exploit the properties of available materials. Hence, there are today greater opportunities to fuse the artistic and structural qualities of a work. This is especially true in those works which, because of their size and function, are entirely structural. Functionality is emphasized by avoiding all purely ornamental touches. Beauty is sought in the simple and spontaneous grace of the basic outline, in the proportion of the masses, and in the rhythm of the form.

It can truly be said that today, for the first time in history, the art of structure has achieved an independent personality, so that its own intimate aesthetic quality can be appreciated. Hence, we can legitimately speak of a structural art as a fact manifested through the technical genius that permeates our contemporary social environment.

The thirst for functional expression refers not only to statical and load-bearing functions. In architecture it is desirable that spaces and volumes (using the strange language of artists, in which space is the three-dimensional extension as seen from the interior, and volume the plastic extension viewed from the outside) express, or at least correspond to, the true purpose of each part, or to the aggregate of all parts. It is desirable that a comprehensive glance at the exterior will reveal what is contained within, including the purpose of the principal functional characteristics. Other eras have achieved this unwittingly, perhaps because their problems were less complex, or perhaps because ideals typical of the epoch were more deeply rooted in the social environment and in the spirit of the artist. The appropriate form of expression thus emerged spontaneously in the course of creative work.

The fact remains that in our time this correlation between form and function is considered a virtue, and other symbolic ambitions are arrested, if not terminated. As regards the functional expressiveness of the structure as such (the expression of statical equilibrium and strength), one consequence, and also a proof that the artist now seeks after the very root of aesthetic quality, is his disdain of ornament. It is now considered that the structure should be beautiful in itself; no additions or trimmings are necessary. The elimination of these extraneous elements is not justified merely on the grounds of economy, although that is an increasingly important factor. Rather, it is part of an intimate desire to attain a complete solution to the total aesthetic problem.

The artist does not wish to resort to these aids that are considered, if not bastard, at least not in keeping with contemporary good taste.

Structures such as suspension bridges, by themselves, as simple structures, can provoke in man all the conscious and unconscious reflexes and reactions associated with artistic emotion. Until recently attempts to induce such reactions have not been feasible. Hence, designers have thrown themselves with abandon into the exploitation of the fresh charm of these new forms, disdaining other well-worn elements, even if their potentialities have not been exhausted.

It may well be that we shall regress. It would not be the first time, in the ebb and flow of history, that superfluous things once again regain a sway previously lost. For it is the superfluous thing that we voluntarily offer. No one demands or requires it of us. It is our generous offering to the sheer joy of living. Yet it is also true, most profoundly so, that in the attainment of the purest aesthetic emotion (as in so many other things in life) simplicity is a virtue. To achieve success, with a minimum of resources, often requires a far keener artistic sense and a greater effort than if we have the help of superfluous and incidental aids. Whether this is an exaggerated attitude or not, today, structural truth is so madly worshiped that mere truth is not enough. We like to appreciate it in its integral and exclusive nakedness. To those who love intensely, everything but the loved object is superfluous; only *in it* is perfection found. Hence, beauty is now sought within a minimum of essential elements. The motto of our age is the Delphic inscription "Nothing unnecessary." If any ornamental theme is permitted, then it is clearly separated and contrasted with the surrounding austere simplicity, thus emphasizing the clear, sincere, unpretentious nature of the ornament, within the whole. Decoration even seeks, in a spirit that is definitely antibaroque, to minimize its own significance.

It is difficult to resolve the conflict between artistic treatment and structural requirements of an architectural work—a conflict that is typical of, though not unique to, monumental works. We might suppose that aesthetically perfect designs would be constructed with materials of greater aesthetic and strength aptitude than the customary ones, for the use of reinforced stone, stonework resistant to tensile forces, is both feasible and sincere. Since only the external surface is visible, we might assume that the observer would be satisfied to imagine a different thickness to correct apparent lack of stability.

The subject of unseen thickness is a fundamental one in construction. It might be said that it constitutes a fourth "dimension" in the interplay of volumes enclosed by the apparent enveloping surfaces. "It is this quality of depth that alone can give life to architecture," said Frank Lloyd Wright. The designer must be continually reminded of the necessity of making it easy for

the observer to sense and to feel these thicknesses. The work cannot be appreciated without the fourth "dimension," essential to the very nature and beauty of the whole. Similarly, the designer must never forget that in construction it is not only what the sight encompasses that is seen, but also its extension in space.

Perhaps it may not be amiss to suggest that our capacity to develop the aesthetic quality of structural harmony, in terms of different materials and its functional requirements, is as undeveloped in our time as orchestration and counterpoint were in the sixteenth century. The reason is possibly the spiritual divorce of our specialized minds.

The goal of great structural engineering feats today is to emphasize the triumph and power of modern technique in the use of the materials at our disposal. An impression of power, or strength, with a simultaneous impression of lightness, gracefulness, and simplicity is often desired. We try to convey an impression that a bridge, which spans a great distance, will produce the same impression of flowing strength as that suggested by an athlete, who jumps without apparent effort or labored technique.

Inevitably positivism, which has invaded everything with its unfortunate consequences, has also dominated the art of building. Even so, the sense of beauty has not been lost, and if we know how to interpret it, we shall learn to value this era of transition in which humanity struggles, so often mistakenly, to reach another stage in its evolution—a stage in which its most deeply felt desires shall triumph and shall find an appropriate expression in new forms and techniques of construction.

When humanity can rest in its peregrinations, when it can recover that peace of mind essential for refinement of artistic feeling, when it finds leisure to repeat and elaborate its basic types, and when the present period of anxious, uncontrolled originality is over, these contemporary tendencies and ideas will mature. There is no essential reason why works will not be created as perfect as those of the classical era. For, indeed, the problems and possibilities of this age are greater than they have ever been.

HOW A BUILDING MAY FAIL
TO BECOME ARCHITECTURE

ALBERT BUSH-BROWN

A building may fail to become architecture on several counts. Of all the failures, a structural one is most clean-cut and leaves no room for dispute. There are also functional failures: of the sort suggested by the current anticipation that paintings will not be well-served by the Guggenheim Museum, of the sort that remarks that the bedrooms in Harvard's Graduate Center provide little comfort; of the sort that accuses the western expanses of glass at the General Motors Technical Center of forcing the air-conditioning system to carry a heat load even in winter; of the sort that recalls the acoustic disturbances and security leaks in the Connecticut General Insurance Building. There were just enough charges that modern schools were expensive, that modern materials disintegrated, to make people who were already suspicious of the modern aesthetic attack its functional merit. Nor had architects in their fascination with research operated with a broad vision of function—for in spite of climatology and experiments into orientation, so little was learned of how a building receives fog, snow, rain, sunlight, and moonlight in graceful ways.

A building may also fail as form, and its failure may cause us to exclude it from any list of fine building, whether it be the Courthouse at Appomattox, the cook shack at the Comstock Lode, or the Paul Revere house, however admirable these may be in other contexts. When we speak of architecture, we speak of excellence of a special kind. A building may gain acclaim for excellence of composition in its elevations, as does the Petit Trianon, or its powerful expression, as does Chartres, in spite of its shortcomings as total form. Since every building is expressive, if only of expediency and indifference, the mark of great architecture does not lie in expression or symbolism, but in the sensuous impact of its space and mass. No beautiful building fails to be expressive, but many expressive ones fail to allow light to fall upon their geometry so as to create rhythm, balance, and scale that we can admire.

A misunderstanding of that point—the difference between expression (style) and formal design (composition)—has done more than anything else to undermine criticism, confuse our histories, and impoverish architectural imagination. For nearly thirty years the literature about architecture has been a polemic about style, not about quality as a function of performance and composition. Expression is a function of style, and style fluctuates as architects take debatable stands on questions of being truthful in expressing a building's

site, its structure and materials, its interior spaces, its function or character, and the time and nation and region in which it was built. On such matters, taste is relative, perhaps relative to various metaphors about nature, but in any case, architects have taken contradictory sides on each of those questions. Whether or not materials and structure should be expressed "honestly" is a stylistic question. Unfortunately, many people identify quality with Georgian style, rather than composition, and the same error has been made with modern architecture and its theory, which have too readily become a matter of promoting styles, instead of a continuously evolving approach to design however structural means and materials or shapes of architectural element (such as staircases and curtain walls) may change.

THE FILM

The youngest, and in many ways the most vigorous of the arts, is the film or cinema. Since it is, like still photography, limited to recording what the camera "sees," it is an art beset with the aesthetic problems inherent in any representational or mimetic art form. Further, since it is so plainly a technological art, dependent on machinery and chemistry, a great many people have been reluctant to grant it the status of art at all. The struggle by many pioneers has been long and hard, and the Museum of Modern Art's vast film collection, its showings of still photographs on the same basis as showings of paintings, all serve to make plain what is now true. The general public and the vast majority of critics and people knowledgeable about art consider the film an advanced and significant art form.

Siegfried Kracauer is very much concerned in his brief statement to set straight the issue of art in the film. He, as well as Arnheim and Roemer, is interested in the qualities which distinguish film from theater, literature, and painting: all forms which are related to the film in no very simple way. It is not sufficient to say that all these forms are present in the film. Such a statement not only would be difficult to defend adequately, but would have very little meaning for our purposes. The film contains music, dance, and architecture as well as almost any other art form one can imagine. But its aesthetic is not necessarily the same as these forms nor dependent upon them. What Kracauer is anxious to have us do is to discard limiting "traditional" views about what the art of film is and to develop, from experience, views which will adequately account for the distinguishing features of film.

Michael Roemer's essay will certainly help us see what the cinema can do and does do that other art forms find impossible. His explanation of how the filmic image can perform the work of dialogue, how this image, in fact, functions cinematically, should help us begin to appreciate the aesthetic possibilities of film. Roemer makes us aware, as does Arnheim, that it is not enough for a film to have a "story" and narrate a sequence of events. A film must, almost in Torroja's terms, be faithful to its own properties and produce an experience. Further, symbol, the moving image, must function in the very ways John Hospers demands of painting or Lewis Mumford demands of architecture.

Without question all these writers are asking that we treat the film as what in fact it is, not as something else. When we begin asking the philosophical questions of Susanne Langer: What does film create? What is its function? we will begin to ask questions with promising aesthetic relevance.

THE ISSUE OF ART

SIEGFRIED KRACAUER

When calling the cinema an art medium, people usually think of films which resemble the traditional works of art in that they are free creations rather than explorations of nature. These films organize the raw material to which they resort into some self-sufficient composition instead of accepting it as an element in its own right. In other words, their underlying formative impulses are so strong that they defeat the cinematic approach with its concern for camera-reality. Among the film types customarily considered art are, for instance, the above-mentioned German expressionist films of the years after World War I; conceived in a painterly spirit, they seem to implement the formula of Hermann Warm, one of the designers of *The Cabinet of Dr. Caligari* settings, who claimed that "films must be drawings brought to life." Here also belongs many an experimental film; all in all, films of this type are not only intended as autonomous wholes but frequently ignore physical reality or exploit it for purposes alien to photographic veracity. By the same token, there is an inclination to classify as works of art feature films which combine forceful artistic composition with devotion to significant subjects and values. This would apply to a number of adaptations of great stage plays and other literary works.

Yet such a usage of the term "art" in the traditional sense is misleading. It lends support to the belief that artistic qualities must be attributed precisely to films which neglect the medium's recording obligations in an attempt to rival achievements in the fields of the fine arts, the theater, or literature. In consequence, this usage tends to obscure the aesthetic value of films which are really true to the medium. If the term "art" is reserved for productions like *Hamlet* or *Death of a Salesman,* one will find it difficult indeed to appreciate properly the large amount of creativity that goes into many a documentary capturing material phenomena for their own sake. Take Ivens's *Rain* or Flaherty's *Nanook,* documentaries saturated with formative intentions: like any selective photographer, their creators have all the traits of the imaginative reader and curious explorer; and their readings and discoveries result from full absorption in the given material and significant choices. Add to this that some of the crafts needed in the cinematic process—especially editing—represent tasks with which the photographer is not confronted. And they too lay claim to the film maker's creative powers.

This leads straight to a terminological dilemma. Due to its fixed meaning, the concept of art does not, and cannot, cover truly "cinematic" films—films, that is, which incorporate aspects of physical reality with a view to making us experience them. And yet it is they, not the films reminiscent of traditional art works, which are valid aesthetically. If film is an art at all, it certainly should not be confused with the established arts.[1] There may be some justification in loosely applying this fragile concept to such films as *Nanook*, or *Paisan*, or *Potemkin* which are deeply steeped in camera-life. But in defining them as art, it must always be kept in mind that even the most creative film maker is much less independent of nature in the raw than the painter or poet; that his creativity manifests itself in letting nature in and penetrating it.

ART TODAY AND THE FILM

RUDOLF ARNHEIM

If the various arts of our time share certain traits and tendencies they probably do so in different ways, depending on the character of each medium. At first glance, the photographic image, technically committed to mechanical reproduction, might be expected to fit modern art badly—a theoretical prediction not borne out, however, by some of the recent work of photographers and film directors. In the following I shall choose a key notion to describe central aspects of today's art and then apply this notion to the film, thereby suggesting particular ways in which the photochemical picture responds to some aesthetic demands of our time.

In search of the most characteristic feature of our visual art, one can conclude that it is the attempt of getting away from the detached images by which artists have been portraying physical reality. In the course of our civilization we have come to use images as tools of contemplation. We have set them up as a world of their own, separate from the world they depict, so that they

[1] Arnold Hauser belongs among the few who have seen this. In his *The Philosophy of Art History*, p. 363, he says: "The film is the only art that takes over considerable pieces of reality unaltered; it interprets them, of course, but the interpretation remains a photographic one." His insight notwithstanding, however, Hauser seems to be unaware of the implications of this basic fact.

may have their own completeness and develop more freely their particular style. These virtues, however, are outweighed by the anxiety such a detachment arouses when the mind cannot afford it because its own hold on reality has loosened too much. Under such conditions, the footlights separating a world of make-believe from its counterpart and the frame which protects the picture from merging with its surroundings become a handicap.

In a broader sense, the very nature of a recognizable likeness suffices to produce the frightening dichotomy, even without any explicit detachment of the image. A marble statue points to a world of flesh and blood, to which, however, it confesses not to belong—which leaves it without a dwelling-place in that world. It can acquire such a dwelling-place only by insisting that it is more than an image, and the most radical way of accomplishing it is to abandon the portrayal of the things of nature altogether. This is, of course, what modern art has done. By renouncing portrayal, the work of art establishes itself clearly as an object possessing an independent existence of its own.

But once this radical step has been taken, another, even more decisive one suggests itself forcefully. It consists in giving up image-making entirely. This can be illustrated by recent developments in painting. When the abstractionists had abandoned the portrayal of natural objects, their paintings were still representing colored shapes dwelling in pictorial space, that is, they were still pretending the presence of something that was not there. Painters tried various remedies. They resorted to collage, which introduced the "real object" into the world of visual illusion. They reverted to trompe l'oeil [1] effects of the most humiliating dullness. They discredited picture-making by mimicking its most commercialized products. They fastened plumbing fixtures to their canvases. None of these attempts carries conviction, except one, which seems most promising, namely, the attachment of abstract painting to architecture. Abstract painting fits the wall as no representational painting ever has, and in doing so it relinquishes the illusion of pictorial space and becomes, instead, the surface-texture of the three-dimensional block of stone.

In this three-dimensional space of physical existence, to which painting thus escapes, sculpture has always been settled. Even so, sculpture, as much as painting, has felt the need to get away from image-making. It replaces imitative shape with the left-overs of industrial machinery, it uses plaster casts, and it presents real objects as artifacts. All these characteristic tendencies in the realm of object-making are overshadowed, however, by the spectacular aesthetic success of industrial design. The machines, the bridges, the tools and surgical instruments enjoy all the closeness to the practical needs

[1] Optical illusion. [Ed.]

of society which the fine arts have lost. These useful objects are bona fide inhabitants of the physical world, with no pretense of image-making, and yet they mirror the condition of modern man with a purity and intensity that is hard to match.

To complete our rapid survey, we glance at the performing arts and note that the mimetic theatre, in spite of an occasional excellent production in the traditional style, has sprouted few shoots that would qualify it as a living medium. Significantly, its most vital branch has been Brecht's epic theatre, which spurns illusionism in its language, its style of acting, and its stage setting, and uses its actors as story-tellers and demonstrators of ideas. Musical comedy, although so different from the epic theatre otherwise, owes its success also to the playing down of narrative illusion. The spectacle of graceful and rhythmical motion addresses the audience as directly as do Brecht's pedagogical expositions. And the modern dance can be said to have made its victorious entrance where the costumed pantomime left off. The most drastic move toward undisguised action seems to have been made by the so-called happenings. They dispense the raw material of thrill, fear, curiosity, and prurience in a setting that unites actors and spectators in a common adventure.

If we have read the signs of the times at all correctly, the prospect of the cinema would seem to look dim—not because it lacks potential but because what it has to offer might appear to be the opposite of what is wanted. The film is mimetic by its very nature. As a branch of photography, it owes its existence to the imprint of things upon a sensitive surface. It is the image-maker *par excellence,* and much of its success derives from the mechanical faithfulness of its portrayals. What is such a medium to do when the artificiality of the detached image makes the minds uneasy?

Ironically, the motion picture must be viewed by the historian as a late product of a long development that began as a reaction to a detachment from reality. The motion picture is a grandchild of the Renaissance. It goes back to the birth of natural science, the search for techniques by which to reproduce and measure nature more reliably, back to the camera obscura, which for centuries was used by painters as a welcome crutch, back to the tracings of shadow profiles, which created a vogue of objective portraiture shortly before photography was invented. The moving photograph was a late victory in the struggle for the grasp of concrete reality.

But there are two ways of losing contact with the world of perceivable objects, to which our senses and feelings are attuned. One can move away from this world to find reality in abstract speculation, as did the pre-Renaissance era of the Middle Ages, or one can lose this world by piercing the visible

surface of things and finding reality in their inside, as did post-Renaissance science—physics, chemistry, psychology. Thus our very concern with factual concreteness has led us beyond the surfaces to which our eyes respond. At the same time, a surfeit of pictures in magazines and newspapers, in the movies and on television has blunted our reactions to the indiscretions and even the horrors of the journalistic snapshot and the Grand Guignol. Today's children look at the tears of tragedy and at maimed corpses every day.

The cinema responded to the demand for concreteness by making the photographic image look more and more like reality. It added sound, it added color, and the latest developments of photography promise us a new technique that will not only produce genuine three-dimensionality but also abolish the fixed perspective, thus replacing the image with total illusion. The live television show got rid of the time gap between the picture and the pictured event. And as the painters took to large-size canvases in order to immerse the eye in an endless spectacle of color, blurring the border between the figment and the outer world, the cinema expanded the screen for similar purposes. This openness of form was supplemented by an openness of content: the short-story type of episode no longer presented a closed and detached entity but seemed to emerge briefly from real life only to vanish again in the continuum of everyday existence.

The extreme attempt of capturing the scenes of life unposed and unrehearsed by means of hidden cameras was received with no more than a mild, temporary stir—somewhere between the keyhole pleasures of the peeping Tom and those of the sidewalk superintendent. For the curious paradox in the nature of any image is, of course, that the more faithful it becomes, the more it loses the highest function of imagery, namely, that of synthesizing and interpreting what it represents. And thereby it loses interest. In this sense, even the original addition of motion to the still photograph was a risky step to take because the enormous enrichment gained by action in the time dimension had to be paid with the loss of the capacity to preserve the lasting character of things, safely removed from their constant changes in time.

Following the example of painting, the cinema has tried the remedy of abstraction. But the experiments, from Hans Richter and Viking Eggeling to Oskar Fischinger, Norman McLaren and Len Lye, have amounted mainly to a museum's collection of venerable curiosities. This may seem surprising, considering the great aesthetic potential of colored shapes in motion. But since abstract painting is also on the decline, my guess is that once the artist abandons image-making he has no longer a good reason to cling to the two-dimensional surface, that is, to the twilight area between image-making and object-making. Hence the temporary or permanent desertion of so many

artists from painting to sculpture and, as I said, the attempts to make painting three-dimensional or attach it to architecture.

The film cannot do this. There seems to be general agreement that the cinema has scored its most lasting and most specifically cinematic successes when it drew its interpretations of life from authentic realism. This has been true all the way from Lumière to Pudovkin, Eisenstein, and Robert Flaherty and more recently de Sica and Zavattini. And I would find it hard to argue with somebody who maintained that he would be willing to give the entire film production of the last few years for Jacques-Yves Cousteau's recent underwater documentary, World Without Sun.

However—and this brings me to the main point of my argument—Cousteau's film creates fascination not simply as an extension of our visual knowledge obtained by the documentary presentation of an unexplored area of our earth. These most authentically realistic pictures reveal a world of profound mystery, a darkness momentarily lifted by flashes of unnatural light, a complete suspension of the familiar vertical and horizontal coordinates of space. Spatial orientation is upset also by the weightlessness of these animals and dehumanized humans, floating up and down without effort, emerging from nowhere and disappearing into nothingness, constantly in motion without any recognizable purpose, and totally indifferent to each other. There is an overwhelming display of dazzling color and intricate motion, tied to no experience we ever had and performed for the discernible benefit of nobody. There are innumerable monstrous variations of faces and bodies as we know them, passing by with the matter-of-factness of herring or perch, in a profound silence, most unnatural for such visual commotion and rioting color, and interrupted only by noises nobody ever heard. What we have here, if a nasty pun is permissible, is the New Wave under water.

For it seems evident that what captures us in this documentary film is a most successful although surely unintentional display of what the most impressive films of the last few years have been trying to do, namely, to interpret the ghostliness of the visible world by means of authentic appearances drawn directly from that world. The cinema has been making its best contribution to the general trend I have tried to describe, not by withdrawing from imagery, as the other arts have, but by using imagery to describe reality as a ghostly figment. It thereby seizes and interprets the experience from which the other visual arts tend to escape and to which they are reacting.

In exploiting this opportunity, the cinema remains faithful to its nature. It derives its new nightmares from its old authenticity. Take the spell-binding opening of Fellini's 8½, the scene of the heart attack in the closed car, stared at without reaction by the other drivers, so near by and yet so distant in their

glass and steel containers, take the complete paralysis of motion, realistically justified by the traffic jam in the tunnel, and compare this frightening mystery with the immediately following escape of the soul, which has all the ludicrous clumsiness of the special-effects department. How much more truly unreal are the mosquito swarms of the reporters persecuting the widowed woman in *La Dolce Vita* than is the supposedly fantastic harem bath of the hero in 8½. And how unforgettable, on the other hand, is the grey nothingness of the steam bath in which the pathetic movie makers do penitence and which transfigures the ancient cardinal.

The actors of Alain Robbe-Grillet move without reason like Cousteau's fishes and contemplate each other with a similar indifference. They practice absent-mindedness as a way of life and they cohabit across long distances of empty floor. In their editing technique, the directors of the *Nouvelle Vague* destroy the relations of time, which is the dimension of action, and of space, which is the dimension of human contact, by violating all the rules in the book—and some readers will guess what book I am referring to. Those rules, of course, presuppose that the film maker wished to portray the physical continuity of time and space by the discontinuity of the pictures.

The destruction of the continuity of time and space is a nightmare when applied to the physical world but it is a sensible order in the realm of the mind. The human mind, in fact, stores the experiences of the past as memory traces, and in a storage vault there are no time sequences or spatial connections, only affinities and associations based on similarity or contrast. It is this different but positive order of the mind that novelists and film directors of the last few years have presented as a new reality while demolishing the old. By eliminating the difference between what is presently perceived and what is only remembered from the past, they have created a new homogeneity and unity of all experience, independent of the order of physical things. When in Michel Butor's novel, *La Modification* the sequence of the train voyage from Paris to Rome constantly interacts with a spray of atomized episodes of the past, the dismemberment of physical time and space creates a new time sequence and a new spatial continuum, namely, those of the mind.

It is the creation and exploitation of this new order of the mind in its independence of the order of physical things which, I believe, will keep the cinema busy while the other visual arts explore the other side of the dichotomy—the world of physical things from which the mind seems so pleasantly absent.

THE SURFACES OF REALITY

MICHAEL ROEMER

As Siegfried Kracauer effectively demonstrates, the camera photographs the skin; it cannot function like an X-ray machine and show us what is underneath. This does not mean, however, that the film-maker has no control over the surfaces rendered by his camera. On the contrary, he *chooses* his surfaces for their content, and through their careful selection and juxtaposition builds a structure of feeling and meaning that are the core of his work.

There are times in the history of the medium when story, treatment and performance drift so far into a studio never-never land that we cannot help but make a virtue of "pure" reality, as free from interference on the part of the film-maker as possible—even at the risk of creating something shapeless. This should not, however, obscure the fact that a film, like a poem or painting, is basically an artifact.

The assertion that film is nothing more than a documentary recording of reality undoubtedly stems from the fact that the medium must render all meaning in physical terms. This affinity for real surfaces, combined with great freedom of movement both in time and space, brings film closer than any other medium to our own random experience of life. Even the realistic playwright, who—until the advent of the camera—came closest to rendering the appearance of reality, is often forced in his structure to violate the very sense of life he is trying to create. But the film-maker can use the flexible resources at his command to approximate the actual fabric of reality. Moreover, he need not heighten his effects in order to communicate, for he can call on the same sensibilities in his audience that we use in life itself.

All of us bring to every situation, whether it be a business meeting or a love affair, a social and psychological awareness which helps us understand complex motivations and relationships. This kind of perception, much of it nonverbal and based on apparently insignificant clues, is not limited to the educated or gifted. We all depend on it for our understanding of other people and have become extremely proficient in the interpretation of subtle signs—a shading in the voice, an averted glance. This nuanced awareness, however, is not easily called upon by the arts, for it is predicated upon a far more immediate and total experience than can be provided by literature and the theater, with their dependence on the word, or by the visual arts—with their dependence on the image. Only film renders experience with enough im-

mediacy and totality to call into play the perceptual processes we employ in life itself.

The fact that film exercises this sort of perceptual capacity is, I believe, one of its chief appeals to us. It gives us practice in the delicate and always somewhat uncertain skill of finding out what is going on. As an extreme example, take these lines from *Marty*. They are spoken in a dance hall during the first encounter between a lonely man and a lonely girl. She says: "I'm twenty-nine years old. How old are you?" And he answers: "Thirty-six."

On the stage or the printed page these lines would fall ludicrously flat. But on the screen, when spoken by performers who can make every detail yield a wealth of meaning, they instantly convey—as they would in life itself—a complex web of feeling: the girl's fear that she might be too old for the man, her need to come right to the point, her relief when he turns out to be older, and finally a mutual delight that their relationship has crossed its first hurdle.

Film thrives on this kind of intimate detail, for the camera reports it so closely that nothing essential is lost to the eye or ear. The camera makes it possible to use the stuff of life itself, without amplification or overstatement and without any loss in dramatic value. What is achieved in a large action or an explicit moment on the stage can be rendered just as dramatically on the screen in small and *implicit* terms, for it is not the magnitude of a gesture that makes it dramatic but its meaning and intention.

This is *not* to say that the medium is most aptly used on the kind of everyday story told in *Marty*, or that low-key dialogue without conflict or strong feeling is always effective on the screen. I quote the scene merely as an example of the medium's capacity for finding meaning in the detail of everyday life and would like to suggest that out of such detail, out of the ordinary surfaces of life, the film-maker can structure *any* kind of situation and story—lyrical or dramatic, historical or contemporary.

Like so many films that deal with the past, Dreyer's *Passion de Jeanne D'Arc* might well have been filled with violent action and threatrical confrontations. Instead the story is told in terms of mundane detail. Thus Jeanne is betrayed at a critical moment by a priest who averts his eyes when she turns to him for help. There is no call for anything more explicit. The betrayal is what matters, and the camera renders it far more credibly and forcefully in a mundane detail than it would be in a highly dramatized gesture.

In *Rashomon* and *The Seven Samurai* Kurosawa deals with events of the thirteenth and sixteenth centuries in the most everyday terms. He knows that our basic daily experience of reality has not changed much over the centuries: a war between bandits and samurai in a feudal Japanese village was as full of

mud and rain, as gritty and as grotesque as a twentieth-century skirmish. Film at its best uses the language of ordinary experience—but uses it subtly and artfully.

In a contemporary setting, Bresson's *A Man Escaped* chronicles the efforts of a French resistance fighter to break out of a German prison. Much of the film takes place within the confines of a cell and the camera records how he painstakingly prepares his escape by fashioning tools out of spoons and rope out of blankets. It is all very ordinary and physical, but out of the grimy detail emerges a devout and heroic assertion of life and human freedom and of the need to preserve them in the face of all odds. In the hands of a sensitive film-maker the ordinary moment becomes a channel for deep feeling and a sequence of apparently insignificant scenes is structured into a world of great complexity.

This use of ordinary surfaces requires great skill and discipline since the audience can sense every false move and movement, every false note in the dialogue, every unsubstantiated relationship. The very thing that works *for* the film-maker if he can master it—reality—can quickly turn against him, so that the most ordinary moment becomes utterly unreal. Not surprisingly most directors avoid the challenge and set their stories in unfamiliar parts, among unusual people and in unusual circumstances.

Because most good films use the language of the commonplace, they tend to have an unassuming appearance, whereas films that make a large claim— that speak nobly and poetically about life, love and death—almost invariably prove to be hollow. A good film is concrete: it creates a sequence of objective situations, actual relationships between people, between people and their circumstances. Thus each moment becomes an objective correlative; that is, feeling (or meaning) rendered in actual, physical terms: objectified.

By contrast, most movies are a series of conventional communicative gestures, dialogues, and actions. Most movie-makers *play* on the feelings of their audience by setting up a sequence of incidents that have a proven effect. The events are not rendered; they are merely *cited*. The films do not use the vocabulary of actuality but rather a second-hand language that has proven effective in other films—a language that is changed only when the audience no longer responds.

This language of conventions gives most pictures the appearance of ludicrous unreality fifteen or twenty years after they have been acclaimed as masterpieces. The dramatic conventions of the 1940's are recognized as a system of hollow clichés by the sixties. When *The Best Years of Our Lives* was first shown, references to the war were enough to make an audience feel

strongly about a situation or character without any substantiation whatever; there were feelings abroad which, when touched, produced the desired effect. By 1964 this is no longer true and the tissue of the film disintegrates.

Audiences can be "played" by a skillful movie-maker with a fair amount of predictability, so that even discriminating audiences are easily taken in. At the beginning of Bergman's *Wild Strawberries* Professor Borg dreams that he is on a deserted street with all its doors and windows shuttered tight. He looks up at a clock that has no hands and pulls out his own watch only to find that its hands are missing also. A man appears on the corner with his head averted; when he turns, he has no face and his body dissolves into a pool on the sidewalk. A glass hearse comes down the street and spills a coffin that opens. Borg approaches and discovers his own body in the coffin. The corpse comes to life and tries to pull him in.

The nightmare quality in this sequence is derivative. The deserted, shuttered street, the clock and watch without hands, the glass hearse, the faceless man are all conventions familiar to surrealist painting and literature. Bergman uses them skillfully and with conviction to produce an effect in the audience, but they are not true film images, derived from life and rendered in concrete, physical terms.

There is a similar nightmare in Dreyer's *Vampire*. A young man dreams that he has entered a room with an open coffin in it. He approaches and discovers that he himself is the corpse. The camera now assumes the point-of-view of the dead man: we look up at the ceiling. Voices approach and two carpenters appear in our field of vision. They close the coffin with a lid but we continue to look out through a small glass window. Talking indistinctly, they nail down the lid and plane the edges of the wood. The shavings fall onto the window. One of them has put a candle down on the glass and wax drips onto it. Then the coffin is lifted up and we pass close under the ceiling, through the doorway, beneath the sunlit roofs and the church steeple of a small town— out into the open sky.

Here the detail is concrete: an experience is rendered, not cited; the situation is objective and out of it emerges, very powerfully, the feeling that Dreyer is after: a farewell to life, a last confined look at the earth before the coffin is lowered into the grave. Once again we note that the unassuming detail can render a complex feeling (or meaning) which eludes the more obviously ambitious but abstract statement.

Good film dialogue, too, has this concrete quality. Like the speech of everyday life, it does not tell you *directly* what is felt or meant. One might call it symptomatic dialogue: symptomatic because it is a surface manifestation of what is going on inside the person. The dialogue in most films is, of course, the

opposite: a direct statement of feeling or meaning: "I love you"; "I am so happy"; "You are this"; "I am that." But just as the action should be a physical or surface correlative that permits the audience to discover for itself the implicit meaning, so the dialogue should be a *surface* that renders its content by implication—not directly. The two lines quoted from *Marty* are good film dialogue. In contrast, here is an incident from Bergman's *The Seventh Seal.*

Shortly before his death the knight Antonius Block shares a meal with a young couple in front of their covered wagon. "I shall always remember this moment," he says. "The silence, the twilight, the bowls of strawberries and milk, your faces in the evening light. Mikhael sleeping, Jof with his lyre. I'll try to remember what we have talked about. I'll carry this moment between my hands as carefully as if it were a bowl filled to the brim with fresh milk. And it will be an adequate sign—it will be enough for me."

Without this lengthy and explicit verbalization, one would have little insight into the feelings of Antonius Block. The situation itself does not communicate them and Bergman uses dialogue as a way of getting us to understand and feel something the film itself does not render. In Kurosawa's *Ikiru,* a petty official who is dying of cancer and trying desperately to give meaning to his life by pushing a playground project through the sterile bureaucracy, stops on his way home from work to look at the evening sky. "It's beautiful," he says to his companion, "but I have no time." Here the dialogue is part of the objective situation. No direct statement is needed since the man and his feelings are clear.

What is true for dialogue is equally true for performance. A good film performance is a carefully integrated sequence of concrete actions and reactions that render the feelings and thoughts of a character. It is not a system of hollow gestures that, like bad dialogue, *tell* the audience what is going on. Most film performances are drawn from the vast repertory of acting conventions. Conversely, the good film actor—whether trained in the Method or not—tries to render feelings through the use of surface correlatives. He is not concerned with the demonstration of feeling but with the symptom of feeling.

Chaplin's best work is continuously physical and concrete. If his performance in *The Gold Rush* had been generalized (or conventionalized) the scene in which he boils and eats his shoe would have become preposterous. He executes it, however, in the most careful physical detail. While the shoe is cooking, he pours water over it as if he were basting a bird. He carves and serves it with meticulous care, separating the uppers from the sole as though boning a fish. Then he winds the limp laces around his fork like spaghetti and sucks each nail as if it were a delicate chicken bone. Thus a totally incongruous

moment is given an absolute, detailed physicality; the extraordinary is made ordinary, credible—and therefore funny.

It must be noted again that while the screen exceeds all other media in verisimilitude, its reality is nevertheless a *mode*. We appear to be looking at reality but are actually looking at a representation of it that may be as carefully structured as a still-life by Cézanne. The film-maker uses the surfaces of life itself—literal photographic images and accurately reproduced sounds. But the arrangement of these images and sounds is totally controlled. Each moment, each detail is carefully coordinated into the structure of the whole—just like the details in a painting or poem. By artfully controlling his images, the film-maker presents an unbroken realistic surface; he preserves the appearance of reality.

This means that he should at no time interpose himself between audience and action. He must be absent from the scene. An example of this is the use of the camera. In the standard film the camera is often editorial; the director uses it to *point out* to the audience what he wants them to see. Imagine a scene between husband and wife: we see them in a medium-shot, talking; then we cut to a close-up of the woman's hand and discover that she is slipping her wedding ring off and on. The director has made his point: we now know that she is unhappily married. But by artificially lifting the detail out of context and bringing it to our attention, the autonomous reality of the scene is violated and the audience becomes aware of the film-maker. Of course a good director may also be said to use the camera editorially—to point out what he wants us to see. But he never seems to be doing so; he preserves the appearance of an autonomous reality on the screen. The moment with the ring would have been incidental to the scene—for the camera must follow the action, not lead it.

Since the process of editing is an obvious and continued intrusion by the film-maker on the material, an editor tries to make most of his cuts in such a way that the cut itself will be obscured. In order to cut from a medium-shot to a close-up of a man, he will probably use a moment when the man rises from a chair or turns rapidly. At such a time the audience is watching the action and is unaware of the jump; once again, the effort is to preserve an apparently autonomous reality.

At the end of *Notti di Cabiria* the girl and the man she has just married are sitting in a restaurant. We see her from the back, talking. Then Fellini cuts to a shot from the front and we see that she has taken out a large wad of bank notes—her savings. We immediately realize, with something of a shock, that

the man is after her money. If Fellini had actually *shown* us Cabiria taking the money out of her pocketbook, the moment would have become self-conscious and overloaded with meaning; we would have had too much time to get the point. By jumping the moment and confronting us suddenly with the money, Fellini renders the meaning *and* preserves the apparent autonomy of the situation.

Spontaneity, the sense that what is happening on the screen is happening for the first time and without plan or direction, is an essential factor in establishing a reality. It is also extremely difficult to achieve since a huge industry has sprung up around the medium, putting enormous financial and technical pressure on the moment before the camera. Years of routine and a high degree of established skill in every department of film-making all conspire against it. From writing and casting to the angles of the camera a monstrous if unintended predictability crushes all life. Even a strong director is often helpless against the machinery; and even location shooting, which should be a liberating force, turns into a dead-end when a huge crew descends on the place, seals it off hermetically and effectively turns it into a studio. The channels have been set up too long and too well; all vision is trapped into standardized imagery and the living moment cannot survive.

For this reason an almost improvised film—like *Shadows* or *Breathless*, made without great skill or art by relatively inexperienced people—can carry far greater conviction than the standard theatrical product. In spite of obvious flaws there is a spontaneity to the action that endows it with life. Of course the experienced director, working in freedom and under good conditions, can achieve spontaneity without relying on improvisation. Kurosawa shot parts of *The Seven Samurai* with several cameras; this made it unnecessary for the actors to repeat, and so deaden, the action with every shift in camera position. Chaplin, on the other hand, used to rehearse and shoot endlessly to achieve a perfect but seemingly effortless result. Both men were after the same thing: spontaneity—and with it, reality.

Our sense of reality is so delicately attuned that certain moments are better left off the screen or the situation is destroyed. This is especially true for violence and death. When someone's head is cut off in a fiction film we know perfectly well that a trick is employed and unless a scene of this kind is handled with great care, it ends up being incredible or even funny. Similarly, when someone dies on the screen and remains in full view, many of us cannot resist watching for the slightest sign of life in the supposed corpse. We are pitting our own sense of reality against the movie-maker's; needless to say, *we* come out on top and the scene is destroyed.

In Dreyer's unproduced script on the life of Christ he describes the cruci-

fixion by showing us the back of the cross, with the points of the nails splintering through the wood. On the screen these would be undeniably real nails going through real wood, and the authenticity of the moment would not be challenged. If, however, Dreyer had chosen to show us the cross from the front we would know absolutely that the nails going through the *flesh* are a deception—and the suffering figure would turn into a performer.

The nail splintering through the wood forces us to use our imagination—forces us to visualize what is happening on the other side of the cross. This involves us in a far deeper participation than could be achieved by the spurious horror of a nail going through the flesh of an actor.

There is something to be learned here about the entire process of perception in film. If we are explicitly told something, as we are in most pictures, we remain passive and essentially outsiders. If, however, we have to draw our *own* conclusions on the basis of evidence presented, as we do in life itself, we cannot help but participate. We become actively involved. When we are told something explicitly, we are in a sense deprived of the experience. It has been digested for us and we are merely informed of the results, or the meaning. But it is *experience* we are after, even if it remains vicarious experience.

This brings us to another characteristic of the medium—one that is profoundly related to our previous discussion. Although the experience of the motion picture audience remains essentially vicarious, film comes closer than any other medium to giving us the illusion of a *primary* experience. This has been studied by psychologists who have found that the dark theater, the bright hypnotic screen, the continuous flow of images and sounds, and the large anonymous audience in which we are submerged all contribute to a suspension of self-awareness and a total immersion in the events on the screen.

Beyond this, however, the medium itself encourages the illusion of a primary participation. The camera can induce an almost physical response—so that when Chaplin sits on a hypodermic needle in the lair of a dope fiend, or when Dreyer's Jeanne d'Arc has her head shaved and some of the hair falls onto her lip, the sensation produced in us is almost physical. Moreover, this physical participation is not limited to sharp sensory detail; it extends to the realm of movement.

Most directors think of the screen as of a *picture* frame within which each shot is carefully composed. They emphasize the *pictorial* quality of film. But while the medium is visual, it is not pictorial in the conventional sense. A sequence of beautifully composed shots tends to leave the audience outside the frame—spectators who are continually aware of the director's fine eye for composition. A good director tries to eliminate this distance between audience

and action, to destroy the screen as a picture frame, and to drag the audience *through* it into the reality of the scene. That is the function of the running shots in *Rashomon* and of the extraordinarily emphatic camerawork of Fellini, who leans subtly into every movement and propels us into the action kinesthetically. By contrast, we have the autonomous camera motion and stiff pictorial composition of most films.

Images of movement rather than beautifully composed shots are at the heart of the medium, and significantly some of the most haunting moments in film derive their effect from motion. In Vigo's *L'Atalante*, a bride on her wedding night, still dressed in her white gown, walks along the deck of a moving barge. The barge moves forward, she is walking toward the stern, and the camera is set on the edge of the canal, so that there is a dark stationary line in the foreground. The combination of the silent forward gliding of the barge with the backward motion of the girl, whose gown and veil are streaming in the wind, has a profound emotional impact; it renders perfectly both her feelings and our own.

At the end of *Ikiru* the dying bureaucrat has succeeded in building the playground. It is a winter night; the camera moves slowly past a jungle-gym; beyond it we see the old man, swaying to and fro on a child's swing and singing to himself under the falling snow. The various components of this scene are hard to separate: the hoarse, cracked voice of the dying man; his happiness; the song itself. But the motion of the camera, the falling snow, and the slow movement of the swing certainly contribute to the extraordinary sense of peace and reconciliation that is communicated by the image.

A last example: in Dreyer's *Day of Wrath,* a witch is burned in a seventeenth-century town. We see her bound to the top rungs of a tall ladder. Then Dreyer cuts to a long-shot and side view: on the left a huge pile of faggots is burning; to the right soldiers are raising the ladder toward the fire by means of long poles. When it stands perpendicular, they topple it forward so that the woman falls screaming across the entire frame toward the flames. The falling arc described by the victim is rendered in coldly objective terms, from far away—but it transmits her terror completely and draws us relentlessly into the action.

Kurosawa has developed a way of staging that makes it hard for an audience to remain detached. On the theory that no one should be seen entirely from the back, many directors stage their scenes in a three-quarter view. As a result, no one is seen full-face: *we* look at the actors, but they look away. In *Rashomon* and *The Seven Samurai*, however, the actors either have their backs to camera or face us frontally. When they face us, they are all but looking at us—with only their eyes turned slightly left or right of lens to indicate that

they are addressing each other and not us. Of course a face seen frontally is much more exposed than a three-quarter view, and far less likely to leave us detached.

Film can further strengthen the illusion of a primary experience by using a subjective point-of-view. In the ancient and Elizabethan theaters, while we remain in objective possession of the entire stage, the poetry and particularly the soliloquy can focus our attention on one person and shift it to his point-of-view. At any given moment the world can be seen through his eyes, subjectively. In the realistic theater, with its fidelity to the surfaces of everyday life, this has become difficult if not impossible. We *know* how Ibsen's Nora sees the world but except for rare moments do not *experience* it from her point-of-view. She cannot, as it were, reach out and envelop us in her vision—as Hamlet and Lear can.

On the screen it again becomes possible to shift from an objective vision of a person to a vision of what *he* sees. This is done continually, often with little understanding or control. We see a girl enter a room in an objective shot. Then the camera renders what *she* sees: there is a party and her husband is talking to another woman. The next moment might be objective again, or it might be seen from the husband's point-of-view. Montage makes it possible to shift from objective to subjective, or from one subjective point-of-view to another. Film can render a place, a person, or a situation not just as they are but in the context of the protagonist's experience—*as* his experience. A point-of-view can be so carefully articulated that we comprehend every object, every passing figure, every gesture and mood in terms of the protagonist. The medium thus extends the meaning of realistic surfaces beyond their objective value; it renders them in their subjective context as well.

This brings us to an apparent paradox, for we have insisted throughout that film is at its best when rendering an objective situation. It is true, of course, that a moment can be rendered subjectively on the screen and still retain its objective reality. When the girl sees her husband talking to another woman, we see them through her eyes and so become privy to a subjective state. But the husband and the other woman are *in themselves* rendered objectively: they look no different; they are not affected by the point-of-view. The basic language of the medium, the realistic surface, has not been violated. The same may be said of most flash-backs: a subjective recollection is rendered—but in objective, undistorted terms.

There are, however, moments on the screen in which the realistic surface is in fact destroyed and a purely subjective state is created. The processional at the end of Vigo's *Zero de Conduite* is shot in slow-motion, with the boys in their white gowns gliding through a snow of pillow feathers to the accompani-

ment of a totally distorted but oddly ecstatic song. In such scenes, and it must be noted that while they are often attempted they do not often succeed, the reality of the feeling is so compelling that an audience accepts and assimilates a totally subjective image. The participation is so intensive that instead of rejecting an image we know to be "unreal," we enter into it eagerly.

When successful, scenes of this kind are deeply moving for they are predicated on a rare and free flow of feeling between audience and material. But they are moments of grace and cannot be counted on—like those rare moments in a performance when pure feeling breaks out of the actor and is communicated directly, without the mediation of a physical correlative.

By and large the language of the medium remains the surface of reality, and there seem to be few experiences that cannot be rendered in this language. Moreover, there is a great challenge in making the commonplaces of life, that have so long eluded art, yield up their meaning and take their rightful place in the larger patterns of existence. Film is indeed, as Kracauer put it, the redemption of physical reality. For we are finally able to use the much-despised and ephemeral detail of everyday life, the common physical dross, and work it into the gold of art.

CONTRIBUTORS

Sir Herbert Read is one of the most prolific writers on art of our time. His works include books about Wordsworth, Shelley, the philosophy of art, and the history of modern painting. He has taught at English and American universities.

Bernard Berenson was one of America's most respected authorities on Italian art. His books include *The Italian Painters of the Renaissance.*

Bertram Jessup is Professor of Philosophy at the University of Oregon. His articles appear frequently in journals devoted to aesthetics and the arts.

William H. Bossart contributes articles to several journals. He is currently teaching at the University of California, Davis.

P. A. Michelis, noted Greek aesthetician, appears regularly in American journals of philosophy.

Curt John Ducasse is Professor of Philosophy at Brown University and has long been one of the country's most prominent aestheticians.

Monroe C. Beardsley, author of *Aesthetics: Problems in the Philosophy of Criticism,* is Professor of Philosophy at Swarthmore College. His is one of the most influential voices in aesthetics today.

Susanne K. Langer must be reckoned among the world's most influential philosophers. She teaches at Connecticut College for Women.

Selma J. Cohen's redoubtable reviews appear in the *Journal of Aesthetics and Art Criticism.* She is on the staff of the Dance Collection of the New York Public Library.

Morris Weitz, professor at Ohio State University, has written several important works in aesthetics which have been influential in our time.

George Santayana, without question, was one of the most significant American philosophers and aestheticians of his or our time. His *Reason in Art* and *The Sense of Beauty* stand as acknowledged classics.

Wayne Shumaker is professor of English at University of California, Berkeley. His scholarly and critical essays have appeared in many journals.

I. A. Richards was a psychologist as well as a student of language and literature. *Practical Criticism* and *Principles of Literary Criticism* paved the way for theories of modern criticism.

Eric Capon is British, Director of Drama Studies at the Guildhall School of Music and Drama. He is a former Director of the Liverpool Playhouse and the Glasgow Theater.

Hugh Kenner, professor at the University of California, Santa Barbara, is a well-known and respected critic of literature and the arts.

Aaron Copland is not only one of America's greatest composers, but also one of our most eloquent commentators on music. *What to Listen for in Music* is a classic study in the field.

Eduard Hanslick had strong feelings about music. His work has been very influential down to our own day.

John Hospers is Professor of Philosophy at Brooklyn College.

F. David Martin appears frequently in journals of philosophy. He is Professor of Philosophy at Bucknell University.

Fanchon Fröhlich studied at Chicago and Oxford. She is also a practicing painter and etcher.

Etienne Gilson is well known for his work on Dante and for his strong interest in scholastic philosophy.

Clement Greenberg is an influential modern American art critic.

Frank Lloyd Wright was the greatest of American architects.

Lewis Mumford has long been an aesthetic conscience for American architects. *The Brown Decades* and *Sticks and Stones* are two of his best-known books.

Eduardo Torroja is a Spanish architect who specializes in reinforced concrete structures. He is described as an architectural engineer.

Albert Bush-Brown, president of Rhode Island School of Design, has appeared in many journals devoted to the arts.

Siegfried Kracauer's work is of primary importance for anyone interested in film and film making.

Rudolf Arnheim's Film as Art (1939) is still regarded as the handbook of film aesthetics. He teaches at Sarah Lawrence College in Bronxville, N. Y.

Michael Roemer is a film critic who lives in New York. He has made his own feature film, with Robert Young, called *Nothing But a Man*.

SELECTED READINGS

The following list of readings is far from complete. It is meant to suggest starting points for interested students in their search for further information in specific areas of aesthetic concern. Note that the volumes from which essays have been selected in this book have not been included in the following list, although they may very often be profitably consulted. Further, the articles here have been reprinted with their full complement of footnotes to offer more scholarly sources which may be investigated. Most of the books in the following list are available in recent editions, many of them inexpensive paperbacks. Note that the volume by Melvin Rader has one of the fullest bibliographies available for modern aesthetics.

GENERAL READINGS

Aldrich, Virgil C.: *The Philosophy of Art*, Englewood Cliffs, 1963.
Beardsley, Monroe C.: *Aesthetics: Problems in the Philosophy of Criticism*, New York, 1958.
Bell, Clive: *Art*, New York, 1914.
Cary, Joyce: *Art and Reality*, New York, 1958.
Collingwood, Robin G.: *The Principles of Art*, New York, 1938.
Croce, Benedetto: *Aesthetic*, New York, 1963 (original edition, 1909).
Dewey, John: *Art as Experience*, New York, 1934.
Ducasse, Curt John: *The Philosophy of Art*, New York, 1929.
Edman, Irwin: *Arts and the Man*, New York, 1939.
Fry, Roger: *Vision and Design*, London, 1920.
Greene, Theodore M.: *The Arts and the Art of Criticism*, Princeton, 1940.
Hall, James B. and Barry Ulanov, *Modern Culture and the Arts*, New York, 1967.
Hofstadter, Albert, and Richard Kuhn (eds.): *Philosophies of Art and Beauty*, New York, 1964.
Langer, Susanne K. (ed.): *Reflections on Art*, Baltimore, 1958.
Munro, Thomas: "Style in the Arts: A Method of Stylistic Analysis," *Journal of Aesthetics and Art Criticism*, vol. 5, pp. 128–158, 1946.
———: *The Arts and Their Interrelations*, New York, 1949.
Ortega y Gasset, Jose: *The Dehumanization of Art*, New York, 1956.
Parker, De Witt: *The Principles of Aesthetics*, New York, 1946.
Pepper, Stephen C.: *The Work of Art*, Bloomington, 1955.
Prall, D. W.: *Aesthetic Analysis*, New York, 1936.
Rader, Melvin (ed.): *A Modern Book of Esthetics*, New York, 1960.
Santayana, George: *Reason in Art*, New York, 1905.

Schneider, Daniel E.: *The Psychoanalyst and the Artist*, New York, 1950.
Tomas, Vincent (ed.): *Creativity in the Arts*, Englewood Cliffs, 1964.
Vivas, Eliseo, and Murray Krieger (eds.): *The Problems of Aesthetics*, New York, 1953.
Weiss, Paul: *Nine Basic Arts*, Carbondale, 1961.

THE DANCE

Cohen, Selma Jeanne (ed.): *The Modern Dance*, Middletown, 1965.
De Mille, Agnes: *The Book of the Dance*, New York, 1963.
————: *Dance to the Piper*, Boston, 1952.
Horst, Louis: *Modern Dance Forms in Relation to the Other Modern Arts*, San Francisco, 1961.
Lawler, Lillian B.: "Terpsichore: The Story of the Dance in Ancient Greece," *Dance Perspectives*, vol. 13, pp. 1–57, 1962.
Maynard, Olga: *American Modern Dancers: The Pioneers*, New York, 1965.
Meerloo, Joost: *The Dance*, New York, 1960.
Mitchell, Jack: *Dance Scene: U.S.A.*, New York, 1967.
Pauley, Herta: "Inside Kabuki: An Experience in Comparative Aesthetics," *Journal of Aesthetics and Art Criticism*, vol. 25, pp. 293–306, 1967.
Selden, Elizabeth S.: *The Dancer's Quest*, Berkeley, 1935.
Terry, Walter: *The Dance in America*, New York, 1956.
Van Praagh, Peggy, and Peter Brinson: *The Choreographic Art*, New York, 1963.

LITERATURE

Auerbach, Erich: *Mimesis*, Princeton, 1953.
Bodkin, Maud: *Archetypal Patterns in Poetry*, Oxford, 1934.
Brooks, Cleanth: *The Well Wrought Urn*, New York, 1947.
Burke, Kenneth: *The Philosophy of Literary Form*, Baton Rouge, 1941.
Eliot, T. S.: *Selected Essays: New Edition*, New York, 1960.
Empson, William: *Seven Types of Ambiguity*, New York, 1930.
Feidelson, Charles: *Symbolism and American Literature*, Chicago, 1953.
Ferguson, Francis: *The Idea of a Theater*, Garden City, 1953.
Forster, E. M.: *Aspects of the Novel*, New York, 1927.
Frye, Northrop: *Anatomy of Criticism*, Princeton, 1957.
Heilman, Robert B.: *This Great Stage*, Baton Rouge, 1948.
Hoffman, Frederick J.: *Freudianism and the Literary Mind*, Baton Rouge, 1945.
Hyman, Stanley Edgar: *The Armed Vision*, New York, 1948.
James, Henry: *The Art of the Novel*, New York, 1934.
Krieger, Murray, *The New Apologists for Poetry*, Minneapolis, 1956.

Leavis, F. R.: *The Great Tradition*, New York, 1949.
Lubbock, Percy, *The Craft of Fiction*, New York, 1931.
Muller, Herbert J.: *Science and Criticism*, New Haven, 1943.
Praz, Mario: *The Romantic Agony*, Oxford, 1933.
Richards, I. A: *Practical Criticism*, New York, 1929.
Schorer, Mark: "Technique as Discovery," *Hudson Review*, Spring, 1948.
Warren, Robert Penn, and Cleanth Brooks: *Understanding Poetry*, New York, 1940.
Wellek, René, and Austin Warren: *Theory of Literature*, London, 1953.
West, Ray B. (ed.): *Essays in Modern Literary Criticism*, New York, 1952, 1962.
Wimsatt, William K., and Monroe C. Beardsley: *The Verbal Icon*, Lexington, 1954.
———— and Cleanth Brooks: *Literary Criticism, a Short History*, New York, 1957.
Winters, Yvor: *In Defense of Reason*, New York, 1947.

MUSIC

Bake, A. A.: "The Aesthetics of Indian Music," *British Journal of Aesthetics*, vol. 4, pp. 47–57, 1964.
Cooper, Martin: *Ideas and Music*, London, 1965.
Debussy, Claude, and others: *Three Classics in the Aesthetics of Music*, New York, 1962.
Erickson, Robert: *The Structure of Music*, New York, 1955.
Gurney, Edmund: *The Power of Sound*, London, 1880.
Haydon, Glenn: *On the Meaning of Music*, Washington: Library of Congress, 1948.
Hindemith, Paul: *Composer's World*, Cambridge, Mass., 1952.
Howard, John Tasker, and James Lyons: *Modern Music*, New York, 1942, 1957.
Ives, Charles: *Essays Before a Sonata, and Other Writings*, in H. Boatwright (ed.), New York, 1962.
Judd, Frederick: *Electronic Music and Musique Concréte*, London, 1961.
Machlis, Joseph: *Introduction to Contemporary Music*, New York, 1961.
Meyer, Leonard B.: *Emotion and Meaning in Music*, Chicago, 1956.
Mitchell, Joyce: "Criteria of Criticism in Music," *Journal of Aesthetics and Art Criticism*, vol. 21, pp. 27–30, 1962.
Portnoy, Julius: *Music in the Life of Man*, New York, 1963.
Sachs, Curt: *The Wellsprings of Music*, The Hague, 1962.
Seashore, Carl E.: *Psychology of Music*, New York, 1938.
Stravinsky, Igor, and Robert Craft: *Expositions and Developments*, Garden City, 1962.
Sullivan, J. W. N.: *Beethoven: His Spiritual Development*, New York, 1927.
Zuckerkandl, Victor: *Sound and Symbol*, New York, 1956.

VISUAL ARTS: PAINTING AND SCULPTURE

Arnheim, Rudolf: *Art and Visual Perception*, Berkeley, 1954.
Berenson, Bernard: *Italian Painters of the Renaissance*, New York, 1957 (original edition, 1894–1907).
Brown, Milton W.: *The Story of the Armory Show*, New York, 1963.
Canaday, John: *Keys to Art*, New York, 1963.
Clark, Kenneth: *The Nude*, Garden City, 1959.
Fried, Michael: "Modernist Painting and Formal Criticism," *American Scholar*, vol. 33, pp. 642–648, 1964.
Gardner, Helen: *Art through the Ages*, New York, 1936, 1959.
Giedion-Welker, G.: *Contemporary Sculpture: An Evolution in Volume and Space*, London, 1962.
Gombrich, E. H.: *Art and Illusion*, New York, 1960.
Kuh, Katherine: *The Artistic Voice: Talks with Seventeen Artists*, New York, 1962.
Lessing, G. E.: *Laocoön*, Boston, 1894.
Martin, F. David: "Naming Paintings," *The Art Journal*, vol. 25, pp. 252–256, 1966.
Neumeyer, Alfred: *The Search for Meaning in Modern Art*, Englewood Cliffs, 1964.
Panofsky, Erwin: *Meaning in the Visual Arts*, Garden City, 1955.
Pelles, Geraldine: *Art, Artists and Society: Painting in England and France, 1750–1850*, Englewood Cliffs, 1963.
Read, Herbert: *A Letter to a Young Painter*, London, 1962.
Shahn, Ben: *The Shape of Content*, Cambridge, Mass., 1957.
Sypher, Wylie: *Four Stages of Renaissance Style*, Garden City, 1955.
Weyl, Herman: *Symmetry*, Princeton, 1952.
Wölfflin, Heinrich: *Principles of Art History*, New York, 1950.

ARCHITECTURE

Burchard, John, and Albert Bush-Brown: *The Architecture of America*, Boston, 1961.
Carritt, E. F.: "The Aesthetic Experience of Architecture," *British Journal of Aesthetics*, vol. 3, pp. 67–69, 1963.
Corbusier, Le: *Towards a New Architecture*, New York, 1927.
Gropius, Walter: *The Scope of Total Architecture*, New York, 1955.
Hitchcock, H. R.: *Architecture*, Baltimore, 1958.
Modisette, Eldon L.: "The Legitimation of Modern American Architecture," *Journal of Aesthetics and Art Criticism*, vol. 20, pp. 251–262, 1962.
Mumford, Lewis: *The City in History*, New York, 1961.
Neutra, Richard: *Survival Through Design*, New York, 1954.
Panofsky, Erwin: *Gothic Architecture and Scholasticism*, New York, 1951.

Paul, Sherman: *Louis Sullivan. An Architect in American Thought*, New York, 1962.
Scott, Geoffrey: *The Architecture of Humanism*, London, 1924.
Sullivan, Louis: *Kindergarten Chats*, New York, 1947.
Torroja, Eduardo: *Philosophy of Structures*, Berkeley, 1958.
Wright, Frank Lloyd: *The Natural House*, New York, 1954.
————: *The Living City*, New York, 1958.

THE FILM

Arnheim, Rudolf: *Film as Art*, Berkeley, 1958.
Barry, Iris: *D. W. Griffith: American Film Master*, New York: Museum of Modern Art, 1940.
Feldman, Joseph and Harry: *Dynamics of the Film*, New York, 1952.
Houston, Penelope: *The Contemporary Cinema*, Baltimore, 1963.
Kaufman, Boris: "Film Making as an Art," *Daedalus*, vol. 89, pp. 138–143, 1960.
Knight, Arthur: *The Liveliest Art*, New York, 1957.
Lawson, John H.: *Film: The Creative Process*, New York, 1964.
Leyda, Jay: *Films Beget Films*, New York, 1964.
Lindgren, Ernest: *The Art of the Film*, New York, 1963.
MacCann, Richard Dyer, (ed).): *Film: A Montage of Theories*, New York, 1966.
Newhall, B.: *Photography*, New York: Museum of Modern Art, 1938.
Nicoll, Allardyce: *Film and Theatre*, New York, 1936.
Nizhny, Vladimir: *Lessons with Eisenstein*, New York, 1962.
Panofsky, Erwin: "Style and Medium in the Motion Pictures," *Critique*, January–February, 1947.
Spottiswoode, Ray: *The Film and Its Techniques*, Berkeley, 1951.
————: *A Grammar of the Film*, Berkeley, 1950.
Stephenson, Ralph and Debrix, J. R.: *The Cinema as Art*, Baltimore, 1965.
Taylor, John Russell: *Cinema Eye, Cinema Ear*, New York, 1964.